GAUGUIN
CÉZANNE
MATISSE

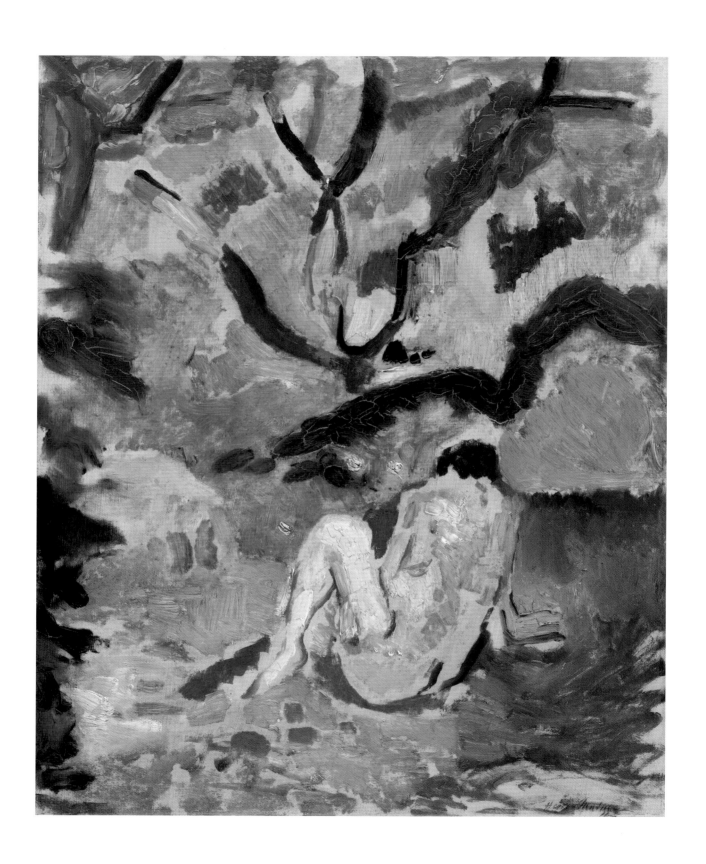

GAUGUIN
CÉZANNE
MATISSE

VISIONS OF ARCADIA

EDITED BY

JOSEPH J. RISHEL

WITH ESSAYS BY

STEPHANIE D'ALESSANDRO, CHARLES DEMPSEY,

TANJA PIRSIG-MARSHALL,

JOSEPH J. RISHEL, AND GEORGE T. M. SHACKELFORD

PHILADELPHIA MUSEUM OF ART

Published on the occasion of the exhibition
Gauguin, Cézanne, Matisse: Visions of Arcadia
Philadelphia Museum of Art
June 20–September 3, 2012

The exhibition was supported by an indemnity from the Federal Council on the Arts and the Humanities. Additional support was provided by Mrs. Louis C. Madeira IV, The Margaret A. Cargill Foundation, The Pew Charitable Trusts, The Annenberg Foundation Fund for Exhibitions, The Robert Montgomery Scott Fund for Exhibitions, The Kathleen C. and John J. F. Sherrerd Fund for Exhibitions, The Arcadia Foundation, Dennis Alter, Barbara B. and Theodore R. Aronson, and other generous individuals.

The accompanying publication was supported by The Andrew W. Mellon Fund for Scholarly Publications at the Philadelphia Museum of Art.

[Credits complete as of May 3, 2012.]

Back jacket (top to bottom): Paul Gauguin, *Where Do We Come From? What Are We? Where Are We Going?*, 1897–98 (pages xi–xii and fig. 146); Paul Cézanne, *The Large Bathers*, 1900–1906 (page xii and fig. 155); Henri Matisse, *Bathers by a River*, 1909–10, 1913, 1916–17 (pages xiii–xiv and fig. 172)

Frontispiece: Henri Matisse, *Nude in a Wood*, 1906 (fig. 59)

Produced by the Publishing Department
Philadelphia Museum of Art
Sherry Babbitt, The William T. Ranney
Director of Publishing
2525 Pennsylvania Avenue
Philadelphia, PA 19130 USA
www.philamuseum.org

Edited by Sarah Noreika
Production by Richard Bonk
Designed by Katy Homans
Color separations, printing, and binding by
Die Keure, Brugge, Belgium

Library of Congress Cataloging-in-Publication Data

Gauguin, Cézanne, Matisse : visions of Arcadia.
 pages cm
Published on the occasion of the exhibition
Gauguin, Cézanne, Matisse: Visions of Arcadia,
Philadelphia Museum of Art, June 20–
September 3, 2012.
Includes bibliographical references and index.
ISBN 978-0-87633-239-9 (pma cloth) –
ISBN 978-0-300-17980-4 (yale cloth)
1. Arcadia in art—Exhibitions. I. Rishel,
Joseph J., curator. II. Philadelphia Museum
of Art, host institution.
 N8205.G38 2012
 759.4074′74811—dc23
 2012013803

Contents

vii LENDERS TO THE EXHIBITION

viii FOREWORD
 Timothy Rub

xi GATEFOLD
 Paul Gauguin, *Where Do We Come From? What Are We? Where Are We Going?*, 1897–98
 Paul Cézanne, *The Large Bathers*, 1900–1906
 Henri Matisse, *Bathers by a River*, 1909–10, 1913, 1916–17

1 Introduction and Acknowledgments
 Joseph J. Rishel

15 Arcadia 1900
 Joseph J. Rishel

125 The Painter's Arcadia
 Charles Dempsey

143 Trouble in Paradise
 George T. M. Shackelford

163 Cézanne, Virgil, Poussin
 Joseph J. Rishel

181 Re-visioning Arcadia: Henri Matisse's *Bathers by a River*
 Stephanie D'Alessandro

195 "Dream the Myth Onwards": Visions of Arcadia in German Expressionist Art
 Tanja Pirsig-Marshall

214 CHECKLIST OF THE EXHIBITION
 Compiled by *Naina Saligram*

233 SELECTED BIBLIOGRAPHY

238 INDEX OF WORKS ILLUSTRATED

243 PHOTOGRAPHY CREDITS

Lenders to the Exhibition

The Art Institute of Chicago

The Barnes Foundation

Jean-Luc Baroni, London

Brooklyn Museum

Mr. and Mrs. Walter F. Brown

The Cleveland Museum of Art

Detroit Institute of Arts

Galerie du Post-Impressionnisme, Paris

The Metropolitan Museum of Art, New York

The Minneapolis Institute of Arts

Musée d'Art Moderne de la Ville de Paris

Musée de Grenoble

Musée de l'Orangerie, Paris

Musée du Louvre, Paris

Musée National d'Art Moderne / Centre de Création Industrielle, Centre Georges Pompidou, Paris

Museo Thyssen-Bornemisza, Madrid

Museum of Fine Arts, Boston

The Museum of Modern Art, New York

Museum Wiesbaden

National Gallery of Art, Washington, DC

National Gallery of Canada, Ottawa

The Phillips Collection, Washington, DC

Stedelijk Museum, Amsterdam

And anonymous lenders

as of May 3, 2012

Foreword

The kernel of thought from which the exhibition *Gauguin, Cézanne, Matisse: Visions of Arcadia* grew came from a simple yet ambitious suggestion made to me several years ago by Joseph J. Rishel, the Gisela and Dennis Alter Senior Curator of European Painting before 1900, and Senior Curator of the John G. Johnson Collection and the Rodin Museum, at the Philadelphia Museum of Art. Would it be possible, he asked, to bring together Paul Cézanne's *Large Bathers*, one of the most celebrated works in the Museum's collection, and, from the collection of the Art Institute of Chicago, Henri Matisse's *Bathers by a River*? Among the finest and most powerful of Matisse's paintings, *Bathers by a River* is also a brilliant response to Cézanne's treatment of the same theme and a testament to the deep regard Matisse had for his work.

Perhaps it would have been sufficient to stop there, but further discussion about these two paintings and their relationship to each other resulted in the decision to explore the profound impact that Cézanne's *Large Bathers* had on the European avant-garde during a period of creative ferment in the first two decades of the twentieth century. Of the several versions of this subject painted by Cézanne, the Philadelphia canvas is both the largest as well as one of his last. When, in 1907, a year after the artist's death, it was exhibited for the first time, its reception quite literally altered the course of modern art. Setting aside the question of why the subject of figures in an idealized landscape held such fascination for the generation of Matisse, André Derain, Pablo Picasso, and Robert Delaunay — to name just a few of the artists who took up this theme — the fact is that it was profoundly influential. The changes it precipitated are most notable in Matisse's art, but there are many other examples to which we can point that clearly reflect a new interest in this theme — and, to frame this more broadly and in a slightly different way, in the image of Arcadia.

The dream of Arcadia, a mythic place of beauty and repose where humankind lives in harmony with nature, has retained an enduring appeal for artists since antiquity. With its promise of calm, simplicity, and order, it has served both as an inspiration — the sought for, but never fulfilled, ideal of a paradise here on earth — and as an image of refuge, a distant place seemingly protected from the vicissitudes of life. On the face of things, we may find it exceedingly curious that a subject so firmly rooted in the classical tradition should have played any role at all in the formation of modern painting. Yet, during the late nineteenth and early twentieth centuries, at a time of sweeping and often disruptive change, this dream clearly found a powerful new currency and once again spurred the imagination of a new generation of painters, many of whom were central to the development of modern art.

Arcadia is, therefore, the overarching theme of this catalogue and the exhibition it accompanies. To amplify and give proper shape to the narrative, we begin by looking back to Nicolas

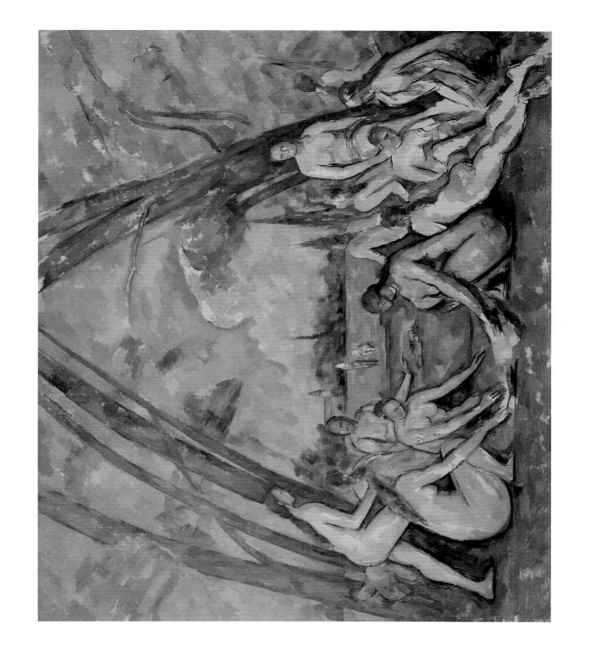

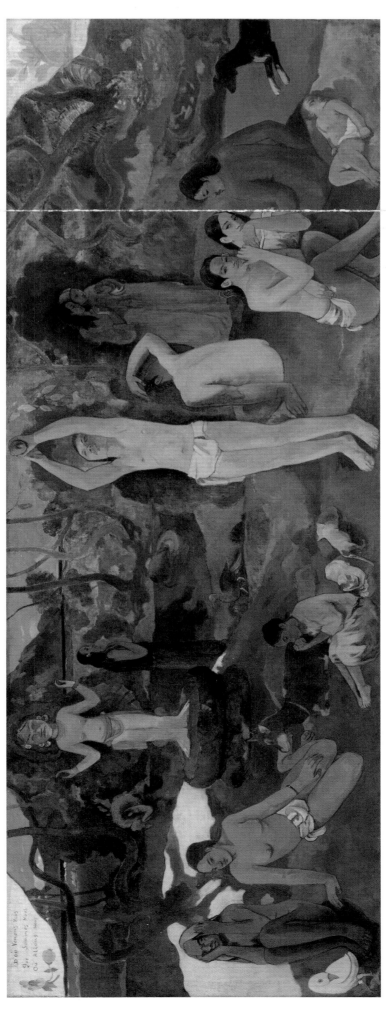

Poussin, whose canvases served as a point of reference for many great painters of the nineteenth century, including Jean-Baptiste-Camille Corot and Pierre Puvis de Chavannes, both of whom remained fascinated with this subject throughout their careers. And we have included a number of works by artists such as Henri Rousseau and Paul Gauguin—most notably the latter's masterpiece *Where Do We Come From? What Are We? Where Are We Going?* (*D'où venons-nous? Que sommes-nous? Où allons-nous?*), from the collection of the Museum of Fine Arts, Boston—who further complicated an already rich and interesting story by imagining an Arcadia far distant in place and in spirit from the classical tradition that was their inheritance.

We are deeply grateful to our colleagues in Chicago and Boston for their willingness to lend their great paintings by Matisse and Gauguin, respectively, to this exhibition, and to the many other lenders, both public institutions and private collectors, who have so generously agreed to help us with the realization of this ambitious project.

I would like to express our sincere gratitude to the many funders who have supported the development of the exhibition and this catalogue: Mrs. Louis C. Madeira IV, The Margaret A. Cargill Foundation, The Pew Charitable Trusts, The Annenberg Foundation Fund for Exhibitions, The Robert Montgomery Scott Fund for Exhibitions, The Kathleen C. and John J. F. Sherred Fund for Exhibitions, The Arcadia Foundation, Dennis Alter, and Barbara B. and Theodore R. Aronson. The exhibition also has been assisted by an indemnity from the Federal Council on the Arts and the Humanities, and I would like to take this opportunity, on the occasion of her retirement, to offer our deepest thanks to Alice Whelihan for her remarkable leadership of this program over the course of many years. I know that I speak for all my colleagues when I say that she has done great things for our field and will be missed dearly. The production of this catalogue was made possible by The Andrew W. Mellon Fund for Scholarly Publications at the Philadelphia Museum of Art.

To the many members of the Museum's staff—recognized by name in the acknowledgments that follow—who have made significant contributions to this project, I extend our gratitude for their dedication and support. Several deserve special mention—Katherine Sachs, Naina Saligram, and Sarah Noreika among them—but the greatest credit is due to Joseph Rishel. In a very busy year he took on yet another project and has carried it off with characteristic intelligence, creativity, and an abundance of good cheer.

Timothy Rub
The George D. Widener Director and Chief Executive Officer

PAUL GAUGUIN
French, 1848–1903
Where Do We Come From? What Are We? Where Are We Going?
(D'où venons-nous? Que sommes-nous? Où allons-nous?)
1897–98
Oil on canvas, 4 feet 6¾ inches × 12 feet 3½ inches (1.39 × 3.75 m)
Museum of Fine Arts, Boston. Tompkins Collection—Arthur Gordon Tompkins Fund, 36.270

PAUL CÉZANNE
French, 1839–1906
The Large Bathers
1900–1906
Oil on canvas, 6 feet 10⅞ inches × 8 feet 2¾ inches (2.1 × 2.5 m)
Philadelphia Museum of Art. Purchased with the W. P. Wilstach Fund. W1937-1-1

HENRI MATISSE
French, 1869–1954
Bathers by a River
March 1909–10, May–November 1913, and early spring 1916–October(?) 1917
Oil on canvas, 8 feet 6⅞ inches × 12 feet 10⁷⁄₁₆ inches (2.6 × 3.92 m)
The Art Institute of Chicago. Charles H. and Mary F. S. Worcester Collection, 1953.158

1
PAUL CÉZANNE
French, 1839–1906
Three Bathers
c. 1875
Oil on canvas, 12 × 13 inches (30.5 × 33 cm)
Private collection

Introduction
and Acknowledgments

JOSEPH J. RISHEL

Daphnis, in radiant beauty, marvels at Heaven's unfamiliar threshold,
and beneath his feet beholds the clouds and stars.
Therefore frolic glee seizes the woods
and all the countryside, and Pan, and the shepherds, and the Dryad maids.
The wolf plans no ambush for the flock, and
nets no snare for the stag; kindly Daphnis loves peace.
—VIRGIL, *Eclogues* 5:56–61

In 2009 the Philadelphia Museum of Art presented the ambitious exhibition *Cézanne and Beyond*, which placed some sixty works by Paul Cézanne in company with more than one hundred paintings and sculptures by nineteen artists, from the early twentieth century to the present, for whom Cézanne has held special meaning.[1] It came as no surprise that one of the most fruitful and compelling engagements was that between Cézanne and Henri Matisse, so concretely documented by the latter's purchase of Cézanne's small *Three Bathers* (1879–82; fig. 2) from the dealer Ambroise Vollard in 1899. Matisse gave the painting to the Musée des Beaux-Arts de la Ville de Paris du Petit Palais in 1936 with the benediction: "In the thirty-seven years I have owned this canvas, I have come to know it quite well, I hope, though not entirely; it has sustained me morally in the critical moments of my venture as an artist; I have drawn from it my faith and my perseverance."[2]

In the 2009 installation (fig. 3) we were able to confirm this sentiment by placing Cézanne's *Three Bathers*, together with the Philadelphia *Large Bathers* (1900–1906; see page xii and fig. 155), near eleven works by Matisse, including the paintings *Bathers with a Turtle* (1907–8; see fig. 173) and *Bather* (1909), and the bronze relief *Back I* (1909). A critical element missing in our display of encounters between these two artists was Matisse's grand *Bathers by a River* from the Art Institute of Chicago (1909–10, 1913, 1916–17; see pages xiii–xiv and fig. 172), which we knew, even as we were starting our preparations for *Cézanne and Beyond*, would not be available for loan since it was undergoing examination in the institute's conservation laboratory. This close study proved to be remarkable in documenting for the first time the picture's long evolution in three working stages, from 1909 until 1917, the findings of which were revealed in the 2010 exhibition *Matisse: Radical Invention, 1913–1917*, in Chicago and at the Museum of Modern Art in New York, and are the basis for Stephanie D'Alessandro's essay in the present catalogue.[3]

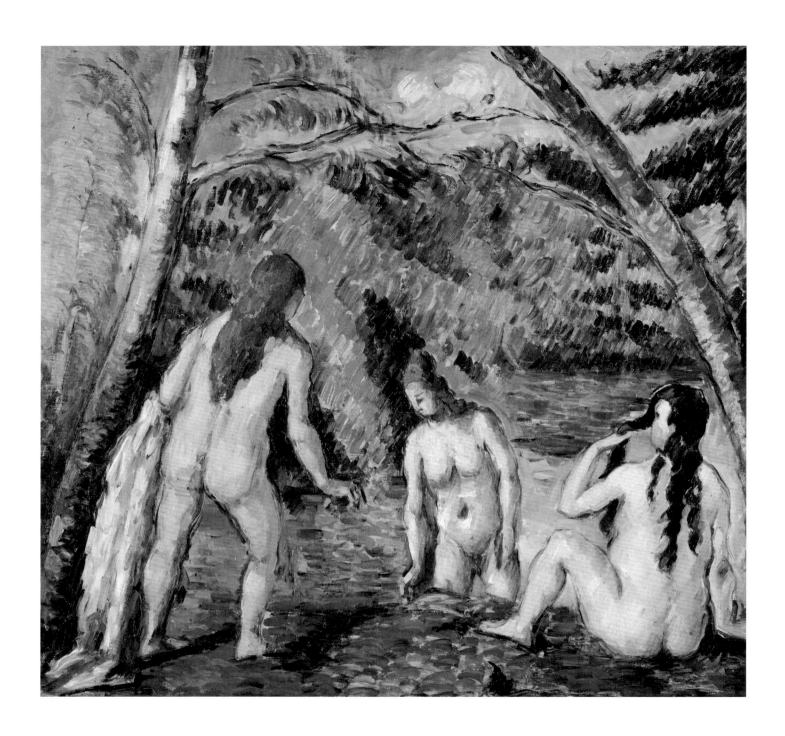

2

PAUL CÉZANNE

French, 1839–1906

Three Bathers

1879–82

Oil on canvas, 20½ × 21⅝ inches (52.1 × 54.9 cm)

Musée des Beaux-Arts de la Ville de Paris du Petit Palais

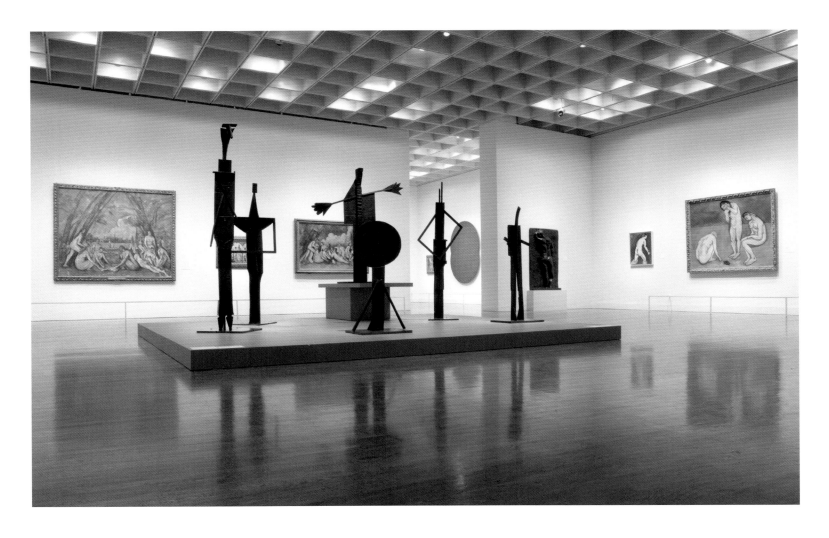

3

Installation view of the exhibition
Cézanne and Beyond, Philadelphia
Museum of Art, 2009

What was a disappointment over incompatible timing in 2009 soon turned into a delightful new opportunity with our Chicago colleagues' very gracious agreement to lend *Bathers by a River* to the Philadelphia Museum of Art in 2012 to be shown next to Cézanne's *Large Bathers*. This occasion proved to be the seed for the present exhibition by allowing us to shift ground a bit — to step back and ask new questions provoked by the pairing of these two masterpieces that long have held central positions in our understanding of the evolution of modern art, and to explore more fully their essential subject: nude players gathering in out-of-time, bucolic settings, often referred to as Arcadia.

The alliance between Matisse's *Bathers by a River* and Cézanne's *Large Bathers* in itself would have been an act of sufficient consequence to stop right there, to continue the essentially formalist pursuits of *Cézanne and Beyond* and give more focus to other issues implicit in the 2009 gathering. However, with the opportunity to include alongside these two pictures Paul Gauguin's epic painting *Where Do We Come From? What Are We? Where Are We Going?* (*D'où venons-nous? Que sommes-nous? Où allons-nous?*) of 1897–98 (see pages xi–xii and fig. 146), a range of new possibilities opened up that have culminated in the present catalogue and exhibition. Primary among them was the chance to expand the long-suspended question of "meaning," specifically the authority of Arcadia as a central concern in the history of French art from Nicolas Poussin in the seventeenth century onward. Our own exploration considers how this interest was confirmed in Cézanne's love of Virgil, inherited by Matisse through association, and transformed, and in many ways intensified,

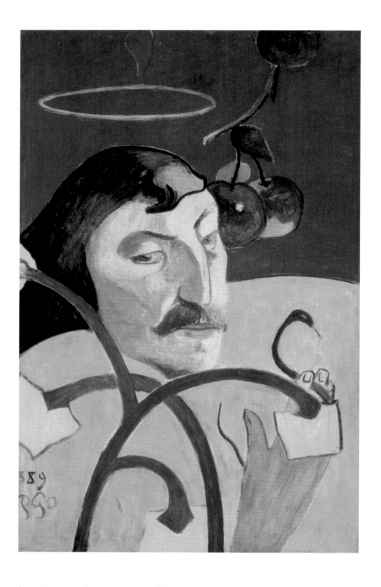

4

PAUL GAUGUIN

French, 1848–1903

Self-Portrait

1889

Oil on wood, 31�5⁄16 × 20⅜ inches
(79.6 × 51.8 cm)

National Gallery of Art, Washington,
DC. Chester Dale Collection,
1963.10.150

by Gauguin's creation of his own repertory of Arcadian longings, both fulfilled and thwarted, that replaced the classical idyll with exotic primitivism, often with remarkably similar ends.

Why did three of the most radical artists of their time, when they wished to make their most public declarations in their largest and most ambitious formats, select, or perhaps revert to, one of the most hallowed and established subjects in the history of Western painting? This, after all, was a subject at the top of the hierarchy of values, firmly established by the authority of the Academy in the seventeenth century when Poussin was reclaimed as a French painter — their "Apollo," in fact — and held in complete faith straight through the nineteenth century to the threshold of the twentieth century, from Jean-Auguste-Dominique Ingres to Jean-Baptiste-Camille Corot to Pierre Puvis de Chavannes, figures whom modern sensibilities have established as *the* masters of the grand manner. Add to this similar works, some even more ambitious in terms of scale, by Émile Bernard, Maurice Denis, Paul Signac, Georges Seurat, Henri-Edmond Cross, Aristide Maillol, André Derain, Pablo Picasso, Henri Rousseau, Robert Delaunay, Albert Gleizes, and Jean Metzinger, and a very engaging terrain of visual exploration presented itself. The result is the exhibition and accompanying catalogue you see here — *Gauguin, Cézanne, Matisse: Visions of Arcadia*, with our three main players bringing into focus the potency with which visions of Arcadia, deeply rooted in French sensibilities, not only were sustained but gained new meaning around 1900.

This is not, of course, a new or an original enterprise; the tracking of classical (and, more to our point, poetic and idyllic) themes among late nineteenth- and early twentieth-century artists abounds in projects as diverse as John Elderfield's presentation of Fauvism; Margaret Werth's lyrical route to Matisse's *Bonheur de vivre* (1905–6; see fig. 58); Annabel Patterson's exploration of the afterlife of Virgil's *Eclogues*; and Serge Lemoine's extravagant tale of Puvis and his influence.[4] We are grateful to them and the many scholars who have laid the foundations for our present endeavors.

To start with our three central artists and their intersection, Matisse's bond with Cézanne has been a touchstone of modern art history, with the artist's oft-quoted statement, "If Cézanne is right, I am right," reconfirmed by the discovery of the long, complex history of his *Bathers by a River*.[5] It is now apparent that what started out in 1909 for Matisse as a rather blithe step away from the gravity of Cézanne, as evidenced by his initial watercolor of the subject (see fig. 175), evolved over time into a highly formal positioning of four figures in separately paneled spaces with a dignity and authority that look right back to Cézanne, whose *Large Bathers* (the version now in the Philadelphia Museum of Art) Matisse would have seen in Paris at the 1907 Salon d'Automne.[6] In magical ways that trace the paintings' suggestive but completely independent evolutions, Matisse's four figures seem to be from the same ether as the bathers in Cézanne's more populated field, sharing a stately, adagio-paced existence with similar physical forms and states of mind (as well as the same poised sense of purpose in the whole of statuesque dancers on a grand stage who are destined never to collide). With sufficient lyrical elements—the two arched parallel lines in the blue and white panels at right, the foliage at left, the panel of "lake" blue at the top, and, of course, the snake protruding from the bottom—Matisse has carried Cézanne (and Poussin, by extension) straight into the twentieth century.

Matisse's concrete connections with Gauguin are less evident. We must thank George Shackelford, who in this catalogue writes on Gauguin and Arcadia, for the notion that the "serpent of temptation" in the black panel of *Bathers by a River* is a near quote from Gauguin's vitiated snake in his 1889 *Self-Portrait* (fig. 4).[7] Matisse owned one work by Gauguin, and one wonders if the grand figures in the latter's 1896 painting *Delightful Day* (*Nave nave mahana*; see fig. 152) were, for Matisse, somehow behind his creation of the increasingly shallow space in *Bathers by a River*.[8] Matisse clearly was well aware of Gauguin's *Where Do We Come From?*: He had recommended it to his Russian patrons Ivan Morozov and Sergei Shchukin for purchase when the painting came back on the market in 1913, the same year that he resumed work on *Bathers by a River*.[9] To what degree Matisse's *Nymph and Satyr* (1908–9; see fig. 70) is a descendent of Cézanne's *Lutte d'amour* (c. 1880; see fig. 67) or of a work by Gauguin is an open question. The fact that Matisse's great escape to Tahiti in 1930 had a profound effect on his choice of imagery for *The Dance* mural commissioned later that year from Albert C. Barnes (see fig. 66) leads one nicely (if not dangerously) down an alley of associative thoughts beyond objective bonds.

Gauguin's attraction to Cézanne—a mixture of stealth, profound need, and intelligent self-knowledge—is a familiar story. While still a stockbroker, he purchased six works by Cézanne, his prized possession and the last to be sold when he was in financial trouble being, famously, *Still Life with Fruit Dish* (1879–80; fig. 5), which positioned him as the surrogate artist in Maurice Denis's

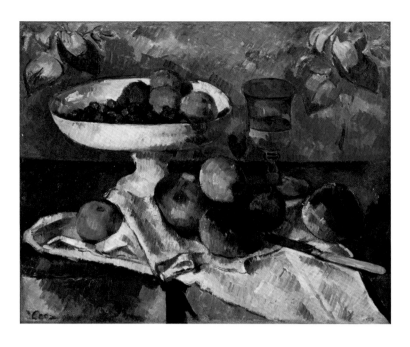

5
PAUL CÉZANNE
French, 1839–1906
Still Life with Fruit Dish
1879–80
Oil on canvas, 18¼ × 21½ inches
(46.4 × 54.6 cm)
The Museum of Modern Art, New
York. Fractional gift of Mr. and Mrs.
David Rockefeller

6
PAUL GAUGUIN
French, 1848–1903
*Woman in Front of a Still
Life by Cézanne*
1890
Oil on canvas, 25¹¹⁄₁₆ × 21⅝ inches
(65.3 × 54.9 cm)
The Art Institute of Chicago. Joseph
Winterbotham Collection, 1925.753

Homage to Cézanne (1900; see fig. 39).[10] Gauguin had quoted Cézanne's still life in *Woman in Front of a Still Life by Cézanne* (1890; fig. 6), about the same time as he reconsidered similar compositions in such works as *Still Life with Bowl of Fruit and Lemons* (c. 1889–90; fig. 7). The memory of the canvas likewise permeated the still lifes he painted in Tahiti, including *Still Life with Teapot and Fruit* (1896; fig. 8).[11]

For *Where Do We Come From?*, the primary issue is how well Gauguin knew Cézanne's *Bathers at Rest* (1876–77; see fig. 165), which his colleague and friend Gustave Caillebotte had acquired in 1881.[12] It seems highly likely that Gauguin knew the picture from the Impressionist show of 1877, given his attention to new art.[13] In *Where Do We Come From?*, the standing male in the center, the distribution of the lounging figures on the left on a shallow shelf of land (*pace* the absence of an idol and lots of wild- and pet life), and especially the oppressive eroticism of the dense and pressing landscape and sky, as well as the deeply sensual nature of the whole, seem to suggest Cézanne's painting as the potent progenitor for Gauguin's masterpiece.

The mining of Cézanne by Gauguin is an open and rich field, but to reverse the equation is to topple it completely, with the Zeusian slam of Cézanne's statement that Gauguin was stealing his "little sensation."[14] Cézanne's suspicions, of course, were right, proven by an 1881 letter from Gauguin to Camille Pissarro, in which the author wryly sought to discover the secret of how Cézanne made those little strokes that are abundantly clear in Gauguin's handling of paint until the end. He wrote to Pissarro in jest (with the humor of a pirate): "If he [Cézanne] finds the recipe for compressing the exaggerated expression of all his sensations into a single and unique procedure, I beg of you to make him talk about it in his sleep, by giving him one of those mysterious homeopathic drugs and come to Paris as soon as possible to tell me about it."[15]

At least from Cézanne's cranky protest we know that Gauguin was sometimes on the elder artist's mind, although not as often or as urgently as he was for Gauguin, a circumstance best

7

PAUL GAUGUIN
French, 1848–1903

Still Life with Bowl of Fruit and Lemons

c. 1889–90

Oil on canvas, 19¹¹⁄₁₆ × 24 inches (50 × 61 cm)

Museum Langmatt Stiftung Langmatt Sidney und Jenny Brown, Baden/Schweiz

8

PAUL GAUGUIN
French, 1848–1903

Still Life with Teapot and Fruit

1896

Oil on canvas, 18¾ × 26 inches (47.6 × 66 cm)

The Metropolitan Museum of Art, New York. The Walter H. and Leonore Annenberg Collection, Gift of Walter H. and Leonore Annenberg, 1997, Bequest of Walter H. Annenberg, 2002 (1997.391.2)

noted by Gauguin's description of Cézanne as "a man of the Midi," who "spends entire days on mountaintops reading Virgil and looking at the sky."[16] There is, however, a set of nagging evidence on which one would love to build. As Isabelle Cahn established, Cézanne rented a studio in Paris in the Villa des Arts at 15, rue Hégésippe-Moreau (see fig. 10) from January 1898 to 1899, during which time Vollard posed for his portrait by Cézanne and exhibited Gauguin's *Where Do We Come From?* at his gallery.[17] Hard evidence like this is the road to madness, as is one's hope to take out Cézanne in advance of an isolated modernism. To follow some, by the 1890s he was too "ahead" to allow anything as superficial as external artistic influences. Perhaps the juxtaposition in our exhibition of these two artists will provoke new insights, but at this writing, one can only speculate that the profound sensuality of Gauguin's masterpiece correlates in some fashion to that with which Cézanne would endow his *Large Bathers*, if not the Philadelphia version, then the version at the Barnes Foundation (c. 1895–1906; see fig. 169), with its sultry density and opulent celebration of flesh.

It is a huge subject, Arcadia, even if we have contained ourselves to works dating from 1884, when Seurat showed his study for *La Grande Jatte* (see fig. 49) at the first Salon des Indépendants, to late in 1917, when Matisse stopped work on *Bathers by a River*, in addition to a handful of major earlier works that provide the foundations and precedents back to Poussin, whose canvases serve as the touchstone for artistic definitions of Arcadia, as Charles Dempsey discusses in this catalogue.[18]

Of course, other equally revealing and pleasurable road maps are available in the loosely defined realm (in poetry as in art) of the pastoral, or the bucolic, the most famous example from the nineteenth century being Édouard Manet's exploitation of the great *Concert champêtre*, attributed to Titian and dated to about 1509 (see fig. 139), for his own *Luncheon on the Grass* (*Le déjeuner sur l'herbe*) (1863; fig. 9), followed in 1876 by his illustrations to Stéphane Mallarmé's poem "L'après-midi

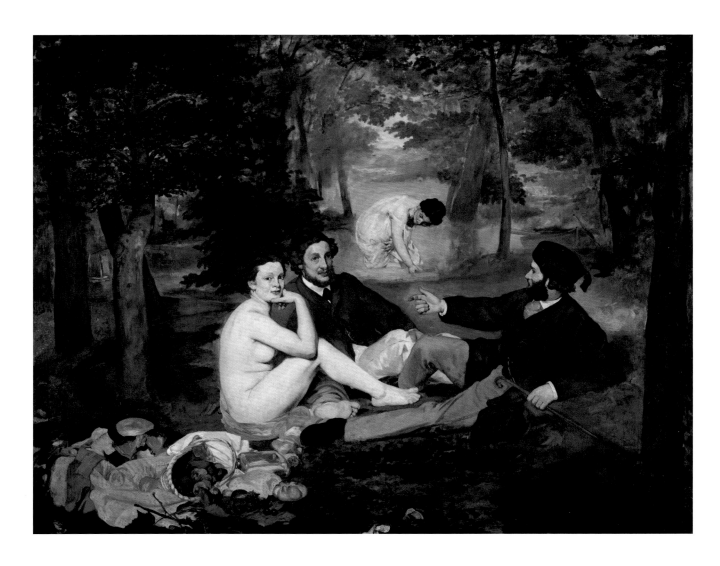

9

ÉDOUARD MANET
French, 1832–1883
The Luncheon on the Grass
(*Le déjeuner sur l'herbe*)
1863
Oil on canvas, 6 feet 9⅞ inches ×
8 feet 10⅛ inches (2.08 × 2.64 m)
Musée d'Orsay, Paris

10

Villa des Arts, 15, rue Hégésippe-
Moreau, Paris

d'un faune" ("The Afternoon of a Faun"; 1876).[19] However, as made evident in many ways by the wonderful exhibition *The Pastoral Landscape: The Legacy of Venice and the Modern Vision* in Washington, DC, in 1988–89, the lines of thought and sentiments in play here are split between the Venetians and the "Poussinistes," with the Arcadian notions at the core of our own exploration in alliance with those of the latter.[20] Perhaps the most telling evidence of this divide is Cézanne's almost caricatured version of Manet's *Luncheon*, his *Pastoral* of 1870 (fig. 11), in which the central male figure, fully clothed and uncomfortable, clearly would rather be somewhere else.

As much as our story is a French one, with its own elegant containment and authoritative tone, we are indebted to Timothy Rub, the George D. Widener Director and Chief Executive Officer of the Philadelphia Museum of Art, for suggesting early on that we step outside—if only to further clarify the purity of the French line into the twentieth century—and include Germans from both Dresden and Munich, as well as one progressive Muscovite, Natalia Sergeyevna Goncharova, and a grand figure from Saint Petersburg, Nicholas Konstantinovich Roerich, all of whom explored Arcadian concerns around 1900 from perspectives quite different from, albeit keenly alert to, those of their colleagues in Paris. The German Expressionists in particular were nurtured by a new "Nietzschean vitalism," as our colleague Michael Taylor has described it, and you will find them in their own supportive essay by Tanja Pirsig-Marshall in this publication.[21]

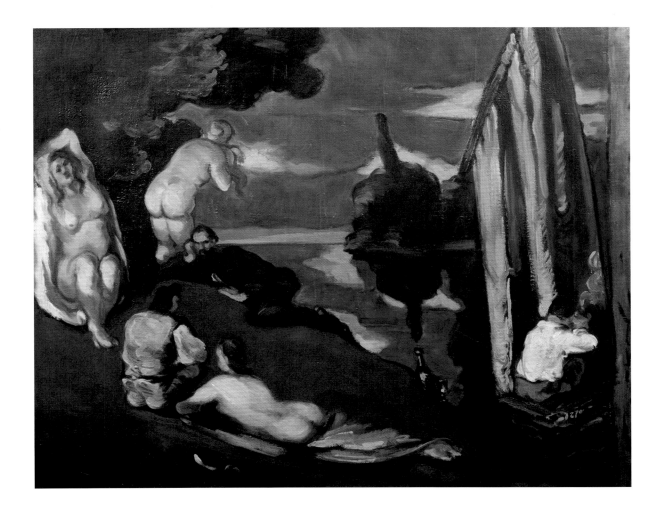

II

PAUL CÉZANNE

French, 1839–1906

Pastoral

1870

Oil on canvas, 25⁹/₁₆ × 31⅞ inches
(65 × 81 cm)

Musée d'Orsay, Paris

All projects have their measure of disappointment, which were slight in our case and perhaps are described best as sins of omission. As aware as we have been of the history of Arcadian literature from Theocritus to Mallarmé, John Milton to Tom Stoppard, we leave it to others, at another moment, to address this in its own right, just as we eagerly await the future scholars who will tackle the ambitious task of writing a summation of the state of Arcadian literature around 1900 with a review of its critical fortunes during the late nineteenth and early twentieth centuries. Just as important is the need to follow through with the suggestion of the conductor Leon Botstein—a thrilling one, in fact, given his enthusiasm for the subject and immediate density of ideas as how best to address it—of taking on a similar exploration of Arcadian themes as they affected music during this time.[22]

In the evolution of this exhibition, many friends and colleagues helped shape the ideas for both the show and the catalogue. First is Françoise Cachin, with whom I worked so closely on the 1995–96 Cézanne retrospective at the Philadelphia Museum of Art. When I proposed to her the idea of exploring modern notions of Arcadia, she leapt at the opportunity, noting that she had wanted to work on the subject since her student days, but it had been deflected by other studies and tasks in her prolific career. The closest she came was in the wonderful 2000–2001 exhibition *Méditerranée: De Courbet à Matisse* at the Galeries Nationales du Grand Palais in Paris, the catalogue of which features

a small section on Arcadia that focuses more on the specificity of place and its effect than on the idea of Virgil's Arcadia and its legacy. We talked and had fun. I dedicate this book to her memory.

My greatest allies in the conception and realization of this project were the museum's director, Timothy Rub, with whom I discussed nearly every work proposed for the show, and Michael Taylor, the museum's former curator of modern art (now director of the Hood Museum of Art at Dartmouth College in Hanover, New Hampshire), to whom full credit should be given for the creation of, and specific selections in, the exhibition's Cubist section, and, most notably, the negotiation for the remarkable loan of Robert Delaunay's *City of Paris* from the Centre Georges Pompidou in Paris. He was kind enough to review my texts, with a sharp eye on the early twentieth-century sections, though any errors in fact and ideas are completely mine. Yve-Alain Bois, along with Neil L. and Angelica Rudenstine, suffered long evenings and dinner tables strewn with still-warm photocopies. Margaret Werth will find much of what she initiated in her 2002 book *The Joy of Life: The Idyllic in French Art, circa 1900* on display in this exhibition. Charles Dempsey and Elizabeth Cropper were very productive interlocutors with ideas in progress, especially since so much of my research and thinking on this subject took place in 2010–11, during a very appreciated year as the Samuel H. Kress Professor at the Center for Advanced Study in the Visual Arts at the National Gallery of Art in Washington, DC. I am indebted particularly to Janna Israel, my research associate at the center, as well as to the many students and colleagues who contributed greatly to the formation of this exhibition's concept and selection of objects, through talks on topics ranging from the artistic use of Virgilian words in antiquity to notions of Arcadia in Puritan New England.

As in the past, I continue my dependence for all issues, large and small, on Adrianne Bratis and Katherine Sachs, to whom I am particularly grateful for steady reminders of the continuing life of Arcadian manifestations in art of our own time. Jennifer Vanim has been, as ever, in central control of nearly all information and images involved in the project as well as the preparation of texts. She was most fortuitously joined rather late in the game by Naina Saligram, as chief researcher and fact-checker, who became a substantial player in the final moldings of the exhibition and catalogue. And a bouquet goes to my colleague Carlos Basualdo, who patiently listened and vetted random thoughts over Sunday suppers.

The critical players in making possible the truly impressive, and in some cases unprecedented, loans to the exhibition are: in Paris, Irène Bizot, Pierre Provoyeur, Vincent Pomarède, Alfred Pacquement, Brigitte Léal, Fabrice Hergott, Guy Cogeval, and Aurélie Gavoille; in Montreuil, Dominique Voynet and Nicoletta Thibault; in Boston, George T. M. Shackelford and Malcolm Rogers; in Chicago, James Cuno, Douglas Druick, and Stephanie D'Alessandro; in New York, Ann Temkin, Cora Rosevear, Gary Tinterow, Richard Aste, Stephane Cosman Connery, and Sandy Heller; in Washington, DC, Earl A. Powell III, Dorothy Kosinski, and Eliza Rathbone; in Minneapolis, Patrick Noon; in Cleveland, William Robinson and David Franklin; in Philadelphia, Judith F. Dolkart and Derek Gillman; in San Antonio, Janet L. Brown, Lenora and Walter F. Brown, and Katherine Luber; in Detroit, Salvador Salort-Pons; in Ottawa, Anabelle Kienle; in London, Jean-Luc Baroni; in Geneva, Paul and Ellen Josefowitz; in Wiesbaden, Alexander Klar; in Amsterdam, Ann Goldstein; and in Madrid, Guillermo Solana.

Others provided scholarly advice and insights, including Nina Athanassoglou-Kallmyer, Harry Cooper, Kathleen A. Foster, Wolfgang Henze, Fred Leeman, Camran Mani, Tanja Pirsig-Marshall, Aimée Brown Price, Christopher Riopelle, Anne Rorimer, Jessica Ruse, Scott J. Schaefer, D. Dodge Thompson, and Jayne Warman.

For their help with and encouragement of the project, we thank William Acquavella, Jette Hoog Antink, Emily Antler, Jennifer Belt, Daniel DeSimone, Charlotte Eyerman, Richard L. Feigen, Hans Geissler, Wanda de Guébriant, Robert L. Herbert, Ingrid Kastel, Albert Kostenevich, Georges Liébert, Charlotte Liébert-Hellman, Deborah Lenert, Aimee Marshall, Gretchen Martin, Georges Matisse, Jacqueline Matisse Monnier, Howell Perkins, Rebecca Rabinow, Virginia Reynolds, Emily Ruotolo, Birgit Schulte, Carla Schulz-Hoffmann, Nicholas Serota, Michael Slade, Lucie Stradnova, Liselotte Stumpf, Peter C. Sutton, Barbara Wood, Sophia Somin Yoo, Wendy Zeiger, and Roman Zieglgänsberger.

At the Philadelphia Museum of Art, we are grateful to those who made this publication a reality—Sherry Babbitt, Richard Bonk, and Sarah Noreika, as well as the catalogue's designer, Katy Homans. We also appreciate the sustained efforts and support of Suzanne F. Wells and Tara Eckert. We are indebted to Ruth Abrahams, Barbara A. Bassett, Lawrence Berger, Ashley Carey, Mary Cason, Mark Castro, Conna Clark, Lindsey Crissman, Cassandra DiCarlo, Gretchen Dykstra, Camille Focarino, Ann Guidera-Matey, Catherine Herbert, Mary-Jean Huntley, Eliza deForest Johnson, Norman Keyes, Teresa Lignelli, Herbert J. Lottier, Martha Masiello, Kelly M. O'Brien, Suzanne P. Penn, Emily Schreiner, Innis Howe Shoemaker, Marla K. Shoemaker, Richard B. Sieber, Mimi B. Stein, Irene Taurins, Jennifer Thompson, Evan B. Towle, Mark S. Tucker, Kristina Garcia Wade, James Wehn, Jason Wierzbicki, Maia Wind, and Rebecca Winnington. The thoughtful design and installation of the exhibition were the work of Jack Schlechter and Jeffrey Sitton, with lighting by Andrew Slavinskas.

To those I have overlooked, I apologize. Finally, it must be noted that many of the ideas presented here, both in the texts and in the selection of works, were spawned through my talks with the late Anne d'Harnoncourt, who, herself a devoted student of John Golding, would be somewhat perplexed to find me writing on Cubism.

1. *Cézanne and Beyond*, Philadelphia Museum of Art, February 26–May 31, 2009. For the exhibition catalogue, see Joseph J. Rishel and Katherine Sachs, eds., *Cézanne and Beyond*, exh. cat. (Philadelphia: Philadelphia Museum of Art, 2009).

2. Matisse to Raymond Escholier, director of the Petit Palais, November 10, 1936, in *Matisse on Art*, ed. Jack D. Flam (London: Phaidon, 1973), p. 75.

3. *Matisse: Radical Invention, 1913–1917*, Art Institute of Chicago, March 20–June 20, 2010; and Museum of Modern Art, New York, July 18–October 11, 2010. For the exhibition catalogue, see Stephanie D'Alessandro and John Elderfield, *Matisse: Radical Invention, 1913–1917*, exh. cat. (Chicago: Art Institute of Chicago, 2010).

4. Elderfield, *The "Wild Beasts": Fauvism and Its Affinities*, exh. cat. (New York: Museum of Modern Art, 1976). See esp.

"The Pastoral, the Primitive, and the Ideal," pp. 97–140; Werth, *The Joy of Life: The Idyllic in French Art, circa 1900* (Berkeley: University of California Press, 2002); Patterson, *Pastoral and Ideology: Virgil to Valéry* (Berkeley: University of California Press, 1987); and Lemoine, ed., *From Puvis de Chavannes to Matisse and Picasso: Toward Modern Art*, exh. cat. ([Milan]: Bompioni, 2002).

5. Matisse, quoted in "Interview with Jacques Guenne" (1925), in Flam, *Matisse on Art*, p. 55. First published as "Entretien avec Henri Matisse," *L'art vivant*, no. 18 (September 15, 1925), pp. 1–6. On Cézanne and Matisse, see especially Yve-Alain Bois, "Cézanne and Matisse: From Apprenticeship to Creative Misreading," in Rishel and Sachs, *Cézanne and Beyond*, pp. 103–35.

6. *The Large Bathers* now in the National Gallery in London (1894–1905; see fig. 170) also was exhibited at the

1907 Salon d'Automne (no. 17; the Philadelphia version was no. 19).

7. Shackelford, conversation with the author, 2010.

8. Matisse acquired Gauguin's *Young Man with a Flower*, also called *Head of a Boy* (1891; Mavromatis Collection, New York), from Vollard in 1900 in exchange for one of his own works. See D'Alessandro and Elderfield, *Matisse*, p. 145; and Alfred H. Barr, Jr., *Matisse: His Art and His Public* (New York: Museum of Modern Art, 1951), p. 39.

9. On Matisse's recommendation to Morozov and Shchukin, see Stephanie D'Alessandro, "Re-visioning Arcadia: Henri Matisse's *Bathers by a River*," in this volume, p. 187; and D'Alessandro and Elderfield, *Matisse*, p. 146. Neither Morozov nor Shchukin purchased the painting, which Vollard originally had sold to Gabriel Frizeau in 1901 and which Frizeau then sold to the Galerie Barbazanges in Paris, probably in 1913.

10. Denis quoted Cézanne's *Still Life with Fruit Dish* in *Homage to Cézanne*. See Joseph J. Rishel, "Arcadia 1900," in this volume, p. 40. On Gauguin as a collector of Cézanne, see Merete Bodelsen, "Gauguin's Cézannes," *Burlington Magazine*, vol. 104, no. 107 (May 1962), pp. 204, 206–9, 211, and "Gauguin, the Collector," *Burlington Magazine*, vol. 112, no. 810 (September 1970), pp. 605–6. Cézanne's still life remained with Gauguin, despite his financial difficulties, until at least 1897, although it did not travel with him to Tahiti. In 1897 Gauguin regretfully wrote to the dealer Georges Chaudet in Paris asking him to sell the picture so he could get money for his hospital bills.

11. On Gauguin's interest in Cézanne as a model for this work, see Joseph J. Rishel, catalogue entry in *Masterpieces of Impressionism and Post-Impressionism: The Annenberg Collection*, new ed., ed. Susan Alyson Stein and Asher Ethan Miller (New York: Metropolitan Museum of Art, 2009), pp. 177–81, cat. 34.

12. The picture was bequeathed to the French state with the rest of Caillebotte's collection upon his death in 1893, but was refused and given instead to Caillebotte's brother.

13. Although Cézanne submitted his picture to the 1877 Impressionist show with the title *Les baigneurs — étude, projet de tableau*, suggesting that the work exhibited was a study and not the final composition, John Rewald has confirmed that *Bathers at Rest* was in fact the painting exhibited. See Rewald, *The Paintings of Paul Cézanne: A Catalogue Raisonné* (New York: Harry N. Abrams, 1996), vol. 1, pp. 177–80, cats. 259–61.

14. "Je n'avais qu'une petite sensation, Monsieur Gauguin me l'a volée!" Cézanne, quoted in Gustave Geffroy, *Claude Monet: Sa vie, son oeuvre* (1924; repr., Paris: Macula, 1980), p. 328; quoted in Guillermo Solana, "The Faun Awakes: Gauguin and the Revival of the Pastoral," in *Gauguin and the Origins*

of *Symbolism*, exh. cat. ([London]: Philip Wilson, 2004), p. 24n29 (my translation).

15. Gauguin to Pissarro, June 1881, in *Correspondance de Paul Gauguin, documents, témoignages*, ed. Victor Merlhès (Paris: Fondation Singer-Polignac, 1984), p. 21, trans. and quoted in Solana, "Faun Awakes," p. 24.

16. Gauguin to Émile Schuffenecker, January 14, 1885, in Merlhès, *Correspondance de Paul Gauguin*, p. 88, trans. and quoted in Françoise Cachin, "A Century of Cézanne Criticism: From 1865 to 1906," in *Cézanne*, ed. Françoise Cachin and Joseph J. Rishel, exh. cat. (Philadelphia: Philadelphia Museum of Art, 1996), pp. 28–29.

17. Cahn, "Chronology," in Cachin and Rishel, *Cézanne*, p. 556. *Where Do We Come From?* was shown, along with nine other paintings by Gauguin, at Vollard's gallery from November 17, 1898, to early January 1899. In 1899 Vollard commissioned Cézanne to paint his portrait, which he stopped working on before leaving for Aix that June.

18. While a definitive date for Matisse's completion of *Bathers by a River* has not been established, Stephanie D'Alessandro and John Elderfield have suggested that Matisse likely finished the canvas in October 1917, when he left for Nice. D'Alessandro and Elderfield, *Matisse*, pp. 346–47.

19. On Manet and Mallarmé, see Jean-Michel Nectoux, *Mallarmé: Un clair regard dans les ténèbres; Peinture, musique, poésie* (Paris: A. Biro, 1998).

20. *The Pastoral Landscape: The Legacy of Venice and the Modern Vision*, jointly held at the Phillips Collection and the National Gallery of Art, Washington, DC, November 6, 1988–January 22, 1989. For the exhibition catalogue, see Robert C. Cafritz, Lawrence Gowing, and David Rosand, *Places of Delight: The Pastoral Landscape*, exh. cat. (Washington, DC: Phillips Collection in association with National Gallery of Art, 1988).

21. Taylor, e-mail message to the author, December 22, 2010.

22. On this topic, see Guy Cogeval et al., *Debussy: La musique et les arts*, exh. cat. (Paris: Flammarion, 2012).

YET YOU, ARCADIANS, WILL SING

THIS TALE TO YOUR MOUNTAINS;
ARCADIANS ONLY KNOW HOW TO SING.

HOW SOFTLY THEN WOULD MY BONES
REPOSE,

IF IN OTHER DAYS YOUR PIPES SHOULD
TELL MY LOVE!

AND OH THAT I HAD BEEN ONE OF YOU,
THE SHEPHERD OF A FLOCK OF YOURS,

OR THE DRESSER OF YOUR RIPENED
GRAPES! . . .

HERE ARE COLD SPRINGS, LYCORIS, HERE
SOFT MEADOWS, HERE WOODLAND;

HERE WITH YOU, ONLY THE PASSAGE OF
TIME WOULD WEAR ME AWAY.

Arcadia 1900

JOSEPH J. RISHEL

It all begins, of course, with Virgil, particularly his *Eclogues* (37 BCE), which set into motion dreams of simple, bucolic pleasures acted out in a pastoral landscape in the valley of Arcadia in Greece, a setting that by the third century BCE had already been transferred to Sicily in the Greek poet Theocritus's *Idylls* (fig. 12), Virgil's model.¹ Arcadia was the home since prehistoric times of a race of shepherds and herdsmen who excelled in singing (often in competition), and in Virgil's world, it is a land of sensual delight, sustained by a diet of milk and honey (the food of the child Jupiter, provided by shepherds and nymphs).

In this Arcadia, fulfilled desire, as well as heartbreak and disappointment, is intertwined with long dalliances and pursuits accompanied by ballads and the pipes of Pan. Death and disorder are just off in the wings—as suggested by Sebastian Brant's illustration for *Eclogue* 5, of the death of the young shepherd Daphnis, the mythological inventor of pastoral poetry (fig. 13)—giving the poems, and nearly all later imaginings of Arcadia, a particularly poignant sense of incomprehensible loss, suffered in a perplexed and noble fashion.² Disengagement and even withdrawal of the gods from the activities of man and woman, leaving us suspended and abandoned but free, are a kind of subplot throughout the *Eclogues*. Virgil's tone is predominantly elegiac, elevated and knowing in profound ways that have carried over to correlated definitions of utopia, paradise, or the golden age. If the *Eclogues* evoke a sense of something lost, provoking nostalgia for a better time on earth, they also promise a harmonious future to come.

Few texts from classical antiquity have had such a rich life in picture-making, from Virgil's own time to the present, albeit with long periods of twilight followed by great bursts of concentration, as we learn from Charles Dempsey in his essay tracking Arcadian images and sentiment from the fourteenth century with the Sienese master Simone Martini to the seventeenth century with the great French classicist Nicolas Poussin.³ In our study, we commence with Poussin, who championed Arcadian notions in art as worthy and noble pursuits, sustained by the French Academy as founding principles of critical judgment well into the nineteenth century. Our central path is to show in a fairly evident track how much Arcadian ideas, and Virgil himself, meant to artists from Poussin to Jean-Auguste-Dominique Ingres, Jean-Baptiste-Camille Corot, and Pierre Puvis de Chavannes, gaining new momentum around 1900 with Paul Gauguin, Paul Cézanne, and Henri Matisse, as well as their contemporaries Émile Bernard, Maurice Denis, Paul Signac, Georges Seurat, Henri-Edmond Cross, Aristide Maillol, André Derain, Pablo Picasso, Henri Rousseau, Robert Delaunay, Albert Gleizes, and Jean Metzinger. In considering how, by the seventeenth century, Arcadian subjects were established firmly as the foundations of the grand manner of French

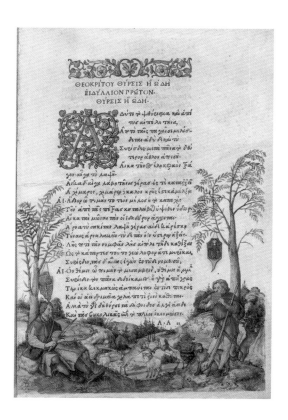

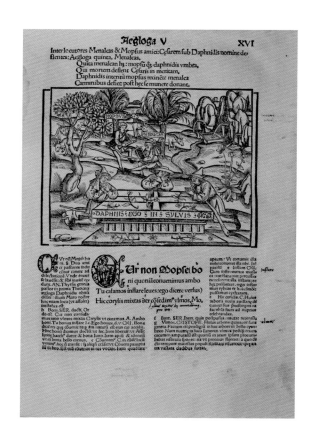

12

ALBRECHT DÜRER

German, 1471–1528

A Pastoral Landscape with Shepherds Playing a Viola and Panpipes

Brush with watercolor and gouache, heightened with pen and ink and gold, cut from and pasted back onto page 1 of Theocritus's *Idyllia* (*Idylls*), 1st ed. (Venice: Aldus Manutius, 1496)
Sheet: 12³⁄₁₆ × 8 inches (31 × 20.3 cm)
National Gallery of Art, Washington, DC. Woodner Collection, 2005.1.1.a

13

SEBASTIAN BRANT

French, 1457–1521

The Tomb of Daphnis

Illustration for *Eclogue 5*
Published in Virgil's *Opera* (Strasbourg: Johann Grüninger, 1502), page XVIr
Woodcut, book: h 12³⁄₁₆ inches (31 cm)
The Library of Congress, Washington, DC. Lessing J. Rosenwald Collection

painting, we look beyond France to explore reflections on Arcadia in the art of early twentieth-century Germany and Russia, and follow our subject's resonance up and through World War I.

NICOLAS POUSSIN (1594–1665)

Nicolas Poussin's fame has never waned from the point, in 1672, when Giovanni Pietro Bellori's *Vite de' pittori, scultori, e architetti moderni* (*Lives of the Modern Painters, Sculptors, and Architects*) set him in place as the heir to the Bolognese painter Annibale Carracci in Rome.[4] And while Poussin spent the majority of his career in Italy, it was the critic André Félibien who established the artist's decidedly French legacy, declaring him to be the French Raphael, who "lifted the whole science of painting as from the arms of Greece or Italy, to bring it to France."[5] In 1647, Félibien, as secretary to the French ambassador to Rome, struck up a friendship with Poussin and even took lessons from the artist. Upon his return to France in 1649, Félibien, in company with Nicolas Fouquet and Jean-Baptiste Colbert, began a sequence of critical declarations on hierarchies within the arts, as well as their centrality to the destiny of France, essentially creating French artistic structures as they survived into the late twentieth century that placed the Roman resident Poussin at the foundation of the French grand manner under the court of Louis XIV.[6]

In the seventeenth century, it was the painter's elevated discretion and elegiac tone (see, for example, fig. 14) that most identified the model of Poussin. During the evolution of French painting in the eighteenth century, this gravitas was lifted in favor of gaiety and frolic, albeit maintained at a fantastical distance — the Cythera of Jean-Antoine Watteau (fig. 15) nudging out Arcadia for a time.[7] But it was with the empire and a general return to classicism, not just as

14

NICOLAS POUSSIN

French, 1594–1665

The Inspiration of the Poet

c. 1629–30

Oil on canvas, 5 feet 11⅝ inches ×
6 feet 11⅞ inches (1.82 × 2.13 m)
Musée du Louvre, Paris

a shift of tastes but as a moral reordering, that Poussin regained the magisterial position he would have for the artists in this survey. His elevated status in the nineteenth century is exemplified by an 1869 article, published in the weekly review *L'artiste*, that not only celebrates the painter as embodying the genius of France, but also defines him according to Arcadian values, describing his existence as "austere and simple, nourished by noble meditations."[8]

Poussin's esteemed reputation intensified with a period of heightened scholarship on the artist during the two decades before World War I. In 1894 Philippe de Chennevières published his *Essais sur l'histoire de la peinture française* (Essays on the history of French painting), which essentially functioned as a monograph on Poussin and lauded "the simplicity, the sobriety in strength, the nobility in grace" of the artist's work.[9] Chennevières's study was followed by new biographies on Poussin by Victor Advielle and Paul Desjardins in 1902 and 1903, respectively; the first French translation of Bellori's *Vite* in 1903; Desjardins's comparative analysis of Poussin, Pierre Corneille, and Blaise Pascal, *La méthode des classiques français*, in 1904; the first comprehensive publication of the artist's correspondence in 1911; and Émile Magne's, Otto Grautoff's, and Walter Friedlaender's important monographs in 1914, which, according to Theodore Reff, established "the basis for modern investigations."[10]

This "revival of critical interest in Poussin," as Reff referred to it, no doubt was stimulated, at least in part, by the 1894 tercentennial celebration of the painter's birth that took place at his birthplace, Les Andelys in Normandy.[11] Featuring a series of speeches in praise of Poussin, the event sought to reclaim him, once again, for France, to confirm the artist as the "father" of the modern French school.[12] The critic Roger Marx, who would become the editor of the *Gazette des beaux-arts*, especially emphasized Poussin's centrality for contemporary artists, whom he felt were

15

JEAN-ANTOINE
WATTEAU

French, 1684–1721

*Pilgrimage to the Island of
Cythera*

1717

Oil on canvas, 4 feet 2¹³⁄₁₆ inches ×
6 feet 4⅜ inches (1.29 × 1.94 m)

Musée du Louvre, Paris

up to the challenge of continuing the legacy of their predecessor. Giving Poussin ultimate priority in the history of French art, Marx declared, "Everything leads to Poussin, and everything follows from him."[13]

In 1904 a critic observed that the Poussin room in the Louvre, which previously had attracted little attention, was populated with "many young men and women copying either his bacchanals or his noble, classical landscapes."[14] The copyists included, among others, Cézanne, Derain, and Matisse.[15] Between 1904 and 1906, Derain, who, as Roger Fry suggested in 1912, carried on the "spirit" of Poussin, made a copy after the elder artist's *Four Seasons: Summer (Ruth and Boaz)* (fig. 16).[16] Matisse copied three Poussin paintings in the Louvre — *Bacchanal, The Four Seasons: Autumn (The Spies with the Grapes of the Promised Land)*, and *Echo and Narcissus* — while a student at the studio of Gustave Moreau from 1892 to 1897.[17] Even more interesting is the faint pencil drawing Matisse made after Poussin's painting *Apollo and Daphne (Apollon amoureux de Daphné)* (fig. 17; see also fig. 136) that Pierre Schneider illustrated in his monograph on the artist and dated to 1930.[18] If Schneider's date is correct, Matisse returned to Poussin's canvas when Arcadia found a second life in his career through the 1930 commissions for the Barnes Foundation mural, *The Dance* (see fig. 66), and for illustrations for Stéphane Mallarmé's *Poésies* (see figs. 61–65).

Poussin's *Apollo and Daphne*, the last painting of his career, entered the Louvre only in 1869. The artist gave the picture to his principal patron when he realized his trembling hands would prevent its completion, explaining its unfinished state, a fact that perhaps made it still more accessible to artists at the turn of the twentieth century. In 1894 the critic Raymond Bouyer bestowed a particularly poetic eulogy on the painting in his poem "Apollon amoureux de Daphné," which he

included as a dedication to Poussin in his important study on landscape painting, *Le paysage dans l'art.* The poem begins:

> With your unbowed breath, nobly, you revive
> the chorus of the sacred groves, mysterious swarm
> evading death, dear Virgil, oh Poussin
> a haven still full of lofty dreams.[19]

In 1911 another painting by Poussin entered the Louvre, *The Inspiration of the Poet* (c. 1629–30; see fig. 14), which often is seen as an image of the artist's poet laureate, Virgil. As Paul Jamot wrote that year, "When [Poussin] speaks of Virgil, it is of a different tone: one feels that he is nourished by Virgil's poems. He thinks he is following painters even if he totally ignores their work, but in reality, it is the poets who inspire him, and it is Virgil above all."[20]

Nor did the preeminence of Poussin wane. In 1938 Maurice Denis celebrated the artist's "poetic conception of painting," revering him then just as intensely as he had forty years earlier in his 1898 article "Les arts à Rome ou la méthode classique."[21] But as much as Poussin did to establish the authority of Virgilian subjects in art, it was a long and complicated evolution of conservative and radical values that brought Arcadian themes to the threshold of modern painting, arching from the seventeenth century into the nineteenth century with Jean-Auguste-Dominique Ingres, with whom we have chosen to pick up the story.

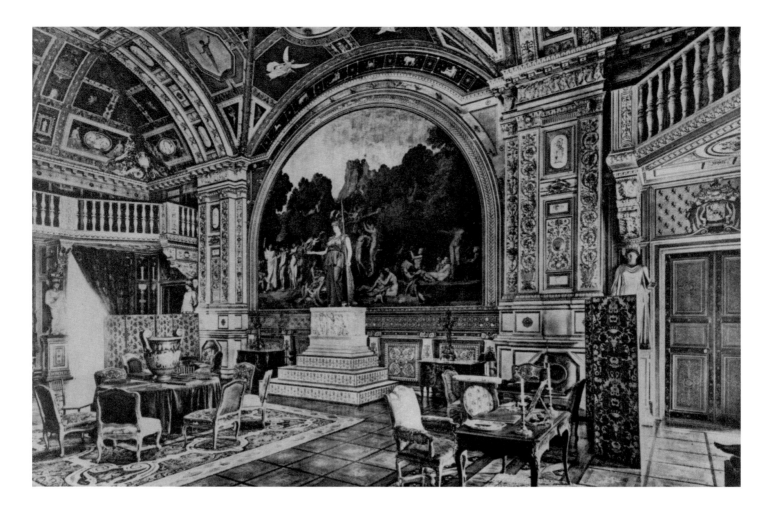

18

Salon de Minerve in the Château de Dampierre, Seine-et-Oise, France, with Simart's statue of Minerva in front of Ingres's mural *The Golden Age*

JEAN-AUGUSTE-DOMINIQUE INGRES (1780–1867)

Jean-Auguste-Dominique Ingres was hailed for his reinforcement of traditional (which is to say historical) subjects, his emphasis on drawing, and his very rational style, even though, in the end, he remained outside the system, a "Chinaman lost in the ruins of Athens," drawn to the exotic and sensual, a perilous balance between the public grand manner and his private ambition.[22] The great opportunity for Ingres came with the 1839 commission from Honoré-Théodore-Paul-Joseph d'Albert, duc de Luynes — a man of deep classical learning, an archaeologist, and a collector of antique armor — for the great hall in the Château de Dampierre, which was then being restored.[23] The hall was dedicated to Minerva, whose statue by Pierre-Charles Simart was installed in 1855 (fig. 18). For Ingres's project, the golden age and the iron age were chosen as the subjects for two facing lunettes (much like those decorated by Raphael in the Vatican Stanze). From 1843 to 1847, Ingres, along with two of his most talented assistants, worked sporadically on the murals, spending his summers at the château. In 1850, however, the patron and the artist mutually consented to abandon the project. The duke did not like the large cast of characters in *The Golden Age*, for which Ingres had made some five hundred preparatory drawings, nor did he care for the amount of nudity in the mural, whose figures were well enough advanced by 1847 to be read quite clearly, as they still can be today. They are illustrated most often, however, by the very refined oil sketch Ingres made in 1862 (fig. 19) as, one cannot help but think, a nostalgic reminiscence of his biggest commission.[24]

19

JEAN-AUGUSTE-DOMINIQUE INGRES

French, 1780–1867

The Golden Age

1862

Oil on canvas, 18¼ × 24⅜ inches (46.4 × 61.9 cm)

Harvard Art Museums / Fogg Museum, Cambridge, MA. Bequest of Grenville L. Winthrop, 1943.247

JEAN-AUGUSTE-
DOMINIQUE INGRES

French, 1780–1867

Tu Marcellus eris (You Will
Be Marcellus; *Aen.* 6:883)

c. 1812

Oil on canvas, 9 feet 11¹¹⁄₁₆ inches ×
10 feet 7³⁄₁₆ inches (3.04 × 3.23 m)
Musée des Augustins, Toulouse,
France

In an 1843 letter to his friend Jean-François Gilibert, Ingres described the vision of
paradise that underlay his project for the château:

> Here is the short program I have conceived for my *Golden Age: A bunch of beautiful, lazy people!*
> I have taken the Golden Age decidedly as the ancient poets imagined it. *The people of that
> generation hardly knew old age. They lived long lives and were always beautiful. Thus, no old ones. They were
> good, just, and loved one [an]other. The only food they ate was the fruit of the earth and the water of the
> fountains, milk and nectar. They lived thus and died while sleeping.*[25]

As Carol Ockman has reminded us, it was Hesiod in his *Works and Days* (c. 700 BCE) who
first described the golden age, setting it on Mount Olympus, where mortals were "rich in their
flocks, dear to the blessed Gods."[26] But for his project Ingres turned to Virgil's fourth *Eclogue*,
which brings in the god Saturn in a second telling of the tale, a sort of recovery of the golden age
from Greek to Roman times; indeed, Ingres's interest in Virgil was already clear from his painting
of about 1812 of the poet reading the *Aeneid* to Augustus, Octavia, and Livia (fig. 20).[27] In keeping
with our theme of Virgilian subjects transported by Poussin into the nineteenth century, Ockman
has offered a particularly telling comparison of the mise-en-scènes in Ingres's *Golden Age* and
Poussin's *Apollo and Daphne* (see fig. 136): Each painting includes sheltering trees that serve as a kind
of division of low-passage space, with reclining figures between the protagonists, gathered left and
right, who frame the picture's center.[28]

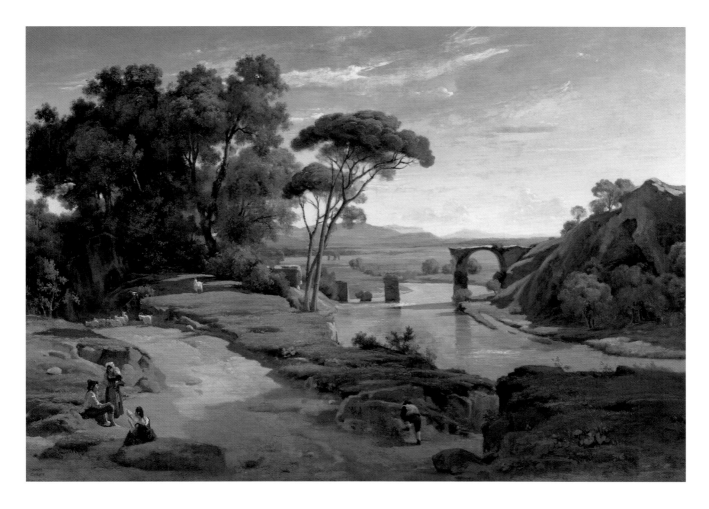

JEAN-BAPTISTE-CAMILLE COROT (1796–1875)

21

**JEAN-BAPTISTE-
CAMILLE COROT**

French, 1796–1875

The Bridge at Narni

1827

Oil on canvas, 26¾ × 37¼ inches
(68 × 94.6 cm)

National Gallery of Canada,
Ottawa. Purchased 1939

If Ingres was, as Robert Rosenblum argued, the staunchest defender of the classical tradition for nearly two-thirds of the nineteenth century, instilling in academic practice a rigidity from which it never recovered, he left behind a penchant for antique sentiment that evolved in a very winning and sweet manner.[29] His greatest heir in sustaining Arcadian sentiments in the lyrical mode was, of course, Jean-Baptiste-Camille Corot, whom the writer Théophile Gautier described as "Theocritus in paint," an artist "nursed on the laps of nymphs."[30] The authority of Corot in the annals of modern art is twofold: as the sustainer of the plein air painters, including Cézanne and Camille Pissarro, and as the gentle guardian of poetic illusion, often with Arcadian themes. In *The Bridge at Narni* (1827; fig. 21), Corot was as true to the light and topography of the landscape as were any of the myriad plein air painters who visited this ancient site, but only he sustained the music of Pan's pipes off in the wings—to the frustration of the critic Émile Zola:

> If M. Corot agreed to kill off, once and for all, the nymphs with which he populates his woods [see, for example, fig. 22] and replace them with peasant women I would like him beyond measure. I know that for this light foliage, this humid and smiling dawn one must have these diaphanous creatures, dreams clothed in vapours. Equally I have sometimes been tempted to ask the master for a more human, vigorous nature.[31]

22

JEAN-BAPTISTE-
CAMILLE COROT
French, 1796–1875

*A Morning (Dance of the
Nymphs)*

1850
Oil on canvas, 38⅞16 × 51⁹16 inches
(98 × 131 cm)
Musée d'Orsay, Paris

Zola's disparaging if rather good-willed comment is directed primarily at works in which the artist withdrew in time to remembered scenes — his so-called souvenirs of special places, such as *Goatherd of Terni*, painted about 1871, almost thirty years after Corot's last visit to Italy in 1843 (fig. 23) — and at his poetic, out-of-time compositions, including *Landscape, Setting Sun (The Little Shepherd)* (1840; fig. 24), the setting of which, as was true of Narni, might still be haunted by Poussin or the great Claude Lorrain.

Other early Arcadian works by Corot draw quite literally from Virgil. His *Silenus* of 1838 (fig. 25) — a subject Poussin had explored nearly two hundred years prior, in a now-lost painting known through a copy by a close follower (fig. 26) — illustrates the protagonist's entrapment and release, at the price of a song, a story described in Virgil's sixth *Eclogue* (6:13–30):

> The lads Chromis and Mnasyllos saw Silenus lying asleep in a cave, his veins swollen,
> as ever, with the wine of yesterday. Hard by lay the garlands, just fallen from his head,
> and his heavy tankard was hanging by its well-worn handle. Falling on him — for oft

23

JEAN-BAPTISTE-
CAMILLE COROT

French, 1796–1875

Goatherd of Terni

c. 1871

Oil on canvas, 32⅜ × 24⅝ inches

(82.2 × 62.5 cm)

Philadelphia Museum of Art.

Bequest of Charlotte Dorrance

Wright, 1978-1-8

the aged one had cheated both of a promised song—they cast him into fetters made from his own garlands. Aegle joins their company and seconds the timid pair—Aegle, fairest of the Naiads—and, as now his eyes open, paints his face and brows with crimson mulberries. Smiling at the trick, he cries: "Why fetter me? Loose me, lads; enough that you have shown your power. Hear the songs you crave; you shall have your songs, she another kind of reward." Therewith the sage begins. Then indeed you might see Fauns and fierce beasts sporting in measured dance, and unbending oaks nodding their crests. Not so does the rock of Parnassus rejoice in Phoebus; not so do Rhodope and Ismarus marvel at their Orpheus.[32]

Such is reality in Arcadia.

24

JEAN-BAPTISTE-CAMILLE COROT

French, 1796–1875

Landscape, Setting Sun (The Little Shepherd)

1840

Oil on canvas, 54 × 43¼ inches (137 × 110 cm)

Musée de la Cour d'Or, Metz Métropole, Metz, France

25

JEAN-BAPTISTE-CAMILLE COROT

French, 1796–1875

Silenus

1838

Oil on canvas, 8 feet 1½ inches × 5 feet 10½ inches (2.45 × 1.79 m)

The Minneapolis Institute of Arts. Bequest of J. Jerome Hill

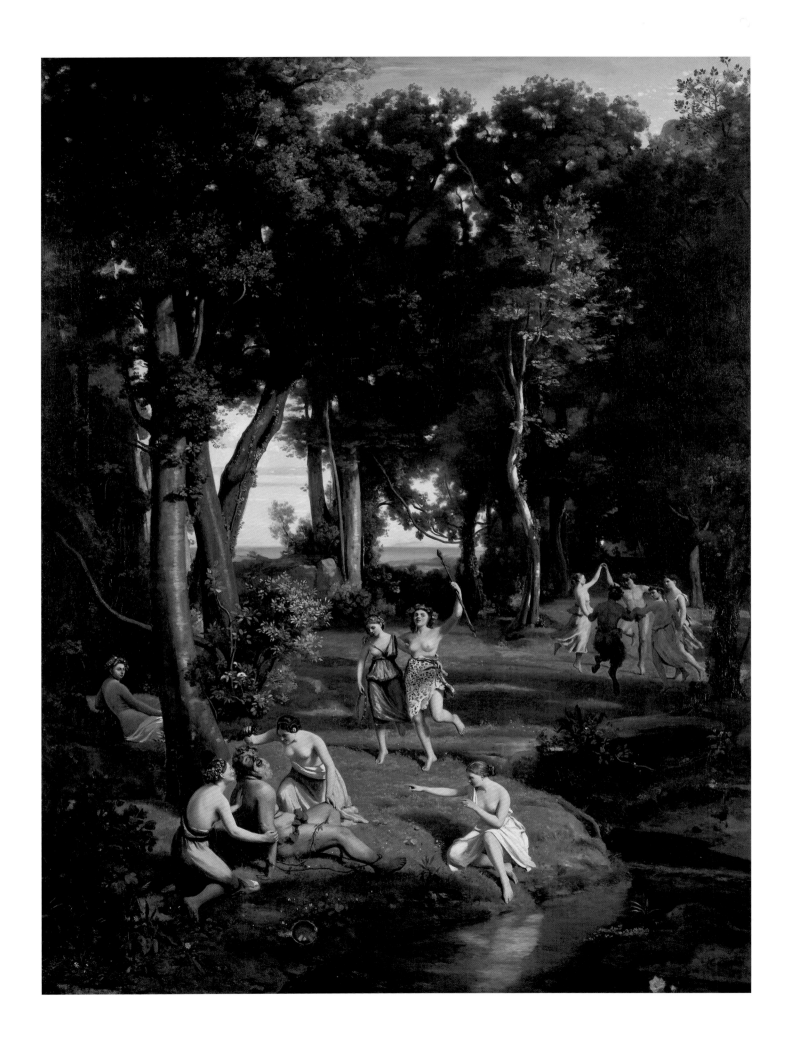

After **NICOLAS POUSSIN**

French, 1594–1665

The Triumph of Silenus

c. 1637

Oil on canvas, 56¼ × 47⁷⁄₁₆ inches

(142.9 × 120.5 cm)

National Gallery, London.

Bought 1824

VIRGIL IN FRANCE

Corot's nearly verbatim illustration of Virgil's text, a picture he painted for the Salon, suggests the fame of, as well as his audience's general familiarity with, the *Eclogues* in nineteenth-century France—an idea that is worth reviewing here, with the artist's *Silenus* in easy view. In the nineteenth century, the foundational French translation of the *Eclogues* was the 1806 edition by Jacques Delille, whose translations of Virgil's complete works are said to have brought back into focus the poet's stateliness. Delille paved the way for a series of new translations and illustrated editions of the *Eclogues* in the nineteenth and early twentieth centuries, with notable examples in our context occurring in 1881, 1884, 1891, and 1906.[33] Suggesting the distinct popularity of the text in France, Bernadette Pasquier has noted that in the nineteenth-century in France, unlike in Italy, Virgil's *Eclogues* were illustrated more widely than was his *Aeneid*.[34] Theodore Ziolkowski has explained that "in France it was the *Eclogues* in particular that caught the literary imagination."[35]

The annotated 1891 edition is particularly noteworthy because it includes an introduction by C.-A. Sainte-Beuve, whose *Étude sur Virgile* (Study of Virgil; 1857) was a landmark in classical studies that celebrated Virgil as "the poet of all of Latinity" whose reputation in France had never fallen.[36] While Sainte-Beuve's *Étude* focused primarily on the *Aeneid*, it was the author's general image of Virgil, an image that can be extended to his Arcadia, that became the predominant view of the

poet in France. Drawing upon the notion of Virgil's fundamental sadness, famously described by François-René Chateaubriand in 1802, Sainte-Beuve wrote, "It is this gravity, this quality of noble and tender reflectiveness, this principle of elevation in placidity and even in frailty, which is at the core of Virgil's existence and which we should never lose sight of in his subject."[37] It was in similar terms that, years later, Erwin Panofksy, in his celebrated essay on Poussin, wrote, "In Virgil's ideal Arcady human suffering and superhumanly perfect surroundings create a dissonance. This dissonance, once felt, had to be resolved, and it was resolved in that vespertinal mixture of sadness and tranquility which is perhaps Virgil's most personal contribution to poetry."[38]

The "mixture of sadness and tranquility" — of idealism, melancholy, and nobility — that mark Virgil and his *Eclogues* attracted both classical and Symbolist poets of the second half of the nineteenth century. Indeed, Virgil's afterlife in modern French literature, as incarnated in the poetry of Victor Hugo, Charles Baudelaire, Stéphane Mallarmé, and, into the twentieth century, Paul Valéry, forms a history parallel to the artistic revival of Arcadian themes.[39] Of particular interest to the artists discussed here, Baudelaire's poem "L'invitation au voyage" ("Invitation to the Voyage"), first published in 1857 in his volume of poetry *Les fleurs du mal* (*The Flowers of Evil*), imagines an edenic world in which man and woman are one with nature — free "to love at leisure," free "to love and to die."[40] Yet, for Baudelaire, this paradise in which "all is order and beauty" lies unequivocally "there," not here ("là, tout n'est qu'ordre et beauté / luxe, calme et volupté," as the poem repeats).[41] His Arcadia is an otherworld, ever distant from the present. Equally evocative for artists of his time was Mallarmé's masterpiece, "L'après-midi d'un faune" ("The Afternoon of a Faun"; 1876), whose subtitle, it must be noted, is "Égloge" ("Eclogue").[42] The poem recounts a faun's encounter with, and longing for, two nymphs in a pastoral idyll, and marks with great poignancy the quality of nostalgic reverie, grounded in Virgil, that is central to all imaginings of Arcadia: "Was it a dream I loved?"[43]

But perhaps no other French writer as self-consciously inscribed Virgil into his work as André Gide. In 1891, the year the poet Jean Moréas founded the École Romane, a movement intended to celebrate and revitalize the Greco-Roman roots of French literature, Gide began reading the *Eclogues*. His sentiments are emblematic of his country's cultural fascination with Virgil's work: "Finished Vergil's [*sic*] *Eclogues*. Read in Latin, one every morning. Ecstatic surprises at first; a little boredom some time after, . . . I think the first is the best — and the IVth. I don't like Silenus. The VIIIth is boring. I know by heart the IInd and the Xth, which Delacroix brought to my attention."[44] Three years later, he returned to the poems:

> I have gone back to Vergil's *Eclogues*. I thought I knew them by heart; I feel as if I had
> never read them; . . . All the rest, thoughts and numbers, can be grasped, learned,
> retained. But the actual harmony of the verses, colors, shapes, music remains some-
> thing *incomprehensible*. Memory can do nothing with it; it remains outside, and stands
> before us, and every time we behold it, we experience new stupefaction.[45]

The very harmony that enamored Gide, which for Virgil was both subject and form, would become the hallmark of the artist named "the French Virgil" by Émile Bernard in 1903 — Pierre Puvis de Chavannes, who in 1896 had commemorated the poet in a mural for the Boston Public Library (represented here by its reduced version; fig. 27).[46]

PIERRE PUVIS DE
CHAVANNES
French, 1824–1898

Virgil, Bucolic Poetry

1896
Oil on canvas, 48¹³⁄₁₆ × 24¹³⁄₁₆ inches
(124 × 63 cm)
Private collection

PIERRE PUVIS DE CHAVANNES (1824–1898)

In his 1946 article "Puvis de Chavannes: Some Reasons for a Reputation," Robert Goldwater, an established scholar of primitive art who in 1957 became the first director of the Museum of Primitive Art in New York, thanked Alfred H. Barr, the director of the Museum of Modern Art in New York, for fostering him upon this path of inquiry.[47] That two of the principal figures in the shaping of attitudes and values about modern art were discussing the importance of Puvis just after the end of World War II, and that Goldwater then proceeded to lay out, in ten dense pages, the critical fortunes of the artist, whose fame had peaked between 1885 and 1900, must be among the first attempts to recover Puvis's stature, including what he had meant to Gauguin, Cézanne, and Matisse.

This said in light of Gauguin's pride that he—along with Signac, Claude Monet, and Pierre-Auguste Renoir—was among some five hundred guests, of varied cuts, left and right, invited to the famous seventieth birthday party for Puvis in 1895, chaired by the sculptor Auguste Rodin.[48] As one principal writer on the event, the critic Gustave Kahn, noted, "Puvis was the great painter who divided us the least."[49] This was indeed the case, as we know from a resurgence of scholarship since Goldwater that has put Puvis back in perspective as an artist who represented the continuity of French art in the grand manner, from Poussin through Corot, expanding

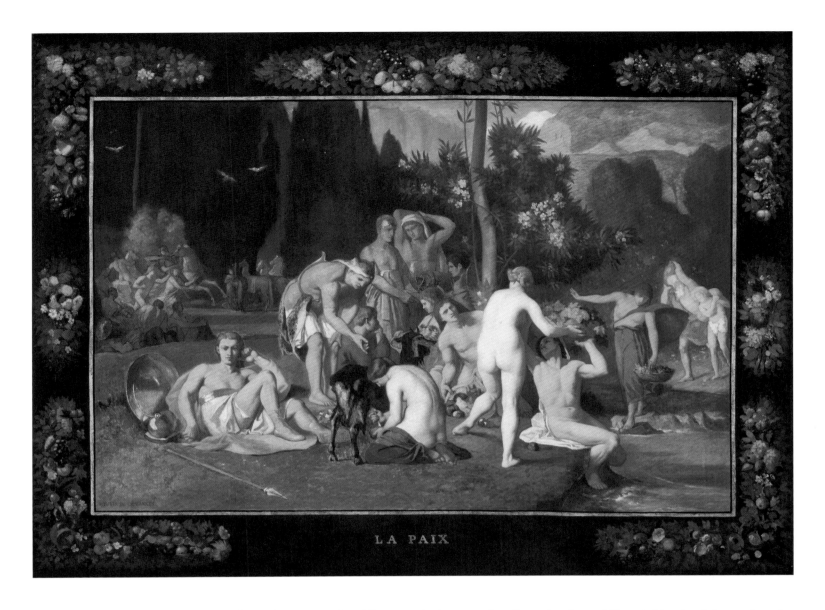

LA PAIX

28

PIERRE PUVIS DE
CHAVANNES
French, 1824–1898

Peace

1867
Oil on canvas, 42⅞ × 58½ inches
(108.9 × 148.6 cm)
Philadelphia Museum of Art. John G.
Johnson Collection, 1917. Cat. 1062

through a series of public commissions coming from the Second French Empire (1852–70) under
Napoleon III and, after 1870, from the resurrected Republic, which declared Arcadian subjects,
now blown large, the model for French values, using the theme's image of lyrical elevation and
gravity to instruct and engage the nation's citizens (see, for example, fig. 154).

The alliance between Arcadia and the state's promotion of national moral order began
with Puvis's first public mural project, comprising two monumental canvases on the themes of
peace and war. The paintings were displayed to great success at the 1861 Salon, where they were
purchased by the French state to decorate the new Musée Napoléon (now Musée de Picardie) in
Amiens. Puvis later added canvases on the themes of work and rest, and all four decorations were
represented at the Exposition Universelle of 1867 through their reductions, including *Peace* (1867;
fig. 28).[50] The imagery of this painting, as Aimée Brown Price has suggested, is drawn from Virgil's
description of the golden age in the fourth *Eclogue* (4:18–23):

> But for you, child, the earth untilled will pour forth its first pretty gifts, gadding ivy
> with foxglove everywhere, and the Egyptian bean blended with the laughing briar;
> unbidden it will pour forth for you a cradle of smiling flowers. Unbidden, the goats
> will bring home their udders swollen with milk.[51]

29

PIERRE PUVIS DE
CHAVANNES

French, 1824–1898

Summer

1891

Oil on canvas, mounted on wall;
19 feet × 29 feet 9⅞ inches (5.79 ×
9.09 m)

Hôtel de Ville, Paris

One of Puvis's last major commissions, his 1891 *Summer* (fig. 29), similarly takes up Arcadian themes. Commissioned for the Zodiac Salon in the rebuilt Hôtel de Ville following the building's destruction during the Paris Commune in 1871, it was one of the artist's most difficult projects, given the narrow space and limited lighting. The reduction, now in the Cleveland Museum of Art (fig. 30), lacks the awkwardness of the door of the original space, with the arrangement and scale of the figures happily readjusted. Having disposed of the specific descriptions of antique dress and arms of *Peace*, Puvis brought the scene into the present—or rather into a Virgilian out-of-time moment. An earlier canvas of the same subject retains a suggestion of narrative (fig. 31), with the harvest in the background in reference to a long history of depictions of the biblical story of Ruth and Boaz (Poussin's famously among them). In the Cleveland reduction, Puvis's purpose is to celebrate social stability through harmony: A fisherman is hard at work in the background, while the mother and child in the foreground (education and familial values implicit) are akin to the figures coming out from their baths on the magic island they inhabit.

Roger Marx declared in 1899, the year after Puvis's death, that his oeuvre as a whole offers "a comforting vision of another, better, world . . . a new Arcadia."[52] This is exemplified in *Summer*, as well as in earlier paintings such as *The Sacred Grove, Beloved of the Arts and Muses* (1884–89; fig. 32) and *Pleasant Land* (1882; fig. 33). Suggesting Puvis's centrality in defining modern visions of Arcadia, Alfred Barr illustrated the latter in his 1951 book on Matisse, writing that the canvas

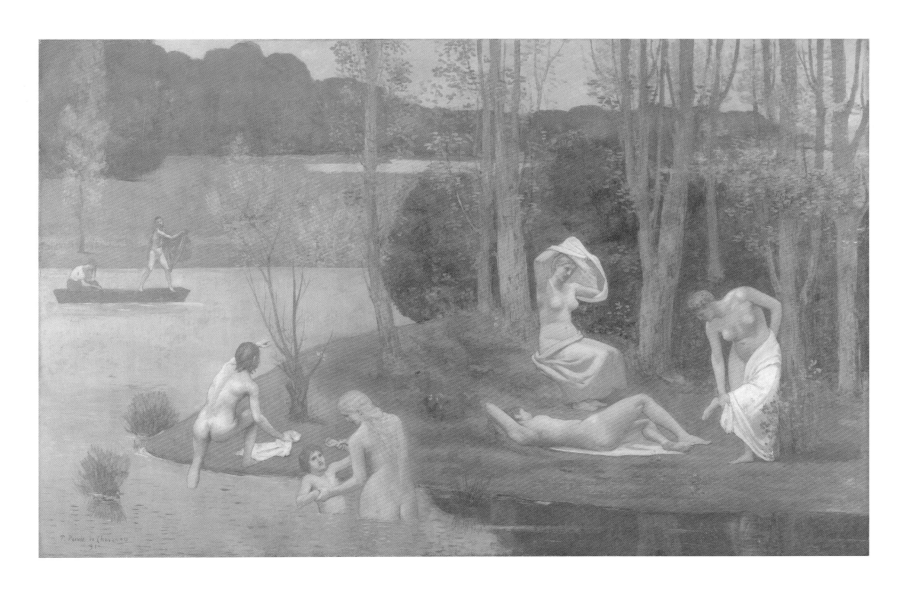

30

PIERRE PUVIS DE CHAVANNES

French, 1824–1898

Summer

1891

Oil on fabric, 4 feet 10⅞ inches × 7 feet 7⁷⁄₁₆ inches (1.5 × 2.32 m)

The Cleveland Museum of Art. Gift of Mr. and Mrs. J. H. Wade, 1916.1056

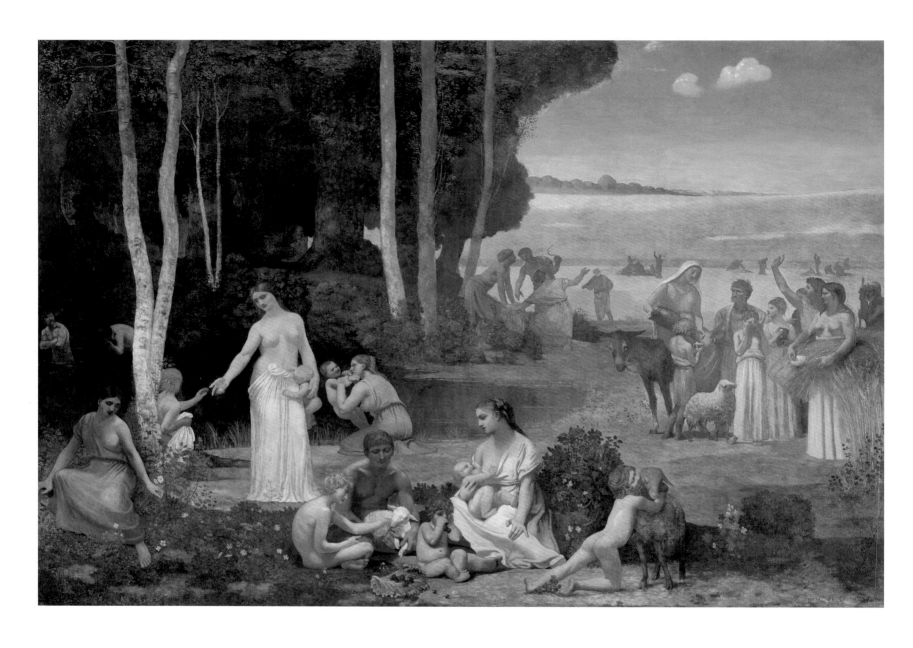

31

PIERRE PUVIS DE CHAVANNES

French, 1824–1898

Summer

1873

Oil on canvas, 10 feet × 16 feet 7½ inches (3.05 × 5.07 m)

Musée d'Orsay, Paris

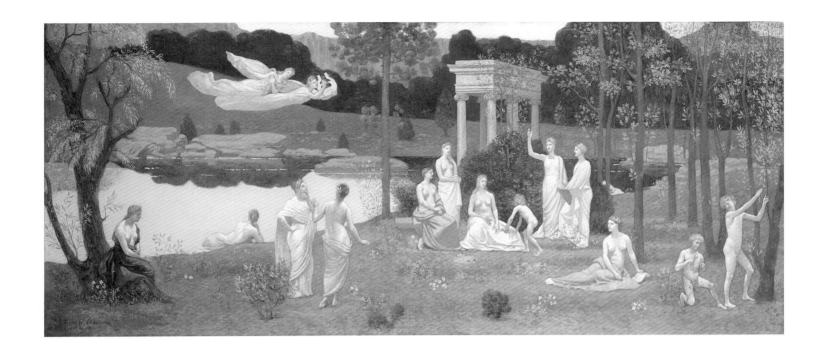

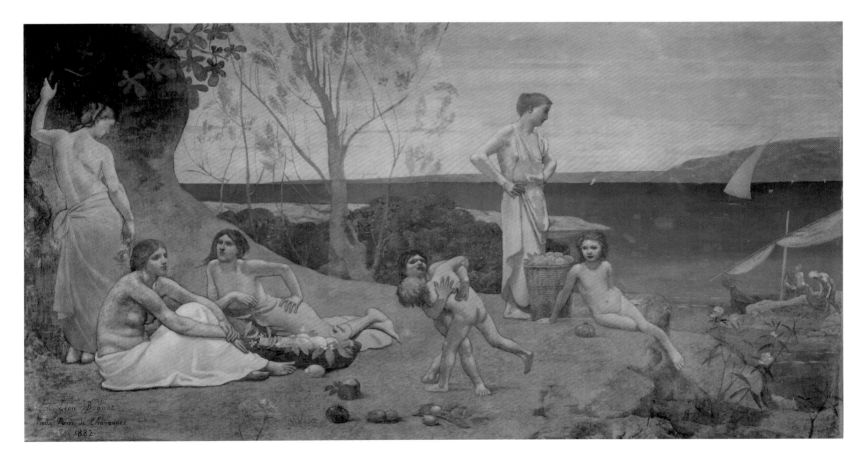

32

PIERRE PUVIS DE CHAVANNES

French, 1824–1898

The Sacred Grove, Beloved of the Arts and Muses

1884–89

Oil on canvas, 3 feet 7/16 inch × 8 feet 6 15/16 inches (0.93 × 2.31 m)

The Art Institute of Chicago. Potter Palmer Collection, 1922.445

33

PIERRE PUVIS DE CHAVANNES

French, 1824–1898

Pleasant Land

1882

Oil on canvas, 7 feet 6 9/16 inches × 14 feet 1 5/16 inches (2.3 × 4.3 m)

Musée Bonnat, Bayonne, France

shares "certain striking resemblances in setting and iconography" with Matisse's *Luxe, calme et volupté* of 1904–5 (see fig. 57).[53]

Although the restoration of Puvis into a revised version of the modern canon, first by such esteemed figures as Goldwater and Barr, followed by the heroic efforts of Richard Wattenmaker, Serge Lemoine, and Aimée Brown Price, now seems a settled affair—even as the balance of persuasion still rests less with the artist's literal achievements and more with his legacy, not just to Matisse but particularly to Cézanne and Gauguin (all of whom are considered in separate essays in this volume)—it is important to keep in mind that these issues of evaluation are hardly new.[54] As Elie Faure wisely noted in his commentary on the 1904 Salon d'Automne, which featured forty-four works by Puvis and thirty-one by Cézanne, "Puvis and Cézanne are side by side at the Salon d'Automne. . . . I do not know, in the history of art, two artists as different on the surface and coming from such opposite directions who have marched toward the same horizon with so much steadfastness . . . the idealist [Puvis] has encountered life, the realist [Cézanne] has glimpsed the dream: . . . Both are pure primitives, and archaic primitives."[55]

To underscore Faure's point, we must consider Cézanne's early *Bathers* (1874–75; see fig. 164) alongside Puvis's much later *Summer* (1891; see fig. 30), a comparison that suggests that the younger artist anticipated the formal and theatrical detachment and otherworldliness that the two artists hold in common. But it would be imprudent to press a relationship between the two too hard, remembering the famous comment that the poet Joachim Gasquet ascribed (albeit long after the fact) to Cézanne, in which the painter, having asked Gasquet to take down the reproduction of Puvis's Sorbonne mural that the poet had displayed in his home, exclaimed, "What bad literature!"[56]

Gauguin and Puvis are a still richer mix, particularly in regard to the younger artist's *Where Do We Come From? What Are We? Where Are We Going? (D'où venons-nous? Que sommes-nous? Où allons-nous?)* (1897–98; see pages xi–xii and fig. 146), which he described to his friend Georges-Daniel de Monfreid as "a fresco whose corners are spoiled with age, which is appliquéd upon a golden wall," thus invoking the elder artist despite his resistance to such comparisons (in 1901 he emphasized their differences, declaring to Charles Morice that "[Puvis] is a Greek, whereas I am a savage").[57] To add to a more expansive discussion of his primitivism and to reinforce George Shackelford's independent essay in this catalogue, it is best to recall the words of Maurice Denis, who in 1903 described Gauguin as "a kind of Poussin without classical culture."[58]

Yet, as much as Gauguin tried to position himself as a "wolf in the woods without a collar," he was never far from this "classical culture."[59] As Stephen Eisenman observed, "Gauguin, the dreamer of dreams, and Gauguin the Symbolist, was also Gauguin the Virgilian and Gauguin the classicist."[60] He "invoked the metaphorical language of Virgil when he described his hope of finding an Arcadian realm 'of ecstasy, peace and art, far from this European struggle for money,'" at the same time casting himself as "a kind of uncertain and posturing Odysseus, wandering the seas, living a life of adventure as well as privation, and longing for a return to the sanctuary and shelter of friends and family."[61] In this sense, he is the artist among those examined here who most needed and best used—though with great intensity and to the point of self-endangerment—Arcadian notions to nurture his art.

ÉMILE BERNARD (1868–1941)

Perhaps best known for his biographical writings on Cézanne, a seductive body of information bent to his own not unpretentious notions about the direction art was taking, Émile Bernard was also an accomplished painter at the very heart of artistic sensibilities at the turn of the twentieth century.[62] When Bernard first visited Cézanne in 1904, the reclusive artist, no doubt flattered by the young artist's knowledge of his work, allowed him to stay and work in his studio at Les Lauves for one month.[63] Their friendship then continued through correspondence, in which Cézanne, in a rather avuncular manner, tried to explain himself to Bernard in essential ways, demonstrating his understanding of his young friend's greenness as well as his own appreciation of a keen audience.[64] Bernard later described Cézanne as "his master. . . . his mentor from the very first," and his early admiration for the artist is clear in his near replica of Cézanne's *Three Bathers* (see fig. 2), which he completed in 1890, well before the two artists had met.[65]

Bernard had formed similar intimacies with other artists, including Gauguin, whom he had met at Pont-Aven in Brittany in 1886, and Paul Sérusier, whom he had met as of 1888 and with whom he became closer when he and Sérusier teamed up with Gauguin to share their aesthetic views. When Vincent van Gogh arrived in Paris in 1886, Bernard was among the first to befriend him. There is even a rare informal photograph of Bernard with Van Gogh, who stands

35
ÉMILE BERNARD
French, 1868–1941

Bathers

1889
Oil on canvas, 36¼ × 28¾ inches
(92 × 73 cm)
Private collection

36
ÉMILE BERNARD
French, 1868–1941

Bathers with Red Cow

c. 1889
Oil on canvas, 36½ × 28⁷⁄₁₆ inches
(92.7 × 72.3 cm)
Musée d'Orsay, Paris

with his back to the camera, on a path along the Seine at Asnières, in the northwestern suburbs of Paris.[66] The two artists kept close company until February 1888, when Van Gogh left for Arles in the south of France, where Bernard sent him a self-portrait, which, at the Dutchman's request, included a portrait of Gauguin, and which Bernard inscribed to his "pal" ("à son copaing [*sic*] Vincent").[67]

Cézanne tried to warn Bernard off both Gauguin and Van Gogh, although rather late in the game, writing to the younger artist in 1904, "I must tell you that I had another look at the study you made from the lower floor of the studio, it is good. You only have to continue in this way, I think. You have the understanding of what must be done and you will soon turn your back on the Gauguins and the [*Van*] Goghs!"[68] Yet, both the rustic primitivism of Gauguin's Pont-Aven and the classicism of Cézanne's Aix provided for Bernard equally straight and open channels to dreams of Arcadian realms as we know them.

This is evident in Bernard's ambitious and inventive decorations for his studio at Asnières, which his grandmother had built for him in the garden of their family's villa in 1887.[69] As MaryAnne Stevens suggested, Bernard may have conceived the project, which he probably carried out in 1889, as a panorama that survives as a triptych of three separate canvases of female nudes in pastoral landscapes, with water-lily ponds, meadows, and forests, as well as grazing sheep and a tail-flicking red cow (figs. 35–37).[70] Other canvases of female bathers may have been associated with this program, but when these paintings are viewed as a triptych, the overlapping elements—a figure moving from the left canvas into the center canvas, a rock shared by the center and right pictures, the

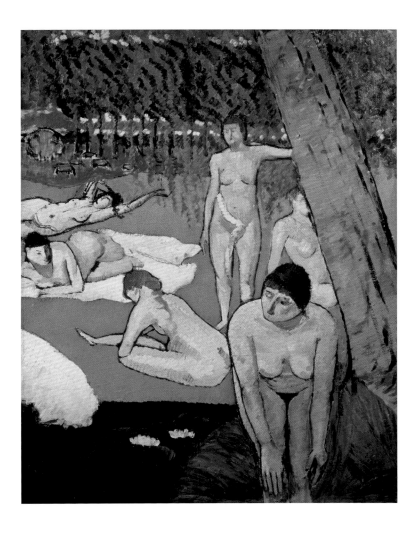

37
ÉMILE BERNARD
French, 1868–1941

Bathers with Water Lilies

c. 1889
Oil on canvas, 36½ × 28½ inches
(92.7 × 72.4 cm)
Private collection

reclining figure's legs in the right canvas extending into the center painting—leave no doubt that they were created as a snug, continuous unit. Large pictorial decorations were not new to the artist, who shared this interest with Gauguin and other Pont-Aven artists.[71]

Surely, for his bather triptych Bernard had been looking at Cézanne, as is suggested not only by its subject but also by the constructed application of paint in parallel patches and bold distortion of some of the figures, such as the woman lying on her hip in *Bathers with Red Cow*, the central panel. It is possible he had seen Cézanne's *Bathers at Rest* (see fig. 165) in the collection of the Impressionist artist Gustave Caillebotte, who had purchased the painting in 1881, which could explain the central painting's blunt fields of brilliant color in the yellow foreground and the blue lake beyond. But the distribution of the figures, who are isolated physically and emotionally, is a clear parallel to Gauguin's depictions of Breton women in the fields, visible in his own *Landscape with Two Breton Girls* (1892; see fig. 34), in which the cow, like that in *Bathers with Red Cow*, is a rustic intrusion from Pont-Aven into Arcadia proper.

None of this is meant to deny the remarkable originality and personal eccentricity of Bernard's paintings, not to mention his uncanny anticipation of where Cézanne would take the bather theme, albeit on an even larger scale, within the next decade and a half—a development that Bernard would not only witness but also, very fortuitously, document, as seen in his 1904 photograph of the elder artist seated in his Les Lauves studio in front of the unfinished canvas of *The Large Bathers* now in the Barnes Foundation (see fig. 171).

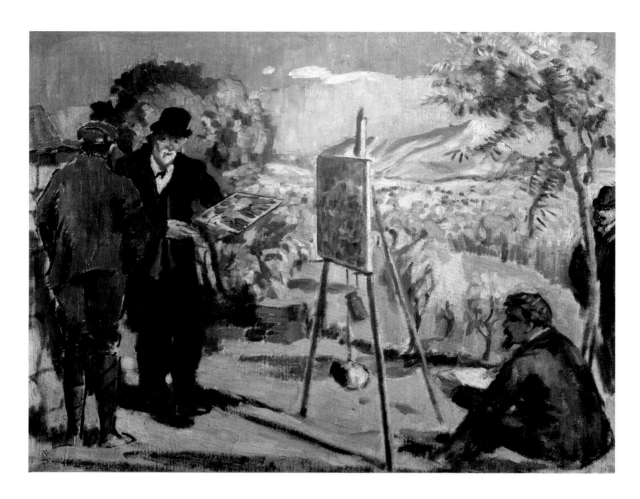

MAURICE DENIS (1870–1943)

Maurice Denis, like Bernard, wrote extensively about Cézanne during the elder artist's lifetime and until shortly after his death in 1906.[72] From Bernard we have an aesthetic and practical catechism on the making and purpose of art, which Cézanne essentially dictated to him and which has provoked almost as much confusion as inspiration in his positioning at the center of modernism. Denis assumed a higher, more theoretical role, speculating in ways already mystical one year after the artist's death on the intrinsic, nonhistorical nature of Cézanne's vision—a vision outside his own time, the chalice of the almost lost virtues of purity and nobility, which set him apart from and above his contemporaries.

Bernard had the advantage of knowing Cézanne well, whereas Denis met him only once, on January 28, 1906, just months before the elder artist's death.[73] He, with his friend the painter Ker Xavier Roussel, and probably with Cézanne's son, Paul, who served as chaperone, made a pilgrimage to Aix to pay homage to his hero, a trip he recorded in a freely worked painting of Cézanne standing outside at his easel, at work on a view of Mont Sainte-Victoire as seen from the road above his studio (fig. 38).[74] This marked the second picture Denis had made in honor of Cézanne—the first, *Homage to Cézanne* (1900; fig. 39), being as historically self-conscious and formal as the Aix painting is intimate and anecdotal. The earlier painting declares the loyalty of Denis and his friends from the Nabis, a loosely defined group of avant-garde artists, including Pierre Bonnard and Édouard Vuillard, who wished to define themselves outside of Neo-Impressionism and align themselves with a new sensibility toward decorative and nontopical

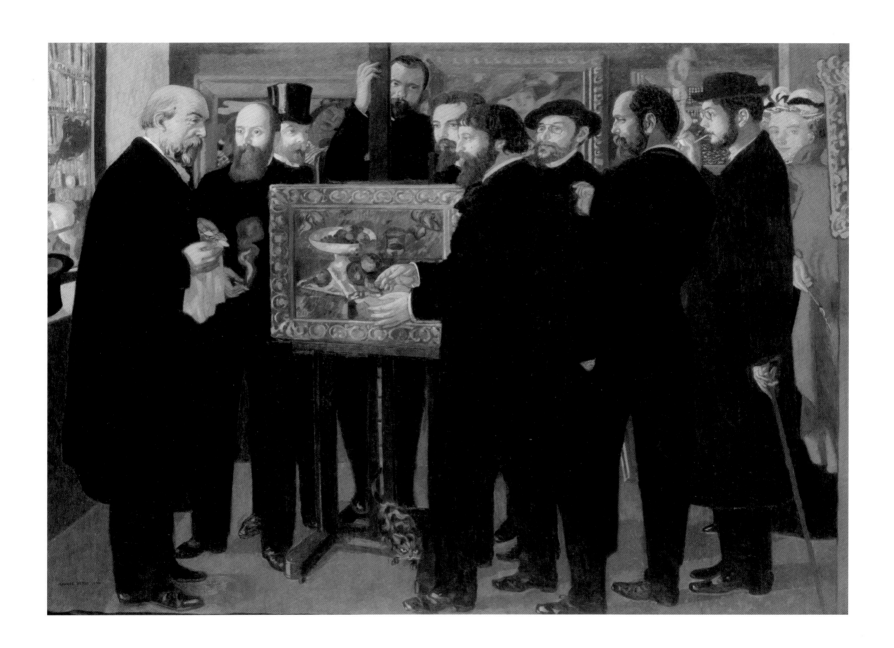

39

MAURICE DENIS

French, 1870–1943

Homage to Cézanne

1900

Oil on canvas, 5 feet 10⅞ inches × 7 feet 10½ inches (1.8 × 2.4 m)

Musée d'Orsay, Paris

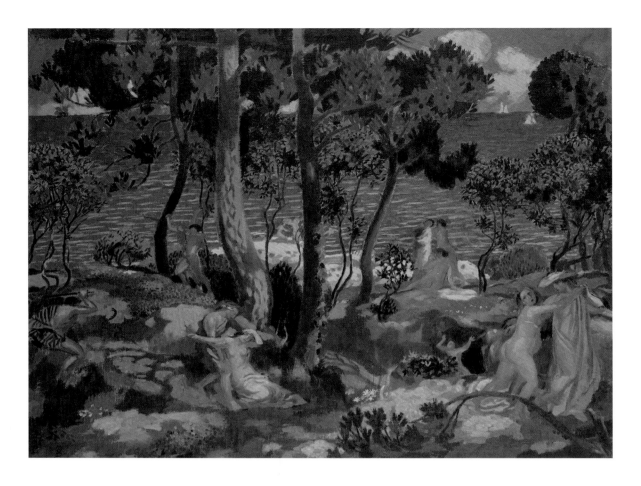

40

MAURICE DENIS

French, 1870–1943

Eurydice

c. 1904

Oil on canvas, 33⁷⁄₁₆ × 43¹¹⁄₁₆ inches
(85 × 111 cm)

Staatliche Museen zu Berlin,
Nationalgalerie. Inv. F.V.181

painting, often with a Symbolist, dreamlike quality. The Nabis, who by 1900 had begun to lose their centrality, were championed by the dealer Ambroise Vollard, who is pictured behind the easel in Denis's *Homage*, a work that points to a tradition of artists' group portraits.[75]

What could not have been lost on anyone in the room was that the painting on the easel, Cézanne's grand *Still Life with Fruit Dish* (1879–80; see fig. 5), previously had belonged to Gauguin, who in 1890 had included the picture in one of his own paintings, *Woman in Front of a Still Life by Cézanne* (see fig. 6). Denis's picture, then, enters as a private salute to Gauguin, the hero of the Nabi artists, while the classicism of Cézanne gave the Nabis their foundation and stability, as well as the grand and gracious manner of Poussin.

Denis's life, unlike Bernard's, followed a stately progression into fame and wealth, launched by his good luck in finding sympathetic colleagues at the Académie Julian in Paris in his youth.[76] But it was his visit to the Puvis exhibition at the Galerie Durand-Ruel in 1887 that set his ambitions on large-scale murals, often based on ancient sources such as Ovid or Virgil. These paintings earned him international clients as far away as Russia as well as commissions to decorate large public and private structures. Two years before his visit to the Puvis show, Denis found his calling as a devout Christian (in 1919 he joined the Dominican Third Order), and he began to paint serene and contemplative images of contemporary and domestic piety and devotion, as well as historical Christian narratives. His neo-Catholic sentiments led him to conservative politics (he joined the Action Française, a royalist movement, in the aftermath of the Dreyfus affair), which did not endear him to some of his colleagues. Margaret Werth has reminded us of Paul Signac's

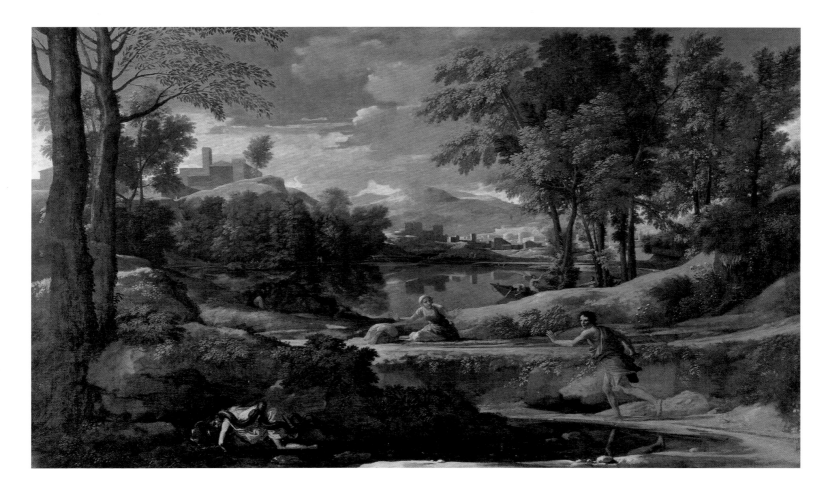

41

NICOLAS POUSSIN

French, 1594–1665

Landscape with a Man Killed by a Snake

c. 1648

Oil on canvas, 3 feet 10⁹⁄₁₆ inches × 6 feet 5⅞ inches (1.18 × 1.98 m)

National Gallery, London. Bought 1947

wry reference to Denis's penchant for "catholicisme sportif" themes, perhaps provoked by the ease with which Denis moved between Christian and pagan subjects, an ability that was central to his even, applied temperament.[77] For example, the character and characterization of Denis's *Orchard of the Wise Virgins* (1893; Galerie Daniel Malingue, Paris), Christian in subject, are of the same tenure as his famous *Muses* of the same year (Musée d'Orsay, Paris).[78] This was, of course, very much Denis's intent, suggesting it was Signac, not Denis, who was the moralist, keeping genres, spiritual or otherwise, within set compartments.

Denis's embrace of ancient literature as a source for his murals and his smaller canvases is evident in the abundance of scenes of satyrs and nymphs throughout his oeuvre, such as those in one of his most ambitious projects, *The Story of Psyche* of 1908–9, a series of seven painted panels commissioned by the collector Ivan Morozov for his mansion in Moscow, which depict episodes from Apuleius's *Metamorphoses* (see fig. 76).[79] Another mythological work, *Eurydice* (c. 1904; fig. 40), is a rare occasion of Denis's theatricality, featuring a violent snake that is nearly as terrifying as the one in Poussin's *Landscape with a Man Killed by a Snake* (c. 1648; fig. 41).

It is with a series of contemporary beach panoramas that Denis perhaps draws closest to the classicism of Cézanne that he had so thoughtfully defined in 1907. Peopled by modern women and children—maternity and the joy of children being among his most affecting themes, both in religious and secular contexts (Denis was the father of nine)—these scenes began to appear in his work around 1898 and increased with his purchase in 1908 of a villa above the sea at Perros-Guirec in Brittany (a place he had known and loved since his Nabi days), which allowed him to play out

42
MAURICE DENIS
French, 1870–1943
Study for "The Beach" (Sketch for "The Golden Age")
1911
Oil on board, 18⅛ × 9⁷⁄₁₆ inches
(46 × 24 cm)
Musée Départemental de l'Oise,
Beauvais, France

the great pleasure he took from the sea views, culminating in *The Beach* (represented here by its study; fig. 42), a panel for *The Golden Age*, a mural cycle commissioned in 1912 for Alexandre Berthier, prince of Wagram, which now decorates the stairwell in the Musée Départemental de l'Oise in Beauvais. One is tempted to think these bathing scenes offered the artist a chance to pull back from any direct textual narrative into a more Symbolist realm, a profoundly sensual, slightly blurred, and dreamy Arcadian vision of a paradise on earth, of human beauty and fecundity awash in radiant light as a sort of joyous hymn. No work represents this better than his *Women by the Sea* of 1911 (fig. 43), in which the young women in the foreground prepare to bathe or, having just bathed, make their toilette, while others tend to playing children, one of whom has made it into the water. It is Denis's favorite time, late on a summer's day, a sunbeam shining on the placid sea. Here he has fulfilled with ease and harmony what he cherished most and understood best in Cézanne, the smiling old man in his 1906 sketch.

43

MAURICE DENIS

French, 1870–1943

Women by the Sea

1911

Oil on canvas, 45^{11}/$_{16}$ × 61^{7}/$_{8}$ inches (116 × 157.2 cm)

The Barnes Foundation, BF293

44
PAUL SIGNAC
French, 1863–1935

In the Time of Harmony (The Golden Age Is Not in the Past, It Is in the Future)

1893–95
Oil on canvas, 9 feet 10⅛ inches × 13 feet 1½ inches (3 × 4 m)
Mairie de Montreuil, France

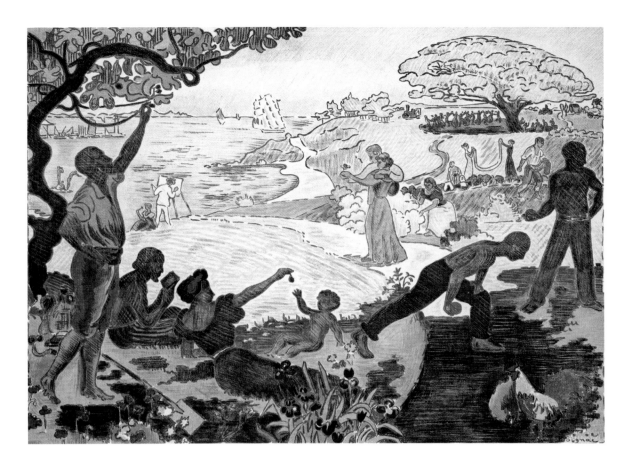

PAUL SIGNAC (1863–1935)
GEORGES SEURAT (1859–1891)

The most ambitious work on the theme of Arcadia in this study is Paul Signac's huge canvas *In the Time of Harmony (The Golden Age Is Not in the Past, It Is in the Future)*, painted between 1893 and 1895 (fig. 44). The picture's title was first recorded when the painting was shown in Paris in the Salon des Indépendants of 1895, an open, nonjuried exhibition with no prizes, established eleven years earlier as an alternative to the official Salon by, among others, Signac, Henri-Edmond Cross, Odilon Redon, and Georges Seurat.

A Parisian born into a life of relative affluence, Signac received little formal instruction as an artist, as eager as he was by his teens to pursue painting. He attached himself to the progressive artists of his day—first Monet and then Pissarro—the latter encouraging Signac's leftist leanings, which would sustain him all his life. Gustave Caillebotte taught him to sail, and, for Signac, with some thirty-two boats recorded in his possession over the course of his life, it was this love of water that led him early in his life to travel down the center of France on the Midi Canal to find his destiny on the French Mediterranean coast. In 1892 he purchased a house and settled almost permanently in Saint-Tropez, which served as the backdrop for his *In the Time of Harmony*.

In 1893 Signac wrote to Cross about his idea for this monumental painting, citing the phrase that became its subtitle, "l'âge d'or n'est pas dans le passé, il est dans l'avenir," which he had read in an article by Charles Malato in *La revue anarchiste*.[80] In our context, the phrase is particularly reminiscent of Virgil's fourth *Eclogue* (4:5–11), which describes the second coming of the golden age:

Now is come the last age of Cumaean song; the great line of the centuries begins anew. Now the Virgin returns, the reign of Saturn returns; now a new generation descends from heaven on high. Only do you, pure Lucina, smile on the birth of the child, under whom the iron brood shall at last cease and a golden race spring up throughout the world![81]

Signac had planned to call the picture *In the Time of Anarchy*, underscoring his fervent hope to make a grand public statement about the benefits of an open society, free of oppression and social hierarchy.[82] The painting depicts a human realm of justice and pleasure, a balanced society at peace, with, as the artist was quick to qualify, "a young couple in the middle: free love!"[83] Capturing an ideal French nation in the spirit of Puvis, *In the Time of Harmony* is an evocation of what was and what still is possible.[84] We know from the alternate title of the color lithograph that Signac made after his painting, *In the Time of Harmony (The Joy of Life—Sunday at the Seaside)* (1895–96; fig. 45), that it is the workers' day off, even as simple labors continue.[85] In the middle ground a sower seeds the fertile land, while others mend nets. In the distance a steam tractor puffs away while women dance gaily in a circle, à la the ring of dancers in Matisse's later paintings *Le bonheur de vivre* (1905–6; see fig. 58) and *Dance (II)* (1910; State Hermitage Museum, Saint Petersburg). In Signac's canvas, industry, leisure, and fellowship thrive in a paradisial landscape in which ripe figs are within easy reach and where fecundity (symbolized by the presence of roosters and hens) abounds.

Signac's public ambitions for his great labor were firm, but his hopes to give the painting a permanent life were frustrated. In 1897 he attempted to show it in the architect Victor Horta's new Maison du Peuple in Brussels, a plan which finally floundered in 1900. He had hoped the painting's lithograph would be circulated broadly through *Les temps nouveaux*, the anarchist journal edited by his friend and activist Jean Grave, but it was never published. Yet any disappointment these setbacks caused seems to have had no severe effect on the young artist, who by 1900 was still in his thirties. His joy in life and optimism, political and personal, are wonderfully described in his biography, written by his granddaughter and published in 1971.[86] Signac's masterpiece finally achieved the public status he had long sought for it, although after his death; in 1938 his family gave the painting to the city hall of Montreuil, just east of Paris, where it still is displayed with great pride and effect.

In its large scale, composition, and theme, *In the Time of Harmony* is a natural and conscious response to Seurat's *Sunday on La Grande Jatte* (1884–86; fig. 46).[87] It was with the support and encouragement of Seurat, whom Signac had met in June 1884 at a meeting to organize the Société des Artistes Indépendants, and the older Pissarro, who embraced Seurat's structured and disciplined Neo-Impressionist method of painting, that Signac found his way. The exhibition of *La Grande Jatte*, along with works by Signac and Pissarro in his newly adopted manner, at the eighth Impressionist exhibition in 1886 put an end to Impressionism as it had been organized as a consolidated group since 1874. Seurat was very shy (Pissarro even described him as "mute"), and thus quite willing, one can imagine, for the energetic and outgoing Signac, whose portrait Seurat drew in 1889–90 (fig. 47), to become the spokesman for the new union of pointillists.[88] As the editor Thadée Natanson observed in his journal *La revue blanc* in 1900, "If one were to make of what is called pointillism a kind of religion, it would claim Delacroix and the impressionists as its prophets, Seurat would be its Messiah, but Paul Signac would appear as its St. Paul."[89] While retaining his

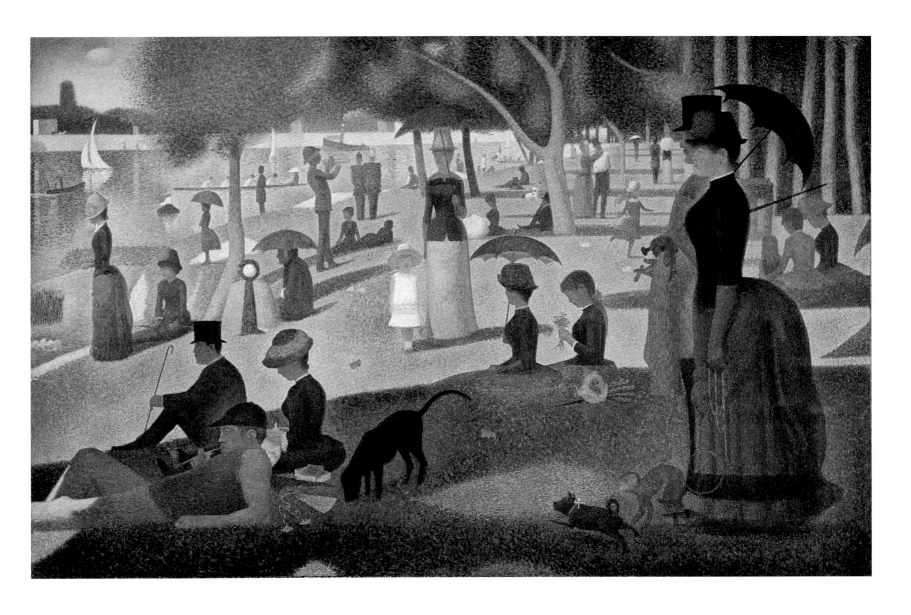

46

GEORGES SEURAT

French, 1859–1891

A Sunday on La Grande Jatte — 1884

1884–86

Oil on canvas, 6 feet 9¾ inches × 10 feet 1¼ inches (2.08 × 3.08 m)

The Art Institute of Chicago. Helen Birch Bartlett Memorial Collection, 1926.224

47

GEORGES SEURAT

French, 1859–1891

Paul Signac

1889–90

Conté crayon on paper, 13⁹⁄₁₆ ×
11 inches (34.5 × 28 cm)

Private collection

48

PAUL SIGNAC

French, 1863–1935

Opus 217: Against the Enamel of a Background Rhythmic with Beats and Angles, Tones, and Tints, Portrait of M. Félix Fénéon in 1890

1890

Oil on canvas, 29 × 36½ inches
(73.7 × 92.7 cm)

The Museum of Modern Art, New
York. Fractional gift of Mr. and
Mrs. David Rockefeller

firm independence and libertarian views throughout his life, with flares of activism particularly during World War I and again during the emerging Nazi threat in the 1930s, Signac never returned to painting a subject political in theme, convinced finally that art was something to please and liberate people as they gained the time and independence of mind to enjoy it.

One of the ironies in the history of modern art in the late nineteenth century is the way in which Signac's painting, so specifically staged as a depiction of figures at leisure on their day off, affected the reading—particularly with attempts to impose a political leaning—on the mixing of classes (with at least one intruder—the reclining man in a sleeveless shirt on the lower left) in Seurat's masterpiece of Sunday leisure. The literature on the politics of *La Grande Jatte* is dense, as are the various needs and desires to position this masterpiece in an anarchist program—a notion supported by Seurat's close relationship with Pissarro and Signac, as well as with one of the great theoretical liberals of the time, Félix Fénéon, whose portrait was painted by his friend Signac in 1890 (fig. 48).[90] However, no overt political position has ever logically been established for *La Grande Jatte*, a painting that Fénéon described as a "modernizing Puvis."[91]

As Stephen Eisenman wisely wrote, "Far from an image of iconic stability that disdains modern history, the *Grande Jatte* is a picture of contingency and contemporaneity; far from a painting of modern life that rejects idealism, Seurat's work is monumental and classic. At once contemporary and timeless, epic and ironic, visionary and realist, the *Grande Jatte* advances no specific political or aesthetic doctrines."[92] In this spirit we have chosen to represent Seurat with the very beautiful study for *La Grande Jatte*, which is absent of the figures who eventually would strive in their mute and stately fashion to set a tableaux as open to interpretation as it is popular (fig. 49). The study marks a step in the temporal evolution of the painting when Seurat was able to work out with great refinement the pattern of shadows in the landscape, perhaps the purest and most poetical moment in the complex making of the final picture.

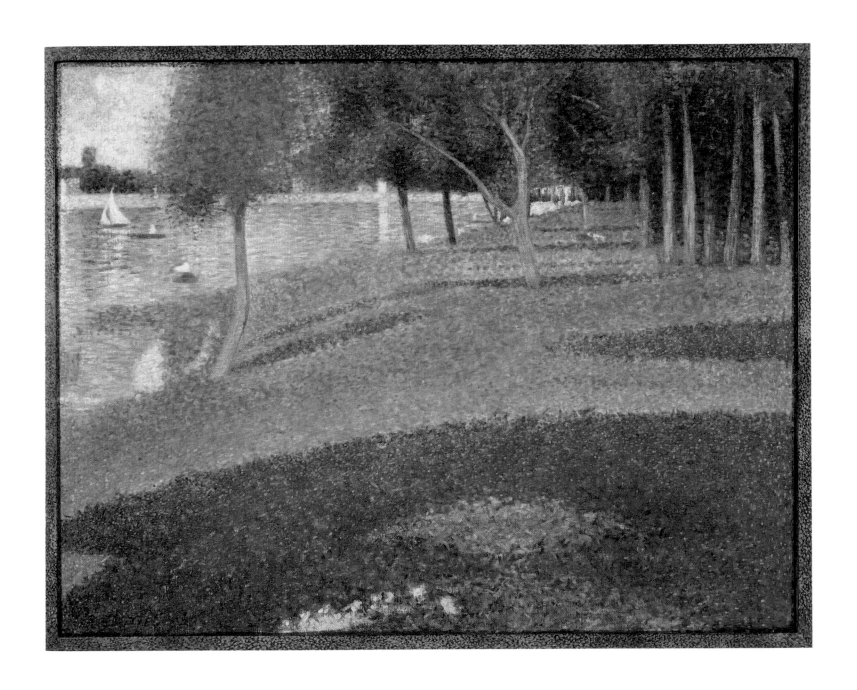

49

GEORGES SEURAT

French, 1859–1891

Landscape, Island of La Grande Jatte

1884, retouched c. 1885, painted border c. 1889–90

Oil on canvas, 27½ × 33¾ inches (69.9 × 85.7 cm) with border

Private collection

HENRI-EDMOND CROSS (1856–1910)
HENRI MATISSE (1869–1954)

Although Henri Matisse is the focus of a separate essay in this volume in which Stephanie D'Alessandro so thoughtfully explores his painting *Bathers by a River* (1909–10, 1913, 1916–17; see pages xiii–xiv and fig. 172) and its long evolution between the past and the future, it is perhaps useful within this overview to expand on Matisse's relationship with Signac and other Neo-Impressionist artists, and how this boded for poetical or pastoral painting, with or without political ambitions, into the twentieth century.[93]

To do this, we need to step back to Henri-Edmond Cross, a central player in the evolution of Neo-Impressionism in the 1890s, whose originality became somewhat lost among his more flamboyant and long-lived colleagues. Although Cross was well aware of Seurat's quiet revolution to exceed Impressionism, he found his bearings as a Neo-Impressionist only in 1891, when he moved to the south of France, first to Cabasson and then to Saint-Clair, a fishing village near Saint-Tropez. There he became close friends with Félix Fénéon as well as the Neo-Impressionist painters Théo van Rysselberghe and Maximilien Luce, and further developed his friendship with Signac (who, at Cross's encouragement, moved to Saint-Tropez in 1892).[94] Together, Signac and Cross took Seurat's finely precise and discreetly divided applications of paint and expanded them into bolder, blunter dashes applied in a mosaic-like way. Cross developed this technique in a very individual manner that perfectly suited the gentle and evocative nature of his art, retreating at times to a realm of pure, poetical innocence, as in his *Landscape with Goats* (1895; fig. 50), and often depicting people in a timeless land that is neither antique nor modern, rarely far from the sea, and particularly active late in the day, as in his *Excursion* of the same year (fig. 51).

The best known of these paintings is Cross's *Evening Breeze* (1893–94; fig. 52), bought by Signac and now in the Musée d'Orsay in Paris. Smaller in scale, and therefore more refined and concentrated, is his *Mediterranean Shores* (1895; fig. 53), wherein women prepare their toilette as men haul nets—the figures captured in their eternal suspension, evoking a golden age that rivals that of Puvis. But unlike Puvis's images that were drawn purely from his imagination, Cross's landscape is awash with the sunlight of his physical surroundings on the Mediterranean coast, fulfilling Signac's charge to "raise a decorative monument" to "this sunny land."[95] Cross's record of the landscape of the south as he found it in the 1890s takes little poetical adjustment to become the realm of Arcadia. ("Paradise regained . . . the color that reigns here is that of dreams elsewhere, but on the shores of Provence it bathes every reality," the writer Colette said of Saint-Tropez, just as the train started to descend on the region and hotels began to rise.)[96] Only when Cross chose, as Signac never did, to people his meadows with mythic figures, as he did in *Faun* (1905–6; fig. 54), would imagination gain, just barely, on observation.

It is through the highly schooled and intelligent Cross that this new way of putting paint on canvas attracted Matisse in the summer of 1904, when the younger artist, encouraged by Signac, rented a house at Saint-Tropez for almost four months. We know from Matisse's oil sketch of his family playing on the beach in front of Signac's villa (fig. 55) that he was determined to take back to Paris his ambitious evocation of the land, the results of which can

50

HENRI-EDMOND CROSS

French, 1856–1910

Landscape with Goats

1895

Oil on canvas, 36¼ × 25⁹⁄₁₆ inches
(92 × 65 cm)
Association des Amis du Petit Palais,
Geneva

51

HENRI-EDMOND CROSS

French, 1856–1910

Excursion

1895

Oil on canvas, 44½ × 63¾ inches
(113 × 161.9 cm)
Chrysler Museum of Art, Norfolk,
VA. Gift of Walter P. Chrysler, Jr.

52

HENRI-EDMOND CROSS

French, 1856–1910

Evening Breeze

1893–94

Oil on canvas, 45¹¹⁄₁₆ × 64⁹⁄₁₆ inches (116 × 164 cm)

Musée d'Orsay, Paris

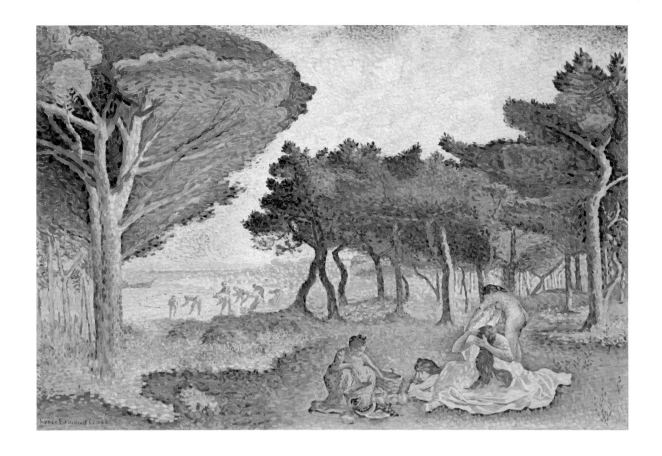

53
**HENRI-EDMOND
CROSS**
French, 1856–1910

Mediterranean Shores

1895
Oil on canvas, 25⅞ × 36½ inches
(65.7 × 92.7 cm)
Mr. and Mrs. Walter F. Brown

54
**HENRI-EDMOND
CROSS**
French, 1856–1910

Faun

1905–6
Oil on canvas, 39⅜ × 31⅞ inches
(100 × 81 cm)
Private collection

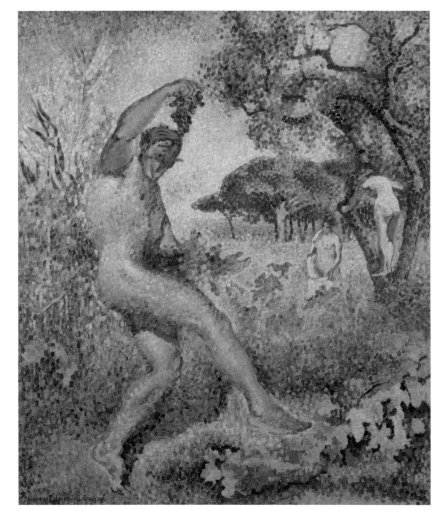

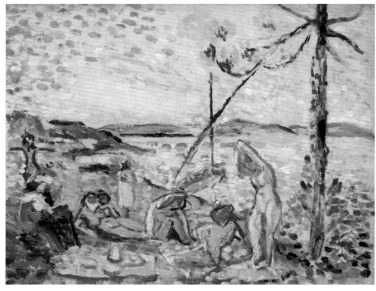

55
HENRI MATISSE
French, 1869–1954
By the Sea (Gulf of Saint-Tropez)
1904
Oil on canvas, 25⁹⁄₁₆ × 19⅞ inches
(65 × 50.5 cm)
Kunstsammlung Nordrhein-Westfalen, Düsseldorf

56
HENRI MATISSE
French, 1869–1954
Study for "Luxe, calme et volupté" (fig. 57)
1904
Oil on canvas, 12⅞ × 16 inches
(32.7 × 40.6 cm)
The Museum of Modern Art, New York. Mrs. John Hay Whitney Bequest

be seen in his painting *Luxe, calme et volupté* (figs. 56, 57), whose title is borrowed from Charles Baudelaire's poem "L'invitation au voyage."[97] The painting was executed with an assertive application of independent, brilliant strokes that far exceed those of Cross or Signac, and it established for Matisse the foundation for still more dramatic and aggressive workings of separate, long strokes of color, sometimes completely unrelated to observed objects. Matisse ran with this new attitude the next summer, when he went down the coast to the fortress town of Collioure, near the Spanish border, where, in the company of André Derain, he created with great energy a body of work that critics would describe as *fauve* (savage).[98] Interestingly enough, Matisse's Fauve paintings stay clear of literary or narrative multifigured compositions. It was left to Derain, with his huge and brilliant 1906 painting *The Dance* (see fig. 88), to return the Fauve style to the theater.

As swiftly as artistic ideas spread through Paris during this remarkable first decade of the twentieth century, in the autumn of 1905 Matisse's move away from experimentations with color to focus on paintings of mythological subjects, in this case more from Ovid than Virgil, was the fastest transition of all. His *Bonheur de vivre* (1905–6; fig. 58)—with its suave fields of opulent color drawn as much from Ingres's exotic palette as from his own knowledge of Persian textiles, was a very sharp turn, which horrified his friend and patron Signac.[99] Brushstrokes disappear in the washes of color that are bound by assertive drawing with the brush, lines "as thick as your

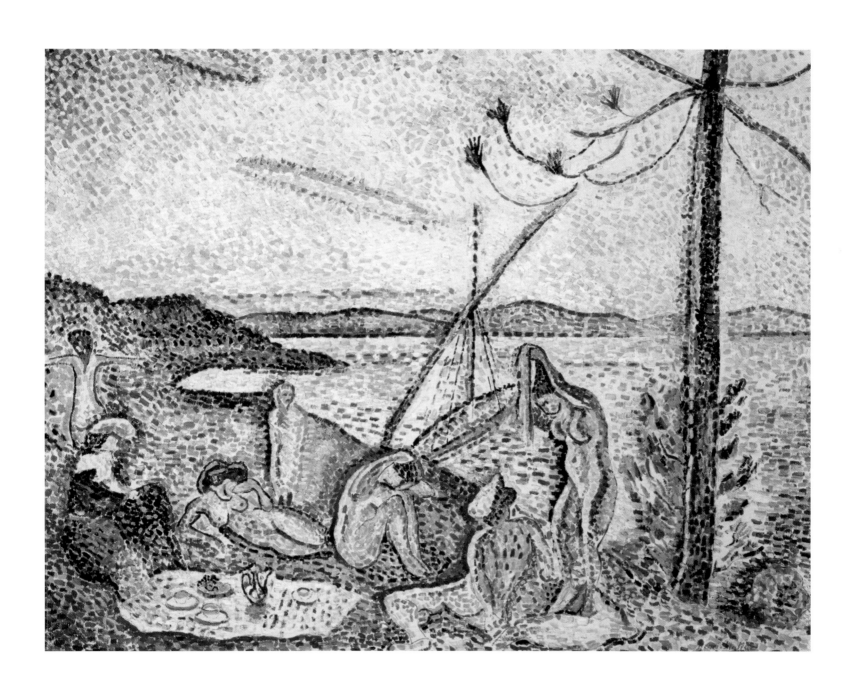

57
HENRI MATISSE
French, 1869–1954

Luxe, calme et volupté

1904–5
Oil on canvas, 38¾ × 46⅝ inches (98.5 × 118.5 cm)
Musée d'Orsay, Paris

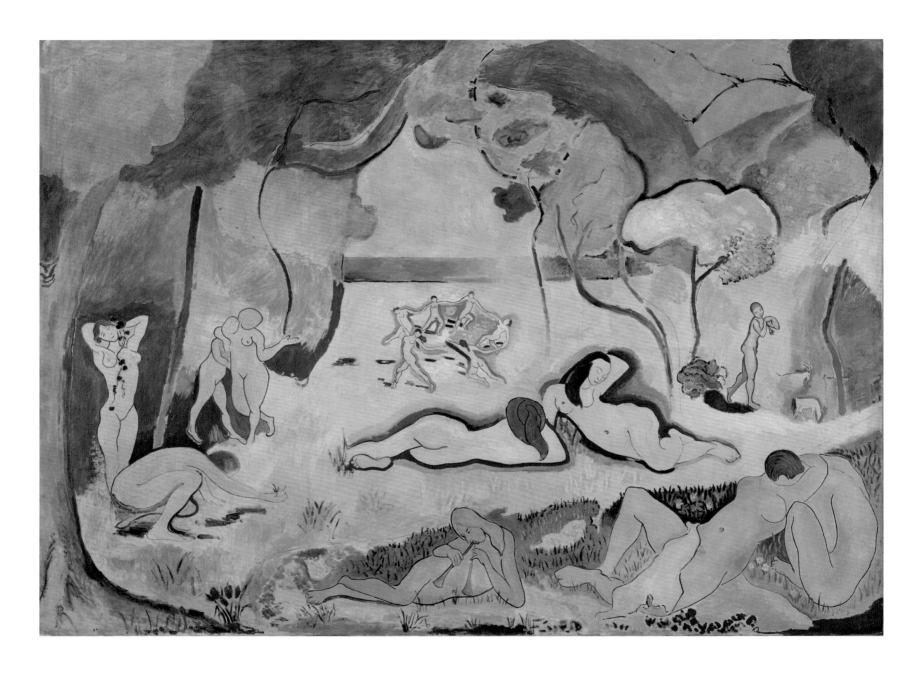

58

HENRI MATISSE

French, 1869–1954

Le bonheur de vivre

1905–6

Oil on canvas, 5 feet 9½ inches × 7 feet 10¾ inches (1.77 × 2.41 m)

The Barnes Foundation, BF719

59

HENRI MATISSE

French, 1869–1954

Nude in a Wood

1906

Oil on board, mounted on panel;
16 × 12¾ inches (40.6 × 32.4 cm)
Brooklyn Museum. Gift of George F.
Of, 52.150

60

HENRI MATISSE

French, 1869–1954

Pastoral

Summer 1906

Oil on canvas, 18⅛ × 21⅝ inches
(46 × 55 cm)
Musée d'Art Moderne de la Ville de
Paris

thumb," as Signac protested (not unlike the leaded-glass outlines of Cézanne's bathers, which ground and define the figures [see, for example, figs. 155, 170]).[100] It is this loss of Divisionist articulation, in particular, that bothered Signac, who did, after all, have the masterpiece of the genre, Matisse's *Luxe, calme et volupté*, hanging in the dining room of La Hune, his villa in Saint-Tropez. According to legend, Matisse asked to have this painting back so he could finish it in the manner of Puvis. Jack Flam described the recorded variant of this encounter, which essentially broke for good the friendship between the two artists:

> Matisse's impatience with neo-impressionist practice and his anticipation of working with flat planes of color are apparent in his 14 July 1905 letter to Signac, in which he criticized his own *Luxe, calme et volupté* (which Signac had recently bought) for its lack of harmony between "the character of the drawing and the character of the painting." Saying that the divisionist painting had destroyed the eloquence of the drawing, Matisse remarked that "It would have sufficed if I had filled in the compartments with flat tones such as Puvis [de Chavannes] uses."[101]

But such swift and edgy transitions of this type, which we are used to seeing in the work of the fast-dancing Picasso, seem somehow foreign to our sense of the wise and calm Apollonian Matisse. Let two small oil sketches done by Matisse during his second visit to Collioure in the summer of 1906 temper this concern. For Matisse, having lived through the riotous reaction to *Le bonheur de vivre* at that spring's Salon des Indépendants, at which Cross's *Faun* also was exhibited, the line between invention and observation, which is to say, fantasy and reality, blurred in very winning ways. A beautiful small sketch in the Brooklyn Museum, *Nude in a Wood* (1906; frontispiece and fig. 59), is a charming echo of the creatures that people the paradise of *Le bonheur de vivre*, even

61–64 *(opposite page)*

HENRI MATISSE

French, 1869–1954

Clockwise from top left:

Vignette with Two Nymphs,
A Faun Playing His Flute
for a Group of Nymphs,
A Swan, and *A Faun with*
a Bunch of Grapes

Illustrations for Stéphane Mallarmé's
poems "L'après-midi d'un faune"
(top left and right; bottom left) and
"Sonnet—Le vierge, le vivace . . ."
(bottom right)

1930–32

Published in *Poésies de Stéphane Mallarmé:*
Eaux-fortes originales de Henri Matisse

(Lausanne: Albert Skira, 1932)

Four etchings, sheets: 13 × 9¹³⁄₁₆ inches
(33 × 25 cm) each

Philadelphia Museum of Art.
Gift of Mrs. W. Averell Harriman,
1952-87-10,p,r,x

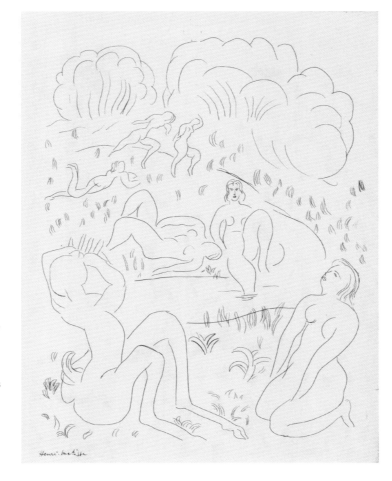

65 *(above)*

HENRI MATISSE

French, 1869–1954

Afternoon of a Faun
(The Concert)

Unpublished illustration for
Stéphane Mallarmé's poem
"L'après-midi d'un faune"

1932

Etching, sheet: 12⅞ × 9¾ inches
(32.7 × 24.8 cm)

The Barnes Foundation, BF1092

if the gender of the figure, who is seen from the back, is not immediately clear, and there is no company to initiate the poetic encounter other than that of nature, which for Ovid and Virgil is perfectly correct. It recalls in many ways Margaret Werth's profound observation in discussing *Le bonheur* that "Matisse's engagement with the heterogeneous tradition of the Western idyll had less to do with a personal 'transcendence' or a 'state of grace achieved through total harmony with nature' than with an attempt to make a modern yet mythic image of idyll which ended in a de-realized yet disturbingly explicit map of desire's origins."[102] More grounded is Matisse's explanation that the nude in question was his wife, Amélie: "For the nude, I go every morning at six to the mountain woods with my wife, who poses leisurely. We've been there at least ten times, never having been disturbed. But it's an hour's walk and we have to return around ten or eleven in the morning in the heat. It's awfully tough."[103]

The beautiful Brooklyn sketch is in happy company with another painting, in this case with two nude figures, which is slightly more ambitious in terms of scale and cast (fig. 60). In this work, painted during the summer of 1906, a more easily discerned nude man and woman lounge in the foreground while their child (a boy?) plays in front of them, perhaps dancing to the piped tunes of the young faun that sits on the edge of the embankment beyond. As Matisse famously said during an interview with Clara MacChesney, "I do not literally paint that table, but the emotion it produces upon me," which in this case moves comfortably from the scene to the imagined— or, to return to Werth, the desired—all in the spirit of the self-conscious irony that threads through many of Matisse's more fanciful works.[104]

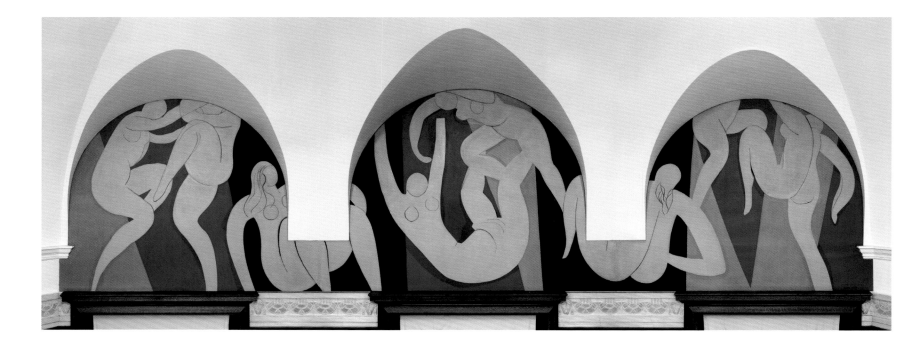

66

HENRI MATISSE

French, 1869–1954

The Dance

1932–33

Oil on canvas; three panels: left, 11 feet 1¾ inches × 14 feet 5¾ inches (3.4 × 4.41 m);
center, 11 feet 8⅛ inches × 16 feet 6⅛ inches (3.56 × 5.03 m); right, 11 feet 1⅜ inches ×
14 feet 5 inches (3.39 × 4.39 m)

The Barnes Foundation, 2001.25.50

67

PAUL CÉZANNE
French, 1839–1906

Lutte d'amour

c. 1880
Oil on canvas, 14¹⁵/₁₆ × 18⅛ inches
(38 × 46 cm)
National Gallery of Art,
Washington, DC. Gift of the
W. Averell Harriman Foundation
in memory of Marie N. Harriman,
1972-9-2

After completing *Bathers by the River* in 1917 and essentially moving permanently from Paris to the south, Matisse's attractions to an Arcadian mode were never far from the surface. The most concrete example is his fortuitous commission in 1930 from the publisher Albert Skira, sponsored in part by gallery owner Marie Harriman in New York, to illustrate Stéphane Mallarmé's collection of poems, *Poésies* (1899), which, of course, had brought back into focus the world of fauns and paradisial desires. The figures that populate Matisse's illustrations for Mallarmé's poems (figs. 61–65), from dancers to a reed piper, closely correlate to those who romp so joyously through the three hemicycles of *The Dance*, his mural at the Barnes Foundation (1932–33; fig. 66), with a glance aside to Cézanne's *Lutte d'amour* (c. 1880; fig. 67).[105]

Finally, there is *La verdure (Nymph in the Forest)* (1935–c. 1943; fig. 68), the tapestry cartoon Matisse worked on at the Hôtel Régina in Cimiez, a neighborhood in Nice, a work that occupied him into World War II. In the picture, a very pink maiden appears to give herself to a dark figure, perhaps a satyr, in a dense forest of aligned trees, a primitive pavilion on the side of a path lined with flowers and decorated with a yellow sail, or veil, which is caught in the wind and blowing freely above the two figures' encounter, lending the image the dreamy, moving quality of Matisse's illustrations for Mallarmé. The figures in *La verdure* are near cousins of the ones he used in two earlier works, a ceramic triptych designed for the German collector Karl Ernst Osthaus in 1907 (fig. 69) and the painting *Nymph and Satyr* (1908–9; fig. 70), which found a second, and equally lusty, life in his illustrations for Mallarmé's *Poésies*.

68

HENRI MATISSE

French, 1869–1954

La verdure (Nymph in the Forest)

1935–c. 1943

Oil on canvas, 7 feet 11¼ inches × 6 feet 4¾ inches (2.42 × 1.95 m)

Musée Matisse, Nice

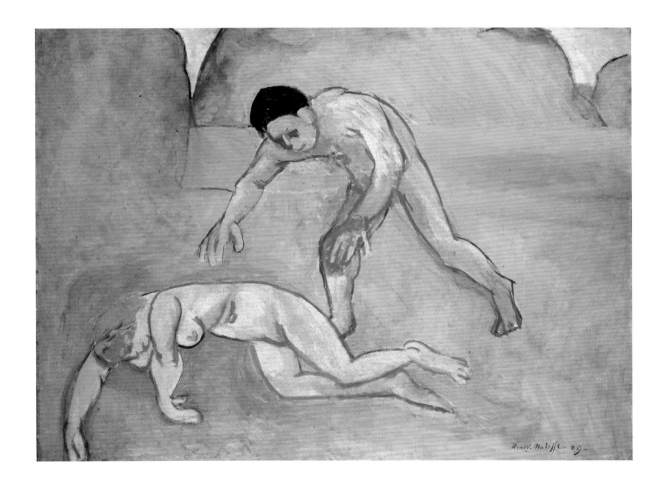

69

HENRI MATISSE

French, 1869–1954

Nymph and Satyr

1907

Painted and glazed ceramic tiles; three panels: left, 23¹⁄₁₆ × 15⁹⁄₁₆ inches (58.5 × 39.5 cm); center, 22¼ × 26⅜ inches (56.5 × 67 cm); right, 22⁷⁄₁₆ × 14¹⁵⁄₁₆ inches (57 × 38 cm)

Osthaus Museum, Hagen, Germany

70

HENRI MATISSE

French, 1869–1954

Nymph and Satyr

1908–9

Oil on canvas, 35¹⁄₁₆ × 45⅞ inches (89 × 116.5 cm)

The State Hermitage Museum, Saint Petersburg

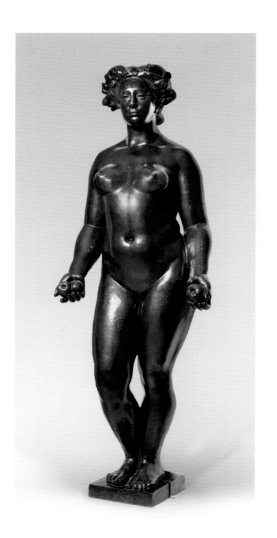

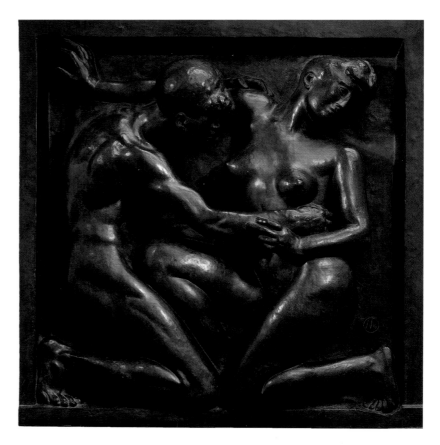

ARISTIDE MAILLOL (1861–1944)

Aristide Maillol was a man of the south, a child of the Mediterranean in the deepest sense, going back to the Romans and Greeks. His investment in upholding the elevated beauty of antique sculpture sustained him throughout his long career, marked by a very disciplined and careful balance of classical formal values and profound sensuality, on par with Renoir, whom Maillol encouraged to take up sculpture late in life. Maillol's fame is as a sculptor, even though he began his career as a painter in quite a progressive and ambitious Neo-Impressionist manner, and his unassuming, almost rustic woodcuts, nearly all on simple themes of Arcadian pleasures and desires, have assured him a position as one of the greatest book illustrators of the twentieth century. Yet another plateau of his growing fame was the commission in 1912 from a committee of artists headed by Franz Jourdain, the founder of the Salon d'Automne, to erect a public monument to Cézanne (see fig. 75).

As he was for Cézanne, Virgil was Maillol's great love. Judith Cladel, Maillol's first biographer, recounted the artist reciting the opening verses of the *Eclogues* at will, even as he insisted on reading the text despite not understanding it.[106] His appreciation of the poet likely had an effect on those around him, including Matisse, whom he had met in the summer of 1905. Banyuls-sur-mer, the Mediterranean fishing town in Roussillon near the Spanish border where Maillol grew up and returned throughout his life, was within walking distance of Collioure. During the summer of 1905, when Matisse was working with Derain in Collioure on their Fauve paintings, which

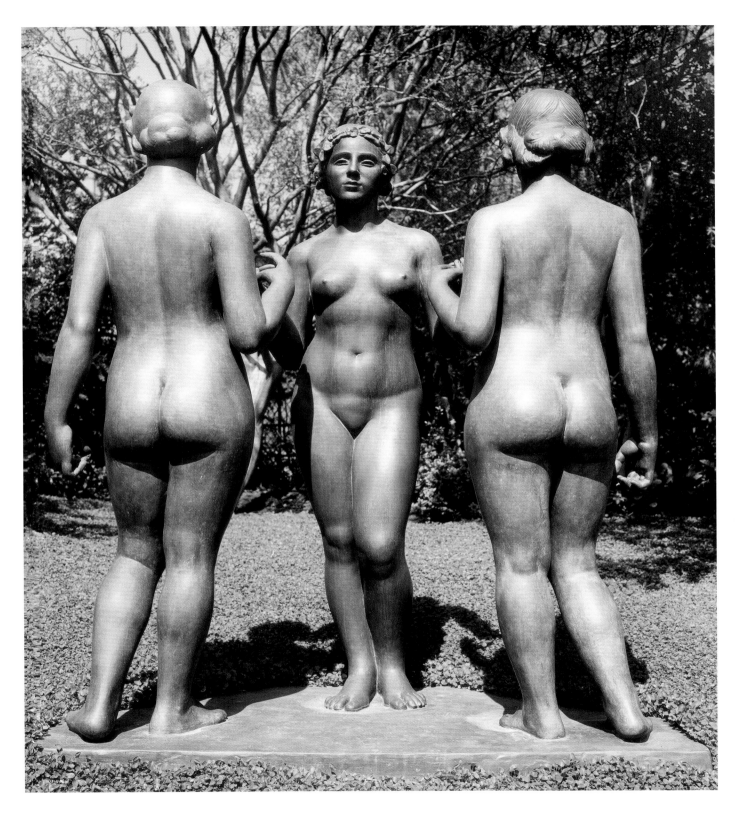

73

ARISTIDE MAILLOL

French, 1861–1944

The Three Nymphs

1930–38

Lead, 62 × 57⅜ × 31½ inches (157.5 × 145.7 × 80 cm)

National Gallery of Art, Washington, DC. Gift of Lucille Ellis Simon, in honor of the
50th anniversary of the National Gallery of Art, 1991.39.1

74
Place du Carrousel, Paris, with
Maillol's sculptures *Venus* (left) and
Nymph (center)

75 (*opposite page, top*)
ARISTIDE MAILLOL
French, 1861–1944
Monument to Cézanne
1912–25 (cast at later date)
Lead, h 7 feet 3⅜ inches (2.22 m)
Collection of Lynda and Stewart
Resnick

would have such a jarring effect in Paris that fall, Gauguin's artist friend Georges-Daniel de Monfreid introduced Maillol to Matisse.[107] One cannot help but wonder how much of Matisse's swiftly evolving imagination was spurred, in some essential way, by this new friendship with this rustic classicist and sensualist during the two-year trajectory in which time he completed *Luxe, calme et volupté* and *Le bonheur de vivre*. Pierre Schneider, in particular, has noted the fertility of the first few years of their acquaintance, when, thanks to Maillol, "Matisse gained a deeper understanding of Gauguin and immersed himself in the Arcadian atmosphere."[108] Although they remained lifelong friends, Maillol's influence on Matisse waned—the two artists, in the end, guided by different aesthetic principles. Matisse remarked that "Maillol's sculpture and my work of the same order are totally unrelated. We never discussed sculpture. We were not on the same wavelength. Maillol worked in masses like the ancients and I in arabesques like the Renaissance sculptors. Maillol didn't like taking risks and I couldn't resist them."[109]

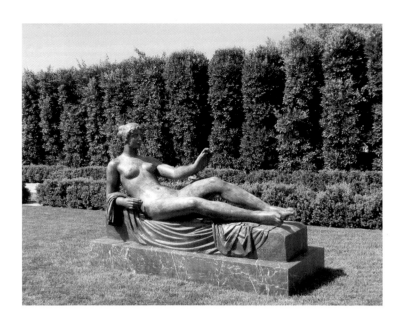

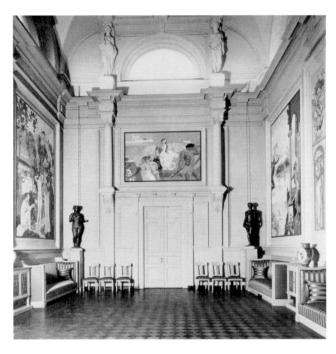

76 (*bottom left*)

Music room of Ivan Morozov's palace in Moscow, with three panels of Denis's mural cycle *The Story of Psyche* and Maillol's sculptures *Pomona* (left; see fig. 71) and *Flora*

77 (*bottom right*)

Living room of Harry Kessler's house in Weimar, with Maillol's sculpture *The Cyclist* in front of Denis's mural *The Forest with Hyacinths*, 1915 Photograph by Henry van de Velde (Belgian, 1863–1957)

Notions of Arcadia, of course, are best played out on a stage with actors in some kind of interaction. While Maillol's oeuvre abounds with single figures — individual nymphs, goddesses, and allegorical personifications, such as Venus, Mediterranean, Flora, Summer, Spring, or Pomona (see fig. 71) — there are few works that involve contact among the players, real or imagined.[110] The high relief *Desire* (1906–8; fig. 72) is Maillol's most sexually forthright creation, while the bronze sculpture *The Three Nymphs* (1930–38; fig. 73) is by comparison remarkably chaste and pastoral, albeit in a robust and hearty way. Maillol described these three nymphs as "too strong [*puissantes*] to represent the Graces," a nod to the liberation of classical boundaries into the present that he used so effectively in his work.[111]

Yet, there are numerous moments of suggested narrative between players to be found in Maillol's sculptures, when considering their placement outdoors, a business about which the artist cared deeply and tried to control. The most dramatic example is at the Place du Carrousel in

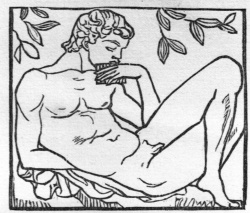

78–82

ARISTIDE MAILLOL

French, 1861–1944

Illustrations for Virgil's
Eclogen (*Eclogues*)

Left to right: frontispiece; *Tityrus
on His Pipe* (*Ecl.* 1, page 4); *The Tomb of
Daphnis* (*Ecl.* 5, page 48); *Nymphs, Goats,
and Animals on a Mountain* (*Ecl.* 6, page
59); and *Corydon and Thyrsis* (*Ecl.* 7,
page 64)

1926

Published by Cranach Press
(Weimar, 1926)

Woodcuts, book: 12½ × 9½ × ¹⁵⁄₁₆
inches (31.8 × 24.1 × 2.4 cm)

Philadelphia Museum of Art. Gift
of Carl Zigrosser, 1964-152-9

Paris, where in 1964–65 under the direction of the French Minister of Culture André Malraux and Maillol's model, Dina Vierny, eighteen of the artist's sculptures were placed in the gardens, which in the early 1990s landscape architect Jacques Wirtz redesigned as allées of high bushes, thus placing the sculptures in happy company within a woodsy setting (fig. 74), an effect repeated in installations as far as Fort Worth and Beverly Hills (see fig. 75). As for his sense of ensemble, it would be nice to know how much control Maillol had over the placement of his four individual bronzes—*Pomona, Flora, Summer,* and *Spring*—in the corners of the huge music room in Ivan Morozov's Moscow palace, underneath Maurice Denis's large mural series *The Story of Psyche* (see fig. 76), which appears to have come off with great panache and stately drama—as the Museum Folkwang in Essen, Germany, demonstrated in its reconstruction of Morozov's installation in an exhibition in 1993, by which time the bronzes had been gilded, to great effect.[112]

Such an alliance of Maillol and Denis is hardly unique, as illustrated by Henry van de Velde's photograph of the living room of the diplomat and collector Harry Kessler's house in Weimar (fig. 77), in which Maillol's sculpture *The Cyclist* (1907–8), a rare male nude by the artist commissioned by Kessler, stands before Denis's mural *The Forest with Hyacinths* (1900). This was among the first commissions Kessler gave to Maillol, followed soon after by five woodcut illustrations for a new edition of Homer's *Odyssey*. In 1908 Kessler invited Maillol to travel to Greece with him and the composer Richard Strauss's librettist Hugo von Hofmannsthal. A more improbable match is hard to imagine: the Anglo-German aristocrat of immense worldliness and culture (Kessler became a major political and cultural figure in the Weimar government after World War I) and the very grounded son of a fisherman from Roussillon.[113]

DAPHNIS EGO IN SILVIS
HINC USQUE AD SIDERA NOTUS
FORMOSI PECORIS CUSTOS
FORMOSIOR IPSE

vielerlei bilder gezeugt hat. / Wie die länder gestaunt
beim gruß der frühesten sonne, / wie sich die wolken
erhöht und fern von oben geregnet, / wie die wälder
ihr haupt gen himmel reckten und einzeln / fremdes
getier die unerforschten berge durchschweifte;

59

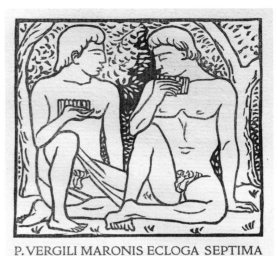

P. VERGILI MARONIS ECLOGA SEPTIMA
✲ MELIBOEUS CORYDON THYRSIS ✲

INCIPIT MELIBOEUS
Forte sub arguta consederat ilice Daphnis,
compulerantque greges Corydon et Thyrsis in unum,
Thyrsis oves, Corydon distentas lacte capellas,
ambo florentes aetatibus, Arcades ambo,
et cantare pares et respondere parati.
huc mihi, dum teneras defendo a frigore myrtos,
vir gregis ipse caper derraverat; atque ego Daphnim
adspicio. ille ubi me contra videt, ocius, inquit

64

On their trip to Greece, the two men conceived a project to produce an illustrated edition
of Virgil's *Eclogues* in three languages (English, French, and German), which Maillol began working
on soon after their return and which took off with the founding of Kessler's Cranach Press in 1913.
They paid remarkable attention to the quality of materials (the paper was handmade by Maillol
and his nephew using silk from China, although for the English edition Japanese paper was used
because of the short supply of silk due to the Chinese revolution) and to the aesthetic design in
terms of balancing text with images, resulting in one of the greatest creations in twentieth-century
book illustration.[114] Maillol prepared forty-three woodcut illustrations, each displaying "Hellenic
grace and fertile invention."[115] His frontispiece (fig. 78) sets the scene with its "indolent, nakedly
erotic tone," free from judgment, time, or harm.[116] Some images are linked to the spirit of the
poems, imbued with a tone of "lighthearted and elegant sexuality"—a piper in repose (fig. 79),
nymphs and satyrs cavorting in a mountain glen (fig. 81), and personifications such as the bibulous
Silenus, which would have made Corot proud (see, for example, fig. 25).[117] Others, however, align
quite literally to the text: The discovery of the tomb of Daphnis illustrates *Eclogue* 5 (fig. 80), as does
Poussin's *Arcadian Shepherds* (c. 1638; see fig. 141), while using an ancient structure in a cemetery in the
hills above Banyuls as his model, bringing it all back to his Mediterranean beginnings.[118] The image
of the piping contest between the amorous Corydon and Thyrsis of *Eclogue* 7 (fig. 82) perhaps most
closely follows Virgil's text ("Arcadians both, ready in a singing match to start, ready to make reply"
[*Ecl.* 7:4–5]). Because of delays during the war and Kessler's demands to continue at the highest level
of production, the first edition did not appear until 1926—just four years before Matisse received
the equally ambitious commission to illustrate Mallarmé's *Poésies* (see figs. 61–65).

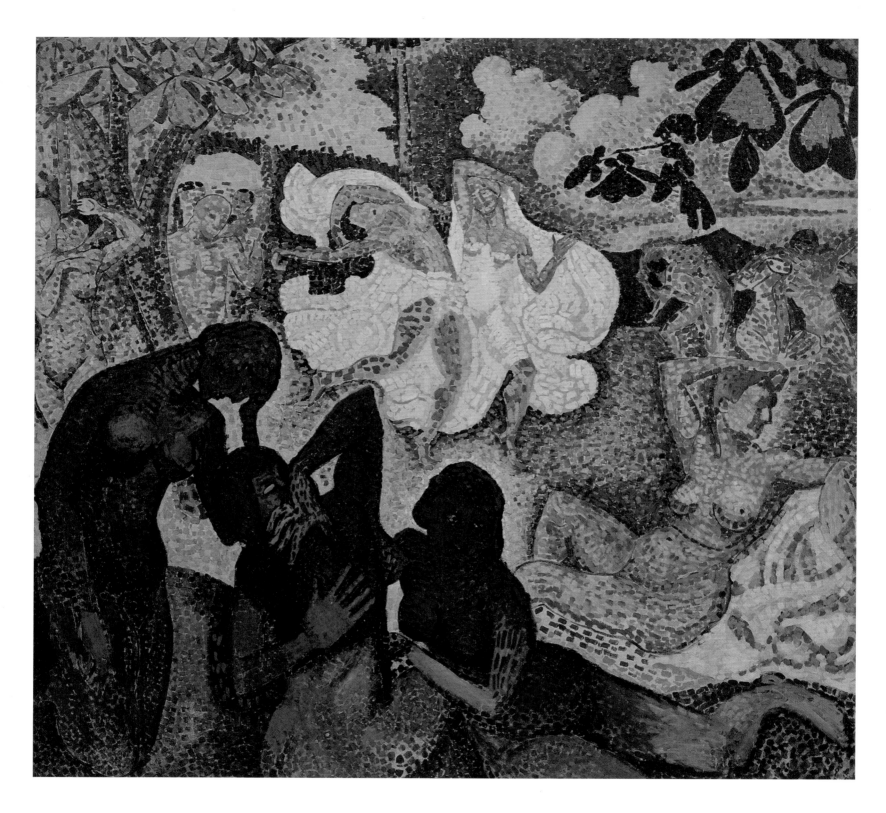

83
ANDRÉ DERAIN
French, 1880–1954

The Golden Age

1905
Oil on canvas, 5 feet 9½ inches × 6 feet 2½ inches (1.77 × 1.89 m)
Tehran Museum of Contemporary Art

84
GEORGES SEURAT
French, 1859–1891
Le chahut
1889–90
Oil on canvas, 67½ × 55⁵⁄₁₆ inches
(171.5 × 140.5 cm)
Kröller-Müller Museum, Otterlo,
The Netherlands

85
ANDRÉ DERAIN
French, 1880–1954
Portrait of Henri Matisse
1905
Oil on canvas, 13 × 16⅛ inches
(33 × 41 cm)
Philadelphia Museum of Art. A. E.
Gallatin Collection, 1952-61-22

ANDRÉ DERAIN (1880–1954)

In 1912 the poet and critic Guillaume Apollinaire summarized the remarkable breadth of André Derain's talents: With his close artist friends Matisse and Maurice de Vlaminck, Derain founded the radical revolution of color, a movement that in 1905 would be tagged "Fauve," and, in fast order, the following year, he, with his close friend Picasso, gave birth to Cubism, the "art of painting new wholes with elements taken, not from the reality of vision, but from the reality of conception."[119] Yet, as accomplished as Derain was during this short time span in evolving both the making of and the purpose of art (he was famously serious on such matters), he neither lingered as a Fauve painter, as grand as his achievements were (his paintings in this style equal those of Matisse in the eyes of many), nor did he pursue his Cubist experiments with objects in space, following so rapidly in the hands of Picasso and Georges Braque, which laid the foundation of modern art. His long and varied career was essentially outside, and often contrary to, what was considered in the later twentieth century as the canonical values of his time. As Isabelle Monod-Fontaine aptly noted, Derain was a man "painting against the tide."[120] For Apollinaire, it was over for Derain by 1910, a claim made by the critic in 1913 that did not hold up to historical fact, as Derain continued through the 1920s and 1930s as an immensely respected, successful artist with a huge international reputation.[121] It was only after the war that many found his work both datedly chic and theatrically morbid.

86

ANDRÉ DERAIN

French, 1880–1954

Letter to Henri Matisse
with a sketch of an
unrealized painting

June 1905
Ink on paper
Archives Henri Matisse

87

ANDRÉ DERAIN

French, 1880–1954

*Bathers in a Landscape
(After Gauguin)*

1905
Oil on canvas, 11 × 16⅝ inches
(28 × 42 cm)
Private collection

Beginning in the 1990s, a revived interest in the artist has taken hold, marked in part by the publication of the catalogue raisonné of his paintings.[122] Understanding his oeuvre in total helps to explain the serious commitment of Derain—who, caught somewhere between Gauguin and Cézanne, was deeply knowledgeable about the art of the past and urgently desired to sustain its values—to combine in very personal ways the two elements that define Arcadian values best: the classical and the primitive.[123] As Simon Schama wrote in his book *Landscape and Memory*, "there have always been two kinds of arcadia: shaggy and smooth; dark and light; a place of bucolic leisure and a place of primitive panic."[124]

The focus here obeys Apollinaire's boundary of 1910 and addresses only Derain's figural paintings, as much as his production is more abundant in landscapes and still lifes. His career took off with his friendship with Vlaminck, whom he famously met on June 18, 1900, after their commuter train from Paris to Chatou, the suburb where they both lived, was derailed.[125] With tremendous vigor, the two made radical departures from the use of color for local intention in paintings that remain jarring in their audacity and joy. Matisse, whom Derain had known since his student days at the Académie Camillo in Paris (where the tonalist painter Eugène Carrière taught), joined the two artists in 1901, making several trips to Vlamnick and Derain's shared studio in Chatou. In the summer of 1905, Derain and Matisse traveled to Collioure in the south of France, where they both, in a surge of energy, painted work of a rapid and radical quality that shocked many when shown in Paris that fall (see, for example, fig. 85).

For Derain, figurative subjects on a large scale seem to have started in 1905, perhaps in response to (or even in competition with?) Matisse's departure into Arcadia in 1904–5, with *Luxe, calme et volupté* (see fig. 57), in which he brought the liberality of the Fauve brushstroke to a Neo-Impressionist mosaic of dashes, a style that suited him for only this short period. Derain's response to Matisse's canvas is *The Golden Age* (1905; fig. 83), which in its cabaret loudness is as far in temperament from his friend's picture as possible.[126] One wonders in fact if he was not working more in reference to Seurat's late cabaret picture, *Le chahut* (1889–90; fig. 84), painted fifteen years earlier. As

88

ANDRÉ DERAIN

French, 1880–1954

The Dance

1906

Oil and distemper on canvas, 5 feet 8⅞ inches × 7 feet 4⅝ inches (1.75 × 2.25 m)

Fridart Foundation

89
ANDRÉ DERAIN
French, 1880–1954
Study of a Maori Carving
1906–7
Colored pencil on paper, 11 ×
8⁷⁄₁₆ inches (28 × 21.5 cm)
Private collection

90
ANDRÉ DERAIN
French, 1880–1954
*Study of a Khmer or Indian
Dancer*
1906–7
Colored pencil on paper, 11 ×
8⁷⁄₁₆ inches (28 × 21.5 cm)
Private collection

much as the rings of dancers in the background may recall those of Corot or Signac (see, for example, figs. 25, 44), and anticipate those of Matisse (see fig. 58), the figures in the foreground (one covering her face in melodramatic repulsion and distress), certainly give the picture a rather sinister, act-out character, a year before Picasso began work on *Les demoiselles d'Avignon* (see fig. 99).

At the same time as he was working on *The Golden Age*, Derain was preparing another large Arcadian-themed canvas, this one explicitly inspired by Virgil. In June 1905 he wrote to Matisse:

I am especially annoyed because I was going to start a large composition after a line from Virgil. All my studies, my drawings, were already done. I was going to start, but then an hour spent in a café in Montmartre rid me of my elation. On the contrary, see how my composition seemed very cold. See, as well, a sketch [see fig. 86]: Women in the shade under some trees, and a river in the sunlight, a line of trees on the other bank. And yet, I must admit, all this seemed monotone. When, for my unhappiness, I saw women made up in garish outfits drinking absinthe, and grenadines etc., and a billiards table, in the Parisian sunlight behind cabs, yellow horses, people in a hurry, I no longer had any will to pursue my original idea.[127]

Although Derain seems to have given up his out-of-time, pastoral canvas in the face of the pressing immediacy of contemporary life, the intended composition is known to us via the description and drawing in his letter, both of which correspond to a small oil sketch of five female nudes that must be one of the completed studies Derain mentioned.[128] To make matters more interesting, this sketch, *Bathers in a Landscape* (fig. 87), has often been referred to as *After Gauguin*, due to the sultry quality of the dark-haired bathers (in fact, it has been dated to 1906,

91

ANDRÉ DERAIN

French, 1880–1954

Earthly Paradise

1906

Watercolor on paper, 19⅝ ×

25½ inches (50 × 65 cm)

Jean-Luc Baroni, London

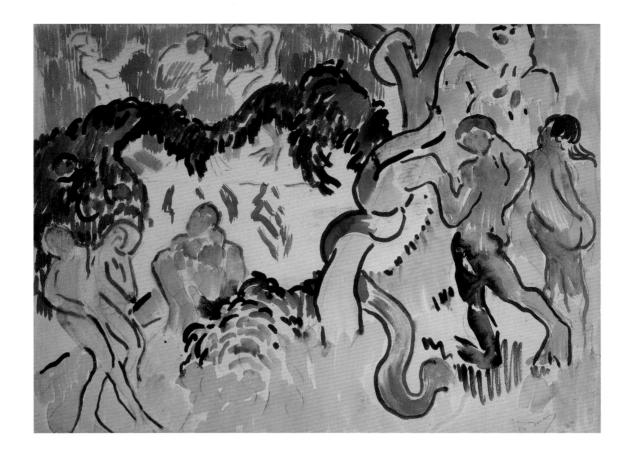

92

ANDRÉ DERAIN

French, 1880–1954

Bacchic Dance

1906

Watercolor and graphite on paper,

19½ × 25½ inches (49.5 × 64.8 cm)

The Museum of Modern Art,

New York. Gift of Abby Aldrich

Rockefeller

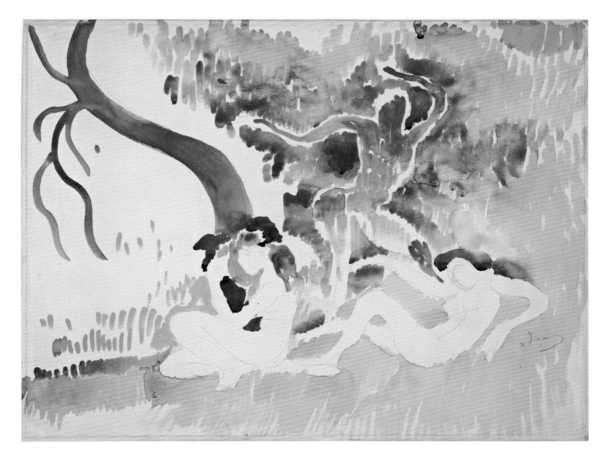

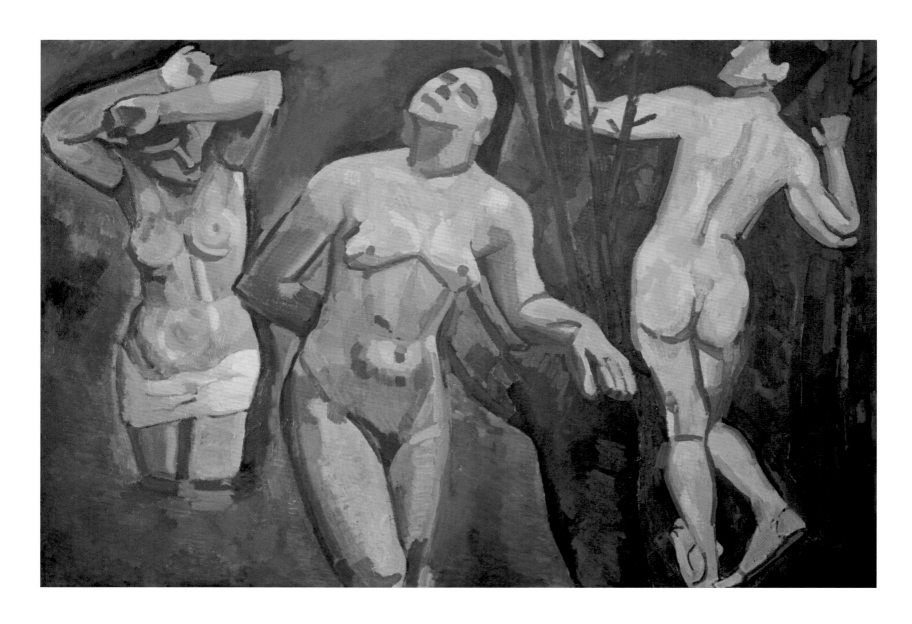

93

ANDRÉ DERAIN

French, 1880–1954

Bathers

1907

Oil on canvas, 4 feet 4 inches × 6 feet 4¾ inches (1.32 × 1.95 m)

The Museum of Modern Art, New York. William S. Paley and Abby Aldrich Rockefeller Funds, 1980

94
Derain in his studio in Paris,
with a framed reproduction of
Cézanne's *Five Bathers* (1885–87;
Kunstmuseum Basel) on the wall
behind him, c. 1908
Published in Gelett Burgess, "The
Wild Men of Paris," *Architectural
Record*, vol. 27 (May 1910)

95
ANDRÉ DERAIN
French, 1880–1954
Les champs-élysées
1907–8
Watercolor and crayon on paper,
16⅜ × 21¾ inches (41.6 × 55.2 cm)
Galerie du Post-Impressionnisme,
Paris

the year of the Gauguin retrospective at the Salon d'Automne).[129] In this case, to assume the Gauguin correlation is, of course, very inviting, with the antic and primitive balancing the Virgilian classicism of Derain's enterprise.

Indeed, as Derain continued to work in the grand tradition of Arcadian themes, Gauguin remained in the back of his mind. What followed was *The Dance* (fig. 88), usually dated to 1906, after Matisse's *Bonheur de vivre* (see fig. 58) had made its debut that spring and after Derain had seen the large Gauguin retrospective that fall, which included several Tahiti pictures and a drawing for *Where Do We Come From?* (see pages xi–xii and fig. 146).[130] Even if the painting's alternate title, *Fresque hindoue* (Hindu fresco), was not used until the 1926 sale of *The Dance*, the implication is that he had applied the convention of classical friezes of draped arches to a non-Western realm, be it Tahiti via Gauguin, or Oceania and Asia via objects Derain had seen at the British Museum, a contention recently put forth upon the discovery of two sketchbooks he had used during his three visits to London between 1906 and 1907 when Vollard commissioned him to paint views of the Thames.[131] Two drawings in these sketchbooks are particularly revealing: that of a Maori mask with tattoo patterns (fig. 89), which may have provided a reference for the patterns of the dress on the dancer at left, and that of a Khmer or Indian dancer (fig. 90), whose pose has a reverse correlation with the figure on the right of *The Dance*.[132] The bacchanalian character that marks *The Dance* is perhaps even more manic in related watercolors, including *Earthly Paradise* (fig. 91) and *Bacchic Dance* (fig. 92), both of 1906.

By the spring of 1907, Derain had moved on. Shown in the 1907 Salon des Indépendants, his large *Bathers* of that year (fig. 93) marks a new sobriety and formal detachment in his work, with its figures precisely playing off one another in space, justifying Apollinaire's remarks about

96
ANDRÉ DERAIN
French, 1880–1954
Bathers
1908
Oil on canvas, 5 feet 10⅞ inches ×
7 feet 6⁶⁄₁₆ inches (1.8 × 2.3 m)
Národní Galerie, Prague

Derain's role in the origins of Cubism. The painting anticipates in many ways the large retrospective that fall of works by Cézanne, whose death the year before, in 1906, most certainly set Derain on a series of small- and large-scale bathers of great stateliness and complexity.[133] While he might have seen some of Cézanne's bather pictures at his dealer Vollard's gallery, Derain had the advantage of studied reference to the art, having added to his studio no later than 1908 a framed reproduction of Cézanne's *Five Bathers* (1885–87; Kunstmuseum Basel), one of the artist's more satisfyingly squared-off and unified decorations of bathers (see fig. 94).[134] Between 1907 and 1909, Derain painted some seventeen variants on the bathers theme, each of increasing gravity, including the serene watercolor *Les champs-élysées* (1907–8; fig. 95) and the stately *Bathers* (1908; fig. 96).[135]

Moments of bacchic exuberance continue to surface in Derain's work, as in *The Hunt* of 1938–44 (fig. 97), a heraldic encounter of figures cavorting with wild beasts that occupied the artist throughout much of World War II. In some references the painting's title appears as *The Golden Age*; in others it is compared to verdure tapestries, or garden tapestries, whose decorative patterns were based on plant forms (the painting did, after all, serve as a tapestry design, as did Matisse's *Verdure* from about the same time [1935–c. 1943; see fig. 68]).[136]

97

ANDRÉ DERAIN

French, 1880–1954

The Hunt (The Golden Age)

1938–44

Oil on paper, mounted on canvas; 8 feet 11⅞ inches × 15 feet 8⁹⁄₁₆ inches (2.74 × 4.79 m)

Musée National d'Art Moderne / Centre de Création Industrielle, Centre Georges Pompidou, Paris

Gift of Alice Derain and Aimé Maeght, 1962 (on deposit at the Musée de l'Orangerie, Paris)

PABLO PICASSO (1881–1973)

98
PABLO PICASSO
Spanish, 1881–1973
Five Nudes (Study for
"Les demoiselles d'Avignon")
(fig. 99)
1907
Watercolor on cream wove paper,
sheet: 6⅞ × 8⅞ inches (17.5 × 22.5 cm)
Philadelphia Museum of Art. A. E.
Gallatin Collection, 1952-61-103

Perhaps more than any other artist in our broad discussion of Arcadia, Pablo Picasso is the most natural: a man deeply seated in his Mediterranean identity and well versed in ancient literature and mythology, all of which amused and sustained him at many (and various) times throughout his life. Yet, when the moment came in 1907 to rewrite the history of painting with his head still fully conscious of the inherited values of the grand manner as confirmed most urgently by Gauguin and Cézanne, he used these very sources to blow the top off nearly all conventions, inventing what would become another, more modern touchstone by high standards. In *Les demoiselles d'Avignon* (1907; figs. 98, 99), Picasso depicted nudes abducted from a lyrical landscape to a very specific interior, albeit taking much of Gauguin and Cézanne, with a glance at Matisse, with them. He knew exactly what he was doing and why, leaving the country for the city with sophistication and ease, Arcadian notions as provocation and foil always in the background.

The swiftness of this transition is made all the more dramatic by what immediately preceded it. The year 1906 was a time when Picasso seemed closest to Arcadian notions, which would release him from the sentimentality (the "illustration," as Leo Stein famously quipped) of his Blue and Rose periods, into an interlude that reached its purest form that summer when he visited the town of Gósol, isolated high in the Spanish Pyrenees.[137] It was a time that Robert Rosenblum called "the calm before the storm," a "quiet coda to the nineteenth century," or "the last gasp of traditional order before the detonation of 1907."[138] And yet, at the same time, it was Picasso's summer in Gósol that, above all, spurred him to experiment with the simplifications of form that would take new life upon his return to Paris.

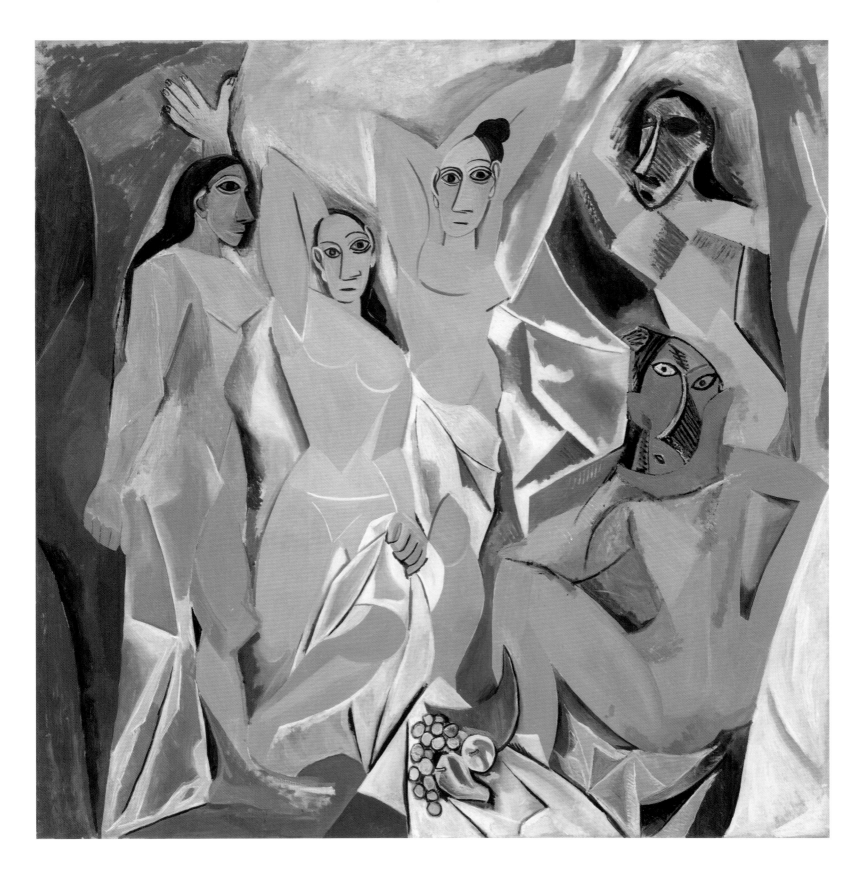

99
PABLO PICASSO
Spanish, 1881–1973

Les demoiselles d'Avignon

1907
Oil on canvas, 8 feet × 7 feet 8 inches (2.44 × 2.33 m)
The Museum of Modern Art, New York. Acquired through the Lillie P. Bliss Bequest

100

PABLO PICASSO

Spanish, 1881–1973

Adolescents

Summer 1906

Oil on canvas, 61¹³⁄₁₆ × 46¹⁄₁₆ inches (157 × 117 cm)

Musée de l'Orangerie, Paris. Collection Jean Walter and Paul Guillaume

101

PABLO PICASSO

Spanish, 1881–1973

Two Youths

Summer 1906

Oil on canvas, 59⅝ × 36⅞ inches
(151.5 × 93.7 cm)

National Gallery of Art, Washington,
DC. Chester Dale Collection,
1963.10.197

This sojourn marked the first time Picasso had been back to Spain in two years, a trip made possible by money earned through the sale of twenty paintings to Vollard that spring. As Fernande Olivier, Picasso's companion at the time, related more than twenty years later, returning to his homeland was a tonic for the artist that renewed his faith in himself and his outlook on life.[139] Olivier's presence at that time, in her prime and still early in their affair, has often been cited as the strongest contribution to Picasso's sustained optimism and happiness, well away from urban complexity into a completely rural place.

In the three months they spent in Gósol, from early June to mid-August 1906, it seems that Picasso gave himself over to the life of local herders and mountaineers—unselfconsciously beautiful as youths, wise and courtly as they aged—producing a remarkable output of canvases and drawings. A set of paintings of nudes, in the same palette (browns, reds, and golds) of low-fire ceramics, reflect the ordered effect Gósol had on Picasso. While not pendants as such, the

paintings *Adolescents*, now in the Musée de l'Orangerie in Paris (fig. 100), and *Two Youths*, in the National Gallery of Art in Washington, DC (fig. 101)—both painted in the summer of 1906—are among Picasso's most natural images of classical simplicity and elegance, with figures in a state of fresh innocence—as was, for Picasso, Gósol itself. The same simplicity, much in accord with the ideals of the Catalonian primitive school that Picasso encountered in Barcelona en route to Gósol, is found in his female nudes from the same period, which evoke memories of Greek korai, just as the boys suggest kouroi (see, for example, the nude youths in *Girl with a Goat* [1906; fig. 102]).[140] They are equally evocative of Gauguin's statuesque figures (see, for example, figs. 146, 152), with both primitive and classical sources serving as models of archaic purity for Picasso. The progeny of that summer are among the most celebratory and joyful works of his career, including *Composition: The Peasants* (1906; fig. 103), which Picasso executed upon his return to Paris, having begun studies for it while in Gósol.

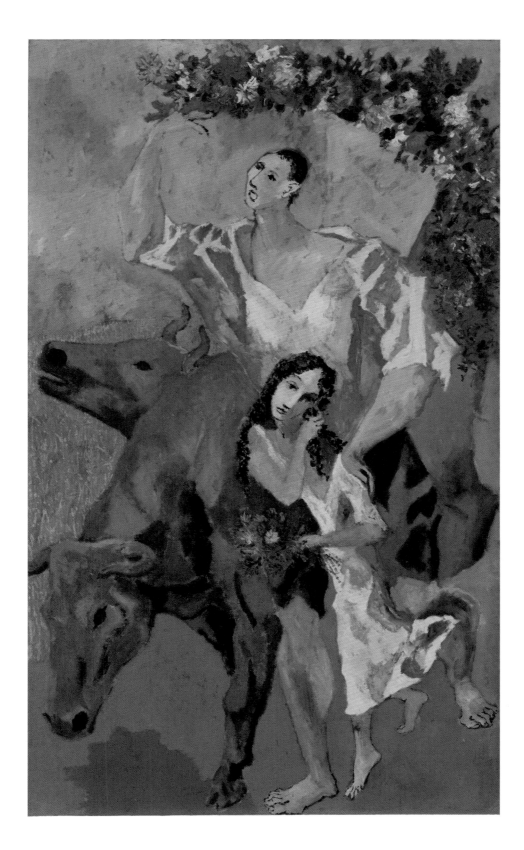

103

PABLO PICASSO

Spanish, 1881–1973

Composition: The Peasants

1906

Oil on canvas, 7 feet 3 inches × 4 feet 3¾ inches (2.21 × 1.31 m)

The Barnes Foundation, BF140

104

PABLO PICASSO

Spanish, 1881–1973

The Watering Place

1905–6

Gouache on tan paper board, 14⅞ ×
22⅞ inches (37.8 × 58.1 cm)
The Metropolitan Museum of
Art, New York. Bequest of Scofield
Thayer, 1982 (1984.433.274)

105

PAUL GAUGUIN

French, 1848–1903

Riders on a Beach

1902

Oil on canvas, 28¾ × 36¼ inches
(73 × 92 cm)
Private collection

106 (*opposite page*)

PABLO PICASSO

Spanish, 1881–1973

Boy Leading a Horse

1905–6

Oil on canvas, 7 feet 2⅞ inches ×
4 feet 3⅝ inches (2.2 × 1.3 m)
The Museum of Modern Art,
New York. The William S. Paley
Collection

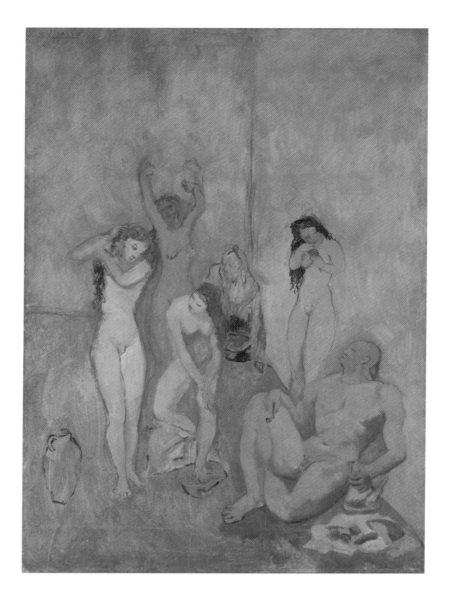

107

PABLO PICASSO
Spanish, 1881–1973
The Harem
1906
Oil on canvas, 60¾ × 43⅝ inches
(154.3 × 110 cm)
The Cleveland Museum of Art.
Bequest of Leonard C. Hanna, Jr.,
1958.45

108

PABLO PICASSO
Spanish, 1881–1973
The Pipes of Pan
1923
Oil on canvas, 6 feet 8¹¹⁄₁₆ inches ×
5 feet 8½ inches (2.05 × 1.74 m)
Musée Picasso, Paris

It is clear that Picasso was struck by this barren and eternal place, as suggested by a group of landscapes very much indebted to Cézanne.[141] But the intention of the figure paintings, with their tone of grave simplicity, set in a more sage and distant time, had already been realized in Paris, before the artist left for Spain, best seen in his works of the fall of 1905 and the following spring that Picasso had made in preparation for a grand panoramic landscape peopled with naked boys and horses, which was never executed but is known today as *The Watering Place*. The concept for the project is realized most fully in a beautiful, matte gouache (1905–6; fig. 104) and is supported by a handful of drawings done in an Ingresque manner as well as a drypoint, all of which suggest that the final canvas was to be an ambitious, lyrical composition in the manner of Puvis.[142] Josep Palau i Fabre gave the project the title *Arcady*, "because this name gives a much more precise idea of the real content and significance of the work. For here Picasso shows us an ideal world, a world all compound of youth and beauty and freedom."[143] Was it to be his own *Bonheur de vivre*, abandoned in the face of Matisse's much more opulent and sensuous painting of the same title, which he saw in the Salon des Indépendants that spring?[144] Or was it his attraction to the genre of Arcadian visions, curiously innocent of calculation, that he found in such late works by Gauguin as his *Riders on a Beach* (1902; fig. 105)?[145]

109

PABLO PICASSO

Spanish, 1881–1973

The Three Graces

1922–23

Etching, sheet: 12¹³⁄₁₆ × 7¾ inches
(32.5 × 19.7 cm)

Philadelphia Museum of Art.
Bequest of Sophie and Adrian
Siegel, 1994-155-46

110

PABLO PICASSO

Spanish, 1881–1973

*Struggle between Tereus and
His Sister-in-Law Philomela*

Illustration for Ovid's *Metamorphoses* 6
(Lausanne: Albert Skira, 1931)

1931

Etching, sheet: 13⅜ × 10⅝ inches
(34 × 27 cm)

Philadelphia Museum of Art. Gift
of an anonymous donor, 1941-117-11

111

Picasso chasing a scorpion in his bath-
tub at the Château de Vauvenargues,
near Aix-en-Provence, 1959
Photograph by David Douglas
Duncan (American, born 1916)
Photography Collection, Harry
Ransom Humanities Research Center,
The University of Texas at Austin

The only full-scale progeny of this project, *Boy Leading a Horse* (1905–6; fig. 106), testifies to the majesty, scale, and simple grandeur of Picasso's intentions for the unrealized canvas. As for the smaller nudes, male and female, that would follow in his summer in Gósol, the open question is whether, in abandoning his plans for the hugely ambitious *Watering Place*, Picasso simply shifted his ambitions to *Les demoiselles*? After all, during his stay in Gósol (a firm resting place for Picasso, even in the idyllic isolation of the village), he also worked on *The Harem* (1906; fig. 107), a hothouse pic-ture à la Ingres, featuring a warden eunuch, that very much shares the tone and elegant line draw-ing of Picasso's other larger Gósol works, but is of a sultriness and opulence that in some ways anticipates *Les demoiselles*, and of course, slants, depending on the reading, the implicit eroticism of the Doric *Adolescents* and *Two Youths*—such sensuality happily in keeping with all things Arcadian, where lust and yearning have been defining elements since Virgil.[146]

Arcadia hardly was left unaddressed over the long evolution of Picasso's career (see fig. 111). His two youths in the Washington picture have their second staging in 1923 with the colossal pair of boys in *The Pipes of Pan* (fig. 108), both of whom seem to hail from a "return-to-order" imperial realm, while at about the same time his penchant for elegance, simplicity, and beauty is revived with supreme delicacy in the etching *The Three Graces* (1922–23; fig. 109). Nor is innocence—in the spirit of Gósol—much evident in the nymphs and satyrs who appear in his illustrations for Ovid's *Metamorphoses* (1931; fig. 110), commissioned in 1929 by Albert Skira, who, of course, was not unaware of Matisse and other artists who were more in tune with the continuity of history and equally in love with the pastoral.

The major reappearance of Arcadia in Picasso's career, the moment that seems to have the joyful assurance of the 1906 works, is in his mural for the Château Grimaldi in Antibes (fig. 112), where he lived in 1946, a release from his long self-interment in Paris during the German occupa-tion. In the painting—his own *Joy of Life*, which received the benediction of Matisse after its com-pletion—it is as if *Le bonheur de vivre* is animated with a whole new cast: a centaur, a satyr, two sheep, and a glorious mortal, her hair caught in the wind.[147] In its exuberance between Poussin and Matisse, Picasso's picture is an affirmation of his dreams of a golden time.

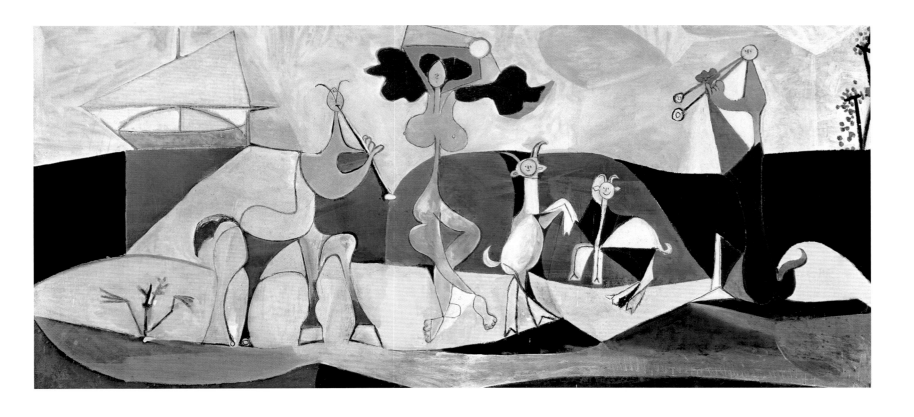

112

PABLO PICASSO

Spanish, 1881–1973

The Joy of Life (Antipolis)

1946

Oil on fibrocement, 3 feet 11¼ inches × 8 feet 2⁷⁄₁₆ inches (1.2 × 2.5 m)

Musée Picasso, Antibes, France

HENRI ROUSSEAU (1844–1910)

The Dream by Henri Rousseau (1910; fig. 113) may be the most familiar and best-loved painting discussed in this essay. It is, in many ways, the most apt and affecting evocation of an Arcadian paradise, full of figures and animation brought into harmony by a piping "Tahitian Orpheus."[148] Few have not fallen under its enchantment, even as a contemporary critic, perplexed and literal-minded, did not, at first, understand the seeming incongruity of the nude woman lounging on a bourgeois Louis Philippe–style velvet couch in the jungle, which Rousseau carefully explained: "This woman asleep on the couch is dreaming she has been transported into the forest, listening to the sounds from the instrument of the enchanter."[149] Simply put, and perhaps the clearest he ever came to addressing his own remarkable powers of imagination, which he conjured as he sat in Paris thinking of distant lands, a poor civil servant, sometimes nearly a pauper, with a petty job as a toll collector, untaught but with his eyes wide open to all the art available to him in the metropolis, certain of his greatness.[150]

According to the American artist Max Weber, he accompanied the thirty-seven-years-older Rousseau, with whom he became best friends, to the posthumous exhibition of Cézanne's works at the 1907 Salon d'Automne. When they approached *The Large Bathers*, which must have been the Philadelphia picture (see page xii and fig. 155), Rousseau remarked, "You know, this is an extremely interesting canvas. I like it very much. Too bad he left so many places unfinished. I wish I had it in my studio, I could finish it nicely."[151]

Rousseau's confidence and assurance of stature among his peers were never in doubt in his own mind (and were justified fully, as time would tell) and, in this particular case, were supported by the fact (for him, if still few others) that displayed in the same space as Cézanne's picture was his own large canvas *The Snake Charmer* (1907; fig. 114), which had been lent by the artist Robert Delaunay. The painting had been commissioned by Delaunay's mother, the countess Berthe Félicie de Rose, who had first met Rousseau at her home, which was full of rare and exotic plants, about which the artist knew a great deal from his many visits to the Jardin des Plantes in Paris. To add to the mix, Mme Delaunay recently had returned from the Indies full of romantic tales.

The haunting *Snake Charmer* and *The Dream*, as well as *Exotic Landscape* and *The Waterfall*, both of 1910 (figs. 115, 116), exemplify the jungle pictures that, according to Christopher Green, the German critic, dealer, and collector Wilhelm Uhde, already in 1911, associated with the work of "the figure perhaps most unchallenged at the centre of most ideas of the 'French Tradition' in the early twentieth century"—namely, Poussin.[152] For Uhde, Rousseau obtained, "in some of his pictures of the virgin forest, . . . an equilibrium one finds only in Poussin."[153] This was a bold assertion in 1911, even as the welcome of Rousseau into the pantheon of high art was formed with certainty during the artist's last years, when building sentiments began the process of placing him at the foundations of modern art. But watching this ascendancy, it is important to realize that as swiftly as it played out after 1910, the year Rousseau died, it would not necessarily have been to his liking, as familiar as he was with the advanced artists he had seen in the annual nonjuried Salon des Indépendants starting in 1884, and in the juried but still progressive Salon d'Automne starting in 1903, as well as those he met at the famous party given in his honor by Picasso in 1908 at the

113

HENRI ROUSSEAU

French, 1844–1910

The Dream

1910

Oil on canvas, 6 feet 8½ inches × 9 feet 9½ inches (2.04 × 2.98 m)

The Museum of Modern Art, New York. Gift of Nelson A. Rockefeller, 1954

114
HENRI ROUSSEAU
French, 1844–1910
The Snake Charmer

1907
Oil on canvas, 5 feet 6⁹⁄₁₆ inches ×
6 feet 2⅝ inches (1.69 × 1.89 m)
Musée d'Orsay, Paris

Bateau-Lavoir in Paris. There, in the presence of many of the most artistically progressive people in Paris, Rousseau roundly announced his equal footing with his host, declaring them the two greatest painters in the world.[154] This did not mean he was interested in these artists as collaborative peers, although he enjoyed their admiration.

Yet, it is impossible not to make comparisons. Gauguin is certainly a tempting touchstone, particularly for the hothouse and tropical subjects that attracted both artists. We know that Gauguin admired Rousseau's work as early as 1890, and the two artists were in touch indirectly through Rousseau's friend and champion Alfred Jarry, the short-lived poet and novelist with whom the Douanier shared a hometown, Laval in northwestern France.[155] But, beyond mutual admiration, the two artists had little concrete connection other than the "Tahitian Orpheus" from Rousseau's *Dream*, with Gauguin's pursuit of paradise in Pont-Aven and the South Seas being very different from Rousseau's inventions drawn from his explorations of the gardens and zoos of Paris and from his own dreams.

Rousseau's interest in Seurat has been argued logically, particularly given his gift for painting isolated figures in open spaces with great discretion, but at no point did he seem to need

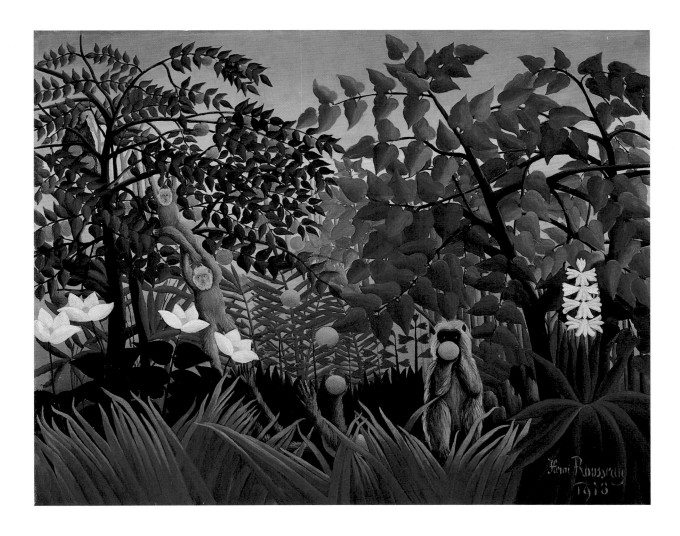

115

HENRI ROUSSEAU

French, 1844–1910

Exotic Landscape

1910

Oil on canvas, 51¼ × 64 inches
(130.2 × 162.6 cm)

The Norton Simon Foundation,
Pasadena, CA, F.1971.3.P

116

HENRI ROUSSEAU

French, 1844–1910

The Waterfall

1910

Oil on canvas, 45¾ × 59⅛ inches
(116.2 × 150.2 cm)

The Art Institute of Chicago. Helen
Birch Bartlett Memorial Collection,
1926.262

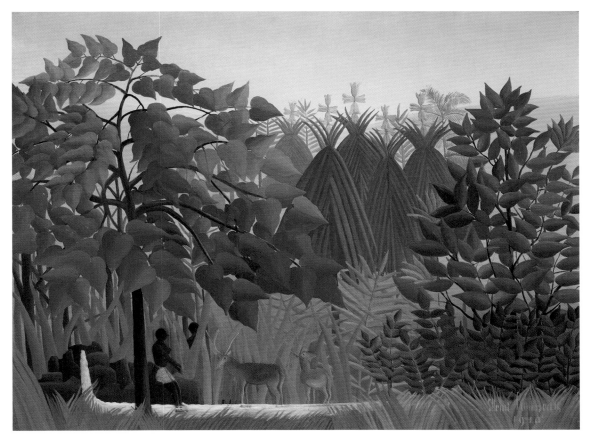

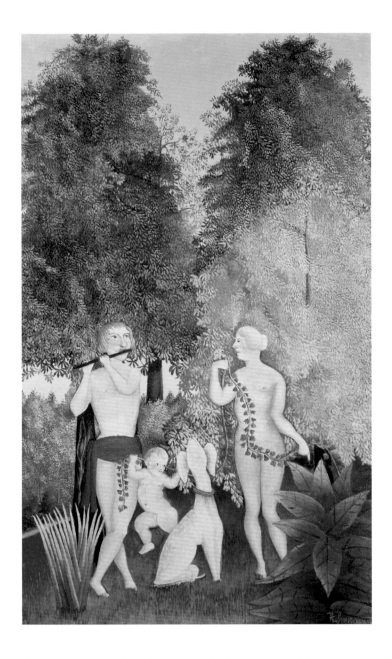

117

HENRI ROUSSEAU

French, 1844–1910

Happy Quartet

1901–2

Oil on canvas, 37 × 22⅝ inches
(94 × 57.4 cm)

Greentree Foundation, New York

the influence of the advanced artistic figures of his day, some of whom praised and defended him. Instead, he was set in the authority of the established art world he grew up in, with a particular loyalty to the nineteenth-century painters William-Adolphe Bouguereau and Jean-Léon Gérôme, the latter of whom, he wrote to the critic André Dupont, instructed him to keep his "naiveté."[156] This held even to his sense of the hierarchy of painting genres as established by the French Academy—starting with still lifes at the bottom, followed by landscapes, portraits, and finally the grand tradition of history paintings. Thanks to Michel Hoog, we know many of the prices he attached, ever optimistically, to the numerous works he submitted to the salons, beginning in 1886. His price, for example, for his wonderful *Happy Quartet* (1901–2; fig. 117), which seems to be his earliest venture into fantastic idylls in a pastoral mode, was two thousand francs, a handsome sum for any painter, far exceeding the typical costs of landscapes, portraits, or still lifes, and in keeping with the prices for works by Ingres in the grand manner.[157] The pedigree of *Happy Quartet* goes back most convincingly to Gérôme's very sexy *Innocence* (1852; Musée Massey, Tarbes, France) and to a picture of male nudes, Perugino's *Apollo and Marsyas*, in the Louvre.[158]

Even his close relationship with Delaunay—who was among his staunchest supporters, owning more than a dozen of his paintings and giving him a very endearing homage by quoting, as discussed below, his self-portrait (see fig. 124), albeit in a secret manner, in his own painting *The City of Paris* (1910–12; figs. 118, 121)—seems to have left no mark on Rousseau's work. Yet, he comes most naturally into our exploration of makers of Arcadian pictures. One can only wish there had been some mechanical way (large sheets of Mylar?) by which Weber could have helped him finish the Cézanne.

ROBERT DELAUNAY (1885–1941)

For the Salon des Indépendants of 1911, Delaunay organized a posthumous retrospective of Rousseau's work, sandwiched in room 42 between the famous rooms 41 and 43, which featured new works by Delaunay, Albert Gleizes, Jean Metzinger, Henri Le Fauconnier, and Fernand Léger, including his *Nudes in the Forest* (1909–10; see fig. 119), that as a group became the sensation of the show. Yet, if this exhibition proved to be the first presentation of Cubism in a broad public way, it was not until the following year that Cubism became the dominating element. Ironically, the movement, set in motion in 1907 with Derain's *Bathers* (see fig. 93) and quickly taken up by Braque and Picasso, was already in 1912 at a kind of half-life in its brief and highly potent history.[159] None of its founders was represented in the salons, Derain having left the unhatched eggs of his creation in the nest by 1910 to begin his lifelong, fashionably unfashionable swim upstream ("against the tide," in Fontaine's words), while neither Picasso nor Braque exhibited publicly in France after 1909, as it was their dealer Daniel-Henry Kahnweiler's policy to keep his artists away from the salons, leaving the stage to the younger generation, the so-called "Salon Cubists"—including Gleizes, Metzinger, Marcel Duchamp, and Francis Picabia—who took full advantage of the opportunity.[160]

In March 1912 Apollinaire declared that "Delaunay's painting is definitely the most important picture in the Salon. . . . This painting marks the advent of a conception of art that seemed to have been lost with the great Italian painters."[161] He was referring to Delaunay's *City of Paris* (see fig. 118), in which the stage-drop curtain of luminous pastel colors applied with constructed Cubist brushstrokes (looking right back to Cézanne) are made translucent, resembling window panes, creating an effect, termed "Orphism" by Apollinaire later that year, that would influence much of Delaunay's future development into abstraction.[162] In the painting, the Three Graces, who are modeled with great aplomb after a first-century Pompeii fresco (see figs. 120, 121) of which Delaunay owned a photograph, are introduced into the center of an animated urban landscape.[163] On the right, the Eiffel Tower, which had been a recurring motif in Delaunay's work for the previous three years (see, for example, his painting and his watercolor of the subject, dating to about 1909 and 1910–11, respectively; figs. 122, 123), is fragmented into gaily syncopated angles. On the left, the city view visible behind a ship moored to a quay on the Seine is more sedate, more miniaturized, and more refined in comparison with the large-scale structures on the right. The boat and quay, in fact, are copied from the left section of Rousseau's self-portrait *Myself, Portrait—Landscape* (1890; fig. 124), which Delaunay had included in his friend's retrospective at the 1911 Salon.[164]

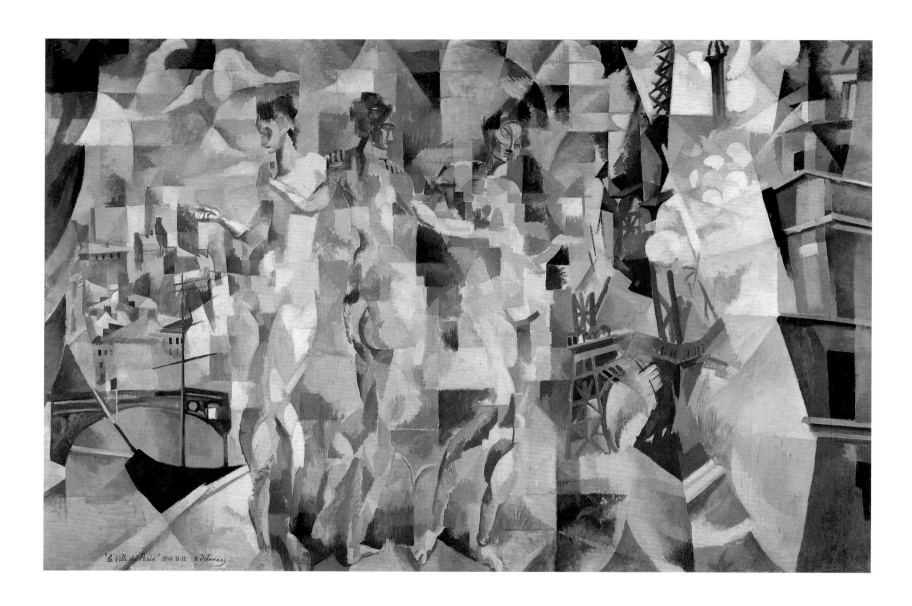

118

ROBERT DELAUNAY

French, 1885–1941

The City of Paris

1910–12

Oil on canvas, 8 feet 9⅛ inches × 13 feet 3¹³⁄₁₆ inches (2.67 × 4.06 m)

Musée National d'Art Moderne / Centre de Création Industrielle, Centre Georges Pompidou, Paris

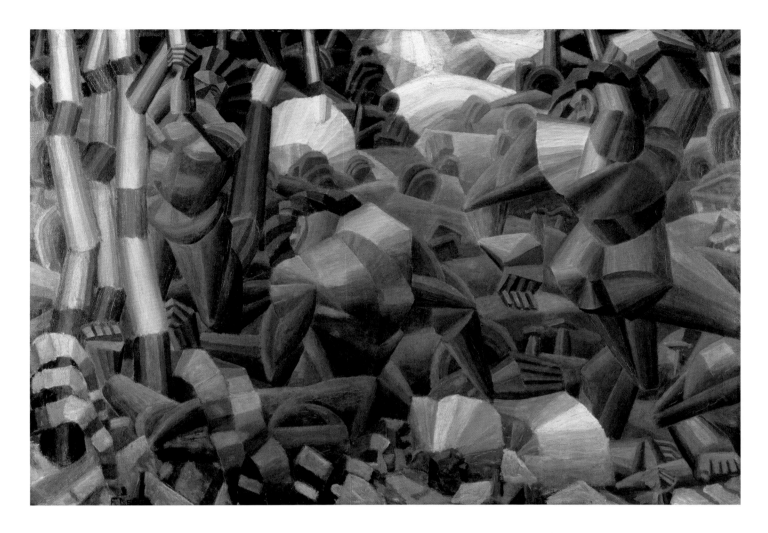

119

FERNAND LÉGER

French, 1881–1955

Nudes in the Forest

1909–10

Oil on canvas, 47¼ × 67 inches
(120 × 170.2 cm)

Kröller-Müller Museum, Otterlo,
The Netherlands

In his review of the 1912 Salon des Indépendants, Apollinaire wrote:

The City of Paris is a painting that concentrates in itself the sum total of artistic efforts ranging as far back, possibly, to the great Italian painters.

One must have the courage to say so. It is no longer a question of experimentation, of archaism, or of cubism.

Here is a candid and noble picture, executed with a passion and an ease to which we are no longer accustomed.[165]

Delaunay must have been thinking of Puvis when working with such concern for beauty on this great scale, yet he also took the audacious liberty of robbing a classical glade of three of its principal players to bring them into the very center of the city, where they enter with grace, blending very beautifully with the rhythms of the town. The general effect of the three combined but discrete fields of different kinds of animation (the boat and city view, the Three Graces, and the Eiffel Tower) recalled, for some, the composition of Botticelli's *Primavera* (see fig. 151).[166]

The charm and theatricality of his vast enterprise—remembering the Delaunays' long love of the theater as designers and major innovators, and their own elegant and fashionable ways, more bohemian than beau monde it must be said—did not sit well with many who saw his tendency toward decoration as straying from the high road of Cubism. This stern view was perhaps best reflected as late as 1971 (when modernism battle lines still maintained some definition) by Douglas Cooper, who contended that *The City of Paris*

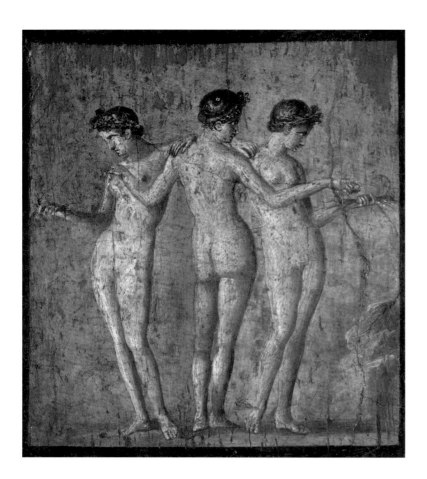

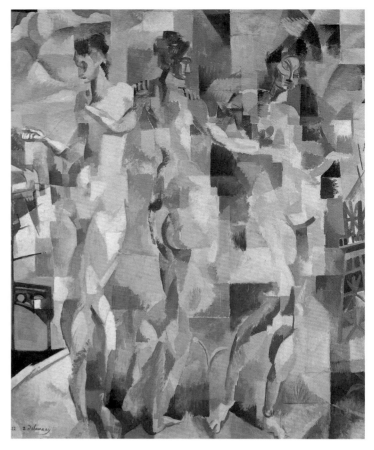

120

The Three Graces

From the house of Titus Denatus
Panthera, Pompeii
c. 65–75
Fresco, 29½ × 23⅝ inches (75 ×
60 cm)
Museo Archeologico Nazionale,
Naples

121

ROBERT DELAUNAY
French, 1885–1941
Detail of *The City of
Paris* (fig. 118)

1910–12
Oil on canvas, 8 feet 9⅛ inches ×
13 feet 3¹³⁄₁₆ inches (2.67 × 4.06 m)
Musée National d'Art Moderne/
Centre de Création Industrielle,
Centre Georges Pompidou, Paris

is anti-Cubist by virtue of the unreality of its conception. For this is a Salon-type homage to Paris expressed through an uncomfortable cubified synthesis of, on the left, a Rousseau-like view of the Seine with a sailing-ship and houses, on the right a fragmented Eiffel Tower with clouds and a building, and in the center a highly elongated representation of a pseudo-classical group of Three Graces, set in an indeterminate foreground space. The whole composition has then been given a decorative, agitated and false life by gay colors, fragmentation, formal contrasts and a skillfully contrived geometric structure. But as a pictorial recreation of reality it deals with another world than that of the *Eiffel Tower*.[167]

He is, of course, right that the painting is completely a product of imagination charged with poetical thoughts, which is our justification for including it here as the prime example of how notions of Arcadian idylls, now reconciled with the domain of the city, play out in the early twentieth century.

Perhaps Cooper's very concerns are the reasons *The City of Paris* was never unpacked upon arriving in New York in early 1913 for the Armory Show. American artists Arthur Bowen Davies, Walt Kuhn, and Walter Pach had visited Paris to request Delaunay's participation in that year's exhibition, and, with the help of the painter Samuel Halpert, the painting was approved for the show. Had it not been rejected at the last minute, purportedly on account of its scale, it certainly would have taken over the room.[168] That distinction was left, at least as a spark of provocation, to Duchamp's *Nude Descending a Staircase (No. 2)* (1912; Philadelphia Museum of Art).

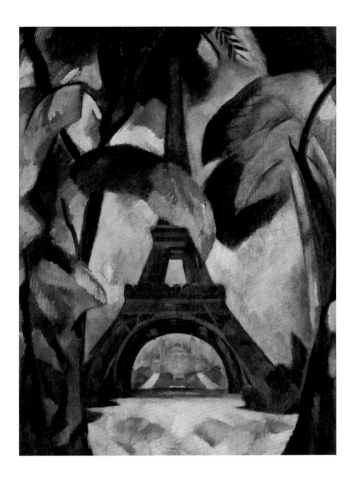

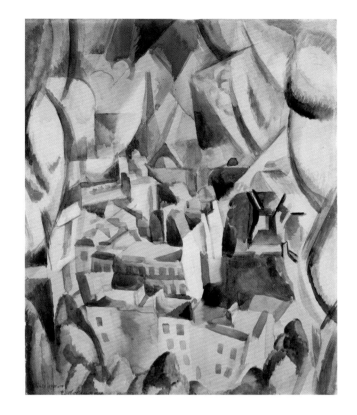

122
ROBERT DELAUNAY
French, 1885–1941
The Eiffel Tower
c. 1909
Oil on canvas, 38 × 27¾ inches
(96.5 × 70.5 cm)
Philadelphia Museum of Art.
The Louise and Walter Arensberg
Collection, 1950-134-42b

123
ROBERT DELAUNAY
French, 1885–1941
The Eiffel Tower
1910–11
Watercolor and gouache on paper,
sheet: 24⅞ × 19⅞ inches (63.2 ×
50.5 cm)
Philadelphia Museum of Art.
A. E. Gallatin Collection, 1952-61-12

124
HENRI ROUSSEAU
French, 1844–1910
Myself, Portrait — Landscape
1890
Oil on canvas, 56¼ × 43¾ inches
(142.9 × 111.1 cm)
Národní Galerie, Prague

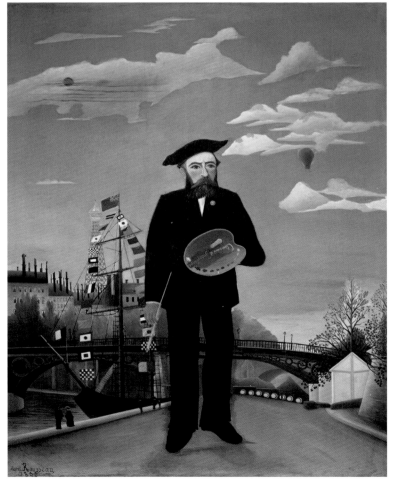

ALBERT GLEIZES (1881–1953)
JEAN METZINGER (1883–1956)

At the 1912 Salon des Indépendants, Albert Gleizes showed his ambitious canvas *Bathers* (fig. 125) alongside Delaunay's *City of Paris* (see fig. 118). If Delaunay was so bold in his paean to the city to bring three classical nudes into the very center of the metropolis, Gleizes, in ways quite realistic, even literal, staged his gathering of bathers in a suburban garden surrounded by wooded hills, with a nearby industrial zone in the next valley, factories and smokestacks given equal time with bosky glades.

The effect of Gleizes's canvas could not be more different from that of Delaunay's. If the entry of the ancients into the modern world as performed by Delaunay is elevating, even patrician, in its serene confidence and ease, magically transforming the city into an ancient realm, Gleizes's players hold poses like those seen in a still photograph—more Crazy Horse than Arcadia or Olympus. One can almost hear the fine gears turning in his carefully wrought figures made up of cubes and circles, fulfilling the famous Cézanne dictum, "Treat nature by means of the cylinder, the sphere, the cone."[169] Gleizes's figures are coordinated skillfully with the landscape and the village beyond, giving the large canvas a mechanistic unity that would be somewhat boring except for the satisfying skill with which the artist brought it all into a wonderful and pleasurable harmony. He aligned the past and the present within a very steady and constant rhythm—which is quite different from, but not out of line with, the celebratory optimism of Delaunay.

Or, perhaps it is the darker side of Gleizes's inherited sense of Arcadian harmony that was his essential concern—a dichotomy trapped in seeming harmony? As Christian Briend contended, "Apparently belonging to an age that is now threatened with extinction, the figures clearly draw on the works of Poussin as filtered through Cézanne's *Bathers* [see, for example, fig. 169]. . . . There is harmonious integration between the figures and the landscape, between the real and the ideal."[170]

Gleizes and Jean Metzinger formed a strong bond as spokesmen for the Cubists when they first met in 1910. In 1912 they jointly published "Cubism," a tract that Robert Herbert, in comparing it with Apollinaire's more discursive "The Cubist Painters" (1913), described as "a more certain embodiment of the ideas of one large group of Cubist painters, and a much more reasoned presentation of artistic theory."[171] The tract was released at the exhibition opening of the Section d'Or, a loose, short-lived but vivacious fellowship of similar-thinking Cubist colleagues—including, among others, Léger, and Picabia, as well as Juan Gris and the Duchamp brothers Marcel, Jacques Villon, and Raymond Duchamp-Villon—which Gleizes and Metzinger enthusiastically joined.[172]

Yet, as much as Gleizes and Metzinger held the same convictions, and shared values that derived from their independent encounters with the work of Braque and Picasso, as well as a profound admiration for Cézanne, they ultimately were driven by quite different temperaments and intentions. Putting into company their two ambitious paintings of bathers, painted one year apart, allows us to consider this in a serious way.

Gleizes's *Bathers* is a magical weaving together of discrete, faceted parts, well within a controlled tonality, with the effect of a grand, autumnal tapestry. Yet, as similar as Metzinger's movement of pieces on the board is to that of Gleizes's, memories of Cézanne being their common reference, Metzinger works with a very different—a grand and stately—tempo and scale of

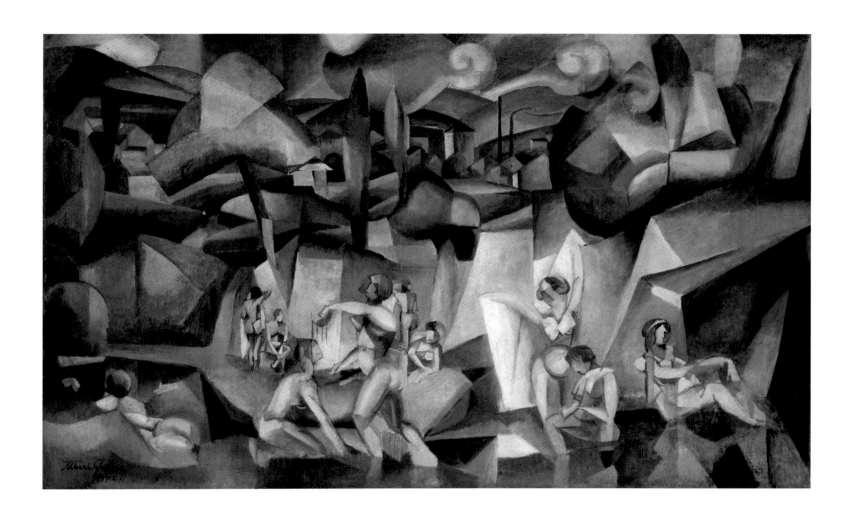

125

ALBERT GLEIZES

French, 1881–1953

Bathers

1912

Oil on canvas, 41⁵⁄₁₆ × 67⁵⁄₁₆ inches (105 × 171 cm)

Musée d'Art Moderne de la Ville de Paris

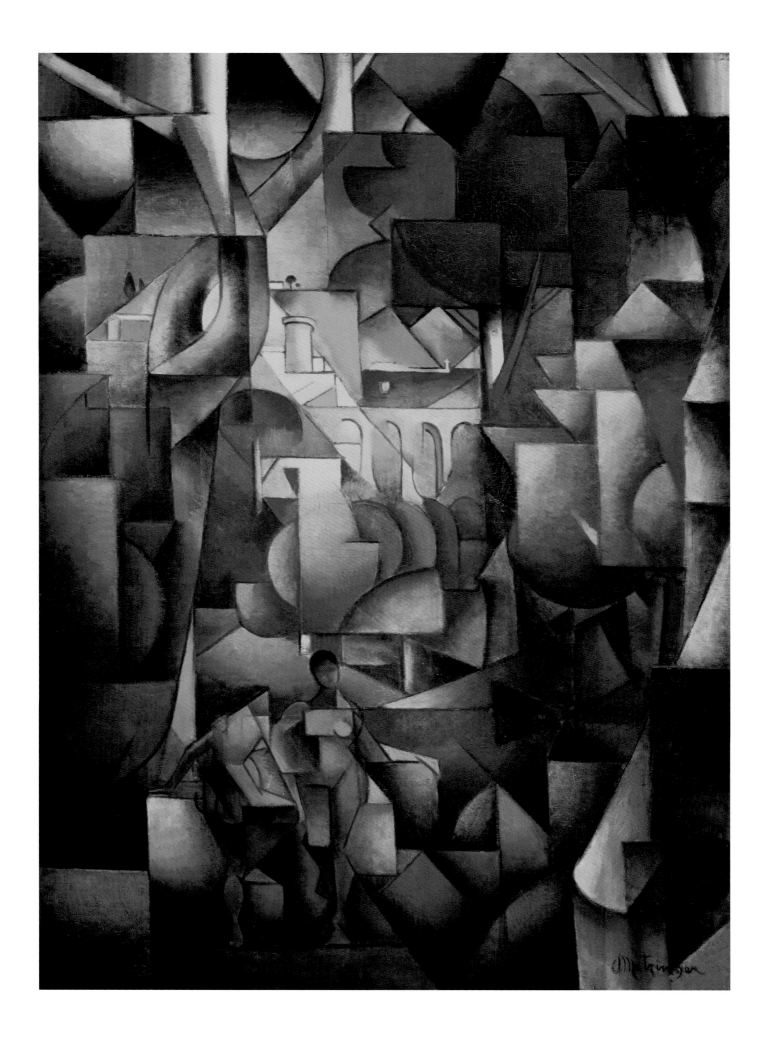

126 (*opposite page*)

JEAN METZINGER

French, 1883–1956

The Bathers

1913

Oil on canvas, 58⅜ × 41⅞ inches
(148.3 × 106.4 cm)

Philadelphia Museum of Art.
The Louise and Walter Arensberg
Collection, 1950-134-140

127 (*above*)

ROBERT DELAUNAY

French, 1885–1941

Three-Part Windows

1912

Oil on canvas, 13⅞ × 36⅛ inches
(35.2 × 91.8 cm)

Philadelphia Museum of Art.
A. E. Gallatin Collection, 1952-61-13

parts. The characters in his *Bathers* (1913; fig. 126) are reduced to two nudes who appear about to ascend into the huge panels of strongly contrasting tones and colors, a brilliantly lit zone with an elegant viaduct in the background and an arching sycamore whose branches extend to the edge of, and beyond, the canvas. It all has an architectural quality, or, better yet, the releasing joy of a stage set, the grand cabaret "Stairway to Paradise."[173]

In both canvases, there is something elegant and chic, particularly in Metzinger's. Certainly, it is this quality that often reads as a trivialization of the higher forms of Cubism. But part of the charm is this painting's retention, or memory, of a subject (and, it must be said, its dated quality), which allows a reassuring gaiety and pleasure, possible in such invented worlds of harmony and timelessness. This is perhaps what the all-knowing Apollinaire meant in 1913 when he hailed Metzinger as an unjustly judged young artist who, "joining forces with Picasso and Braque, founded the city of Cubism. Strict discipline reigns there but there is no risk of its becoming a system and freedom is more widespread than anywhere else."[174]

This "freedom" was not without its difficulties, as the politics of Cubism heated up in accord with growing apprehension about the cataclysm that was approaching in 1914. In the critical debates surrounding the early demonstrations of Cubism in the Salon, the opponents of the new movement took a decidedly nationalistic turn. As Pascal Rousseau explained, "The young Cubists were not only rebuked for rejecting beautiful forms; they were also accused of making compromises with the ultra-subjective aesthetics from across the Rhine"—"Munich Cubism," as it was called.[175] (Perhaps not unrelated was the fact that both Braque and Picasso were financed by German dealers, Kahnweiler and Uhde.) In rebuttal, the Salon Cubists, led by Gleizes and Metzinger, were quick to make clear that they were firmly in line with the "French rationalist tradition" of Poussin and Ingres.[176] And for Delaunay, his *City of Paris*, "constructed upon the harmony of the golden mean with, at its center, three Graces . . . marked a return in force of the 'grand subject.'" What was not recognized was an even greater threat than German influences, one well within the measure of classical rationalism: a kind of pure abstraction that Delaunay, with his wife, Sonia, took up with their "luminist" ways, first in the "Windows" series of 1912 (fig. 127), then evolving to still further geometric restrictions—a rethinking of Arcadia, perhaps, as a now purely formal harmony.[177]

WASSILY KANDINSKY

Russian, 1866–1944

*The Garden of Love
(Improvisation Number 27)*

1912

Oil on canvas, 47⅜ × 55¼ inches
(120.3 × 140.3 cm)

The Metropolitan Museum of
Art, New York. Alfred Stieglitz
Collection, 1949 (49.70.1)

FRANZ MARC (1880–1916) AND DER BLAUE REITER

Coincidentally, the direction Delaunay had chosen was on a path near to that of his German friend Franz Marc, and their degrees of correlation and separation are revealing for our exploration of Arcadia as a painted subject in early twentieth-century art. The two artists first met in Paris in October 1912, although Marc already knew Delaunay's work from the first exhibition of the Expressionist group Der Blaue Reiter (The Blue Rider) in Munich in 1911.[178] In parallel to Delaunay's move into a kind of paradise of light and abstraction—Apollinaire's Orphism—Marc's mystical vision held to nature and its beasts (see, for example, figs. 198, 199). As he wrote in 1910,

> My aims are not targeted along the lines of a particular type of animal painting. I am seeking a good, rich and clear style in which some of that which we modern painters will have to say in the future can be completely realized. And that would perhaps be a sensibility for the organic *rhythm* of all things, a pantheistic empathy with the trembling and flow of blood in nature, in the trees, in the animals, in the air—I am trying to turn that into a *picture* with new movements and colours that mock our old easel painting. In France they have indoctrinated themselves for this subject matter for more than half a century . . . and the youngest Frenchmen are currently involved in a wonderful competition to reach this goal.[179]

The essential musical quality and luminous arching colors of Delaunay's and Marc's work could be understood as an abstracted realism for the Frenchman or a subjective mysticism for the German, with the latter eventually finding the former's work "Latin" and "scholastic," while Delaunay found his friend's painting tainted by "mysticism" and a propensity for "metaphysics."[180] All of which, of course, is very subjective, whereas one knows with hindsight that they both were within a magnetic field emanating from Munich, an even more assured and confident way into the finding of a new order by the Russian-cum-German visionary Wassily Kandinsky, who, in his *Concerning the Spiritual in Art* (1911), put in words what he had with great difficulty been articulating with canvas and color. This turn to abstraction put to rest any question of objects and subjects for some time, wonder and transience coming to have many of the same values of earlier Arcadian myth-making, their equation for Kandinsky seen best in abstracted yet edenic canvases such as his *Garden of Love (Improvisation Number 27)* (1912; fig. 128).[181]

NATALIA SERGEYEVNA GONCHAROVA (1881–1962)
NICHOLAS KONSTANTINOVICH ROERICH (1874–1947)

For all the mobility of the many players in the history of art following the invention of Cubism, one of the most remarkable paths was that of Natalia Sergeyevna Goncharova. Born into a privileged and distinguished family (the writer Alexander Pushkin was a direct ancestor), she grew up in the country, which she credited with cementing her close contact with the Russian land. She was educated in Moscow during a period of increasing experimentation and revolution. Through the great collections formed by the Russian textile merchants Ivan Morozov and Sergei Shchukin, she and her colleagues had broad access to the advanced painting of Paris, particularly works by Gauguin, Cézanne, and Matisse. Early in her lifetime, in alliance with the painter Mikhail Larionov, she helped organize a Salon showing in Moscow of French and Russian paintings, which featured two hundred works by fifty French artists, including Braque, Cézanne, Cross, Denis, Derain, Gauguin, Gleizes, Maillol, Matisse, Metzinger, Roussel, Signac, and Van Gogh.[182] Like many of her colleagues in Moscow, she was quick to see the direction of Cubism, as well as where she wished to take it, and early radical differentiations soon were established even as she, just as quickly, shifted to things nearer to her fundamental concerns, a reversion to a style of painting that combined an alert understanding of the primitivism of Gauguin along with her own knowledge and affection for Russian popular arts, including not only paintings but also ceramics, textiles, and toys.

Goncharova and Larionov broke away from the abandoned exhibition organization called the Knave of Diamonds to found in 1911 their own group called the Donkey's Tail.[183] Goncharova dominated the group's first exhibition in 1912, with over fifty works, many of them in her self-termed "Neo-Primitive" style, in which landscape, through the seasons, reflects her profound love of the land and the joy of her childhood growing up in the country. Among the works she included in the show was *Boys Bathing* (c. 1910; fig. 129), a very knowing and witty send-up of conventional pastoral painting, in which cut-out paper trees shelter dark-haired men and boys who are splashing around like figures in a Cézanne painting, with, one suspects, less necessity to touch

129 (*opposite page*)

NATALIA SERGEYEVNA GONCHAROVA

Russian, 1881–1962

Boys Bathing

c. 1910
Oil on canvas, 45½ × 37 inches
(115.5 × 94 cm)
Museum Wiesbaden, Germany

130 (*above*)

NICHOLAS KONSTANTINOVICH ROERICH

Russian, 1874–1947

Our Forefathers

c. 1911
Tempera on burlap, 18⅞ × 31⅛ inches
(47.9 × 79.1 cm)
Philadelphia Museum of Art.
Gift of Christian Brinton, 1941-79-67

on Poussin or Virgil for their pleasures.[184] In 1912 Goncharova was invited by Kandinsky, whom she had met in 1910, to participate in the spring and fall Blaue Reiter exhibitions in Munich and Berlin; she also submitted paintings for Roger Fry's second Post-Impressionist exhibition at the Grafton Galleries in London that year. Although she herself did not make the journeys, these critical shows established her reputation in the West, which reached great heights in Paris the next year when the founder of the Ballets Russes, Sergei Diaghilev, asked her to design the sets and costumes for the ballet production of *Le coq d'or.*

Of the same period as Goncharova's *Boys Bathing,* Nicholas Konstantinovich Roerich's painting *Our Forefathers* (c. 1911; fig. 130), is another Russian take, albeit more literary and spiritual than his counterpart's canvas, on Arcadian conventions, wherein a young piper enchants a group of bears with his music in a vast summer panorama. Roerich's life was no less cosmopolitan or sophisticated than that of Goncharova. He was raised in a landed family in Saint Petersburg and had an early education in painting and archaeology as well as what would become cultural anthropology, which is why Diaghilev asked him to design the sets and costumes for his Paris production of Igor Stravinsky's ballet *The Rite of Spring,* which was set in primeval Russia and became the sensation and scandal of Paris when it debuted in 1913. *Our Forefathers,* painted at the outset of Roerich's collaboration with Stravinsky, may have been conceived as a sketch for the opening of the production.[185] The picture, with its Orpheus-like protagonist, reflects the artist's awareness of current trends in French painting from Gauguin to Rousseau (Roerich had studied at the Atelier Cormon in Paris from 1900 to 1901 and had exhibited at the Salon d'Automne of 1906, the year of the large Gauguin retrospective), while drawing upon Slavic folklore in which bears appear as man's ancestors, suggesting the artist's uniquely mystical nationalism.[186] As Jackie Wullschlager wisely noted,

Roerich's "dream was to translate the primitive idiom of Gauguin's Tahiti paintings, which he had just discovered in Paris, into an art that reflected the remote Russian past."[187] Here, as if to answer Gauguin's enigmatic question "Where do we come from?," Roerich dove into the primordial realm of Russian origins.

The same year that his designs for *The Rite of Spring* debuted in Paris, the bonds between the west and the east banks of the Rhine and the east beyond came to a striving and poignant head at the First German Autumn Salon at the gallery Der Sturm in Berlin, in which seventy-five artists from twelve countries exhibited together. The show featured the work of French post-Cubists, German Expressionists, and Italian Futurists, including Delaunay, Gleizes, Goncharova, Kandinsky, Marc, and Metzinger, as well as Giacomo Balla, Umberto Boccioni, Marc Chagall, Marsden Hartley, Paul Klee, August Macke, Piet Mondrian, and Gino Severini. The exhibition also included a retrospective of twenty-two works by Rousseau, who was shown as the father of the modern tradition.[188] Macke's wife, Elisabeth Erdmann-Macke, described it as "the convening of the most diverse artists from the most diverse nations, a true fraternization in spirit, far removed from all momentary political controversies. And really! All the participants believed in the possibility of such an understanding across all borders."[189] It was, in effect, a utopian gathering. Yet, the spirit of social harmony that underlay the exhibition did not last. As Erdmann-Macke, whose husband died in battle in 1914, continued, "There was something delightful about this thought. But it did not take long until it was shown to be an illusion."[190]

"THE GOLDEN AGE IS NOT IN THE PAST, IT IS IN THE FUTURE"

The war did not, of course, drop a curtain completely on the theme of Arcadia we have traced from Poussin into the twentieth century, as we have seen that artists such as Marc, Goncharova, and Roerich found it reassuring to shift Arcadian concerns to the realm of children and animals. Following the war, Picasso, Matisse, Derain, and Maillol, among others, continued to hold Arcadia dear as it suited them.

Nor has the love for Arcadia been exhausted in our own time. Let four examples illustrate its continued resonance.[191] In 2011 the last exhibition of Cy Twombly held during his lifetime took place at the Dulwich Picture Gallery in London, and paired the artist with Poussin, deeming both "Arcadian painters."[192] The exhibition came at the end of the long interplay within Twombly's work of words and images, the antique and the modern, his fundamental Arcadian concerns expressed with unmatched purity in his 1973 series of eight drawings that consist solely of the name "Virgil," a motif he took up again two years later in a lithograph from his portfolio *Six Latin Writers and Poets* (1975–76; fig. 131). American artist Charles Ray has long positioned himself as a distiller of simple sentiments into universal values, be it with an exact replica of a noble, fallen tree in California (*Hinoki* of 2007; Art Institute of Chicago), or an oversize nude boy holding a frog (fig. 132), whose innocence matches that of Picasso's *Two Youths* (see fig. 101). Swiss artist Pipilotti Rist brought bacchantic revels back into the modern city in her video installation *Ever Is Over All* (1997; fig. 133), which juxtaposes vibrant images of lush flowers with a narrative scene of a

131

CY TWOMBLY

American, 1928–2011

Virgilius

1975

From the portfolio *Six Latin Writers and Poets* (Berlin: Propyläen-Verlag, 1976)
Embossed lithograph, plate: 13 × 10 inches (33 × 25.4 cm)
The Museum of Modern Art, New York. Gift of Arthur Stanton

132

CHARLES RAY

American, born 1953

Boy with Frog

2008

Cast stainless steel and acrylic polyurethane, 8 feet × 2 feet 5½ inches × 3 feet 5¼ inches (2.44 × 0.74 × 1.05 m)
Private collection

133

PIPILOTTI RIST

Swiss, born 1962

Ever Is Over All

1997

Two laser disc players, two video projectors, one audio system; dimensions variable

Courtesy the artist; Luhring Augustine, New York; and Hauser and Wirth

134

OLAFUR ELIASSON

Danish, born 1967

The Weather Project

Installation in the Turbine Hall at the Tate Modern, London

2003

Monofrequency lights, projection foil, haze machine, mirror foil, aluminum, scaffolding; dimensions variable

Courtesy the artist; Tanya Bonakdar Gallery, New York; and Neugerriemschneider, Berlin

135
OLAFUR ELIASSON
Danish, born 1967
New York City Waterfalls
View of the waterfalls at the
Brooklyn Bridge (left) and
Governors Island (right background)
Presented by the Public Art Fund
in collaboration with the City of
New York
2008
Four man-made waterfalls; h 90–120
feet (27.4–36.6 m) each
Courtesy the artist; Tanya
Bonakdar Gallery, New York; and
Neugerriemschneider, Berlin

beautiful woman, with "frolic glee" (*Ecl.* 5:58) smashing cars with a phallic thistle as she walks down the street, bringing both sides of Arcadia—pastoral and peril—together in one, dreamlike work. And finally, Danish artist Olafur Eliasson has taken to a new level of meaning the issues of public declaration and scale that concerned Gauguin, Cézanne, Matisse, and their contemporaries. His *New York City Waterfalls* (2008; fig. 135), a public art commission consisting of four waterfalls constructed along New York's East River, brought nature into the heart of the city, recalling Delaunay's similar endeavor (see fig. 118). Five years earlier, in *The Weather Project* (2003; see fig. 134), Eliasson similarly turned the notion of an imagined paradise into a physical reality, in which a glowing sun shines over the viewer, who is no longer an onlooker but is now a participant, an inhabitant of Arcadia.

But that, of course, is another exhibition.

1. Erwin Panofsky has perhaps best articulated Virgil's centrality to notions of Arcadia as they survived in literature and art: "It was, then, in the imagination of Virgil, and of Virgil alone, that the concept of Arcady, as we know it, was born—that a bleak and chilly district of Greece came to be transfigured into an imaginary realm of perfect bliss." Panofsky, "*Et in Arcadia ego*: Poussin and the Elegiac Tradition," in *Meaning in the Visual Arts: Papers in and on Art History* (Garden City, NY: Doubleday, 1955), p. 300. On the relationship between Virgil's *Eclogues* and Theocritus's *Idylls*, see Bruno Snell, "Arcadia: The Discovery of a Spiritual Landscape," in *The Discovery of the Mind: The Greek Origins of European Thought*, trans. T. G. Rosenmeyer (Oxford: Basil Blackwell, 1953), pp. 281–310.

2. Gregson Davis emphasized the underside of Virgil's Arcadia: "The world of the *Eclogues* is permeated through and through with portrayals of human infelicity, catastrophic loss, and emotional turbulence. The defining tenor of these poetic sketches is a profound anxiety about the human capacity to cope with misfortune." Davis, introduction to *Virgil's "Eclogues*," trans. Len Krisak (Philadelphia: University of Pennsylvania Press, 2010), p. ix.

3. Dempsey, "The Painter's Arcadia," in this volume, pp. 125–41.

4. Bellori, *Le vite de' pittori, scultori, e architetti moderni* (Rome: Per il suceso, al Mascardi, 1672).

5. Félibien, preface to *Entretiens sur les vies et sur les ouvrages des plus excellents peintres anciens et modernes* (Paris, 1666–88), trans. and quoted in Claire Pace, "André Félibien (1619–95)," in *Key Writers on Art: From Antiquity to the Nineteenth Century*, ed. Chris Murray (New York: Routledge, 2003), p. 103. The eighth part of Félibien's *Entretiens* (1685) is a biography of Poussin. On Félibien's positioning of Poussin as the French Raphael, see Claire Pace, "The Four Biographers of Poussin: The Present State of Questions," in *Félibien's Life of Poussin* (London: A. Zwemmer, 1981), p. 24.

6. Félibien's best-known articulation of the hierarchy of genres appears in his preface to the *Conférences de l'Académie Royale de Peinture et de Sculpture pendant l'année 1667* (Paris, 1668), in *Les conférences de l'Académie Royale de Peinture et de Sculpture au XVIIᵉ siècle*, ed. Alain Mérot (Paris: École Nationale Supérieure des Beaux-Arts, 1996), p. 50.

7. On the transformation of Poussin's reputation in the eighteenth century, see Richard Verdi, "On the Critical Fortunes—and Misfortunes—of Poussin's 'Arcadia,'" *Burlington Magazine*, vol. 121, no. 911 (February 1979), pp. 94–104, 107.

8. M. A. Joly, "Le Poussin et l'art en 1868," *L'artiste*, March 1, 1869, p. 399. All translations are my own except as noted.

9. Chennevières, *Essais sur l'histoire de la peinture française* (Paris, 1894), p. 79, quoted in Joyce Henri Robinson, "A 'Nouvelle arcadie': Puvis de Chavannes and the Decorative Landscape in Fin-de-Siècle France" (PhD diss., University of Virginia, 1993), p. 85. For a detailed account of Poussin's status in the nineteenth century, see Robinson, "A 'Nouvelle arcadie,'" chap. 3. Chennevières's study originally was published in installments in *L'artiste* from 1890 to 1893.

10. Advielle, *Recherches sur Nicolas Poussin et sur sa famille* (Paris: G. Rapilly, 1902); Desjardins, *Vie de Nicolas Poussin* (Paris: H. Laurens, [1903]); Bellori, *Vie de Nicolas Poussin*, trans. Georges Rémond (Paris: Bibliothèque de l'Occident, 1903); Desjardins, *La méthode des classiques français* (Paris: A. Colin, 1904); Charles Jouanny, ed., *Correspondance de Nicolas Poussin* (Paris: J. Schemit, 1911); Magne, *Nicolas Poussin, premier peintre du roi, 1594–1665* (Brussels: G. Van Oest, 1914); Grautoff, *Nicolas Poussin, sein Werk und sein Leben*, 2 vols. (Munich: Georg Müller, 1914); and Friedlaender, *Nicolas Poussin, die Entwicklung seiner Kunst* (Munich: R. Piper, 1914). These sources are all referenced by Reff, "Cézanne and Poussin," *Journal of the Warburg and Courtauld Institutes*, vol. 23, nos. 1–2 (January–June 1960), pp. 166, 166nn117–18. On Poussin's revived status at the turn of the twentieth century, see also Richard Verdi, "Cézanne and Poussin: The Critical Context," in *Cézanne and Poussin: The Classical Vision of Landscape*, exh. cat. (Edinburgh: National Galleries of Scotland, 1990), pp. 59, 59nn35–36.

11. Reff, "Cézanne and Poussin," p. 166.

12. Roger Marx, quoted in "Le IIIᵉ centenaire de Nicolas Poussin," *L'artiste*, June 1894, p. 463.

13. "Tout aboutit à Poussin et tout en découle." Ibid., p. 464.

14. Georges Dralin, "Propos," *L'occident*, no. 30 (May 1904), pp. 235–39, quoted in Reff, "Cézanne and Poussin," p. 167.

15. On Cézanne's copies after Poussin, see Joseph J. Rishel, "Cézanne, Poussin, Virgil," in this volume, pp. 165–66.

16. "[Poussin's] spirit seems to revive in the work of artists like Derain." Fry, "The French Post-Impressionists" (1912), in *Vision and Design*, ed. J. B. Bullen (London: Oxford University Press, 1981), p. 169. First published as "The French Group," introduction to *Second Post-Impressionist Exhibition: Grafton Galleries*, exh. cat. (London: Ballantyne, [1912]).

17. Christian Zervos, "Henri Matisse: Notes on the Formation and Development of His Work," in *Henri Matisse*, by Christian Zervos et al. (Paris: Cahiers d'Art, 1931), p. 12, nos. 11–13. See also Alfred H. Barr, Jr., *Matisse: His Art and His Public* (New York: Museum of Modern Art, 1951), p. 33. Matisse's copy of Poussin's *Autumn* (which both Zervos and Barr referred to as *The Bunch of Grapes*) seems to have been destroyed, while his copy of *Echo and Narcissus* was purchased by the French state. Poussin's *Bacchanal* (referred to by Barr as *Bacchante*) is possibly *Bacchanal with a Woman Playing the Guitar* (see fig. 143).

18. Schneider, *Matisse*, trans. Michael Taylor and Bridget Stevens Romer (New York: Rizzoli, 1984), p. 242 (illus.); see also pp. 548, 598. The Louvre archives do not have a record of Matisse's copying this painting; however, the artist's close friends Albert Marquet and Henri Manguin both registered to copy *Apollo and Daphne* early in their careers, on February 5, 1898, and March 20, 1902, respectively. Wanda de Guébriant, Archives Matisse, e-mail message to author, November 30, 2011.

19. "Par ton souffle invaincu, noblement, tu ranimes / Le choeur des bois sacrés, mystérieux essaim / Dérobant à la mort, vieux Virgile, ô Poussin / Un asyle encor vert des pensers magnanimes." Bouyer, "Apollon amoureux de Daphné" (February 4, 1891), in *Le paysage dans l'art* (Paris, 1894), quoted in Robinson, "A 'Nouvelle arcadie,'" p. 90n57.

20. "Mais quand il [Poussin] parle de Virgile, c'est d'un autre ton: on sent qu'il est nourri de ses poèmes. Il croit imiter les peintres dont il ignore totalement les oeuvres; mais, en réalité, ce sont les poètes qui l'inspirent, et c'est Virgile surtout." Jamot, "'L'inspiration du poète' par Nicolas Poussin," *Gazette des beaux-arts*, vol. 6 (1911), p. 192. Jacques Rivière also celebrated the entry of Poussin's *Inspiration of the Poet* into the Louvre with an article further corroborating the relevance of the painter for the young generation of artists. Rivière, "Poussin et la peinture contemporaine," *L'art décoratif*, vol. 27 (1912), pp. 133–48.

21. Denis, "Poussin et notre temps," *L'amour de l'art*, no. 5 (June 1938), p. 185. For Denis's reverence of Poussin, see Denis, "Les arts à Rome ou la méthode classique" (1898), in *Le ciel et l'arcadie*, ed. Jean-Paul Bouillon (Paris: Hermann, 1993), pp. 55–69.

22. "C'est un peintre chinois égaré, au XIXᵉ siècle, dans les ruines d'Athènes." Théophile Silvestre, *Histoire des artistes vivants français et étrangers: Études d'après nature* (Paris, 1856), p. 33.

23. For more on the duke, see Carol Ockman, "The Restoration of the Chateau of Dampierre: Ingres, the Duc de Luynes and an Unrealized Vision of History" (PhD diss., Yale University, 1982), esp. pp. 77–87.

24. Ingres and his assistants worked almost exclusively on *The Golden Age* and had not started painting *The Iron Age* when the project was disbanded. Only two studies for *The Iron Age* are known to exist.

25. Ingres to Gilibert, July 20, 1843, trans. and quoted in Gary Tinterow, "Paris, 1841–1867," in *Portraits by Ingres: Image of an Epoch*, ed. Gary Tinterow and Philip Consibee, exh. cat. (New York: Metropolitan Museum of Art, 1999), p. 360 (italics in

original). For Ingres's complete description of *The Golden Age* to Gilibert, see Ockman, "Restoration," app. 1, pp. 227–28.

26. See Ockman, "Restoration," pp. 123–44. Hesiod, *Works and Days*, in *"Theogony" and "Works and Days" [by] Hesiod [and] "Elegies" of Theognis*, trans. Dorothea Wender (Harmondsworth, UK: Penguin, 1973), quoted in Ockman, "Restoration," p. 123.

27. As Ockman explained, the presence of Saturn in Virgil's golden age is especially salient for Ingres, who included the god on the right of his Dampierre mural in 1846, and who, in the 1862 sketch, painted him watching over the scene from behind. Ockman, "Restoration," p. 124.

28. Ibid., pp. 152–54. Klaus Berger also made a connection between these two works: "Now, I believe that Poussin did give help to Ingres in some respects and that a work like *Apollo and Daphne* in its mellow mood, its interrelation between nude figures and landscape space, the parallel pattern between human and tree groups, could not have failed to inspire the master of Montauban." Berger, "Poussin's Style in the XIX Century," *Gazette des beaux-arts*, vol. 45 (1955), p. 167.

29. Rosenblum, *Jean-Auguste-Dominique Ingres* (New York: Harry N. Abrams, 1967), p. 9.

30. Gautier, *La presse*, March 27, 1840, trans. and quoted in Robert Snell, "Journalist and Contemporary," in *Théophile Gautier: A Romantic Critic of the Visual Arts* (Oxford: Clarendon, 1982), p. 166. According to Etienne Moreau-Nélaton, it was Gautier who said, "[Corot] a été bercé sur les genoux des nymphes," to which Corot purportedly responded, "Mais c'est la pure vérité . . . vous savez que la boutique de la belle dame était le rendez-vous des graces" (But it's the pure truth . . . you know that my mother's shop was the meeting place of the graces). Moreau-Nélaton, "Premières années (1796–1825)," in *L'oeuvre de Corot: Catalogue raisonné et illustré*, by Alfred Robaut (Paris: H. Floury, 1905), vol. 1, p. 19.

31. Zola, "Adieu d'un critique d'art" (1866), in *Le bon combat: De Courbet aux impressionniste; Anthologie d'écrits sur l'art*, ed. Jean-Paul Bouillon (Paris: Hermann, [1974]), p. 73, trans. and quoted in Michael Clarke, "Corot: Between the Classical and the Modern," in *Cézanne and Poussin: A Symposium*, ed. Richard Kendall (Sheffield, UK: Sheffield Academic Press, 1993), p. 84.

32. Except as noted, texts and translations of Virgil, with some modifications of my own, are from *Eclogues, Georgics, Aeneid I–VI*, vol. 1 of *Works*, trans. H. Rushton Fairclough, Loeb Classical Library (London: W. Heinemann, 1916).

33. See Bernadette Pasquier, *Virgile illustré: De la Renaissance à nos jours en France et en Italie* (Paris: Jean Tuzot, 1992), pp. 265–85. The 1881 edition of the *Eclogues* was translated by André Lefèvre, with illustrations by Auguste Leloir; the 1884 edition was intended for children, suggesting the rootedness of

Virgil in French culture; and the 1906 edition included illustrations by Adolphe Giraldon.

34. Ibid., p. 36.

35. Ziolkowski, "Virgil on the Continent," in *Virgil and the Moderns* (Princeton, NJ: Princeton University Press, 1993), p. 58.

36. "He is a poet who, in France, has not ceased to be in use and in the affections of all. But why do I say, in France? Virgil, from the very moment his work appeared, has been the poet of all of Latinity." Sainte-Beuve, *Étude sur Virgile, suivie d'une étude sur Quintus de Smyrne* (Paris, 1857), p. 35. On Sainte-Beuve's introduction to the 1891 edition of the *Eclogues*, see Pasquier, *Virgile illustré*, p. 276.

37. "C'est ce sérieux, ce tour de réflexion noble et tendre, ce principe d'élévation dans la douceur et jusque dans les faiblesses, qui est le fond de la nature de Virgile, et qu'on ne doit jamais perdre de vue à son sujet." Sainte-Beuve, *Étude sur Virgile*, p. 57. On Chateaubriand's description of Virgil's sadness (*tristesse*), see ibid., p. 52.

38. Panofsky, "*Et in Arcadia ego*," p. 300.

39. See esp. Ziolkowski, "Virgil," pp. 57–76; Stephen F. Walker, "Mallarmé's Symbolist Eclogue: The 'Faun' as Pastoral," *PMLA*, vol. 93, no. 1 (January 1978), pp. 106–7; L. A. Bisson, "Valéry and Virgil," *Modern Language Review*, vol. 53, no. 4 (October 1958), pp. 501–11; and A. Bourgery, "*Les Bucoliques* de Virgile dans la poésie moderne," *Revue des études latines*, vol. 23 (1945), pp. 134–50.

40. "Aimer à loisir / Aimer et mourir." Baudelaire, "L'invitation au voyage," in *Les fleurs du mal: Édition de 1861*, ed. Claude Pichois ([Paris]: Gallimard, 1972), p. 89.

41. Ibid.

42. Mallarmé gave this subtitle to the poem in its third and final state when it was published in 1876. Renato Poggioli was the first to emphasize the significance of the subtitle to the understanding of Mallarmé's poem as an heir to the pastoral tradition, although he did not specifically discuss its resonance with Virgil's *Eclogues*. Poggioli, "'L'Heure du Berger': Mallarmé's Grand Eclogue," in *The Oaten Flute: Essays on Pastoral Poetry and the Pastoral Ideal* (Cambridge, MA: Harvard University Press, 1975), pp. 283–311.

43. "Aimai-je un rêve?" Mallarmé, "The Afternoon of a Faun" (1876), in *Poems*, trans. Roger Fry (New York: New Directions, 1951), pp. 80–81.

44. Gide, quoted in Jean Delay, *The Youth of André Gide*, trans. June Guicharnaud (Chicago: University of Chicago Press, 1963), p. 277; quoted in Ziolkowski, "Virgil," p. 59.

45. Ibid (italics in original).

46. "On pourrait le nommer le Virgile français." Bernard, "Puvis de Chavannes" (1903), in *Propos sur l'art*, ed. Anne Rivière, Collection écrits sur l'art (Paris: Nouvelles Éditions Séguier, 1994), vol. 1,

p. 59. In his mural cycle at the Boston Public Library, Puvis depicted Virgil as the personification of bucolic poetry, in company with Homer, as epic poetry, and Aeschylus, as dramatic poetry.

47. Goldwater, "Puvis de Chavannes: Some Reasons for a Reputation," *Art Bulletin*, vol. 28, no. 1 (March 1946), pp. 33–43.

48. For an account of the banquet and the great moment of celebration around Puvis, see "Puvis de Chavannes," special issue, *La plume*, no. 138 (January 15, 1895), pp. 27–63.

49. Kahn, "Et le cher Baudelaire au grand coeur douleureux!," *Silhouettes littéraires* (Paris: Éd. Montaigne, 1925), p. 112, trans. and quoted in Jennifer L. Shaw, "Conclusion: The Banquet for Puvis de Chavannes," in *Dream States: Puvis de Chavannes, Modernism, and the Fantasy of France* (New Haven, CT: Yale University Press, 2002), p. 185.

50. The four reductions of 1867 are now divided between two museums: *Peace* and *War* are at the Philadelphia Museum of Art, and *Work* and *Repose* are at the National Gallery of Art in Washington, DC.

51. Virgil, *Ecl.* 4:18–23, quoted in Price, catalogue entry in *Pierre Puvis de Chavannes* (New Haven, CT: Yale University Press, 2010), vol. 2, p. 79, cat. 109.

52. Marx, "Puvis de Chavannes," *Revue encyclopédique*, December 23, 1899, p. 1077, trans. and quoted in Margaret Werth, "Idyll of the Living Dead," in *The Joy of Life: The Idyllic in French Art, circa 1900* (Berkeley: University of California Press, 2002), p. 26. For more on Puvis's work in relation to Marx's evaluation, see esp. Robinson, "A 'Nouvelle arcadie.'"

53. Barr, *Matisse*, pp. 17 (illus.), 60.

54. On Puvis's place in the modern canon, see Wattenmaker, *Puvis de Chavannes and the Modern Tradition*, exh. cat. (Toronto: Art Gallery of Ontario, 1975); and Serge Lemoine, ed., *From Puvis de Chavannes to Matisse and Picasso: Toward Modern Art*, exh. cat. ([Milan]: Bompioni, 2002). For the most comprehensive account of Puvis's work, see Price, *Puvis de Chavannes*.

55. Faure, "Le Salon d'Automne," *Les arts de la vie* (November 1904), pp. 293–94, trans. and quoted in Werth, "Idyll," p. 203. For Cézanne's and Puvis's showings at the Salon d'Automne, see *Catalogue des ouvrages de peinture, sculpture, dessin, gravure, architecture et art décoratif exposés au Grand Palais des Champs-Elysées* (Paris: Société du Salon d'Automne, 1904), pp. 106–10.

56. "Quelle mauvaise littérature!" Cézanne, quoted in Gasquet, "La Provence," in *Cézanne*, rev. ed. (1926; repr., [Grenoble]: Cynara, 1988), p. 75. Puvis's mural *Sorbonne*, or *Sacred Grove* (1887–89), commissioned for the main lecture hall of the newly rebuilt Sorbonne, depicts a panoramic wood filled with personifications of the various disciplines, each dressed in classical garb, that were

offered by the university following its curricular reform. The mural is discussed and illustrated in Price, catalogue entry in Price, *Puvis de Chavannes*, vol. 2, pp. 308–16, cat. 335.

57. Gauguin to Monfreid, February 1898, in *Gauguin's Letters from the South Seas*, trans. Ruth Pielkovo (repr., New York: Dover, 1992). Gauguin to Morice, July 1901, trans. and quoted in Stephen F. Eisenman, *Gauguin's Skirt* (London: Thames and Hudson, 1997), p. 42. For Gauguin's complete description of *Where Do We Come From?*, see Shackelford, "Trouble in Paradise," pp. 153, 155.

58. Denis, "L'influence de Paul Gauguin" (1903), in *Théories, 1890–1910: Du symbolisme et de Gauguin vers un nouvel ordre classique*, 4th ed. (Paris: L. Rouart et J. Watelin, 1920), p. 171, trans. and quoted in Richard Shiff, "The Cézanne Legend," in *Cézanne and the End of Impressionism: A Study of the Theory, Technique, and Critical Evaluation of Modern Art* (Chicago: University of Chicago Press, 1984), p. 165.

59. Gauguin to Morice, July 1901, p. 42.

60. Eisenman, *Paul Gauguin* (Barcelona: Ediciones Polígrafa, 2010), p. 9.

61. Ibid.

62. For Bernard's writings on Cézanne, see his *Souvenirs sur Paul Cézanne* (Paris: Société des Trentes, 1912); "Paul Cézanne," *L'occident*, July 1904, pp. 17–30; and "Une conversation avec Paul Cézanne," *Mercure de France*, June 1, 1921, pp. 372–97. *Souvenirs sur Paul Cézanne* was first published as "Souvenirs sur Paul Cézanne et letters inédites," pts. 1 and 2, *Mercure de France*, October 1, 1907, pp. 385–404; October 16, 1907, pp. 606–27. The entirety of Bernard's article in *L'occident* and excerpts from "Une conversation" are published in Michael Doran, ed., *Conversations avec Cézanne* ([Paris]: Macula, 1978), pp. 30–42 and 162–65, respectively.

63. Bernard wrote his first article on Cézanne in 1891, well before he had met the artist. See Bernard, "Paul Cézanne," *Les hommes d'aujourd'hui*, no. 387 (February–March 1891). In March 1905 Bernard returned to Aix for a second visit to see Cézanne.

64. Doran, *Conversations*, pp. 26–30, 43–48.

65. Bernard, *Souvenirs*, trans. and quoted in MaryAnne Stevens, "Introduction: Émile Bernard and His Artistic Literary Context / Einleitung: Émile Bernard und sein künstlerischer und literarischer Kontext," in *Émile Bernard, 1868–1941: A Pioneer of Modern Art / Ein Wegbereiter der Moderne*, ed. MaryAnne Stevens, exh. cat. (Zwolle, The Netherlands: Waanders Verlag, 1990), p. 21. For Bernard's copy of Cézanne's *Three Bathers*, see Jean-Jacques Luthi, *Émile Bernard: Catalogue raisonné de l'oeuvre peint* (Paris: Editions SIDE, 1982), cat. 263 (illus.).

66. The photograph is illustrated in MaryAnne Stevens, "Chronology / Chronologie," in Stevens, *Émile Bernard*, p. 97.

67. MaryAnne Stevens, "Paintings: Portraits / Gemälde: Porträts," in Stevens, *Émile Bernard*, pp. 198–200, cat. 56 (illus.).

68. Cézanne to Bernard, April 15, 1904, in *Paul Cézanne: Letters*, ed. John Rewald, 4th ed. (1976; repr., New York: Da Capo, 1995), p. 301 (italics in original).

69. The decorative purpose of the group of paintings is made clear by a sheet of nude studies related to the poses of the figures in the final canvases, which is inscribed "pour la decoration de mon atelier" (for the decoration of my studio). See MaryAnne Stevens, "Drawings and Watercolours / Zeich-nungen und Aquarelle," in Stevens, *Émile Bernard*, p. 235, cat. 83 (illus.).

70. MaryAnne Stevens suggested the possibility of the paintings' triptych arrangement (although she acknowledged that the group may have been meant for a "larger sequence of works"), pointing to the connections among the three canvases and noting that all three canvases share almost exactly the same dimensions, further corroborating their unity. Stevens, "Paintings: Bathers / Gemälde: Badende," in Stevens, *Émile Bernard*, pp. 159–63. Jean-Jacques Luthi, however, did not see the three paintings as a unit. Bernard, he claimed, understood two of the paintings, *Bathers with Red Cow* and *Bathers with Water Lilies* (see figs. 36, 37), as pendants, and Luthi dated both to 1887. Based on Bernard's inscription, he dated the third picture, *Bathers* (formerly in the collection of Mrs. Frederick C. Havemeyer in New York), to 1889. Luthi proposed that the latter may have been joined by other pictures of female nudes in landscapes that date to about 1889, with the suite ending with a moralizing picture of the Temptation of St. Anthony. Luthi, *Émile Bernard*, cats. 67, 68, 206–10, 212.

71. In 1887 Bernard decorated the dining room and a guest room, including the rooms' windowpanes, at the inn of Mme Lemasson in Saint-Briac, a small town on the coast of Brittany, not far from Pont-Aven.

72. Denis's most famous discourse on Cézanne is "Cézanne," *L'occident*, September 1907, pp. 118–33, in Doran, *Conversations avec Cézanne*, pp. 166–80. For an English translation, see "Cézanne," pts. 1 and 2, trans. Roger Fry, *Burlington Magazine*, vol. 16 (January 1910), pp. 207–19; (February 1910), pp. 275–80.

73. In a letter to his wife, Denis described meeting Cézanne "as the highlight of the day." Denis to Marthe Denis, January 28, 1906, in Denis, *Journal*, vol. 2 (Paris: La Colombe, 1957), p. 30; trans. and quoted in Carina Schäfer, catalogue entry in *Maurice Denis: Earthly Paradise, 1870–1943*, ed. Jean-Paul Bouillon, exh. cat. (Paris: Éditions de la Réunion des Musées Nationaux, 2006), p. 216, cat. 77.

74. On this same trip, Denis and Roussel paid visits to Henri-Edmond Cross, Pierre-Auguste Renoir, and Paul Signac.

75. For Denis's *Homage*, the most notable reference is to Henri Fantin-Latour's *Homage to Delacroix* (1864; Musée d'Orsay, Paris).

76. His colleagues at the academy included Bonnard, Sérusier, Henri Gabriel Ibels, and Paul Ranson.

77. Signac, journal, April 25, 1898, quoted in Margaret Werth, "Le bonheur de vivre," in Werth, *Joy of Life*, p. 197.

78. Denis's *Orchard of the Wise Virgins* and *Muses* are illustrated in Bouillon, *Maurice Denis*, p. 155, cat. 35, and p. 157, cat. 36, respectively.

79. For illustrations of *The Story of Psyche*, see ibid., pp. 261–67, cats. 101a–f.

80. "Malato's phrase . . . could be inscribed on the frame" (La phrase de Malato . . . pourrait être inscrite sur le cartel). Signac to Cross, 1893, Archives Signac, Paris, quoted in Françoise Cachin, "Paul Signac: La vie et l'oeuvre," in *Signac: Catalogue raisonné de l'oeuvre peint*, ed. Françoise Cachin and Marina Ferretti-Bocquillon (Paris: Gallimard, 2000), p. 52. For Malato's phrase, see *La revue anarchiste*, November 1, 1893, p. 78.

81. Hesiod conceived of the golden age as a definitively lost paradise, while Virgil was the first poet to imagine a future golden age. Owen Lee, *Death and Rebirth in Virgil's Arcadia* (Albany: State University of New York Press, 1989), p. 77.

82. Describing the project to Cross in the summer of 1893, Signac wrote: "The *boules* player is becoming a minor figure in: in the time of anarchy (title not definite)" (Le joueur de boules devient un personnage épisodique de: au temps d'anarchie [titre à chercher]). Signac to Cross, [summer 1893], Archives Signac, Paris, quoted in Marina Ferretti-Bocquillon, catalogue entry in *Signac et Saint-Tropez, 1892–1913*, by Françoise Cachin, Jean-Paul Monery, and Marina Ferretti-Bocquillon, exh. cat. (Saint-Tropez: Musée de l'Annonciade, 1992), p. 52, cat. 7. On the anarchist leanings of the Neo-Impressionists, see Robert L. Herbert and Eugenia W. Herbert, "Artists and Anarchism: Unpublished Letters of Pissarro, Signac, and Others" (1960), in *From Millet to Léger: Essays in Social Art History*, by Robert L. Herbert (New Haven, CT: Yale University Press, 2002), pp. 99–114; Eugenia W. Herbert, *The Artist and Social Reform: France and Belgium, 1885–1898* (New Haven, CT: Yale University Press, 1961); John G. Hutton, *Neo-Impressionism and the Search for Solid Ground: Art, Science, and Anarchism in Fin-de-Siècle France, Modernist Studies* (Baton Rouge: Louisiana State University Press, 1994); and Robyn Roslak, *Neo-Impressionism and Anarchism in Fin-de-Siècle France: Painting, Politics, and Landscape* (Burlington, VT: Ashgate, 2007).

83. "Au centre un jeune couple: l'amour libre!" Signac to Cross, [summer 1893], p. 52, cat. 7.

84. On Signac's reverence for Puvis, see esp. Françoise Cachin, "The Neo-Impressionists and Puvis de Chavannes," in Lemoine, *From Puvis de Chavannes*, pp. 123–24.

85. For Signac's lithograph, see E. W. Kornfeld and P. A. Wick, *Catalogue raisonné de l'oeuvre gravé et lithographié de Paul Signac* (Berne: Editions Kornfeld et Klipstein, 1974), no. 14.

86. Françoise Cachin, *Paul Signac*, trans. Michael Bullock (Greenwich, CT: New York Graphic Society, 1971).

87. Signac was particularly self-conscious about the scale of *In the Time of Harmony*, writing to Cross, "We should paint large-scale." Signac to Cross, n.d., Archives Signac, Paris, trans. and quoted in Cachin, "Neo-Impressionists," p. 123.

88. Pissarro to Signac, February 24, 1888, in *Correspondance de Camille Pissarro*, ed. Janine Bailly-Herzberg (Paris: Valhermeil, 1986), vol. 2, p. 218, trans. and quoted in Jodi Hauptman, introduction to *Georges Seurat: The Drawings*, exh. cat. (New York: Museum of Modern Art, 2007), p. 13.

89. Natanson, *La revue blanc*, 1900, quoted in Cachin, *Paul Signac*, p. 41.

90. See "The *Grande Jatte* at 100," special issue, *Art Institute of Chicago Museum Studies*, vol. 14, no. 2 (1989), esp. Linda Nochlin, "Seurat's *Grande Jatte*: An Anti-Utopian Allegory," pp. 133–153, and Stephen F. Eisenman, "Seeing Seurat Politically," pp. 211–22; and Robert L. Herbert, ed., *Seurat and the Making of "La Grande Jatte,"* exh. cat. (Chicago: Art Institute of Chicago, 2004).

91. Fénéon, "Les Impressionnistes en 1886," in *Oeuvres* (Paris: Gallimard, 1948), trans. and quoted in Shaw, "Conclusion," p. 189.

92. Eisenman, "Seeing Seurat Politically," p. 216.

93. See D'Alessandro, "Re-visioning Arcadia: Henri Matisse's *Bathers by a River*," in this volume, pp. 181–93.

94. In November 1891 Signac wrote to Cross, asking him to "describe to me the charms of your land" (décrivez-moi les charmes de vos contrées). To which Cross responded, "Hills of pines and corks come to fade gently into the sea, offering, in passing, a sandy beach unknown on the bank of the Channel" (Des collines de pins et de chênes-lièges viennent mourir doucement dans la mer et s'offrent, en passant, une plage de sable d'un [grain?] ignoré au bord de la Manche). Signac was so enamored with Cross's descriptions of Saint-Tropez that he decided to relocate there permanently. Signac and Cross, quoted in Cachin, "L'arrivée de Signac à Saint-Tropez," in Cachin, Monery, and Ferretti-Bocquillon, *Signac et Saint-Tropez*, pp. 13–14.

95. Signac to Cross, n.d., Archives Signac, Paris, trans. and quoted in Cachin, "Neo-Impressionists," p. 123.

96. Colette, trans. and quoted in Schneider, *Matisse*, p. 249. On the Mediterranean as a physical paradise, see Françoise Cachin, *Méditerranée: De Courbet à Matisse*, exh. cat. (Paris: Réunion des Musées Nationaux, 2000).

97. It is often assumed that Matisse began *Luxe, calme et volupté* while in Saint-Tropez. See, for example, John Elderfield, *The "Wild Beasts": Fauvism and Its Affinities*, exh. cat. (New York: Museum of Modern Art, 1976), p. 97. Jack Flam, however, claimed that Matisse likely brought back *By the Sea* (see fig. 55) to Paris in fall 1904 and began work on the compositional studies for *Luxe, calme et volupté* after seeing that year's Salon d'Automne, which featured a retrospective of Puvis's work. Flam, *Matisse: The Man and His Art, 1869–1918* (Ithaca, NY: Cornell University Press, 1986), pp. 115–16. Still, Catherine Cecelia Bock asserted that the work done in Saint-Tropez during the summer of 1904, including *By the Sea* and a pencil drawing of the pine tree that reappears on the right of *Luxe, calme et volupté*, suggests that the painting was "conceived, planned, and begun under the direct influence of Signac and Cross." Bock, "Henri Matisse and Neo-Impressionism, 1898–1908" (PhD diss., University of California, Los Angeles, 1977), p. 242.

98. The name "Fauve" typically is attributed to Louis Vauxcelles, who, according to Matisse, upon seeing an Italianate sculpture surrounded by works by Derain, Matisse, Jean Puy, and others at the 1905 Salon d'Automne, exclaimed, "Donatello au milieu des fauves" (Donatello among the wild beasts). Vauxcelles (quoted by Matisse), quoted in E. Tériade, "Matisse Speaks," pt. 2, *Art News Annual*, vol. 50, no. 7 (November 1951), p. 43.

99. Sixty-eight works by Ingres, including *Turkish Bath* and several studies, were exhibited at the 1905 Salon d'Automne. A preparatory drawing for Ingres's *Golden Age* was also shown. See *Catalogue des ouvrages de peinture, sculpture, dessin, gravure, architecture et art décoratif exposés au Grand Palais des Champs-Elysées* (Paris: Société du Salon d'Automne, 1905), pp. 185–89. For Ingres's influence on the composition of *Le bonheur de vivre*, see esp. Roger Benjamin, "Ingres chez les Fauves," *Art History*, vol. 23, no. 5 (December 2000), pp. 743–71; and Philip Dagen, "L'age d'or: Derain, Matisse et le bain turc," *Bulletin du Musée Ingres*, nos. 53–54 (December 1984), pp. 43–54.

100. Signac wrote of *Le bonheur*: "Matisse whose attempts I have liked up to now seems to me to have gone to the dogs. Upon a canvas of two and a half meters he has surrounded some strange characters with a line as thick as your thumb. Then he has covered the whole thing with flat well-defined tints which—however pure—seem disgusting." Signac to Charles Angrand, January 14, 1906, trans. and quoted in Barr, *Matisse*, p. 82.

101. Flam, "Henri Matisse," in *Great French Paintings from The Barnes Foundation: Impressionist, Post-Impressionist, and Early Modern*, by Richard J. Wattenmaker et al. (New York: Alfred A. Knopf, 1993), p. 230n9 (brackets in Flam).

102. Werth, "Engendering Imaginary Modernism: Henri Matisse's *Bonheur de vivre*," *Genders*, vol. 9 (Fall 1990), p. 51. Werth cites Flam, *Matisse*, p. 157.

103. "Pour le nu, je vais tous les matins à six heures dans les bois de la montagne avec ma femme qui pose tranquillement. Nous y sommes allés une dizaine de fois, nous n'avons jamais été dérangés. Mais il y a une heure de marche et il nous faut revenir à dix ou onze heures du matin par la forte chaleur, c'est assez dur." Matisse to Henri Manguin, n.d., quoted in Jack Flam, "Matisse à Collioure, évolution du style et datation des tableaux," in *Matisse—Derain: Collioure 1905, un été fauve*, by Joséphine Matamoros et al., exh. cat. (Paris: Gallimard, 2005), p. 38.

104. Matisse, quoted in MacChesney, "A Talk with Matisse, 1912," in *Matisse on Art*, ed. Jack Flam (London: Phaidon, 1973), p. 51.

105. Schneider, *Matisse*, p. 620.

106. "I love Virgil, and I read him even when I don't understand the text" (J'adore Virgile et je le lis quand même, dans le texte, sans le comprendre). Maillol, quoted in Cladel, *Aristide Maillol: Sa vie—son oeuvre—ses idées* ([Paris]: Éditions Bernard Grasset, [1937]), p. 158. Cladel continued, "And Maillol cites a few verses, beginning with the famous *Tityre, tu patulae recubans* [the opening lines of the *Eclogues*]." Ibid. (italics in original).

107. Schneider, *Matisse*, p. 255.

108. Ibid., p. 558.

109. Matisse, quoted in *Écrits et propos sur l'art*, ed. Dominique Fourcade ([Paris]: Hermann, [1972]), p. 48; trans. and quoted in Schneider, *Matisse*, p. 558.

110. For illustrations of Maillol's sculptures *Venus, The Mediterranean, Flora, Summer,* and *Spring*, see Bertrand Lorquin, *Aristide Maillol* ([Milan]: Skira, 2002), pp. 109, 42, 72–73, and 75, respectively.

111. Maillol, quoted in Cladel, *Maillol*, p. 120.

112. *Morozov and Shchukin, the Russian Collectors: Monet to Picasso*, Museum Folkwang, Essen, Germany, June 25–October 31, 1993; Pushkin Museum, Moscow, November 30, 1993–January 30, 1994; and State Hermitage Museum, Saint Petersburg, February 16–April 16, 1994. For the Maillol and Denis commissions and illustrations, see Georg-W. Költzsch, ed., *Morozov, Shchukin, the Collectors: Monet to Picasso; 120 Masterpieces from the Hermitage, St. Petersburg, and the Pushkin Museum, Moscow*, trans. Eileen Martin, exh. cat. (Cologne: DuMont, 1993), cats. 53–70.

113. For more on Kessler and Maillol's relationship, see esp. Annabel Patterson, "Post-Romanticism:

Wordsworth to Valéry," in *Pastoral and Ideology: Virgil to Valéry* (Berkeley: University of California Press, 1988), pp. 306–16 (under "'A Book for Kings, Students or Whores': The Cranach Press *Eclogues*").

114. Patterson, "Post-Romanticism," pp. 308–9.

115. Harry Kessler, *Prospectus* (1927), in Roderick Cave, *The Private Press* (New York: R. R. Bowker, 1983), quoted in Patterson, "Post-Romanticism," p. 309.

116. Patterson, "Post-Romanticism," p. 312.

117. Ibid.

118. Ibid, pp. 312, 312n60.

119. Although Apollinaire wrongly noted that Derain and Matisse met in 1905, his words nonetheless underscore the importance of Derain to the course of modern art: "That year [1905] André Derain met Henri Matisse, and from this meeting was born the famous school of the fauves. . . . I note this meeting because it is worth while [*sic*] to make clear the part played by André Derain, an artist who came from Picardy, in the evolution of French art. In the following year he made friends with Picasso, and this friendship had as its almost immediate effect the birth of cubism." Apollinaire, "The Beginnings of Cubism" (1912), in *Cubism*, ed. Edward F. Fry, trans. Jonathan Griffin (New York: McGraw-Hill, 1966), p. 103. First published in *Le temps*, October 14, 1912.

120. Monod-Fontaine, "André Derain: Painting against the Tide," in *André Derain: An Outsider in French Art*, exh. cat. ([Copenhagen]: Statens Museum for Kunst, 2007), p. 11.

121. "Thereafter Derain withdrew and for a time he neglected to participate in the art of his time. The most important of his works are the calm, profound paintings (up to 1910)." Apollinaire, "Die moderne Malerei" (1913), in *A Cubism Reader: Documents and Criticism, 1906–1914*, ed. Mark Antliff and Patricia Leighten, trans. Jason Gaiger (Chicago: University of Chicago Press, 2008), p. 472. First published in *Der Sturm*, February 1913, pp. 272ff.

122. Michael Kellerman, *André Derain: Catalogue raisonné de l'oeuvre peint*, 3 vols. (Paris: Éditions Galerie Schmit, 1992–99).

123. Derain held deep regard for art of the past: "My obsession was the Louvre, and not a day went by that I didn't step inside." Derain, quoted in Gaston Diehl, *Derain* (Paris, [1964?]), p. 16; quoted in Susan L. Ball, "The Early Figural Paintings of André Derain, 1905–1910: A Re-evaluation," *Zeitschrift für Kunstgeschichte*, vol. 43, no. 1 (1980), p. 80n10. For Derain's drawings after Delacroix, Ingres, Poussin, and Titian, see Bernard Dorival, "Un album de Derain au Musée National d'Art Moderne," *La revue du Louvre*, vol. 19, nos. 4–5 (1969), pp. 257–68.

124. Schama, *Landscape and Memory* (New York: Alfred A. Knopf, 1995), p. 517.

125. For more on this fortuitous meeting, see Charles Chassé, *Les fauves et leur temps* (Lausanne, France: Bibliothèque des Arts, 1963), pp. 127–28.

126. The title of this work, *The Golden Age* (*L'âge d'or*), is posthumous and first appeared at the 1950 Venice Biennale. See Elderfield, *Wild Beasts*, pp. 102n32, 105.

127. "Je suis surtout embêté parce que j'allais commencer un grand ouvrage de composition sur un vers de Virgile. Toutes mes esquisses, mes dessins étaient faits. J'allais commencer, puis une heure passée dans un café de Montmartre m'a chassé cette exaltation. Par une contrepartie, voici comment ma composition me semblait très froide. Voici du reste un croquis. Des femmes dans l'ombre sous des arbres, puis [crossed out] un fleuve dans le soleil, une ligne d'arbres à l'autre rive. Or, quand j'eus bien convenu [*sic*], cela me parut monotone. Quand, pour mon malheur, j'ai vu des femmes fardées à costume voyant qui buvaient des absinthes vertes, des grenadines, etc., puis un billard vert, dans un soleil parisien derrière des fiacres, des chevaux jaunes, des gens pressés, je n'ai plus eu aucun courage pour ma première idée." Derain to Matisse, June [15–20], 1905, in Rémi Labrusse, "Correspondance: André Derain, Henri Matisse," in *Matisse, Derain: La vérité du fauvisme*, by Rémi Labrusse and Jacqueline Munck (Paris: Hazan, 2005), p. 333.

128. Labrusse, "André Derain, Henri Matisse," p. 333n11.

129. For the 1906 dating and the title *After Gauguin*, see, for example, Judi Freeman, *The Fauve Landscape*, exh. cat. (Los Angeles: Los Angeles County Museum of Art, 1990), p. 288, pl. 302; and Suzanne Pagé, ed., *André Derain: Le peintre du "trouble moderne*," exh. cat. (Paris: Musée d'Art Moderne de la Ville de Paris, 1994), p. 472, cat. 56. Kellerman, for his part, gave the painting the title *Baigneuses dans un paysage* (Bathers in a landscape) and dated it to 1905–6. Kellerman, *André Derain*, vol. 1, p. 235, no. 377.

130. According to Susan Ball, *The Dance* "could only have been painted in late fall 1906, after Derain had returned from London, after he had seen the Gauguin retrospective at the Salon d'Automne, and after he knew Matisse had abandoned divisionism." Ball, "Early Figural Paintings," p. 84. Kellerman dated the work to about 1905–6, with the likely implication that related watercolors and sketches were done in 1905. Kellerman, *André Derain*, vol. 1, p. 233, no. 374. Elderfield suggested that *The Dance* was started in either late summer 1905 or summer 1906. Elderfield, *Wild Beasts*, p. 105. The 1906 Salon d'Automne retrospective featured 227 works by Gauguin. See *Catalogue des ouvrages de peinture, sculpture, dessin, gravure, architecture et art décoratif exposés au Grand Palais des Champs-Elysées*, exh. cat. (Paris: Société du Salon d'Automne, 1906), pp. 191–201.

131. Léon Pédron sale, Hôtel Drouot, Paris, June 2, 1926, no. 12. For the auction catalogue, see Hôtel Drouot, *Tableaux modernes, aquarelles, pastels, dessins* (Paris, 1926). For Derain's three visits to London, see Rémi Labrusse et al., *André Derain: The London Paintings*, exh. cat. (London: Courtauld Institute of Art Gallery, 2005). On the sketchbooks, see esp. Rémi Labrusse and Jacqueline Munck, "André Derain in London (1906–07): Letters and a Sketchbook," *Burlington Magazine*, vol. 146, no. 1213 (April 2004), pp. 243–60.

132. Among other sources for Derain's painting is the figure of Isaiah from the Abbey of Sainte-Marie in Souillac, France, which, as Susan Ball noted, corresponds with the figure at the center-left of *The Dance*, medieval art having been another love for Derain. Ball, "Early Figural Paintings," pp. 85–86.

133. *Exposition rétrospective d'oeuvres de Cézanne au Salon d'Automne*, Grand Palais, Paris, October 1–22, 1907. The influence of Cézanne as seen in Derain's *Bathers*, as well as a repositioning of this work in the context of the development of Cubism, is addressed in William Rubin, "Cézannism and the Beginnings of Cubism," in *Cézanne: The Late Work*, ed. William Rubin, exh. cat. (New York: Museum of Modern Art, 1977), pp. 156–58.

134. The reproduction is first documented in Gelett Burgess's article, "The Wild Men of Paris," *Architectural Record*, vol. 27 (May 1910). However, Burgess's interviews likely took place in the winter of 1908–9. See Ball, "Early Figurative Paintings," pp. 88, 88n41.

135. For Derain's paintings of bathers from this moment, see Kellerman, *André Derain*, vol. 1, nos. 380–96.

136. For the painting *The Hunt*, which often is referred to as *La chasse*, Bernard Dorival proposed the title *L'age d'or* (The golden age). Dorival, "L'age d'or, de Derain," *La revue du Louvre*, vol. 14, no. 3 (1964), pp. 145–49. On the painting's relationship to verdures, Miriam Simon explained that "the importance of the vegetation recalls the 'verdures' of the seventeenth century, in which the stylization of each species makes different types of foliage identifiable." Simon, catalogue entry in Pagé, *André Derain*, p. 274, cat. 174 (as *L'age d'or*).

137. Stein, "More Adventures," in *Appreciation: Painting, Poetry and Prose* (New York: Crown, 1947), p. 174.

138. Rosenblum, "Picasso in Gósol: The Calm before the Storm," in *Picasso: The Early Years, 1892–1906*, ed. Marilyn McCully, exh. cat. (Washington, DC: National Gallery of Art, 1997), p. 263.

139. Olivier recalled, "The Picasso I saw in Spain was completely different from the Paris Picasso . . . He radiated happiness and his normal character and attitudes were transformed." Olivier, *Picasso and His Friends*, trans. Jane Miller (New York:

Appleton-Century, 1965), p. 93, quoted in John Richardson, *A Life of Picasso* (New York: Random House, 1991), vol. 1, p. 436.

140. On the revival of Catalonian nationalism and its ideals of classical beauty, see Josep Palau i Fabre, *Picasso: The Early Years, 1881–1907*, trans. Kenneth Lyons (Barcelona: Ediciones Polígrafa, 1985), pp. 439–40. Korai are archaic Greek sculptures of standing nude female youths; kouroi are their male counterparts.

141. The landscapes inspired by Cézanne include *View of Gósol* (private collection) and *Landscape* (Musée Picasso, Paris), both of 1906 and illustrated in Maria Teresa Ocana, ed., *Picasso: Landscapes 1890–1912; From the Academy to the Avant-Garde*, exh. cat. (Barcelona: Lunwerg Editores, 1994), fig. 101 and pl. 173, respectively.

142. For illustrations of the related studies, see Palau i Fabre, *Picasso*, nos. 1191–95. On Puvis's influence, especially as seen in the matte, fresco-like quality of the surface of Picasso's gouache, see Richardson, *Life of Picasso*, vol. 1, p. 424. Puvis's manner of painting would certainly have been known to Picasso from the artist's retrospective featuring forty-four works at the 1904 Salon d'Automne.

143. Palau i Fabre, *Picasso*, p. 434.

144. As suggested in Richardson, *Life of Picasso*, vol. 1, p. 424.

145. As Gary Tinterow noted, Picasso likely saw this picture at Vollard's 1903 exhibition of Gauguin's work. Tinterow, catalogue entry in *Picasso in the Metropolitan Museum of Art*, ed. Gary Tinterow and Susan Alyson Stein, exh. cat. (New York: Metropolitan Museum of Art, 2010), p. 83, cat. 29.

146. Ingres's *Turkish Bath* (1862; Musée du Louvre, Paris), along with numerous studies, had been exhibited to much fanfare at the 1905 Salon d'Automne.

147. "I saw the Museum of Antibes. There are some extraordinary Picassos." Matisse to his son Pierre, April 14, 1948, trans. and quoted in Yve-Alain Bois, *Matisse and Picasso*, exh. cat. (1998; repr., Paris: Flammarion, 2001), p. 192.

148. Michel Hoog, catalogue entry in *Henri Rousseau*, by Roger Shattuck et al., exh. cat. (New York: Museum of Modern Art, 1985), p. 250, cat. 66.

149. Rousseau to André Dupont, April 1, 1910, quoted in "Le Douanier," ed. Guillaume Apollinaire and Jean Cerusse, special issue, *Les soirées de Paris*, no. 20 (January 15, [1914]); trans. and quoted in Hoog, catalogue entry, p. 250, cat. 66.

150. Though Rousseau was called "le douanier" throughout his lifetime, he was not actually a customs officer. See Carolyn Lanchner and William Rubin, "Henri Rousseau and Modernism," in Shattuck et al., *Henri Rousseau*, pp. 37, 37n12.

151. Rousseau, quoted in Weber, untitled typed manuscript, [1907], p. 2; quoted in Sandra E. Leonard, *Henri Rousseau and Max Weber* (New York: Richard L. Feigen, [1970]), pp. 22–23. Both the Philadelphia Museum of Art and the National Gallery, London, versions of *The Large Bathers* (see p. xii and fig. 155; fig. 170) were shown in the 1907 Salon d'Automne, nos. 19 and 17, respectively. Rousseau must have been referring to the Philadelphia picture on account of its unfinished state.

152. Green, "The Great and the Small: Picasso, Henri Rousseau and 'The People,'" in *Picasso: Architecture and Vertigo* (New Haven, CT: Yale University Press, 2005), p. 102.

153. Uhde, *Henri Rousseau* (Paris: E. Figuière, 1911), pp. 49–50, quoted in Green, "Great and the Small," p. 102.

154. "We are the greatest painters of our time, you in the Egyptian style, I in the modern." Rousseau, quoted in "Chronology," in Shattuck et al., *Henri Rousseau*, p. 94. The 1908 banquet was immortalized by Gertrude Stein (one of the attendees) in her *Autobiography of Alice B. Toklas* (1933; repr., New York: Modern Library, 1993), pp. 139–45.

155. As later recorded by the painter J. E. S. Jeanès, Gauguin, standing before Rousseau's self-portrait (see fig. 124) at the 1890 Salon des Indépendants, exclaimed: "There is the truth . . . the future . . . that, that is Painting!" Jeanès, *D'après nature, souvenirs et portraits* (Besançon, France: Granvelle, 1946), quoted in Henry Certigny, catalogue entry in *Le Douanier Rousseau en son temps: Biographie et catalogue raisonné* (Tokyo: Bunkazai Kenkyujo, 1984), vol. 1, p. 83, cat. 45.

156. "If I have kept my naïveté, it is because Monsieur Gérome . . . as well as [academic painter] Monsieur [Félix Auguste] Clément . . . always told me to keep it; in the future you won't find it shocking any longer." Rousseau to Dupont, [April 1, 1910?], quoted in Apollinaire and Cerusse, "Le Douanier," p. 57; trans. and quoted in Lanchner and Rubin, "Henri Rousseau," p. 35. On Rousseau and Seurat, see Lanchner and Rubin, "Henri Rousseau," pp. 41–43.

157. Hoog, catalogue entry in Shattuck et al., *Henri Rousseau*, p. 150, cat. 22.

158. Ibid., pp. 148–50, figs. 1, 3. Hoog credited the comparison to Gérôme's *Innocence* to Dora Vallier. See Vallier, *Henri Rousseau* (Paris: Flammarion, 1979), pp. 31–32.

159. Perhaps the best survey of Cubism in all its manifestations is still John Golding, *Cubism: A History and an Analysis, 1907–1914*, 3rd ed. (Cambridge, MA: Belknap, 1988).

160. On Kahnweiler's aim to bar his artists from the Paris salons, see Pierre Daix, "Cubists Circles in Paris," in *Cubists and Cubism* (New York: Rizzoli, 1982), p. 72. Picasso, as it were, had never exhibited at the salons, and Braque's last salon appearance was in 1908. Both artists' work could be seen in Paris at Kahnweiler's gallery on rue Vignon and at Uhde's small private gallery. Vollard also held an exhibition of Picasso's work in the winter of 1910–11. By 1914 Picasso had held major solo exhibitions in England, Germany, Spain, and the United States. See Golding, *Cubism*, pp. 3, 11.

161. Apollinaire, "Le Salon des Indépendants" (1912), in *Apollinaire on Art: Essays and Reviews, 1902–1918*, ed. LeRoy C. Breunig (New York: Viking, 1972), p. 212, quoted in Sherry A. Buckberrough, "Laon and the *City of Paris*—January–March, 1912," in *Robert Delaunay: The Discovery of Simultaneity*, Studies in the Fine Arts: The Avant-Garde, no. 21 (Ann Arbor, MI: UMI Research Press, 1982), p. 92. First published in *L'intransigeant*, March 19, 1912.

162. Apollinaire discussed "Orphism," or "Orphic Cubism," as one of four types of Cubism (the name comes from the mythological musician and poet Orpheus, and thus refers to pure, lyrical painting, a "music" of colors), first in a lecture soon after the opening of the Section d'Or exhibition in fall 1912, and then in his famous tract *Les peintres cubistes* (1913). See Apollinaire, *The Cubist Painters*, trans. Patricia Roseberry ([Harrogate, UK]: Broadwater House, 2000), pp. 39–40. See also Virginia Spate, "Apollinaire's Orphism," in *Orphism: The Evolution of Non-figurative Painting in Paris, 1910–1914*, Oxford Studies in the History of Art and Architecture (Oxford: Oxford University Press, 1979), pp. 60–81.

163. Michel Hoog, "La ville de Paris de Robert Delaunay: Sources et développement," *La revue du Louvre*, vol. 15, no. 1 (1965), p. 30.

164. Hoog noted that the self-portrait and Rousseau's landscape *Notre Dame* (1909; Phillips Collection, Washington, DC), which shows a similar view of the city, were owned by Sonia and Robert Delaunay. Ibid., p. 32. However, Certigny's catalogue raisonné of Rousseau's work suggests that the Russian painter Comte Serge Jastrebzoff purchased the self-portrait directly from Rousseau in 1910. Certigny, catalogue entry, p. 85, cat. 45.

165. Apollinaire, "Salon des Indépendants" (1912), in *Apollinaire on Art*, p. 219, quoted in Buckberrough, *Robert Delaunay*, pp. 92–93.

166. Hoog, "Ville de Paris," p. 30.

167. Cooper, *The Cubist Epoch* ([London]: Phaidon, [1971]), p. 83.

168. See Milton W. Brown, *The Story of the Armory Show* (New York: Joseph H. Hirshhorn Foundation, 1963), pp. 120–21.

169. Cézanne to Émile Bernard, April 15, 1904, in Rewald, *Paul Cézanne*, p. 301. In actuality Cézanne's pronouncement had little to do with his work.

170. Briend, "Artists' Biographies: Albert Gleizes," in Lemoine, *From Puvis de Chavannes*, p. 513.

171. Herbert, "Gleizes and Metzinger: Cubism," in *Modern Artists on Art: Ten Unabridged Essays*, ed. Robert L. Herbert (1964; repr., Englewood Cliffs, NJ: Prentice-Hall, [1965]), p. 1.

172. The idea for the first Section d'Or exhibition, which was held concurrently with the 1912 Salon d'Automne, came out of the meeting of this circle of artists at Jacques Villon's studio in Puteaux, a suburb of Paris, giving the group the designation "Puteaux Cubists," or sometimes "Salon Cubists." The fellowship essentially had disbanded by the next year. See esp. R. Stanley Johnson, *Cubism and La Section d'Or: Reflections on the Development of the Cubist Epoch, 1907–1922* (Düsseldorf: Klees/Gustorf, 1991); and Cécile Debray and Françoise Lucbert, *La Section d'Or: 1925, 1920, 1912*, exh. cat. (Paris: Éditions Cercle d'Art, 2000).

173. This motif was made particularly famous by George Gershwin's "I'll Build a Stairway to Paradise," written and composed for George White's show *Scandals* (1922), and has survived into film.

174. Apollinaire, *Cubist Painters*, p. 66.

175. This and the following two quotations are from Rousseau, "Orphism: The 'Voice of Light,'" trans. Simon Pleasance, in *Marc, Macke und Delaunay: The Beauty of a Fragile World (1910–1914)*, ed. Susanne Meyer-Büser (Hannover, Germany: Sprengel Museum, 2009), p. 22. This volume includes translations of the essays originally published in Susanne Meyer-Büser, ed., *Marc, Macke und Delaunay: Die Schönheit einer zerbrechenden Welt (1910–1914)*, exh. cat. (Hannover, Germany: Sprengel Museum, 2009).

176. Gleizes and Metzinger both emphasized that they understood Cubism as a continuation of the French grand manner. See esp. Gleizes, "La tradition et le cubisme" (1913), in Antliff and Leighten, *Cubism Reader*, pp. 460–70.

177. Discussing the poetic nature of the "Windows" pictures, Golding wrote, "Delaunay himself claimed that the inspiration for these paintings of scenes through open windows came to him on reading a poem by Mallarmé." Golding, *Cubism*, p. 165.

178. At the time, Marc, who had been coming to Paris since 1903, was there with August Macke, and the two made a trip to see Delaunay in his studio, where they encountered his new "Windows" pictures (see, for example, fig. 127). After leaving Paris, Marc wrote to Wassily Kandinsky that "Delaunay interested me *very* much, French through and through, but open and intelligent. . . . he is now working towards entirely constructive pictures without any representationality, one could say: pure sound fugues." Marc to Kandinsky, October 5, 1912, trans. and quoted in Ulrich Krempel, "'We Look to the Stars': Marc und Delaunay; A Correspondence about the New Art, 1912–1914," in Meyer-Büser, *Marc, Macke und Delaunay*, p. 18 (italics in original). Delaunay had been invited to participate in the first Blaue Reiter exhibition by Kandinsky, who first had encountered the Frenchman's work through his student Elisabeth Epstein, a close friend of Sonia Delaunay. Robert Delaunay contributed four paintings to the exhibition, which opened on December 18, 1911, at the Thannhauser gallery in Munich and was Marc's first contact with original works by Delaunay.

179. Marc to Reinhard Piper, December 1908, quoted in Reinhard Piper, *Das Tier in der Kunst* (Munich, 1910), p. 190; trans. and quoted in Krempel, "'We Look to the Stars,'" p. 18.

180. Marc to Delaunay, December 1912, and Delaunay to Marc, April 1913, trans. and quoted in Rousseau, "Orphism," p. 24.

181. On Kandinsky's Arcadian image-making, see Rose-Carol Washton Long, "Kandinsky's Vision of Utopia as a Garden of Love," *Art Journal*, vol. 43, no. 1 (Spring 1983), pp. 50–60.

182. This show, which opened in Moscow in April 1908, was the first of three Salon of the Golden Fleece (Salon Zolotogo Runa) exhibitions, so called after the magazine that sponsored them, *Zolotoe runo*. The second Golden Fleece exhibition took place in January 1909 and featured recent Fauve paintings, including works by Derain and Matisse, and the third occurred at the end of 1909 but did not include contemporary French artists. Goncharova had first shown in Paris in 1906 in the exhibition of Russian art at the Salon d'Automne, organized by Sergei Diaghilev, and, beginning in 1922, became a regular contributor to the Paris salons.

183. The group had formed in the spring of 1911, and its name came from a joke played the previous year by a group of French artists who had sent a painting by Joachim Boronali, *Sunset over the Adriatic*, to the Salon des Indépendants. The painting had been executed by a donkey with a paintbrush attached to its tail. See Anthony Parton, *Goncharova: The Art and Design of Natalia Goncharova* (Suffolk, UK: Antique Collectors' Club, 2010), p. 63.

184. Despite Goncharova's early exposure to and fascination with French art, she attempted to resist European influences on her painting, writing, "When I follow the path of Cézanne, my works satisfy me less than those that derive from totally different artifacts such as icons, the Gothic style, and so on . . . I'm not European at all. Eureka." Goncharova, Album [1911?], in *Amazons of the Avant-Garde: Alexandra Exter, Natalia Goncharova, Liubov Popova, Olga Rozanova, Varvara Stepanova, and Nadezhda Udaltsova*, ed. John E. Bowlt and Matthew Drutt, exh. cat. (New York: Solomon R. Guggenheim Foundation, 2000), p. 309. *Boys Bathing* is typically dated to 1911, but here I have followed the dating of Roman Zieglgänsberger of the Museum Wiesbaden in Germany, who has proposed, based on the picture's style, that it in fact was painted earlier, around 1910.

185. Peter Hill, "Origins," in *Stravinsky: The Rite of Spring* (New York: Cambridge University Press, 2000), p. 5.

186. Ibid.

187. Wullschlager, "St. Petersburg, 1907–1908," in *Chagall: A Biography* (New York: Albert A. Knopf, 2008), p. 61.

188. For more on the First German Autumn Salon, see Peter Selz, *German Expressionist Painting* (Berkeley: University of California Press, 1957), pp. 265–73.

189. Erdmann-Macke, *Erinnerung an August Macke* (Stuttgart, 1962), pp. 214ff., trans. and quoted in Ursula Heiderich, "'The Comely Fruit of Light': August Macke and Robert Delaunay," in Meyer-Büser, *Marc, Macke und Delaunay*, p. 14.

190. Ibid. For more on the effect of the war on Marc and Macke, see Tanja Pirsig-Marshall, "'Dream the Myth Onwards': Visions of Arcadia in German Expressionist Art," in this volume, pp. 208–13.

191. With special thanks to Katherine Sachs for her insights on these contemporary visions of Arcadia. For other contemporary artists' considerations of Arcadia, see Diana Nemiroff, *Elusive Paradise: The Millennium Prize*, exh. cat. (Ottawa: National Gallery of Canada, 2001).

192. *Twombly and Poussin: Arcadian Painters*, Dulwich Picture Gallery, London, June 29–September 25, 2011. For the exhibition catalogue, see Nicholas Cullinan, *Twombly and Poussin: Arcadian Painters*, exh. cat. (London: Dulwich Picture Gallery, 2011).

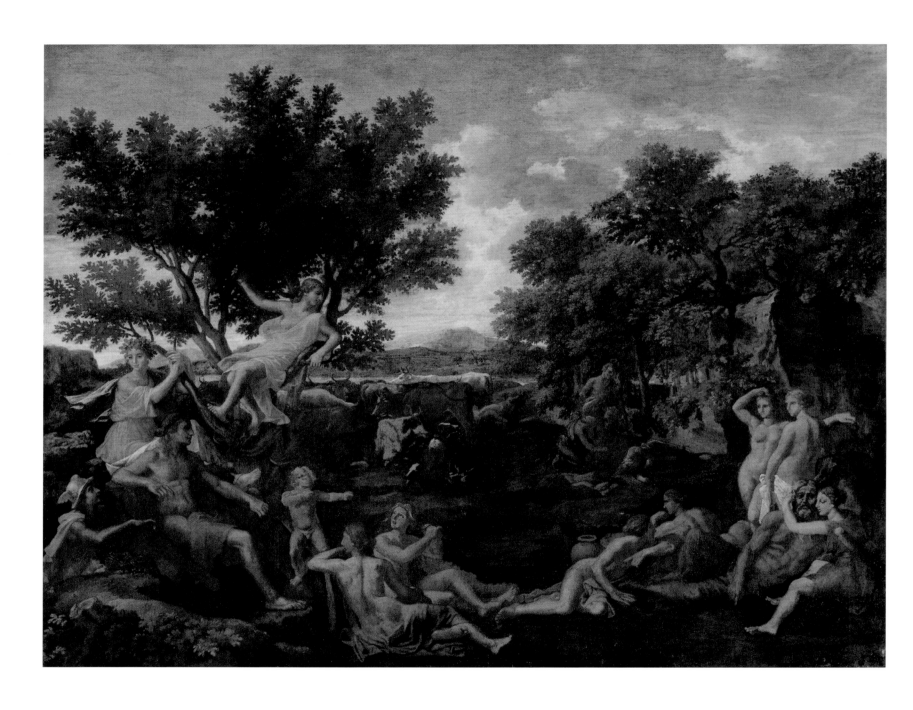

136

NICOLAS POUSSIN

French, 1594–1665

Apollo and Daphne (Apollon amoureux de Daphné)

1664

Oil on canvas, 5 feet 1 inch × 6 feet 6¾ inches (1.55 × 2 m)

Musée du Louvre, Paris

The Painter's Arcadia

CHARLES DEMPSEY

> *Signorelli's . . . greatest surviving work, the Berlin* Pan *[fig. 138], that fascinating dream-picture which anticipates two such seemingly different but essentially similar romanticisms, Poussin's and Gauguin's.*
> —BERNARD BERENSON, *The Drawings of the Florentine Painters*

Virgil's *Bucolics* (37 BCE), familiarly known as the *Eclogues* (literally, "short poems" or "selections"), are the first Latin poems in the pastoral mode. They explicitly take as their point of departure Theocritus's *Idylls*, poems by the third-century-BCE Greek (whom Virgil acknowledged to be the first to write bucolic poetry) that are set in the sun-drenched hills and pastures of the author's native Sicily. However, although the *Eclogues* are filled with references to Theocritus, invoking his *Sicelides Musae* (Sicilian muses), it was Virgil who originally named Arcadia—the immemorially ancient Greek territory peopled by a race of men older than the moon (Ovid, *Fast.* 2.290: "Arcades, et luna gens prior illa fuit")—as the nostalgically remote, ideal, and purely literary landscape of pastoral, in which shepherds and goatherds first sang rustic verses as they whiled away the time tending their flocks. Virgil's reason for this undoubtedly was that the principal god of Arcadia was known widely to be Pan: "Pan deus Arcadiae venit, quem vidimus ipsi" (*Ecl.* 10.26; Pan came, Arcady's god, and we ourselves saw him).[1] Pan is the shepherds' god (Pan Nomios), and it was he who first tied hollow reeds together and taught shepherds the singing of rustic verse:

> *Mecum una in silvis imitabere Pana canendo.*
> *Pan primum calamos cera coniungere pluris*
> *instituit, Pan curat ovis oviumque magistros.*

> (*Ecl.* 2.31–33; With me in the woods you shall imitate Pan in song.
> Pan first taught men to join several reeds together with wax;
> Pan who has flocks of sheep in his care and the shepherds who watch over them.)

The genre of pastoral is notoriously difficult to define precisely, even though most of us have a fairly clear idea of its meaning, one based on mood, locale, and descriptive paraphernalia. Our conception, however, inevitably is colored not only by the poetry of antiquity, but also by the poetry written in the wake of the sixteenth- and seventeenth-century literary war that sought to establish the rules governing pastoral poetry, a dispute that had been provoked by the publication of Torquato Tasso's *Aminta* (1580) and Giovanni Battista Guarini's *Pastor fido* (1590).[2] Consequently, for the first time pastoral as a poetic genre was fully disputed and given definition, with the purpose of filling the lacuna created by Aristotle's failure to consider the form (which he would

have had to be prescient to do). In earlier Renaissance criticism, pastoral, for metrical reasons and on the basis of excellent ancient authority, was subsumed under the category of epic, which incorporated all three *genera dicendi*, or classes of speech—high, middle, and low styles, with bucolic defined as the low form. This categorization was based partly on the writings of the fourth-century Latin grammarian Servius, whose important commentary on Virgil's poetry regularly was read together with the poet's texts. Servius characterized Virgil's verse as progressing from the *humilis character* (humble character) of the *Eclogues*, peopled with rustic shepherds; to the *medius* (middle-class language) of the *Georgics*, addressed to farmers; to the *grandiloquens* (lofty speech) appropriate to the princes and captains portrayed in the *Aeneid*.⁵ Even today pastoral often is characterized as a subgenre, appearing in such various forms as lyric, dramatic, allegorical, and romance poetry and prose. It is less a genre than it is a poetic theme organized around a group of conventions; set in a *locus amoenus*, a pleasant rural retreat far from strife or the fraudulent cares of sophisticated life in the city, it treats in song of the loves, laments, and rivalries of shepherds. Far from being poetically crude or naive, however, pastoral is influenced heavily by Greek Alexandrian verse as absorbed by such Latin neoteric poets (the "new" or "modern" poets, as they were called) as Catullus and the young Virgil himself.

The patron saint of Latin pastoral is indeed Virgil, in whose hands bucolic is poetry less of description than it is of sentiment, nostalgically evoking the innocence and emotional intensity of remembered youth spent in simplified and perfected rural surroundings. It is a poetry of shepherds, often combining a young, aspiring singer in company with an older, more experienced one, or sometimes with a fugitive from the city (not least Virgil himself under the pseudonym Tityrus). They sit in the cooling shade of beeches, and rival each other in singing of the irrecoverable intensity and transience of youthful love and desire. Characteristically, the season is summer, and the time late afternoon when the sun begins to decline, the shadows lengthen, and the hour approaches for driving the flocks back to their stalls: "Ite domum saturae, venit Hesperus, ite capellae" (*Ecl.* 10.77; Go on home, my full-fed goats—the Evening Star is coming—go on home).

Pastoral themes have a continuing presence in late medieval and early Renaissance literature, from lesser works by Dante Alighieri and Giovanni Boccaccio in the fourteenth century to three particularly influential examples, each written toward the end of the fifteenth century: the great Florentine classical scholar and poet Angelo Poliziano's court mime *Orfeo*; Baptista Mantuanus's *Adolescentia*, in which Christian allegory is intermixed with Virgilian bucolic; and Jacopo Sannazaro's *Arcadia*, written in the Italian vernacular and combining poetry and prose. In painting, Simone Martini produced an especially enchanting treatment of the pastoral theme in his frontispiece to a manuscript of Virgil (c. 1340; fig. 137), which was owned by none other than Petrarch (who himself had experimented with this theme). Virgil, an open book on his lap and pen poised in his hand, sits on the grass beneath the spreading branches of a tree at the upper right. In the lower-right corner a shepherd milks his sheep; behind him a farmer with a pruning hook tends his vines. Above the farmer a soldier, armed with a long spear, stands next to a well-dressed young man who is pulling back a muslin curtain, behind which the figure of Virgil had been veiled. The setting of the scene, as Annabel Patterson wrote, "is predominantly pastoral,

137

SIMONE MARTINI

Italian, 1283–1344/49

Frontispiece to a
manuscript of Virgil

c. 1340

16⅛ × 10⁷⁄₁₆ inches (41 × 26.5 cm)

Biblioteca Ambrosiana, Milan

Virgil's own pose reflecting the rural leisure that makes writing possible, the pose and role that he, in the first eclogue, had permanently assigned to Tityrus."[4] It is, however, pastoral in an allegorical mode, setting forth Virgil's progression as a poet from bucolic to didactic to epic verse, ascending upward through the *genera dicendi* as described in Servius's commentary. The shepherd represents the *Eclogues*, the farmer the *Georgics*, and the soldier the *Aeneid*. The courtly youth drawing back the curtain is Servius, Virgil's principal explicator. All this is stated explicitly in the verses written on the two scrolls below the figure of the poet, which Petrarch composed and, as Pierre de Nolhac first recognized, inscribed in his own hand:

> *Ytala praeclaros tellus alis alma poetas,*
> *Sed tibi Graecorum dedit hic attingere metas.*
> *Servius altiloqui retegens archana Maronis*
> *Ut pateant ducibus pastoribus atque colonis.*

> (Italian soil has nourished other distinguished poets, but this
> one gave you access to the standard of the Greeks. Servius
> uncovers the hidden secrets of Virgil so that they may be
> revealed to military leaders, to shepherds, and to farmers.)[5]

138

LUCA SIGNORELLI
Italian, c. 1450–1523

Pan

1488–91
Oil on canvas, 6 feet 4⅜ inches ×
8 feet 5 inches (1.94 × 2.55 m)
Formerly Kaiser-Friedrich-Museum,
Berlin

The first systematic attempt at painting in a pastoral mode, however, setting the scene in Arcadia (Virgil's bucolic *locus amoenus*), was made by the painter Luca Signorelli in his *Pan* (1488–91; fig. 138). This work, formerly in the Kaiser-Friedrich-Museum in Berlin, was one of the great cultural losses of World War II, having been destroyed completely in the disastrous fire at the Flakturm Friedrichshain in 1945. As a mythological subject (or, in contemporary terms, a poetic fable), *Pan* is virtually without parallel in Signorelli's work. As Herbert Horne observed, on account of the painting's "learned and highly imaginative conception" of its subject, as well as its enormous size (about 6½ × 8½ feet), *Pan*—together with Sandro Botticelli's *Primavera* (c. 1477; see fig. 151) and *Birth of Venus* (c. 1484)—stood virtually alone among the relatively few paintings of mythological subjects in fifteenth-century Florence. This circumstance strongly suggests that the painting responds to the poetic and artistic tastes of the de facto head of the Florentine state Lorenzo de' Medici (himself an accomplished poet and for whom, according to Vasari, Signorelli painted *Pan*), no less than it does to the intervention of Poliziano, who was a member of Lorenzo's household and tutor to his children.[6]

Although Signorelli's painting is lost, a single original color negative survives, which confirms the acute observations of Roger Fry in 1901, who noted the artist's rendering of the long shadows cast by the figures and the atmospheric effect of approaching evening: "when the sun has already set in clear aether, when the moon begins to tell on the intense violet of an Italian sky, while the clouds, lit by the sun's afterglow, still compete with its growing light."[7] In 1909 Hans Posse also noted these coloristic and atmospheric effects, describing the deep blue sky and rose-colored horizon lit by "the setting sun that casts ever-lengthening shadows" (die tiefstehende Abendsonne, die länge Schatten).[8] Signorelli's *Pan* is unique for its period in attempting to invoke the appearance and mood of such twilight effects, something undoubtedly motivated by the artist's desire to summon forth the characteristic atmosphere of the Virgilian pastoral. Pan, seated in the center of the painting, is greeted by an elderly shepherd, while a second shepherd, leaning on his staff, looks on at the right. The other figures, with their classic adolescent beauty and white skin unreddened by the sun, are identified by their nudity or virtual nudity (as in the vine garland covering the modesty of the reclining youth in the foreground) as divinities of the place—that is, as the nymphs and fauns who are the companions of "Pan deus Arcadiae" (*Ecl.* 10.26). The peculiar and unfamiliar imagining of Pan—youthful and rubicund, with horns in the form of the crescent moon, wearing a star-spangled kerchief and holding a staff that curves entirely back upon itself (hence not a conventional or even usable shepherd's crook)—is directly dependent upon Servius's commentary on Virgil's *Eclogue* 2.31 ("imitabere Pana canendo"):

> For Pan is a rustic god, formed in the similitude of nature. Whence also he is called Pan, i.e., *omne*, All-things. And he has horns in the likeness of the sun's rays and the moon's horns. His face is ruddy in likeness to the aether. On his breast is a starred fawn-skin, an image of the skies. His lower part is hispid on account of the trees, the undergrowth, and wild beasts. He has goat's feet to show the solidity of the earth. He has a pipe of seven reeds in accordance with the harmony of the heavens in which there are seven zones. He has a shepherd's staff or crook: this is a stick curved back upon itself in accordance with the solar year, which returns upon itself. And since he is the god of all nature, poets have feigned that he fought with Love and by him was overcome, since we read that *Omnia vincit amor* [*Ecl.* 10.69]. So Pan, according to the fables, loved the nymph Syrinx, who, when he followed her, called upon the Earth for help, and was turned into a reed, which Pan, in order to solace his love, cut and made into a pipe.[9]

Signorelli's utilization of Servius's allegorization of Pan as the god of nature, especially evident in his depiction of Pan's horns as the horns of the moon and the god's star-spangled kerchief, did not require special assistance, for, as we have seen, Virgil's poetry and Servius's commentary were read together regularly. Yet, Signorelli's puzzling inclusion in his Arcadia of clouds forming fantastic images of mounted soldiers, as well as the military triumphal arch appearing between Pan and the shepherd who welcomes him, certainly depends upon the philological expertise of Poliziano. For Poliziano in his *Miscellanea* (1489), a gathering of one hundred short essays devoted to solving various classical linguistic problems, had demonstrated that panic terrors were so named after Pan, who had

put the Titans to flight in battle by arousing in them irrational fears that were caused by nothing more than insubstantial phantasms, such as random formations of shapes in clouds. For this reason, he wrote, Pan is both a sylvan god and a god of war ("Pan nemorum, bellique potens").[10] We might speculate that Poliziano also helped Signorelli to imagine what is the most original part of his Arcadian vision, namely, the afterglow of the setting sun that lent his painting its haunting poetry.

Be that as it may, Servius's commentary had already long been absorbed into Italian poetry and literature, in works by Petrarch, Boccaccio, and Sannazaro, among others.[11] Indeed, Lorenzo de' Medici himself followed Servius in describing Pan as a god of sublunar nature in his *Altercazione* (also called *De summo bono*) of 1473, a philosophical poem on the conditions of happiness, in which he expressed a desire to flee the corruptions of the city for the simpler life of the country:

> *Sanza esser suto da altro nume scorto,*
> *modulato ho con la zampogna tenera*
> *el verso, col favor che Pan ne ha porto:*
> *Pan, quale ogni pastore onora e venera,*
> *il cui nome in Arcadia si celèbra,*
> *che impera a quel che si corrompe e genera.*

> (Without having been guided by another god, I have set my verse to the delicate sound of the pipe, under the protection that Pan has brought to it: Pan, whom every shepherd honors and venerates, whose name is celebrated in Arcadia, who rules all corruptible and generative things.)[12]

Despite its haunting beauty, Signorelli's *Pan* still carries an aftertaste of philological learning that accounts not only for the peculiarities in its imagery but also for its pleasingly archaic expressiveness, which is, after all, not inappropriate to the theme of Arcadia and the nostalgic evocation of the inexpressibly ancient bucolic life, when country folk lived in the closest familiarity with Pan and his followers, those woodland spirits, fauns, dryads (tree nymphs), and naiads (water nymphs) who animate every tree and stream.

It is in early sixteenth-century Venice, however, that pastoral landscape truly came into its own, a circumstance that was the basis for an exhibition at the National Gallery of Art and the Phillips Collection, in Washington, DC, in 1988–89.[13] There is no need to overburden this essay with examples, for which one alone will suffice. This is the famous *Concert champêtre*, attributed to Titian and datable to about 1509 (fig. 139), a profoundly Virgilian vision that is not so much an illustration of a particular poem as it is an expression of the universal pastoral situation in which Virgil's *Eclogues* are set. The scene, as usual, is late afternoon; the setting sun casts a rosy light on the clouds on the left, and evening begins to darken the sky at the right, while a goatherd drives his flock homeward. Two poets sit in the shade of a tree—one a rustic shepherd clad in rough fustian, the other a young nobleman who is dressed richly in magnificent red silk. Having abandoned the cares of the city, he strums his lute and sings of love to his rapt companion (for the lute is the instrument par excellence of love songs). Two nymphs are in attendance, one seated with her back

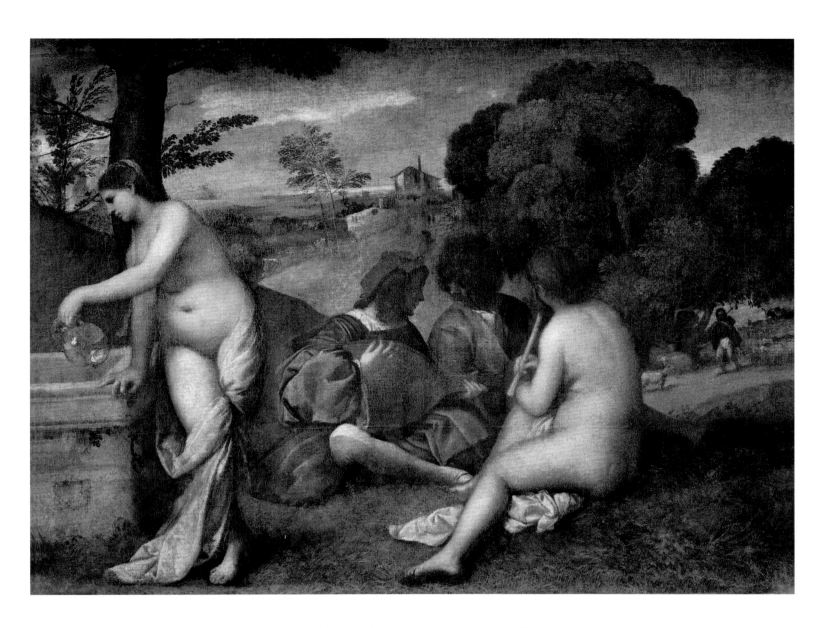

139

Attributed to **TITIAN**

Italian, active Venice, c. 1485/90?–1576

Concert champêtre

c. 1509

Oil on canvas, 42¹⁵⁄₁₆ × 53¹⁵⁄₁₆ inches
(109 × 137 cm)

Musée du Louvre, Paris

to the viewer, delicately holding a primitive oaten flute in her fingers, and the other filling a glass pitcher with water from a well. Their nudity identifies them as divinities, as it does for their counterparts in Signorelli's *Pan*; the one at the well no doubt a naiad, the other perhaps a dryad. A prudish commonplace in the scholarly literature claims that these voluptuously nude nymphs, as divinities, are invisible to the clothed male poets.[14] Yet, such an interpretation runs counter to the spirit of Virgil's poetry, which nostalgically evokes a timeless place of natural innocence, where shepherds and Pan, together with the minor divinities of the country—the spirits of the trees and streams—live in the closest familiarity with one another (as they do in Signorelli's *Pan*; "Pan . . . venit, quem vidimus ipsi" [*Ecl.* 10.26]), and in which the actual presence of the rustic gods is made palpable: "Fortunatus et ille, deos qui novit agrestis, / Panaque Silvanumque senem Nymphasque sorores!" (*G.* 2.493–94; Blessed is he who knows the woodland gods, / Pan and old Silvanus and the sister Nymphs!)

However, the theme of pastoral painting did not become permanently fixed in the European imagination until the seventeenth century. The reasons for this are complex, but certainly central to the emergence of its popularity was, as discussed above, the late sixteenth-century

140

ANNIBALE CARRACCI

Italian, 1560–1609

Landscape with Flight into Egypt

1604

Oil on canvas, 4 feet × 7 feet
6 9/16 inches (1.22 × 2.3 m)

Galleria Doria Pamphilj, Rome

literary battle over the rules of pastoral poetry, waged after the publication of Guarini's *Pastor fido* and Tasso's *Aminta*. Above all, the enthusiasm for the lyrical moments of pastoral interlude in Tasso's *Gerusalemme liberata* (1581), his great narrative of the battle for Jerusalem, attracted the attention of painters. As Rensselaer W. Lee amply demonstrated, the Bolognese painters Ludovico, Annibale, and Agostino Carracci and their followers especially popularized the painting of lyrical themes from *La Gerusalemme*, which became as subjects for painters almost as sought after as ancient mythological fables.[15] The episodes from Tasso's epic that they chose for treatment were not those of heroic conflict (so popular in the preceding century), but rather the moments of respite from them. The Carracci turned to Tasso's lyrical interludes, such as the tale of Erminia and the shepherds, in which the lovesick heroine seeks a brief refuge from high moral purpose and the strife of conflict, finding solace in the humble home of a shepherd and his sons, and passing the time inscribing the name of her lover, Tancredi, on the trunks of trees. It was Annibale Carracci who introduced an especially influential variation of the pastoral in his lunette of the flight into Egypt for the Palazzo Aldobrandini (now the Galleria Doria Pamphilj) in Rome (1604; fig. 140), imagining the religious subject in an unmistakably bucolic setting, evocative not so much of Arcadia literally as of a late summer afternoon in the Roman Campagna, with a telltale shepherd driving his flock to the river. Annibale's invention had an enduring effect on his followers, especially Domenichino, who collaborated with Annibale on the lunettes for the Aldobrandini, and slightly later Claude Lorrain. It was indeed Claude more than anyone else who succeeded in identifying the Roman Campagna with the Virgilian *locus amoenus*, even as Virgil had substituted the Greek Arcadia for Theocritus's Sicily.

141

NICOLAS POUSSIN

French, 1594–1665

*The Arcadian Shepherds
(Et in Arcadia ego)*

c. 1638

Oil on canvas, 33⁷⁄₁₆ × 47⅝ inches
(85 × 121 cm)

Musée du Louvre, Paris

The greatest interpreter of the pastoral sentiment in painting, however, was the French-man Nicolas Poussin. Perhaps his most famous painting, *The Arcadian Shepherds (Et in Arcadia ego)* in the Louvre (c. 1638; fig. 141) has a fair claim to be the canonical treatment of the pastoral theme. It depicts a group of shepherds who have stumbled across a tomb and are engrossed in puzzling out the meaning of the enigmatic inscription incised upon it—"Et in Arcadia ego" (I too am in Arcadia)—a grim reminder that even in Arcadia there is death. Interpreters have remained as perplexed as the shepherds by this inscription. (Is it Death who speaks, or the occupant of the tomb?) Erwin Panofsky's classic essay on the painting offers by far the most sensitive reading of its imagery.[16] In it he emphasized the painting's elegiac aura, so characteristic of Poussin, which evokes a sentiment of bittersweet nostalgia for the intensity of youthful bliss and the certainty of its passing (a feeling that is profoundly Virgilian), whether in bucolic themes or in Ovidian sub-jects that deal with the fervor and transience of young love and the transformative power of love to transcend even death itself, such as the death and metamorphosis of Narcissus.

Before moving to Rome in 1624, Poussin had been befriended in Paris by the Italian poet Giambattista Marino, with whom he used to read poetry and whom the young painter impressed with his acumen. Marino helped bring Poussin to Rome, supplying him with an introduction to the court of Cardinal Francesco Barberini, who, however, was on the verge of departing for a two-year diplomatic mission to Paris and Madrid. Poussin, like so many painters then flocking to Rome in search of fortune, therefore was forced for a time to fend for himself. As Federico Zeri has shown, artists in Poussin's position, isolated from traditional sources of revenue and protection, turned to the nascent and rapidly growing market in order to sell their works, a

142

TITIAN

Italian, active Venice, c. 1485/90?–1576

The Andrians

1523–26

Oil on canvas, 5 feet 8⅞ inches ×
6 feet 4 inches (1.75 × 1.93 m)
Museo Nacional del Prado, Madrid

circumstance that encouraged the popularization of many new genres of painting—still lifes, various kinds of landscapes, architectural fantasies, marine paintings, battle scenes, and the like—as painters sought to establish specialties by which their work might become known and attract buyers.[17] There is no doubt that Poussin at first thought to specialize in heroic battle pieces, constructing a *maniera magnifica* (magnificent manner) on the scale of easel paintings that might rival the heroic, and huge, Roman frescoes by artists such as Giulio Romano, Perino del Vaga, and Cavaliere d'Arpino. However, Poussin soon turned to the invention of another genre, pastoral landscapes that intermixed Virgilian and Ovidian reminiscences, which I have called mythological idylls.[18] This new genre met with instant success, inspiring a legion of skilled imitators and copyists (and with them serious attributional problems that plague scholars to this day), and quickly became a part of the repertoire of European painting in the seventeenth and eighteenth centuries.

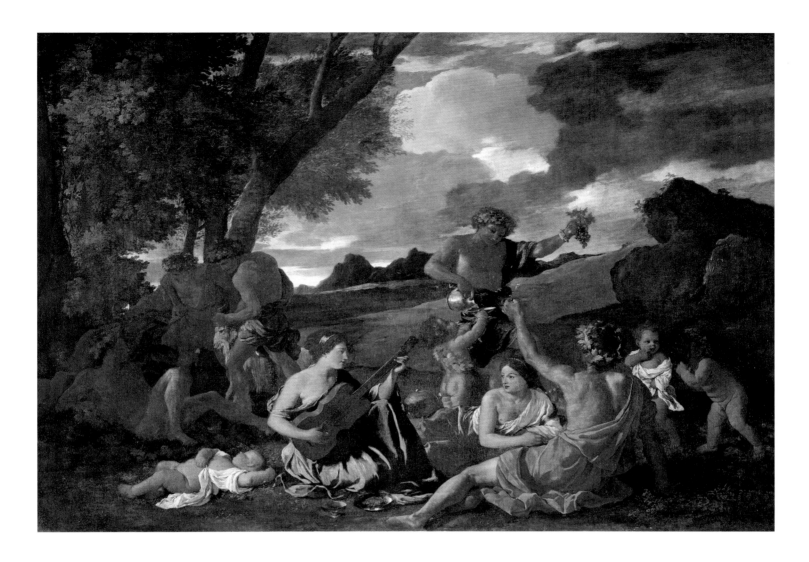

143

NICOLAS POUSSIN

French, 1594–1665

Bacchanal with a Woman Playing the Guitar

c. 1627

Oil on canvas, 47⅝ × 68⅞ inches
(121 × 175 cm)

Musée du Louvre, Paris

In the art-historical literature, these paintings (dating between c. 1625 and 1630) have been taken as evidence of Poussin's so-called neo-Venetian phase, inspired by his close study of Titian's famous bacchanals then in Rome's Villa Ludovisi — *The Garden of Venus* (1518–19) and *The Andrians* (1523–26; fig. 142), now in the Museo Nacional del Prado in Madrid; and *Bacchus and Ariadne* (1520–23), now in the National Gallery of Art in London. Poussin, along with the Flemish sculptor François Duquesnoy, with whom Poussin shared rooms in 1626, studied these paintings as well as the Ludovisi's ancient sculptures. Characteristic examples of Poussin's early neo-Venetianism include his *Nurture of Bacchus* (c. 1627; Musée du Louvre, Paris), in which the voluptuous sleeping nymph in the foreground directly derives from the artist's study of Titian's *Andrians*; the even more explicitly erotic *Sleeping Nymph with Satyrs* (c. 1626; Kunsthaus, Zurich); and *Landscape with a Satyr* (c. 1626; Musée Fabre, Montpellier, France). Also typical of this phase is his *Omnia vincit amor* (*Love Conquers All*) in the Cleveland Museum of Art (c. 1625–27), the very title of which is a quotation from Virgil's *Eclogue* 10.69, and in which the image of Amor grasping Pan's goatee and pulling him to his knees is further determined by Servius's comment on this passage (as quoted above), reporting that poets have feigned that Love (*amor*) conquers (*vincit*) Pan (= *omnia*). Poussin's debt to Titian's bacchanals is especially apparent in his brushwork and chiaroscuro rendering of sun-dappled fields and the bosky glades so essential to the great Venetian painter's evocation of the pastoral pleasance, or *locus amoenus*.

An especially telling example of Poussin's neo-Venetianism is his *Bacchanal with a Woman Playing the Guitar* (c. 1627; fig. 143), which without doubt is inspired directly by Titian's *Andrians*. There is also no doubt that at the same time his pastoral vision — "a nostalgic reverie" of youth and love, in Pierre Rosenberg's words — is founded in Virgil rather than in Titian's own point of departure, namely, the third-century Greek Philostratus's description in the *Eikones* of an ancient painting of the inhabitants of the isle of Andros.[19] This is evident in the *scherzo*, or playful whimsy, introduced at the right, the figure of a putto with a Silenus mask frightening his youthful companion, a motif derived from ancient sarcophagus reliefs showing the vintage with putti, one of them hiding behind a Silenus mask. This motif is explained by Virgil's account of why it is that a goat, whose sharp tooth destroys the vine, is sacrificed to Bacchus, and how the ancient Italian country folk danced and sang ribald verses to Bacchus, putting on masks of hollowed cork and hanging *oscilla* (waving masks) from the trees as a kind of scarecrow to keep away the goat (*G.* 2.381–96; "the doomed he-goat, led by the horn, shall stand by the altar," Virgil's passage concludes, "and we will roast the rich flesh on spits of hazel"). This description motivated the scene on the left of Poussin's painting, where a goatherd leads a goat by the horn, not to an altar, but to Bacchus himself, drunken and reclining in the shade of a tall tree.

The *scherzo* of the masked putto is one to which Poussin returned on several occasions, most notably in two small paintings of reveling infants (c. 1626; Palazzo Barberini, Rome); and it is one that was made famous by his friend Duquesnoy in a marble relief sculpture (c. 1626; Galleria Doria Pamphilj, Rome), which often was copied in various media over the next two centuries, as well as in a second relief by Duquesnoy, identified by his (and Poussin's) biographer Giovanni Pietro Bellori as "another invention, taken from the poetry of Virgil" — namely, the story of Silenus bound with a vine and forced to sing by the nymphs (*Ecl.* 6).[20]

In another crucial feature Poussin departed from his Venetian model in *Bacchanal with a Woman Playing the Guitar* and other paintings of his early neo-Venetian period. Titian's figures in *The Andrians* appear in contemporary dress and with such up-to-date accoutrements as the breathtaking Venetian glass pitcher that is the compositional fulcrum of the painting, changed by Poussin into a bunch of grapes held up by a satyr. A similar contemporary reference in Titian's painting appears in the two young women, both in sixteenth-century dress, who recline next to a sheet of paper bearing the music and words for a French *chanson d'amour* (love song) attributed to the Flemish composer Adriaen Willaert, then in service at the court of Ferrara. The figures in Poussin's *Bacchanal with a Woman Playing the Guitar*, on the other hand, in common with his other paintings of this period, are shown in generically antique costumes. Even the simple guitar played by the woman, although certainly modern in form, has ancient precedent and justification as an instrument in the cithara, from which the word "guitar" (*chittara* in Italian) is derived. Although these costumes are not yet the carefully researched antiquarian reconstructions of ancient dress characteristic of the artist's mature works, they nonetheless set the scene and its inhabitants outside the world of Poussin and his contemporaries, placing them (as does Virgil) in a location beyond time, a nostalgic world of literary imaginative conjuring, a half-remembered reverie of times and places that never truly existed, but for all that are longed for even more intensely. "Blessed is he who knows the woodland gods," as Virgil wrote of his own shepherd-poets

144
NICOLAS POUSSIN
French, 1594–1665
The Triumph of David
c. 1629
Oil on canvas, 39⅜ × 51³⁄₁₆ inches
(100 × 130 cm)
Museo Nacional del Prado, Madrid

(*G.* 2.493), and it is precisely the creation of a semidivine Virgilian *locus amoenus* and the idyllic sentiment it invokes that is the index of Poussin's originality in establishing the new genre of the mythological idyll. Yet, precisely because of this new genre's instant success and its many imitators, sight has been lost of Poussin's invention and attention focused more narrowly on his debt to Venetian painterly effects.

Poussin's early idylls were produced over a span of roughly a half-dozen years and at the very beginning of his long residency in Rome, from 1624 until his death in 1665, save for a two-year return to Paris in 1640–42. But the elegiac sentiment informing them was one he continued to evoke throughout his lengthy career, whether in paintings of Ovidian bittersweet lamentation for lost loves and their transformative immortalization in the inexorable natural cycle of birth, death, and regeneration, such as we see in his *Realm of Flora* (1631; fig. 153); or in his tender, and infinitely sad, *Narcissus Mourned by Echo* (c. 1631; Musée du Louvre, Paris), set in a glade of Arcadian loveliness illuminated by the warm, roseate glow of the declining sun. Poussin's *Triumph of David* in the Prado (c. 1629; fig. 144), at one and the same time the culmination and transformation of his early idylls, depicts the youthful Israelite simultaneously as poet, warrior, and king. He is seated

and gazing in melancholic reflection at the head of Goliath and the trophies won from him. A winged female, at once Victory and Muse, prepares to crown him with an oak-leaf garland (the Roman award for valor in battle) while simultaneously reaching out for the king's crown soon to follow, held up for her by an attendant putto. Two companion putti support a stringed instrument, the psalter with which David accompanied the singing of his psalms, one of whom idly plucks a string. The lone note seems to reverberate throughout the painting, reinforcing the golden tone of the setting sun that establishes a melancholic nostalgia that metonymically identifies Israel with Arcadia.

Metonymy is the poetic figure for substitution, whereby one term — in this case Israel — is signified by another — Arcadia — and thereby takes on its sense and coloration. And it is by metonymy that it may be said that Poussin throughout his career depicted the ancient world in the image of Virgil's Arcadia, a nostalgic vision of irrecoverable beauty and natural harmony that prompted Bernard Berenson, in the quotation with which I have prefaced this essay, to speak of Poussin's romanticism.[21] This applies to his treatment of both classical and biblical subjects, such as his paintings of the Old Testament story of the infant Moses rescued from the Nile, in the Louvre (1647) and the National Gallery in London (1650), which are set in carefully reconstructed classical Egyptian landscapes.[22] On occasion he explicitly returned to the theme of Arcadia, as in *The Arcadian Shepherds*, in which the baffled shepherds first encounter the presence of death in Arcadia and with it the realization that not only they but possibly even Arcadia itself will have an end. At other times Poussin's Arcadian theme, though palpable, is not located geographically, as in his *Landscape with a Man Killed by a Snake* (c. 1648; see fig. 41), where we see an ancient city by a small lake, enjoyed by figures fishing, strolling in the clear air, or reclining by the side of the water, a scene of idyllic peace and serenity about to be disrupted by the grim discovery of a dead youth enwrapped by a snake at the edge of the water. Even in such serene natural and civic perfection there is death, in this instance violent death: I too was in Arcadia.

Poussin's magnificent late landscape paintings return again to the theme, one that recurred in different forms throughout his career. The series of the *Seasons* (1660–64; Musée du Louvre, Paris), for example, rehearses the story of mankind from Adam and Eve in the Garden of Eden to the earth's near total destruction in the Flood, the whole allegorized in the annual cycle of the seasons (another frequent theme in Poussin's work), with its promise of springtime regeneration and the revival of Arcadian innocence. Poussin's *Landscape with Polyphemus* in the State Hermitage Museum in Saint Petersburg (c. 1658; fig. 145) is an idyll set in Theocritus's Sicily, where the country folk plow and sow seeds in fertile fields, their labors watched over by a river god and three nymphs, one of whom is startled by a satyr leering from behind a bush.

And in Poussin's last painting, *Apollo and Daphne (Apollon amoureux de Daphné)* in the Louvre (1664; see fig. 136), the greatness of which is unobscured by the fact that the artist was constrained by illness to leave it unfinished, even so presenting it as a gift to his close friend and sometime patron Cardinal Camillo Massimi (owner of an earlier version of *The Arcadian Shepherds*, of c. 1626, now in Chatsworth House, Derbyshire, England), the artist returned for one last time to the great theme of Arcadia.[23] The subject of this complex painting has long been found perplexing, not because the principal actors — at the left Apollo with his lyre and Cupid aiming his lead-tipped

145

NICOLAS POUSSIN

French, 1594–1665

Landscape with Polyphemus

c. 1658

Oil on canvas, 5 feet 1 inch × 6 feet 6⅜ inches (1.55 × 2 m)

The State Hermitage Museum, Saint Petersburg

arrow at Daphne, who clings to her river-god father for protection, at the right—are difficult to identify, but because of the addition of so many seemingly unrelated subsidiary episodes: Mercury stealing an arrow from Apollo's quiver, for example, and especially the dead youth lying next to a pile of earth by the bank of the river, whose corpse is contemplated by a shepherd and a young woman. Mercury was born on Mount Cyllene in Arcadia, however; and in remotest antiquity, contrary to Ovid's claim that the story of Apollo and Daphne occurred in Thessaly, Apollo too was an Arcadian god tending his cattle (Apollo Nomios, the *deus pastoralis*, or shepherds' god of Arcadia) and Daphne the daughter of Ladon ("Daphne, Ladonis fluminis Arcadiae filia," in Servius's words), the most beautiful river in Arcadia.[24] Her chastity was pledged to the huntress Diana, to which the quiver with which Poussin (unusually) endowed her attests. She was loved by the Arcadian prince Leucippus, who disguised himself as a woman in order to be near her. But the jealous Apollo increased the heat of the sun so that Daphne's companion nymphs sought to cool themselves in the stream. Stripping the reluctant Leucippus of his clothing and seeing that he was no woman, they killed him with their javelins, leaving him dead by the side of the river.

In Servius's telling there were those who claimed that Apollo Nomios, not Pan, was the inventor of the bucolic and that it was he who first sang pastoral poetry to his herds in Arcadia. But in Poussin's painting Apollo has not yet sung. Poussin's theme is not yet the poet but the poet's subject, the tragic love and loss that is forever identified with the place, Arcadia. We see Leucippus, the first to die for love in Arcadia, and Daphne, not yet pursued by Apollo or transformed into the poet's laurel. We are left to contemplate the origins of the pastoral genre, the sentiment that preceded the poem and willed its existence.

It is tempting to try to find in Poussin's *Apollo and Daphne*, in compositional terms at least— a grouping of bathing nymphs framed on both sides by trees—a precedent for Paul Cézanne's magnificent *Large Bathers* in the Philadelphia Museum of Art (1900–1906; see page xii and fig. 155), even though the complexities of Cézanne's enterprise, both as a painter in general and as an interpreter of a species of turn-of-the-century urban pastoral in particular, respond to exigencies far more various and demanding. Cézanne, however, certainly was at ease reading the classics, although the status of pastoral had undergone significant revisions by the nineteenth century, and of his own reverence for Poussin there is no doubt. Evidence of his admiration, which includes his copying of Poussin's *Arcadian Shepherds*, is indeed abundant in his own work and statements.[25] On a broader scale, Poussin's thoughts and achievements had lain at the heart of French thinking about the arts ever since his being enshrined in the Académie Royale de Peinture et Sculpture in Paris, under the directorship of the painter Charles Le Brun, and the power of his precedent had not diminished. Michael Fried never wrote truer words than when he observed that for the great tradition of French art Poussin stood as a "surrogate ancient."[26] Poussin was acknowledged universally to be the *fons et origo*, the fountainhead for all that was to come in painting, whether as a force to be resisted or absorbed, and the power of his example has never dimmed. Cézanne stands as one of his very greatest disciples.

1. All texts and translations of Virgil, with some modifications of my own, are from *Eclogues, Georgics, Aeneid I–VI*, vol. 1 of *Works*, trans. H. Rushton Fairclough, Loeb Classical Library (London: W. Heinemann, 1916).

2. See Bernard Weinberg, "The Quarrel over Guarini's *Pastor Fido*," in *A History of Literary Criticism in the Italian Renaissance* ([Chicago]: University of Chicago Press, [1963]), vol. 2, pp. 1074–1105.

3. "Tres enim sunt [characters] humilis, medius, grandiloquens . . . Nam in Aeneide grandiloquum habet: in Georgicis medium: in Bucolicis humilem." Servius, "In Virgilii Bucolica Commentarius," in *Commentarii in Virgilium Serviani; Sive Commentarii in Virgilium, qui Mauro Servio Honorato tribuuntur*, ed. H. Albertus Lion (Göttingen, 1826), vol. 2, p. 95.

4. Patterson, "Medievalism: Petrarch and the Servian Hermeneutic," in *Pastoral and Ideology: Virgil to Valéry* (Berkeley: University of California Press, 1987), p. 20. See also C. Jean Campbell, "'Symone nostro senensi iocundissima': The Court Artist; Heart, Mind, and Hand," in *Artists at Court: Image-Making and Identity, 1300–1550*, ed. Stephen J. Campbell (Boston: Isabella Stewart Gardner Museum, 2004), pp. 33–45.

5. Nolhac, *Pétrarque et l'humanisme* (Paris, 1907), vol. 1, p. 141. The translation of the inscription is mine.

6. Horne, *Botticelli, Painter of Florence* (London: G. Bell and Sons, 1908; repr., Princeton, NJ: Princeton University Press, [1980]), p. 59. For an illustration of Botticelli's *Birth of Venus* (Galleria degli Uffizi, Florence), see ibid., p. after 148.

7. Fry, "The Symbolism of Signorelli's 'School of Pan,'" *Monthly Review*, December 1901, p. 111. See also, most recently, Philippe Morel, "Le règne de Pan," in *Images of the Pagan Gods: Papers of a Conference in Memory of Jean Seznec*, ed. Rembrandt Duits and François Quiviger, Warburg Institute Colloquia 14 (London: Warburg Institute, 2009), pp. 309–28.

8. Posse, ed., *Die Gemäldegalerie des Kaiser-Friedrich-Museums: Vollständiger beschreibender Katalog mit Abbildungen sämtlicher Gemälde* (Berlin: J. Bard, 1909), vol. 1, s.v. "Signorelli" (my translation).

9. Servius, "Commentarius," p. 107, trans. and quoted in Fry, "Symbolism," p. 113 (translation modified).

10. Poliziano, "Panici terrores qui vocentur, eoque locupletissimi citati testes," chap. 28 in *Miscellaneorum centuria una*, in *Opera: Quorum primus hic tomus complectitur* (Lyons, 1536), p. 565. See also Charles Dempsey, "Spirits of the Nightmare," in *Inventing the Renaissance Putto* (Chapel Hill: University of North Carolina Press, 2001), pp. 124–26.

11. See Reinhard Herbig, "Alcuni dei ignudi," *Rinascimento*, vol. 3 (1952), pp. 3–23.

12. Lorenzo de' Medici, *De summo bono* 4.1–6, in *Tutte le opere*, ed. Paolo Orvieto (Rome: Salerno Editrice, [1992]), vol. 2, p. 951 (my translation).

13. *The Pastoral Landscape: The Legacy of Venice and the Modern Vision*, jointly held at the Phillips Collection and the National Gallery of Art, Washington, DC, November 6, 1988–January 22, 1989. For the exhibition catalogue, see Robert C. Cafritz, Lawrence Gowing, and David Rosand, *Places of Delight: The Pastoral Landscape*, exh. cat. (Washington, DC: Phillips Collection in association with the National Gallery of Art, 1988). See also David Rosand, "Pastoral Topoi: On the Construction of Meaning in Landscape," in *The Pastoral Landscape*, ed. John Dixon Hunt, Studies in the History of Art, vol. 36 (Washington, DC: National Gallery of Art, 1992), pp. 161–77.

14. This suggestion, which has endured with remarkable tenacity, originally was proposed by Philipp Fehl in "The Hidden Genre: A Study of the *Concert Champêtre* in the Louvre," *Journal of Aesthetics and Art Criticism*, vol. 16, no. 2 (December 1957), pp. 153–68.

15. This was a notion to which Lee returned many times in various articles and lectures, and which he first stated in his classic study, *Ut pictura poesis: The Humanistic Theory of Painting* (New York: W. W. Norton, [1967]). See esp. chap. 7, "Rinaldo and Armida."

16. Panofsky, "*Et in Arcadia ego*: Poussin and the Elegiac Tradition," in *Meaning in the Visual Arts: Papers in and on Art History* (Garden City, NY: Doubleday, 1955), pp. 295–320.

17. Zeri, "La nascita della 'Battaglia come genere' e il ruolo del Cavalier d'Arpino," in *La battaglia nella pittura del XVII e XVIII secolo*, ed. Patrizia Consigli Valenti ([Parma]: Banca Emiliana, 1986), pp. ix–xxvii.

18. Dempsey, "Nicolas Poussin et l'invention de l'idylle mythologique," in *Daniel Arasse: Historien de l'art*, ed. Danièle Cohn (Paris: Cendres, 2010), pp. 121–32.

19. Rosenberg, *Nicolas Poussin, 1594–1665*, exh. cat. (Paris: Réunion des Musées Nationaux, 1994), p. 153. See also Claire Pace's excellent essay, "'Peace and Tranquility of Mind': The Theme of Retreat and Poussin's Landscapes," in *Poussin and Nature: Arcadian Visions*, ed. Pierre Rosenberg and Keith Christiansen, exh. cat. (New York: Metropolitan Museum of Art, 2008), pp. 73–89.

20. Bellori, "Life of François du Quesnoy: Fleming of Brussels; Sculptor," in *The Lives of the Modern Painters*, trans. Alice Sedgwick Wohl, with notes by Hellmut Wohl, critical ed. (New York: Cambridge University Press, 2005), p. 228. For illustrations of Poussin's drawings and Duquesnoy's marble relief sculpture, see Charles Dempsey, "Idle Fancies and Childish Follies," in *Inventing the Renaissance Putto*, figs. 52–54.

21. Berenson, "Signorelli," in *The Drawings of the Florentine Painters* (Chicago: University of Chicago Press, 1938), vol. 1, p. 31.

22. See Charles Dempsey, "Poussin and Egypt," *Art Bulletin*, vol. 45, no. 2 (June 1963), pp. 109–19, figs. 5, 6.

23. For an extended discussion of *Apollo and Daphne*, see Elizabeth Cropper and Charles Dempsey, *Nicolas Poussin: Friendship and the Love of Painting* (Princeton, NJ: Princeton University Press, 1996), pp. 303–12.

24. Servius, "Commentarius," p. 116.

25. See Richard Verdi, *Cézanne and Poussin: The Classical Vision of Landscape*, exh. cat. (Edinburgh: National Galleries of Scotland, 1990), esp. pp. 44–45, figs. 27, 28.

26. Fried, "Antiquity Now: Reading Winckelmann on Imitation," *October*, vol. 37 (Summer 1986), p. 93.

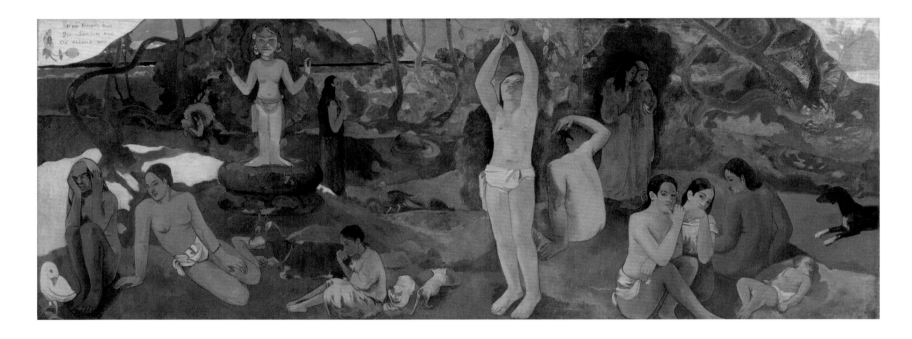

146

PAUL GAUGUIN

French, 1848–1903

Where Do We Come From? What Are We? Where Are We Going? (D'où venons-nous? Que sommes-nous? Où allons-nous?)

1897–98

Oil on canvas, 4 feet 6¾ inches × 12 feet 3½ inches (1.39 × 3.75 m)

Museum of Fine Arts, Boston. Tompkins Collection — Arthur Gordon Tompkins Fund, 36.270

Trouble in Paradise

GEORGE T. M. SHACKELFORD

Paul Gauguin, the shepherd poet of Symbolism, in Arcadia? The notion is intriguing, in light of the artist's mature preference for painting in relatively remote locales, far from artistic capitals, and the repeated references in his correspondence, as well as in his paintings and graphic arts, to places rural and remote, agrarian, unspoiled, and primitive.[1] Gauguin famously sought an escape from the corruption and demands of modern life, believing that he might find in the tropics of the South Seas a simpler lifestyle, his own personal idyll. If Paris could be likened to Athens, could Tahiti have been his Arcadia? But was Arcadia what Gauguin was actually looking for? Or, better yet, what kind of Arcadia would Gauguin have imagined?

Gauguin's experience of the world outside European metropolises was more extensive than that of any other French artist of his generation. In the summer of 1849, when the future artist was little more than a year old, his family emigrated to Peru, where his father hoped to prosper in his journalistic career. His father died on the way to South America, however, leaving Gauguin, along with his mother, Aline, and his sister, Marie, to the care of his maternal great-uncle in Lima. In 1855 the family returned to France.

Gauguin enlisted in the merchant marine in 1865, when he was seventeen, and thus resumed his career as a traveler, sailing around the world before leaving the service in 1871. Back in Paris, he sought the care and advice of Gustave Arosa, who had been his guardian before his majority (Gauguin's mother had died while he was away). Arosa was immersed in the world of art, as a photographer, a publisher, and a collector of modern French paintings. It was he who introduced Gauguin to his future wife, Mette Gad, a young Danish woman, whom the artist married in 1873. They would have five children together, the first, a son, in 1874.

At the time of his son's birth, Gauguin was working in the stock exchange, but he, along with Arosa, was seriously interested in painting. In fact, he had begun to paint, and in 1876 he successfully submitted a canvas to the Salon. Within the year, he was balancing his career as a stockbroker with that of a painter, a radical and risky position for a young man with relatively few connections to the establishment. Gauguin already had formed a small collection of paintings by the artists who became known as the Impressionists, showing a particular affinity for the works of Paul Cézanne and Camille Pissarro. He lent paintings by Pissarro to the Impressionist exhibition of 1879, and at the last minute he became an exhibitor, too.[2] Although he initially was admitted to this group of independent artists as a talented amateur, he became a dedicated participant in the enterprise, showing at each of the remaining exhibitions held by the Impressionists in 1880, 1881, 1882, and 1886.

He decided to abandon the business of the stock market for the business of art in late 1883 when he moved his family from Paris to Rouen, in search of a less expensive life outside the French capital, in a smaller provincial city. Less than a year later, however, Mette and the children left France for Copenhagen, seeking her family's support. Gauguin joined them in Denmark at the end of the year, but by the summer of 1885 he had returned to Paris. The couple would remain apart, although in contact with each other, until a final rupture in 1897.

Gauguin's art-making was moving forward at a fast pace, as was his thinking about the nature of art and how it should be pursued. He had come to understand that art was not merely visual, but also deeply poetic and charged with emotions best expressed through the language of form and color. In a series of "Notes synthétiques" (Synthetic notes), written in 1885, he described painting as "the most beautiful of all the arts . . . the summation of all our sensations, and contemplating it we can each, according to our imagination, create the story, in a single glance our souls can be flooded with the most profound reflections; no effort of memory, everything summed up in a single instant."[3] At the same time—even, perhaps, as a logical next step—he came to the conclusion that his art, and possibly all good art, needed to evolve beyond its present state—above all, to break from Impressionism. This difference, he felt, had to be expressed not only in a work of art's emotional character but also in its physical appearance. In May 1885 he wrote to Pissarro that, as far as he was concerned, "there is no such thing as exaggerated art. And I even believe that there is salvation only in extremes."[4]

His search for these extremes took him from Paris to Brittany on the northwest coast of France, where he settled in Pont-Aven in July 1886. In the 1880s Brittany might rightly have been described as a ready-made Arcadia for modern painters, complete with thriving international artists' colonies and pensions eager to provide for creative talent looking for inspiration in the region's rocky pastures. Gauguin, however, had other things in mind than the transcription of the picturesque countryside peopled by simple peasants. True, in his Breton compositions shepherds and pig herders tend their beasts, girls dance in meadows, and boys bathe or wrestle in grassy glades beside running streams. Yet, he admired Brittany not for its quaintness but for its underlying coarseness, its brutality, what he called in a letter to his painter friend Émile Schuffenecker the region's "savage, primitive quality," continuing, "When my clogs echo on this granite ground, I hear the dull, muted, powerful sound I am looking for in painting."[5]

Seeking inspiration from places even more remote, in April 1887 Gauguin traveled to the Caribbean, working briefly as a laborer on the Panama Canal and then settling in the French colony of Martinique, where he remained for several months. There, too, his attention turned to the lives of the men, women, and children he saw around him—"the continual to-and-fro of Negro women dressed in colorful rags, with an infinite variety of graceful movements."[6] The dreamy quality of what Gauguin painted in the tropics of the New World demonstrates a more fluid side of the primitive Arcadian idylls that had resulted from his close contact with the Breton peasantry. A critic praised Gauguin's rendering of this other world, admiring the "undergrowth full of monstrous vegetation and flora, with its formidable torrents of sun," and finding in the works "an almost religious mystery, a sacred abundance quite Edenic."[7]

Gauguin departed Martinique for France in the autumn of 1887, returning to Pont-Aven

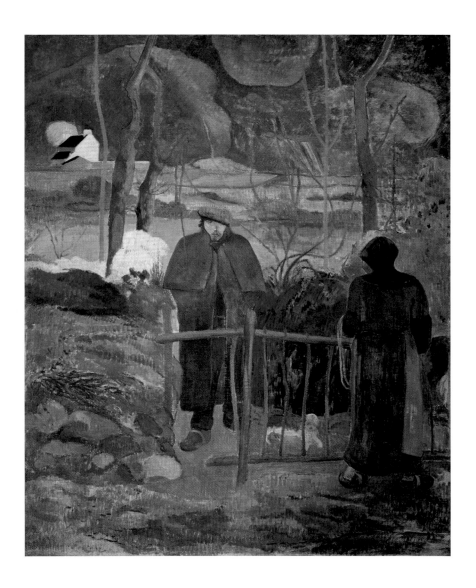

147
PAUL GAUGUIN
French, 1848–1903

Bonjour, Monsieur Gauguin

1889
Oil on canvas glued on panel,
44½ × 36¼ inches (113 × 92 cm)
Národní Galerie, Prague

by early 1888. Shortly thereafter, his friend Vincent van Gogh determined to leave Paris for the south of France—to seek, so to speak, a "Japanese" Arcadia in Arles, far from the temptations and depredations of the city—but Gauguin remained behind, confirmed in his preference for the rocky seaside country of the northwest.[8] But by that October he was convinced by his friend and his friend's brother Theo van Gogh—who happened to be a dealer whose favor Gauguin much wanted to curry—to join Vincent in the "studio of the south," and to realize there, however tentatively, the Dutchman's fantasy of a utopian community of artists, working in harmony with one another and with nature. The story of their tumultuous time together—filled with inspiration, exasperation, and ultimately despair—is legendary; by Christmastime Gauguin abandoned the unhappy Van Gogh in the hospital at Arles, returning to Paris and its avant-garde milieu.[9]

Nonetheless, he soon realized that Paris was not the place in which his art would flourish. He spent most of 1889 in Brittany, with trips to Paris to organize an exhibition of his work and that of his vanguard colleagues, who called themselves Impressionists as well as Synthetists, a new term that suggested the duality of artificiality and poetic and visual synthesis in their work. The show was held at the Café des Arts, also known as the Café Volpini, just outside the fairgrounds of the Exposition Universelle. In the autumn of 1889 the artist painted *Bonjour, Monsieur Gauguin* (fig. 147), a testament to the degree to which he felt uneasy in his adopted landscape, despite his

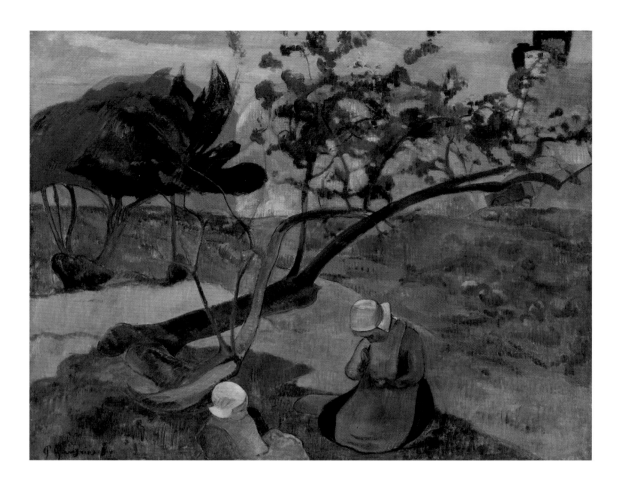

PAUL GAUGUIN

French, 1848–1903

Landscape with Two Breton Women

1889

Oil on canvas, 28½ × 36 inches (72.4 × 91.4 cm)

Museum of Fine Arts, Boston. Gift of Harry and Mildred Remis and Robert and Ruth Remis, 1976.42

admiration for it. In the composition—the title of which derives from Gustave Courbet's famous *Bonjour, Monsieur Courbet* (1854; Musée Fabre, Montpellier, France), which Gauguin and Van Gogh had seen in Montpellier a year before, in 1888—the painter, muffled in a greatcoat and wearing a beret and Breton clogs, is in the countryside, the rocky landscape receding to a horizon that might be the edge of the sea, a farmhouse perched at left beneath the cloud-filled sky. Gauguin, with a dog at his side, stands at a gate, on the other side of which a peasant woman turns as if to acknowledge his presence. "How can we fail to understand the artist's feelings?" Charles Morice, Gauguin's poet friend, wrote thirty years later. "Do we not discern his anguished soul quivering in the depths of the troubled landscape, whence he comes toward us? And the peasant woman, is she not right to feel uneasy?"[10]

The sense of unease—of something lying beneath the apparent subjects of his paintings—had become, and would remain, the hallmark of Gauguin's art. In his *Landscape with Two Breton Women*, also from the autumn of 1889 (fig. 148), he intimated a spiritual dimension in an otherwise quotidian subject, painting the figure at right in such a way as to make the viewer believe that she is praying, although she is actually eating. Earlier, he had painted a powerful scene of women in prayer before a statue of Christ in a landscape—a statue transposed from a chapel wall to this setting in Gauguin's mind, and seemingly coming to life in the imagination of the women confronting it. This work, his famous *Yellow Christ* (1889; Albright-Knox Art Gallery, Buffalo), appears in the background of a subsequent self-portrait that Gauguin almost certainly began in the autumn of 1889 and revisited the following year (fig. 149), when he added to the composition a second self-portrait, a pot sculpted in clay like a primitive totem, that Gauguin described as

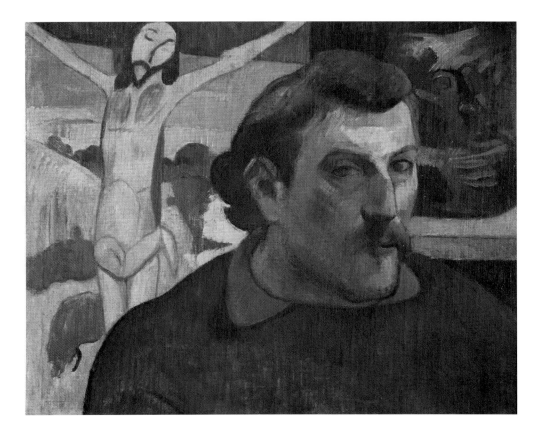

149
PAUL GAUGUIN
French, 1848–1903

Self-Portrait with Yellow Christ

1889–91
Oil on canvas, 14¹⁵⁄₁₆ × 18⅛ inches
(38 × 46 cm)
Musée d'Orsay, Paris

a "devil all doubled up to endure his pain."[11] Bracketed by images of piety and suffering, Gauguin stares at the viewer as if to say: What will become of me?

"You know that I have Indian blood, Inca blood in me, and it's reflected in everything I do," Gauguin wrote to Theo van Gogh in 1889. "It's the basis of my personality; I try to confront rotten civilization with something more natural, based on savagery."[12] The desire to seek a location even more savage preoccupied Gauguin at the end of 1889 and through 1890. He sought to separate himself — ostensibly forever — from Paris and the corrupting influences of the world of art he had come to disdain, the tyranny of the official system, certainly, but also the pettiness of even the advanced circles with which he was associated. Casting about for an idea of where he might go next, he researched the far-flung colonies of France, but rejected first one place and then another. It was probably at the display devoted to the French colonies at the 1889 exposition that he first thought of Tahiti, in French Polynesia, as a destination. Little by little his goal became to transfer his life to the island, a place he dreamed of as the land far from Paris in which the poetry of his art could find its most sincere expression, and, true to his propensity for the savage and the extreme, a place more vastly remote from Paris than Arcadia was from Athens.

In September 1890, two months after Van Gogh's death, Gauguin wrote to the artist Odilon Redon, declaring, "I shall go to Tahiti and I hope to end my days there. I judge that my art, which you like, is only a seedling thus far, and out there I hope to cultivate it for my own pleasure in its primitive and savage state. In order to do that I must have peace and quiet. Never mind if other people reap glory! Here, Gauguin is finished, and nothing more will be seen of him."[13] About February 1891 he wrote to his wife in Copenhagen, of his wish to "flee to the woods on a

South Sea island, and live there in ecstasy, in peace and for art. With a new family, far from this European struggle for money. There, in Tahiti, in the silence of the lovely tropical night, I can listen to the sweet murmuring music of my heart, beating in amorous harmony with the mysterious beings of my environment. Free at last, with no money troubles, and able to love, to sing and to die."[14]

His decision to leave behind Paris and the world of art that it represented, ironically, was carried out in public. "I'm leaving so that I can be at peace, so that I can rid myself of the influence of civilization," Gauguin announced to the journalist Jules Huret in February 1891, at the time of the auction sale of his paintings that was to finance his journey. "I want to create only simple art. To do that, I need to immerse myself in virgin nature, to see only savages, to live their life, with no other care than to portray, as would a child, the concepts in my brain using only primitive artistic materials, the only kind that are good and true."[15]

Gauguin's desire to communicate his ideas through primitive, childlike means was no doubt real. But it must be recognized that his public, almost notorious, separation from Paris was a posture. For several years, as he increasingly became sophisticated and adept at managing the vagaries of his own reputation, he had fostered the image of the outsider, the pilgrim of art, by virtue of what he submitted for exhibition in Paris, as well as in Scandinavia and the Low Countries, and through his interviews with the press and the stories about himself that he put into circulation. As Béatrice Joyeux-Prunel noted,

> Gauguin was one of the first artists of the Parisian avant-garde to exploit, systematically and logically, the adage that "no man is a prophet in his own country." He saw, better than others, how to gamble on the logics of separation that obtained in the modern art market. An artist who could prove that he had been welcomed abroad would be still better placed on his home turf. So Gauguin became a veritable professional exile: his canvases flung far and wide, himself an exile in his own art, referring incessantly to an "elsewhere." Thus, essentially, was constructed his own myth.[16]

The conundrum in his departure for Tahiti rests in the contradiction between Gauguin's stated goal to flee to freedom, to live "in ecstasy, in peace and for art," and his real need to sell works of art to live. How could he go away "to love, to sing and to die" and be "free at last, with no money troubles" if "nothing more" were to be seen of him? He had no long-term concrete plans for survival in his imagined Arcadia. But for the short term, Gauguin's strategy for selling his works to fund his travel was a success: For an artist of testy temperament, with a reputation for irascibility, who was far from being at the forefront of the market, the auction result of some 9,600 francs was a decent outcome for the sale of thirty paintings. In late March 1891, a month after the auction, a banquet was held at the Café Voltaire to celebrate Gauguin's departure, attended by more than forty members of the Parisian vanguard. On the first of April, Gauguin sailed from Marseilles to Tahiti, arriving in Papeete, its capital, more than two months later, in early June.

Was Gauguin's proclaimed desire to live and die in Tahiti sincere? At his farewell banquet, his friend the poet Stéphane Mallarmé invited the guests to "drink to the return of Paul Gauguin," as if it were assumed that his departure was for a sojourn, not for a lifetime.[17] For Gauguin to remain a vital artist, complete isolation from his past and from Paris was unthinkable. Yet the two

years he spent in Tahiti, from 1891 to 1893, changed his art forever and resulted in the work that, to a later generation, secured the artist's renown. The paintings and sculptures produced during this time, his first of two Tahitian sojourns—the astonishing landscapes of tropical vegetation, the island transpositions of Judeo-Christian iconography, and the languorous images of Tahitian beauties, many of which are profoundly personal ruminations on the character of his lover, Tehamana—were superbly realized and deeply felt.[18] It would be unfair to assume that these two years in Tahiti were calculated on market principles, but the fact remains that Gauguin painted for an audience, and there was none for his work in Polynesia. There was no Arcadia without Athens, no paradise without Paris.

In 1893, then, he returned to Paris, to mount an exhibition of the remarkable works he created in Tahiti (some of which he previously had sent to Mette in Copenhagen, in the futile hope of selling them there). Held at the Galerie Durand-Ruel in November 1893, the exhibition was a mixed success critically and not at all a success financially. Along with a handful of Breton canvases, including *Bonjour, Monsieur Gauguin*, and a number of his "ultra-barbaric" carvings, he showed forty-one paintings from Tahiti.[19] They were inscribed with "exotic" titles such as *Vahine no te vi, Parau na te varua ino, Te nave nave fenua*, or *Parahi te marae* (1892; fig. 150).[20] Priced at roughly three times what his paintings had sold for two years before, only eleven pictures found buyers—but among the buyers were people whom Gauguin much admired, notably Edgar Degas. The public in attendance was baffled, but Gauguin put on a brave face. As Morice recalled, "He watched the public, and listened. Soon there could be no doubt: they did not understand. It was the final split between Paris and himself, all his great projects were ruined, and—perhaps the cruelest blow to his proud spirit—he had to admit that he had made his plans poorly . . . No one can imagine the anguish that tore at his heart . . . [but] he was the Indian who smiled through his torture."[21]

Following the debacle of the exhibition, Gauguin, accompanied by Annah la Javanaise, a thirteen-year-old girl from Ceylon (now Sri Lanka), and her monkey, settled into a very public bohemian existence in Paris, hosting evenings in his studio and participating in the life of the city's advanced artistic circles. This lasted from the late autumn of 1893 until the spring of 1894, when he departed again for Brittany. But even there he was beset by troubles, financially and personally, and in September he announced to his artist friend Georges-Daniel de Monfreid that he had "come to an unalterable decision—to go and live forever in Polynesia."[22] By mid-autumn he was back in Paris. At a banquet at the Café Escoffier in December he publicly announced his intention of returning to the South Seas. "Paul Gauguin had to choose between the savages here or the ones over there," announced the *Journal des artistes*. "Without a moment's hesitation, he will leave for Tahiti."[23]

Although he did not depart until July 1895, more than six months later, he never would return to Paris. The rest of Gauguin's career was spent in the South Pacific, first in Tahiti, from late 1895, then in the Marquesas Islands, from 1901 until his death in May 1903. Yet, although he had left Paris behind, he never was able to free himself completely from its influence. First, in Papeete he had to deal with the French: officials of the colonial government, who sometimes employed Gauguin when he needed funds, or colonists, who might offer the soon-beleaguered artist occasional work—as a drawing instructor, for instance. In addition, painting supplies had

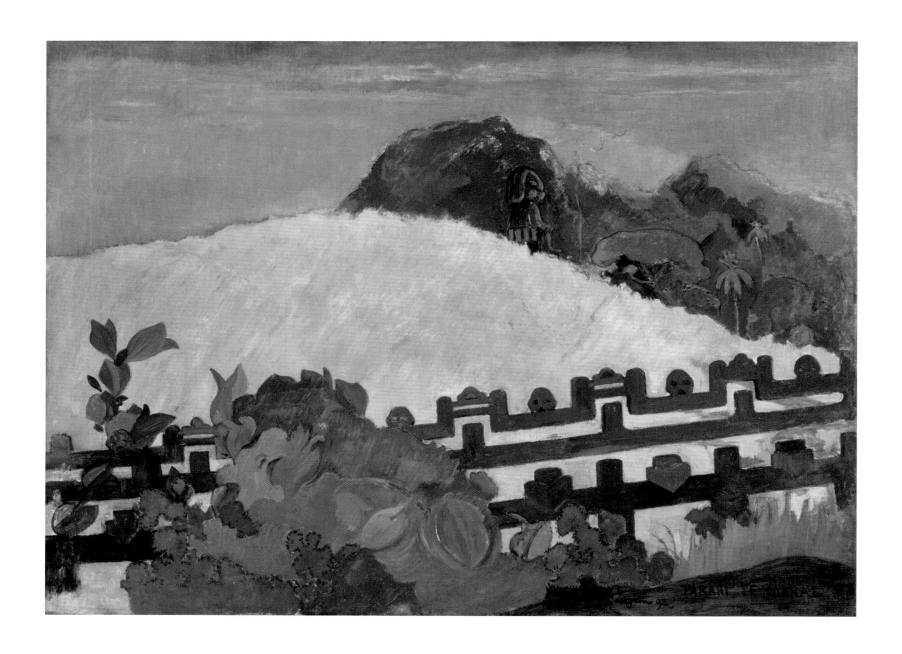

150

PAUL GAUGUIN

French, 1848–1903

The Sacred Mountain (Parahi te marae)

1892

Oil on canvas, 26 × 35 inches (66 × 88.9 cm)

Philadelphia Museum of Art. Gift of Mr. and Mrs. Rodolphe Meyer de Schauensee, 1980-1-1

to come from France and were long in arriving: Indeed, anything shipped from Paris, a package or a letter, would take two months to reach him at his South Seas home. Gauguin had to send paintings to Paris for sale, so that he might have money to live on, and he waited impatiently not only for income but also for praise. His letters, however, reveal his acceptance of this reality: "We must do the best we can and it is a long way from Tahiti to Paris," he wrote to Monfreid in July 1897. "I see no possible means of transport for a year and then I doubt whether I shall have anything to send."[24]

Over the course of the months following his letter to Monfreid, Gauguin sank into one of the most depressive periods of his career. Deeply unhappy, sick of body and mind, he felt sure that he soon would die. Nonetheless, he was writing furiously, resulting in a manuscript of ruminations on art-making and its formal principles, and its poetic goals, which he titled "Diverses choses" ("Miscellaneous Things"). Concerned with issues of pictorial strategy, but fundamentally a study of the power of color and its ability to convey emotion, the text is filled with commentary on his own principles and on his appreciation of the contributions of artists from the past, from Raphael to Eugène Delacroix. His manuscript reveals that the worlds of art and literature were ever present in Gauguin's mind. Far from having left Europe behind in Polynesia, he seemed, in the solitude of his hut in Tahiti, to have come to understand the world he had left behind more fully and on his own particular terms. Over days and nights he pored over his collection of hundreds of prints and photographs — his traveling museum of reproductions of the art of the past, documenting everything from the reliefs and statues of the ninth-century Buddhist temple of Borobudur in Indonesia to the paintings of the fifteenth-century Florentine artist Sandro Botticelli — or over books that he had brought with him from home, obtained in Polynesia, or had memorized. This absorption in the product of the world he abandoned for a new existence fueled his thinking, shaping his ideas as he set down his feelings in words. Through study and composition he thus engaged in a conversation with the Athenians, as it were, from a far Arcadia.

His first concern was color, "the language of the listening eye . . . suited to help our imaginations soar, decorating our dream, opening a new door onto mystery and the infinite."[25] "Color," he wrote, "being enigmatic in itself, as to the sensations it gives us, then to be logical we cannot use it any other way than enigmatically every time we use it, not to draw with," as great masters of color such as Delacroix had done, "but rather to give the musical sensations that flow from it, from its own nature from its internal, mysterious, enigmatic power," much as Beethoven had done. Gauguin's writing became still more abstract in his attempt to describe the ability of his strain of visual Symbolism to unite the senses in appreciation of a work of art. "Color which, like music, is a matter of vibrations," he said, "reaches what is most general and therefore most undefinable in nature."

In a separate section of "Diverses choses," he addressed issues of religious thought, revealing his idea that in modern times humankind should transcend the traditional boundaries and limitations of outmoded religion, to bring belief systems "together in one philosophical comprehension, merge them, identify them in a single, revitalized whole, richer and more fertile" than before.[26] "Given this ever-present riddle: Where do we come from? What are we? Where are we going?, what is our ideal, natural, rational destiny?" he asked.

And under what conditions can it be accomplished? or what is the law, what are the rules for accomplishing it in its individual and humanitarian meaning? A riddle which, in these modern times, the human mind does need to solve in order to see the way before it clearly, in order to stride firmly toward its future without stumbling, deviating, or taking a step backward; and this must be done without wavering from the wise principle which consists of making a tabula rasa of all earlier tradition.

In painting, by extension, Gauguin argued that it would be impossible for the aesthetic problem he posed to "be solved by a mathematical equation or explained by literary means."[27] Rather, it could be solved only pictorially, for "of all the arts, painting is the one which will smooth the way by resolving the paradox between the world of feeling and the world of intellect. Has this movement of painting through color been glimpsed, put into practice by someone? I will not draw any conclusions, nor name anyone. That is up to posterity," he concluded, in a scarcely veiled reference to his own ambition.

By the end of 1897 Gauguin's long-envisioned project for a great painting, the program for which he had outlined in "Diverse choses," was well underway.[28] It was his desire to make a painting that, true to his ideas, transcended the obsolete boundaries of conventional representation to unite the great traditions of French art: the rigorously intellectual classicism epitomized by Nicolas Poussin and the ineffable, indefinable colorism represented by Delacroix. This work, of course, is, Gauguin's masterpiece, *Where Do We Come From? What Are We? Where Are We Going? (D'où venons-nous? Que sommes-nous? Où allons-nous?)* of 1897–98 (see pages xi–xii and fig. 146).

The largest painting Gauguin ever attempted, it measures more than thirteen feet in width. It is painted on a burlap support over a roughly applied white ground, the whole composition broadly sketched in long strokes of Prussian blue pigment. On this base Gauguin created a magnificent, profoundly moving, panoply of human life, set in a landscape at once brooding and joyous. At the upper left on a field of yellow gold he inscribed the words that serve as the painting's title and that begin his disquisition on religion in "Diverses choses" — "D'où venons nous? Que sommes nous? Où allons nous?"

Gauguin claimed that he finished the painting in January 1898. Although none of the letters he wrote at the end of 1897 mentions the canvas being in progress, he must have worked on it over several weeks, if not months. He wrote to Monfreid about the painting in February 1898; if his account of what happened is faithful, upon completing the picture he went up into the hills, armed with poison, to take his own life. He did not succeed, either because he took too little of the arsenic he claimed to have used, or too much for his body to hold down. After what he described to Monfreid as "a night of terrible suffering," he returned to his home.[29] In the letter, he went on to include his first transcription of the painting into words, still the most immediate explanation of its origins and meaning:

> Before I died I wished to paint a large canvas that I had in mind, and I worked day and night that whole month in an incredible fever. Good God, it's not a canvas done like a Puvis de Chavannes, with a drawing from life, a preparatory cartoon, etc. It's all straight from the tip of the paintbrush on sackcloth full of knots and wrinkles, so the appearance is terribly rough.

They will say that it is careless, unfinished. It's true that it's not easy to judge one's own work, but in spite of that I believe that this canvas not only surpasses all my preceding ones, but that I shall never do anything better, or even like it. Before death I put into it all my energy, a passion so painful in circumstances so terrible, and my vision was so clear that all haste of execution vanishes and life surges up. It doesn't stink of models, of technique, or of pretended rules — of which I have always fought shy, though sometimes with fear.

It is a canvas four meters fifty in width, by one meter seventy in height. The two upper corners are chrome yellow; with an inscription on the left and my name on the right, like a fresco whose corners are spoiled with age, and which is attached to a golden wall.

The composition consists of twelve figures disposed against the lush landscape of Tahiti. In his letter to Monfreid, Gauguin included a rough sketch of the painting, and was at pains to describe and to elucidate the characters one by one, moving from right to left. "To the right, at the lower end," he wrote, are "a sleeping child and three crouching women," whose poses recall the groups of women and children that had peopled his canvases from 1891 to 1893.[30] Beyond them, to the left and shown as if emerging from a cloud, "two figures dressed in purple confide their thoughts to one another," flanked by "an enormous crouching figure, out of all proportion, and intentionally so," who "raises its arm and stares in astonishment upon these two, who dare to think of their destiny." Moving to the left, "a figure in the center is picking fruit." Gauguin next mentioned, again to the left, "two cats near a child. A white goat. An idol, its arms mysteriously raised in a sort of rhythm, seems to indicate the Beyond . . . then lastly, an old woman nearing death." This woman, in the artist's words, "appears to accept everything, to resign herself to her thoughts. She completes the story! At her feet a strange white bird, holding a lizard in its claws." The painter inexplicably omitted from his description the languid beauty who sits, literally and figuratively, between the old woman and the child eating a fruit.

Gauguin told Monfreid that the setting for the painting was "the bank of a river in the woods. In the background the ocean, then the mountains of a neighboring island. Despite changes of tone, the coloring of the landscape is constant, either blue or Veronese green." The scenery is, in fact, a remarkable combination of the real and the imagined. In the upper left a distant view of the neighboring island of Moorea, drenched in sunlight, frames the statue of the moon goddess Hina, a wholly fictional sculpture based on Asian prototypes. In the upper right the river rises from the earth among the roots of purau trees, whose branches, interlacing and repeating across the upper register of the canvas, provide a rhythmic parallel to the movement of the water from right to left. The ground, cast into deep shadow or brilliantly illuminated — as in the pink passages at far left — often is painted quite delicately, pigments placed beside and over one another in sensuous, vaporous layers.

True to his habits, Gauguin had rifled his "museum" of reproductions to find ideas for the figural poses. The women at right who gaze quizzically at the viewer were lifted almost whole from Borobudur carvings. Gauguin had seen a cast of the temple at the Exposition Universelle in Paris in 1889, and had procured photographs of some of its reliefs, which proved endless sources

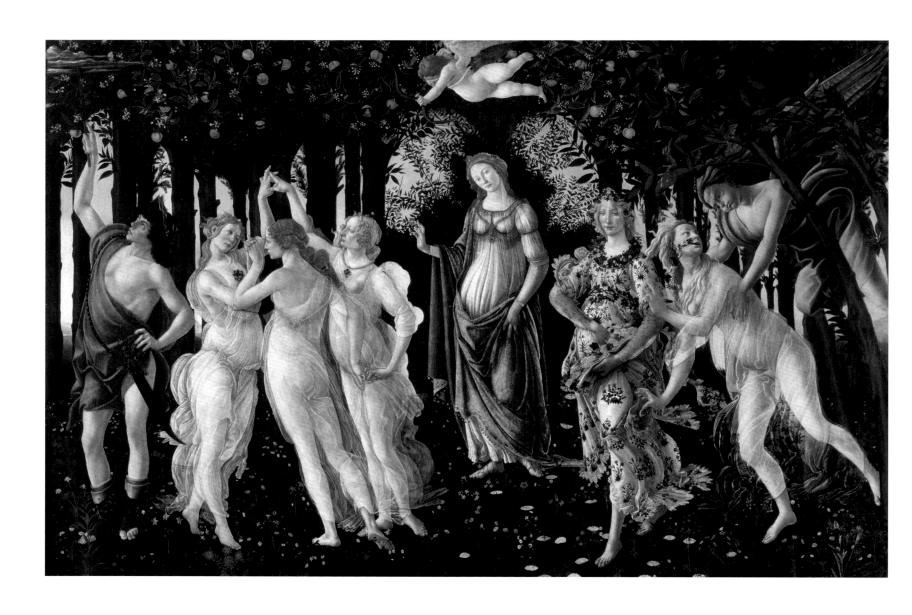

151

SANDRO BOTTICELLI

Italian, 1445–1510

La primavera

c. 1477

Tempera on panel, 6 feet 7¹⁵⁄₁₆ inches × 10 feet 3⅝ inches (2 × 3.14 m)

Galleria degli Uffizi, Florence

152

PAUL GAUGUIN

French, 1848–1903

Delightful Day (Nave nave mahana)

1896

Oil on canvas, 37⅜ × 51³⁄₁₆ inches (95 × 130 cm)

Musée des Beaux-Arts de Lyon, France

of inspiration to him. The central figure, a kind of Polynesian Adam, derives from a sculpted bodhisattva in one of the Borobudur photographs, together with the pose of a male nude from a drawing in the Louvre in Paris, which in Gauguin's time was thought to be by Rembrandt.[31] From memory or from earlier drawings that he kept with him, Gauguin painted the "old woman nearing death," whose infolded pose comes from that of a mummified corpse from Peru that Gauguin had seen at the Musée de l'Homme in Paris—a figure that first appears in his art in the 1880s and stayed in his imagination, through multiple transmutations, for the rest of his life.[32]

For Gauguin, *Where Do We Come From?* was, self-consciously, a masterpiece. It was meant to be his testament, a summation of his achievements and the conclusion—in logic, as well as in fact, had his suicide taken place—of his aesthetic, philosophical, and poetic career. It was also a translation into Gauguin's pictorial language of quotations from the history of art. Its sources are many and varied. Individual figures might be traced, as suggested above, to Buddhist carvings, works by Rembrandt, or artifacts from anthropology museums. Botticelli's famous *Primavera* (c. 1477; fig. 151), in which figures are arrayed against a grove of trees, probably was a source for the compositional structure of *Where Do We Come From?*, as well as for that of Gauguin's earlier painting of paradisial pleasure *Delightful Day (Nave nave mahana)* of 1896 (fig. 152).

The curious independence of Gauguin's figures may be an echo of Botticelli's enigmatic allegory, in which the participants, on the whole, seem to be unaware of one another. Their organization in a stately frieze, however, represents one of the great visual traditions of French art,

ever present from the portals of Gothic cathedrals to the hieratic compositions of Jacques-Louis David and Jean-Auguste-Dominique Ingres. It should thus come as no surprise that another source of Gauguin's inspiration must have been found in the work of Poussin, France's greatest classicist, whose ability to group figures in stately progressions within landscape settings and to orchestrate pictorial movement among figures is unrivaled. Specifically, both the details and the overall arrangement of *Where Do We Come From?* display a striking resemblance to one of Poussin's masterpieces, *The Realm of Flora*, painted in 1631 in Rome (fig. 153).[33] Poussin's painting shows a group of figures—mortals beloved of the gods, whom, according to Ovid, love transformed into flowers. The landscapes of the two paintings bear comparison, each with contrasting zones of dark and light, flowing water, and the presence of a statue at left. Among the figures, the woman at far right in *Where Do We Come From?* echoes the nymph holding a vase in the foreground of *Flora*; Gauguin's seated figure who stares at the pair of shadowy wanderers suggests Poussin's figure of Clytie, who shields her face with her hand as she gazes in astonishment at Apollo in his chariot; and even the figure of "Adam" in Gauguin's masterpiece recalls the naked figure of Hyacinth in Poussin's picture, who stands with his arm encircling his head.

Gauguin, however, never would have seen Poussin's *Flora*. Although it was in a French collection in the late seventeenth century, since 1722 it had been in the royal collections in Dresden, and by Gauguin's time the painting was one of the prized possessions of the Gemäldegalerie there. He must instead have owned a reproduction of the painting. It is possible that he obtained an impression of the engraving made of the picture in 1686 or a copy of the reproduction of it in the edition of Poussin's works published by Firmin-Didot in 1845.[34] But both of these reverse the image, and Gauguin's quotations argue for a direct reproduction. He much more likely owned a photograph of the painting, specifically one retailed by the Paris firm Adolphe Braun and listed as number 717 in the firm's 1887 catalogue of available reproductions, each priced at fifteen francs.[35]

Where Do We Come From? was not, however, merely a modernization or a personalization of a classical French prototype. Gauguin took care to distance his work, whenever he subsequently described it, from the tradition of allegory that stretched back to Poussin and that Pierre Puvis de Chavannes represented most conspicuously, in works such as *Inter Artes et Naturam* (1890; fig. 154), which had been exhibited at the Salon of 1890, or even his less symbolic *Summer* (1891; see fig. 30). In a February 1898 letter to Monfreid, Gauguin was keen to reject such comparisons. After *Where Do We Come From?* had been shown in Paris, in 1899 Gauguin wrote to the critic André Fontainas, who had complained that "there is nothing [in the work] that reveals to us the meaning of the allegory."[36] "Well," Gauguin replied to Fontainas, "my dream cannot be apprehended, it requires no allegory; being a musical poem, it needs no libretto," calling to his aid the poet Mallarmé's dictum that "the essential quality of a work consists precisely in what is not expressed."[37]

Despite the fact that he decoded the painting to more than one correspondent, to Monfreid in 1898 and Morice in 1901—perhaps so that it could be elucidated further to a future critic or to a prospective buyer—Gauguin did not intend *Where Do We Come From?* to be read bit by bit, as a compendium of symbols with a cumulative meaning or allegorical unity. Instead, he told his friends, as well as his critics, that the painting was not, "like those of Puvis de Chavannes," the sort of work that "originated from an idea, *a priori*, abstract, which I sought to vivify by plastic

153

NICOLAS POUSSIN

French, 1594–1665

The Realm of Flora

1631

Oil on canvas, 51⁹⁄₁₆ × 71¼ inches (131 × 181 cm)

Staatliche Kunstsammlungen, Gemäldegalerie Alte Meister, Dresden

154

PIERRE PUVIS DE CHAVANNES

French, 1824–1898

Inter Artes et Naturam

1890

Oil on canvas, 9 feet 8⅛ inches × 27 feet 2¾ inches (2.95 × 8.3 m)

Musée des Beaux-Arts, Rouen

representation."[38] When in 1901 he wrote about the painting to Morice, he gave a close reading of its components, but he insisted that "explanatory attributes—known symbols—would congeal the canvas into a melancholy reality, and the problem indicated would no longer be a poem."[39]

By rights Gauguin painted *Where Do We Come From?* as a statement of his deepest convictions. Its title posed a series of unanswerable questions, questions that were meant to perplex the viewer and to make the experience of seeing the picture a memorably troubling one. But the painting is also a declaration of Gauguin's power and ambition. This decree was made, inescapably, to an audience half a world away: a shout of anguish, perhaps, but also of glory, from paradise to Paris, from Arcadia to Athens.

The story of what happened to *Where Do We Come From?* after its completion makes this clear. Probably in January 1898, as he was finishing the large painting, he set to work on an ancillary series of smaller canvases of identical size, each an extract or echo of motifs found in the larger panel, executed in a range of colors intended to complement the principal work.[40] By July 1898, six months after he attempted suicide, he had finished the group. He then sent them, along with his masterwork, to Monfreid, with the explicit goal of presenting, as well as selling, his paintings to a Parisian audience.

At the earliest Gauguin could have anticipated a reaction to the shipment by the end of the year. He waited desperately to receive news of the pictures' fate—"waiting impatiently for the next mail," he wrote, "in a hurry to know whether I am wrong or not."[41] In the end he did not learn until early 1899, in a letter from his friend Georges Chaudet, that the paintings had been exhibited at the Galerie Ambroise Vollard to considerable success among avant-garde critics.[42] As he received the reviews, he disputed their assertions, argued with their conclusions, or thanked those critics who had been his supporters. The masterpiece had had its effect.

While he received letters from his friends associated with the exhibition, and while he read in the press echoes of his masterpiece's reception, there is only circumstantial evidence of other artists' reactions to it. The artists who had dealings with Vollard are likely to have seen it, of course. They include Gauguin's mentor Degas, whom the dealer had been courting, and the great Cézanne, who from January 1898 to 1899 rented a studio in Paris in the Villa des Arts (see fig. 10), during which time he painted Vollard's portrait. Until 1901, in fact, the canvas remained with Vollard, and thus it could be—and almost certainly was—seen by the younger artists who interacted with the gallery: the Nabi painters Pierre Bonnard, Maurice Denis, and Édouard Vuillard, all of whom Vollard promoted as printmakers; Henri Matisse, who in 1899 traded Vollard work of his own for a picture by Gauguin; and Pablo Picasso, whose first Paris exhibition was held at Vollard's gallery in 1900.[43]

In the two years following the exhibition, although Gauguin continued to paint major canvases, the fate of *Where Do We Come From?* preoccupied him. In a May 1901 letter to Gauguin, Morice proposed offering the painting to the French nation, for the Musée du Luxembourg in Paris, the state's official museum of contemporary art. "Degas, Redon, Dolent, Rouart, more and still more will contribute," Morice suggested, naming artists and collectors who might donate funds toward its purchase. "Needless to say," he went on, "the Luxembourg will refuse. But it would be a chance to publicize your name."[44] Upon receiving the letter in July, Gauguin leapt at

the suggestion, writing immediately to Monfreid with a list of potential subscribers to the campaign and addressing a lengthy letter to Morice (the letter in which, as discussed above, he explained the painting without, he said, wanting to explain it).[45]

By this time, it had been three years since Gauguin had shipped the painting to Paris, and thus just as long since he last had seen it. While he may have had a drawing or photograph of the picture to remind him of its details, he wrote to Morice about it with fluency, as if he were standing before it. He could catalogue its elements and explain their function to his friend, but its meaning? That was meant to be obscure. The memory of the painting, its rumination on the eternal themes of life, and its profound association with death — his own, perhaps — acted on Gauguin like a *tupapau*, a native spirit watching the living, haunting and powerful. Its title, boldly inscribed on its surface, against a ground of gold, is as enigmatic to a modern audience as is the inscription on the tomb, "Et in Arcadia ego," was to Poussin's ancient shepherds (see fig. 141).

"But for the public," Gauguin asked, "why should my brush, free from all constraint, be obliged to open everybody's eyes?"[46] To Paris — to the likes of Cézanne and Matisse — went the painting, imbued with its own "internal, mysterious, enigmatic power." It brought with it a message: I, Paul Gauguin, am here in Arcadia. Look upon this, and listen for the music of my heart.

1. The research discussed here is explored in greater detail in George T. M. Shackelford and Claire Frèches-Thory, *Gauguin Tahiti*, exh. cat. (Boston: Museum of Fine Arts, 2004). See esp. the introduction and the essays "The Return to Paradise: Tahiti, 1885–1897" and *"Where Do We Come From? What Are We? Where Are We Going?,"* by George T. M. Shackelford, pp. 3–13, 145–65, and 168–203, respectively.

2. Gauguin's *Bust of Emile Gauguin, the Artist's Son* (1877–78; Metropolitan Museum of Art, New York) was exhibited *hors catalogue*. See Ruth Berson, ed., *The New Painting: Impressionism, 1874–1886* (San Francisco, CA: Fine Arts Museums of San Francisco, 1996), vol. 1, pp. 113, 132. For a broader discussion of Gauguin's Impressionism, see Richard R. Brettell and Anne-Birgitte Fonsmark, *Gauguin and Impressionism*, exh. cat. (New Haven, CT: Yale University Press, 2005).

3. Gauguin, "Notes synthétiques" (1885), trans. and quoted in *Gauguin by Himself*, ed. Belinda Thomson (Boston: Little, Brown), p. 33.

4. Gauguin to Pissarro, late May 1885, trans. and quoted in Charles F. Stuckey, "The Impressionist Years," in *The Art of Paul Gauguin*, by Richard R. Brettell et al., exh. cat. (Washington, DC: National Gallery of Art, 1988), p. 15.

5. Gauguin to Schuffenecker, late February 1888, in *The Writings of a Savage*, ed. Daniel Guérin, trans. Eleanor Levieux (New York: Viking, 1978), p. 23 (translation modified).

6. Gauguin to Schuffenecker, early July 1887, in *Correspondance de Paul Gauguin, documents, témoignages*, ed. Victor Merlhès (Paris: Fondation Singer-Polignac, 1984), pp. 156–57 (my translation).

7. Octave Mirbeau, "Paul Gauguin," *L'écho de Paris*, February 16, 1891, trans. and quoted in Daniel Wildenstein, *Gauguin:*

A Savage in the Making; Catalogue Raisonné of the Paintings, 1873–1888 (Milan: Skira, 2002), vol. 2, p. 333.

8. Van Gogh fantasized that Arles would be like the Japan of his imagination, with the atmosphere and light that he had admired in Japanese prints.

9. For the best account of Gauguin and Van Gogh in Arles, see Douglas W. Druick and Peter Kort Zegers, *Van Gogh and Gauguin: The Studio of the South*, exh. cat. (Chicago: Art Institute of Chicago, 2001).

10. Morice, *Paul Gauguin*, new ed. (Paris: H. Floury, 1920), quoted in Françoise Cachin, catalogue entry in Brettell et al., *Art of Paul Gauguin*, p. 173, cat. 95.

11. Gauguin, quoted in Cachin, catalogue entry in Brettell et al., *Art of Paul Gauguin*, p. 128, cat. 65.

12. Gauguin to Theo van Gogh, November 20 or 21, 1889, trans. and quoted in Thomson, *Gauguin by Himself*, p. 111.

13. Gauguin to Redon, September 1890, quoted in Guérin and Levieux, *Writings of a Savage*, p. 44.

14. Gauguin to Mette Gad, in *Paul Gauguin: Letters to His Wife and Friends*, ed. Maurice Malingue, trans. Henry J. Stenning (Cleveland: World, 1949), p. 137, no. 100.

15. Gauguin, quoted in Huret, "Paul Gauguin devant ses tableaux," *L'écho de Paris*, February 23, 1891 (my translation).

16. Joyeux-Prunel, "'Les bons vents viennent de l'étranger': La fabrication internationale de la gloire de Gauguin," *Revue d'histoire moderne et contemporaine*, vol. 52, no. 2 (April–June 2005), p. 118 (my translation).

17. Mallarmé, quoted in *Correspondance, 1862–1898*, ed. Henri Mondor (Paris: Gallimard, 1973), vol. 4, pt. 1, p. 211n3.

18. For an in-depth exploration of Gauguin's work from his first trip to Tahiti, see Shackelford and

Frèches-Thory, *Gauguin Tahiti*, esp. pt. 1, "The First Polynesian Sojourn, June 1891–June 1893." For his images of Tehamana, see, in particular, *The Ancestors of Tehamana* (*Merahi metua no Tehamana*) of 1893 (Art Institute of Chicago) and *The Spirit of the Dead Watching* (*Manao tupapau*) of 1892 (Albright-Knox Art Gallery, Buffalo). For illustrations of these works, see Shackelford and Frèches-Thory, *Gauguin Tahiti*, pp. 36 and 55, respectively.

19. "In my two years' stay, some months of which went for nothing, I have turned out sixty-six canvases of varying quality and some ultra-barbaric sculpture." Gauguin to Monfreid, [April–May?] 1893, in *Gauguin's Letters from the South Seas*, trans. Ruth Pielkovo (repr., New York: Dover, 1992), p. 36. All subsequent citations to correspondence between Gauguin and Monfreid are to this volume. First published 1923 by W. Heinemann as *The Letters of Paul Gauguin to Georges Daniel de Monfreid*. This letter was redated to late March 1893 in Richard S. Field, *Paul Gauguin: The Paintings of the First Voyage to Tahiti* (New York: Garland, 1977), p. 367. For more on the sculpture Gauguin created during his first trip to Tahiti, see Anne Pingeot, "Sculpture of the First Voyage," in Shackelford and Frèches-Thory, *Gauguin Tahiti*, pp. 68–79.

20. *Woman with a Mango* (*Vahine no te vi*; Baltimore Museum of Art), *Words of the Devil* (*Parau na te varua ino*; National Gallery of Art, Washington, DC), *The Delightful Land* (*Te nave nave fenua*; Ohara Museum of Art, Kurashiki, Japan), and *Parahi te marae* (*The Sacred Mountain*; Philadelphia Museum of Art [see fig. 150]), all dated to 1892, are illustrated in Shackelford and Frèches-Thory, *Gauguin Tahiti*, pp. 293, 40, and 38, respectively.

21. Morice, *Paul Gauguin*, new ed. (Paris: H. Floury, 1920), p. 31.

22. Gauguin to Monfreid, [October–November 1894], p. 36. For the date of this letter, I have followed Jean Loize, who redated it to September 20, 1894. See Loize, *Les amitiés du peintre Georges-Daniel de Monfreid et ses reliques de Gauguin: De Maillol et Codet à Segalen*, exh. cat. ([Paris?]: J. Loize, 1951), p. 20.

23. *Journal des artistes*, December 16, 1894, trans. and quoted in Brettell et al., *Art of Paul Gauguin*, p. 294.

24. Gauguin to Monfreid, July 14, 1897, p. 54.

25. All quotations in this paragraph are from Gauguin, "Miscellaneous Things," in Guérin and Levieux, *Writings of a Savage*, pp. 145–47.

26. Ibid., pp. 166–67.

27. Ibid., p. 147.

28. See ibid., pp. 134–35.

29. This and the following comments to Monfreid are from Gauguin to Monfreid, February 1898, pp. 59–63 (translation modified).

30. See, for example, Gauguin's *Women of Tahiti* of 1891 (Musée d'Orsay, Paris) and *What! Are You Jealous?*

(*Aha oe feii?*) of 1892 (State Pushkin Museum of Fine Arts, Moscow). Both works are illustrated in Shackelford and Frèches-Thory, *Gauguin Tahiti*, pp. 31 and 53, respectively.

31. Gauguin's Borobudur photographs are illustrated in Elizabeth C. Childs, "'Catholicism and the Modern Mind': The Painter as Writer in Late Career," in Shackelford and Frèches-Thory, *Gauguin Tahiti*, pp. 233, 248. For an illustration of the Louvre drawing, see Lawrence Gowing, letter to the editor, *Burlington Magazine*, vol. 91, no. 561 (December 1949), p. 354. See also Yann le Pichon, *Gauguin: Life, Art, Inspiration*, trans. I. Mark Paris (New York: Harry N. Abrams, 1987), p. 215; and Musée Départemental du Prieuré, *Le chemin de Gauguin, genèse et rayonnement*, 3rd ed., exh. cat. (Saint-Germain-en-Laye, France: Musée Départemental du Prieuré, 1986), p. 180. On Gauguin's sources of inspiration, see Stephen F. Eisenman, *Gauguin's Skirt* (New York: Thames and Hudson, 1997), pp. 145–47.

32. See, for example, Gauguin's *Breton Eve (I)*, *Breton Eve (II)*, and *Women Bathing* in Wildenstein, *Savage in the Making*, cats. 333–35, respectively. See also Wayne V. Andersen, *Gauguin's Paradise Lost* (New York: Viking, [1971]), pp. 89–90; and Wayne V. Andersen, "Gauguin and a Peruvian Mummy," *Burlington Magazine*, vol. 109, no. 769 (April 1967), pp. 238–42, fig. 78.

33. For a discussion of Poussin's painting, see Pierre Rosenberg, catalogue entry in *Nicolas Poussin, 1594–1665*, by Pierre Rosenberg and Louis-Antoine Prat, exh. cat. (Paris: Réunion des Musées Nationaux, 1994), pp. 203–5, cat. 44.

34. *Oeuvres complètes de Nicolas Poussin*, 2 vols. (Paris: F. Didot, 1845). I am grateful to Geneviève Plonge of the Musée du Louvre in Paris for providing me with the reference to this publication.

35. See Braun et Cie, *Catalogue général des photographies inaltérables au charbon et héliogravures faites d'après les originaux peintures, fresques, dessins et sculptures des principaux musées d'Europe, des galeries et collections particulières les plus remarquables* (Paris: Ad. Braun, 1887), p. 23, no. 717. I am grateful to Nicholas Wise of the Frick Collection in New York for finding this catalogue reference.

36. Fontainas, "Revue du mois: Art moderne," in *Mercure de France*, vol. 29 (January 1899), p. 238 (my translation).

37. Gauguin to Fontainas, March 1899, in Malingue and Stenning, *Letters to His Wife and Friends*, p. 217, no. 170. See also Jules Huret, "Interview with Stéphane Mallarmé," in *Enquête sur l'évolution littéraire* (Vanves, France: Editions Thot, 1982), p. 77. First published in *L'écho de Paris*, March 3, 1891.

38. Gauguin to Fontainas, August 1899, p. 221, no. 172.

39. Gauguin to Morice, July 1901, in Malingue and Stenning, *Letters to His Wife and Friends*, p. 227, no. 174.

40. On these ancillary canvases, see Shackelford, "*Where Do We Come From?*," p. 184.

41. Gauguin to Monfreid, December 12, 1898, p. 71, (translation modified).

42. Chaudet to Gauguin, photocopy of typed transcription of letter, January 15, 1899, in Service du Documentation, Musée d'Orsay, Paris.

43. For Vollard's relations with the Nabis and with Picasso, see Gloria Groom, "Vollard, the Nabis, and Odilon Redon," and Gary Tinterow, "Vollard and Picasso," in *Cézanne to Picasso: Ambroise Vollard, Patron of the Avant-Garde*, ed. Rebecca A. Rabinow, exh. cat. (New York: Metropolitan Museum of Art, 2006), pp. 82–99 and 100–117, respectively. Matisse obtained Gauguin's *Young Man with a Flower* (1891; Mavromatis Collection, New York). See Georges Wildenstein, *Gauguin* (Paris: Beaux-Arts, 1964), no. 422.

44. Morice to Gauguin, May 22, 1901, in *Lettres de Gauguin à Daniel de Monfreid*, ed. Victor Segalen and A. Joly-Segalen, rev. ed. (Paris: G. Falaize, 1950), pp. 217–18.

45. Gauguin to Monfreid, July 1901, p. 87. Gauguin to Morice, July 1901, no. 174, pp. 227–28.

46. Gauguin to Morice, July 1901, no. 174, pp. 227–28.

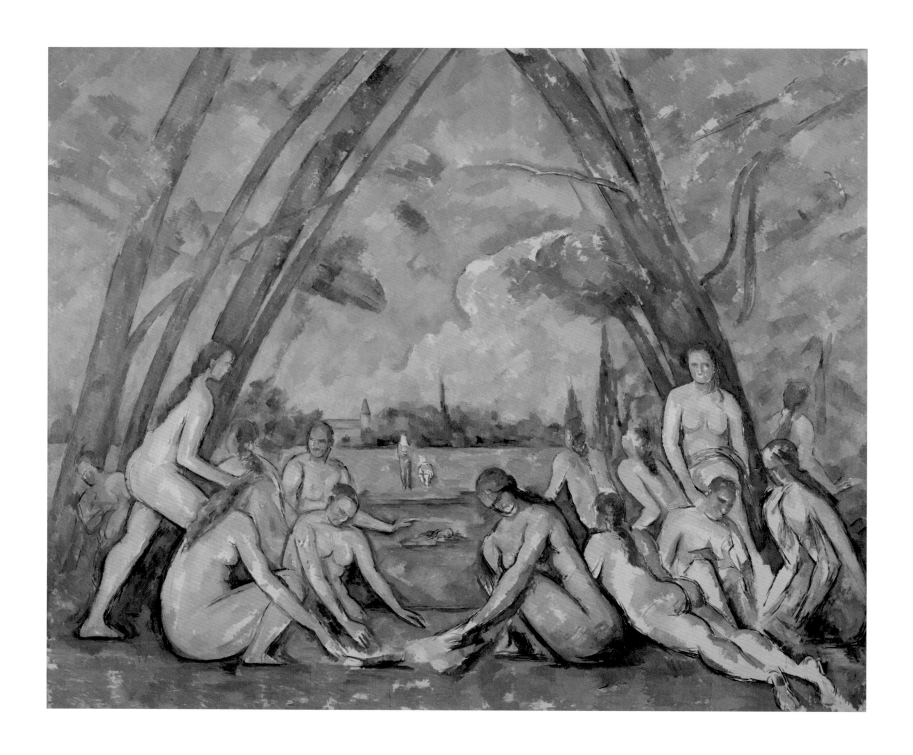

155

PAUL CÉZANNE

French, 1839–1906

The Large Bathers

1900–1906

Oil on canvas, 6 feet 10⅞ inches × 8 feet 2¾ inches (2.1 × 2.5 m)

Philadelphia Museum of Art. Purchased with the W. P. Wilstach Fund, W1937-1-1

Cézanne, Virgil, Poussin

JOSEPH J. RISHEL

The profound link between Paul Cézanne and the ancients, especially Virgil, is beyond dispute. The prevalence of mythological subjects in his oeuvre—his small painting *Satyrs and Nymphs* (c. 1867; fig. 156) being just one example—has been the focus of some of the more elevated pages of art-historical literature. Most famous, perhaps, is Meyer Schapiro's discussion, published in 1979, of the artist's lost canvas *The Judgment of Paris* (1883–85; fig. 157).[1] More recent explorations of the Arcadian aspects of Cézanne's work include Nina Athanassoglou-Kallmyer's chapter on the artist's interpretation of his surroundings in Provence as a veritable earthly paradise, and Paul Smith's analysis of the relationship between Virgil's poetry and Cézanne's landscapes as filtered by the poet-philosopher Joachim Gasquet.[2]

The dilemma, should there be one, is whether Cézanne's imagination was stocked more by words or by images. While the role of Virgil, his *Eclogues* in particular, is a special element in Cézanne's aesthetic makeup, his relationship with Nicolas Poussin, the classic entry into Arcadian subjects, often is proposed as being on equal footing in an *ut pictura poesis* (as is painting so is poetry) equation with Virgil's writings.[3]

CÉZANNE AND VIRGIL

As a boy in the town of Aix-in-Provence in the south of France, Cézanne received a stern and rigorous education in the classics, which he welcomed with only occasional exceptions.[4] He excelled in Greek and Latin; two books awarded for his distinction in these subjects are still in his studio at Les Lauves in Aix.[5] As a young man, he even translated Virgil's second *Eclogue*, and his friend the writer Émile Zola asked Cézanne to send him the translation.[6]

Cézanne's candid correspondences as a schoolboy with his pals Zola and Jean-Baptistin Baille (the three of whom were known as "the three inseparables") document the long Arcadian summers of their childhood, spent swimming in and lounging about the Arc River.[7] In a letter of April 1858 to Zola, who recently had left Aix for Paris, Cézanne made vivid the pastoral nature of the three friends' youth, imbued with the spirit of, as well as references to, Virgil's *Eclogues*:

> Do you remember the pine-tree which, planted on the banks of the Arc, bowed its shaggy head above the steep slope extending at its feet? This pine, which protected our bodies with its foliage from the blaze of the sun, ah! may the gods preserve it from the fatal stroke of the woodcutter's axe.
>
> We think that you will come to Aix for the holidays and that then, *nom d'un chien*, then long live joy![8]

156

PAUL CÉZANNE

French, 1839–1906

Satyrs and Nymphs

c. 1867

Oil on canvas, 9¹⁄₁₆ × 11¹³⁄₁₆ inches
(23 × 30 cm)
Christie's, London (as of February
4, 2003)

(Virgil's *Eclogues* begin, "You, Tityrus, lie under the canopy of a sheltering beech / wooing the woodland Muse on slender reed" [*Ecl.* 1.1–2]).[9] The following year, Cézanne nostalgically sketched boys bathing on the last page of a letter to Zola (fig. 158), perhaps his first treatment of the bather theme.[10]

Smith has noted that Cézanne and Zola modeled themselves in a competitive exchange on the dialogues of Virgil's protagonists.[11] In 1858 Cézanne wrote a poem to his friend, which he prefaced, "I see that after my brush, my pen can say nothing good and today I should attempt in vain":

> To sing to you of some forest nymph
> My voice it is not sweet enough
> And the beauties of the countryside
> Whistle at those lines in my song
> That are not humble enough.[12]

It is this poetic dreaminess, in contrast to the formidable powers of observation, that laid the foundations of Cézanne's art. Paul Gauguin, who, with the exception of Henri Matisse, understood and mined Cézanne better than any other artist, recognized the importance of Cézanne's connection with Virgil better than most:

> Behold Cézanne the misunderstood, the essentially mystical nature of the Orient (his
> face resembles an old man from the Levant), he cherishes in forms a mystery and a heavy
> tranquility like a man reclining to dream, his color is grave like the character of Orientals;
> a man of the Midi, he spends entire days on mountaintops reading Virgil and looking at

157
PAUL CÉZANNE
French, 1839–1906
The Judgment of Paris
1883–85
Oil on canvas, 20½ × 24⁷⁄₁₆ inches
(52 × 62 cm)
Lost (presumed destroyed during
World War II)

the sky, also his horizons are high his blues very intense and the red he uses has an astonishing vibration. Like Virgil who has several meanings and can be interpreted at will, the literature of his paintings has a parabolic meaning with two aims; his foundations are as imaginative as they are real. To sum up, when one sees a painting by him one cries out to oneself, Strange but it's madness — Separate mystic writing, *drawing* of same.[13]

This was said in 1885, years in advance of Cézanne's beginning work on *The Large Bathers* now in the Barnes Foundation (c. 1895–1906; see figs. 169, 171), perhaps his most mysterious evocation of Arcadia.

CÉZANNE AND POUSSIN

The documented resources on Cézanne's interest in Poussin are limited. Much of the authority stems from Cézanne's wish to "remake Poussin after nature," a statement reported by Émile Bernard in 1907 and again in 1921, and supported by similar assertions by, among others, Gasquet, the writer Léo Larguier, and the dealer Ambroise Vollard.[14] Bernard was not the first to recount this sentiment; in 1905 the painter Charles Camoin declared that Cézanne, whom he had visited in Aix in 1901 during his military service, sought "to bring Poussin back to life by way of nature," just as Maurice Denis, later that year, called him the "Poussin of still-life and green landscape."[15] But it was Bernard who set in motion the idea of Cézanne's strong association with Poussin.

Technical evidence of Cézanne's connection with Poussin is even sparser. In 1863 Cézanne first registered to make copies in the Louvre, and on April 19, 1864, he requested permission to begin a now-lost copy of Poussin's *Arcadian Shepherds (Et in Arcadia ego)* (see fig. 141).[16] Three drawings by Cézanne after Poussin, two of which are after figures from *The Arcadian Shepherds* (figs. 159, 160)

158
PAUL CÉZANNE
French, 1839–1906
Bathing
Drawing on letter to Émile Zola
June 20, 1859
Ink on paper
Bibliothèque Nationale, Paris

and all of which date to as late as 1887–90, survive from his subsequent visits to the Louvre. A photograph of Poussin's painting still hangs in Cézanne's studio at Les Lauves, where the artist moved in 1902.[17]

If Bernard, through his widely circulated recollections, set in motion the idea of Cezanne's strong link to Poussin, it was Gasquet who broadcast the notion with greater conviction, in part due to his regionalist sentiments as a native of Aix and his conservative politics, which made Provence, not France, his *patrie* (homeland), and Cézanne his hero.[18] Gasquet's father, Henri, was a childhood friend of Cézanne's, and the artist painted both Henri's and Joachim's portraits in 1896.[19] Cézanne and the younger Gasquet maintained a friendship for about five years, but drifted apart in the early 1900s. We know from Cézanne's courteous response that the younger Gasquet had sent him a copy of his book of poems *Les chants séculaires* (1903), which includes a paean to Poussin that begins "Poussin, when I think of you, I see Arcadia once more," and quickly sweeps on to celebrate the master in terms of the author's homeland:

> And that, to awaken our land that sleeps,
> Under these trees bathed in an austere dream
> You painted the shepherds of a new golden age.
> Oh the most noble ideal, lost Arcadia![20]

Gasquet did not publish anything on Cézanne until 1921 (by which time the relationship of Cézanne and Poussin was generally assumed), when Bernheim-Jeune printed his biography of the artist.[21] Despite the time lapse between the end of the two men's friendship and the book's publication, as well as the inventive flair of the author's writing, Gasquet's text still offers a

159, 160
PAUL CÉZANNE
French, 1839–1906
After Poussin: Arcadian Shepherd (left) and *Arcadian Shepherdess* (right)
From sketchbook BS II, pages L verso (left) and XLVII verso (right)
1887–90
Graphite on paper, 8¼ × 4¹³⁄₁₆ inches (20.9 × 12.2 cm) (left); 7¹⁵⁄₁₆ × 4¹³⁄₁₆ inches (20.2 × 12.2 cm) (right)
Kunstmuseum Basel, Kupferstich-kabinett

161
NICOLAS POUSSIN
French, 1594–1665
Detail of *The Arcadian Shepherds (Et in Arcadia ego)* (fig. 141)
c. 1638
Oil on canvas, 33⁷⁄₁₆ × 47⅝ inches (85 × 121 cm)
Musée du Louvre, Paris

wonderfully urgent celebration of Cézanne in the company of Poussin. The book, written largely between 1912 and 1913, is divided into two parts—a biographical overview of Cézanne, followed by an invented dialogue between the author and the artist, in which Gasquet portrayed Cézanne as speaking directly, here on his association with Poussin:

> A Provençal Poussin, that would fit me like a glove . . . Time and again I've wanted to rework the *Ruth and Boaz* motif . . . As in his *Triumph of Flora*, I'd like to link the curve of women's bodies with the shoulders of hills, or give the delicacy of an Olympian plant and the heavenly ease of a Virgilian line to a girl gathering fruit, as in his *Autumn* . . . Puvis owes a lot to that *Autumn* . . . I'd like to combine melancholy and sunshine . . . There's a sadness in Provence which no one has expressed; Poussin would have shown it in terms of some tomb, underneath the poplars of the Alyscamps . . . I'd like to put reason in the grass and tears in the sky, like Poussin . . . But you have to learn to be content with what you've got . . . You really need to see and feel your subject very clearly, and then if I express myself with distinction and power, there's my Poussin, there's my classicism.[22]

The best occasion to test the relationship between Cézanne and Poussin was the beautiful exhibition *Cézanne and Poussin: The Classical Vision of Landscape* at the National Gallery of Scotland in Edinburgh in 1990.[23] The oddity of this exhibition's fruitful line of thought is that there are only a handful of what could be called pure landscapes by Poussin, since the great majority of his work comprises narrative figure paintings, just as about one-third of Cézanne's oeuvre is dedicated to invented figurative narratives. The exhibition, however, confronted the bias toward figurative

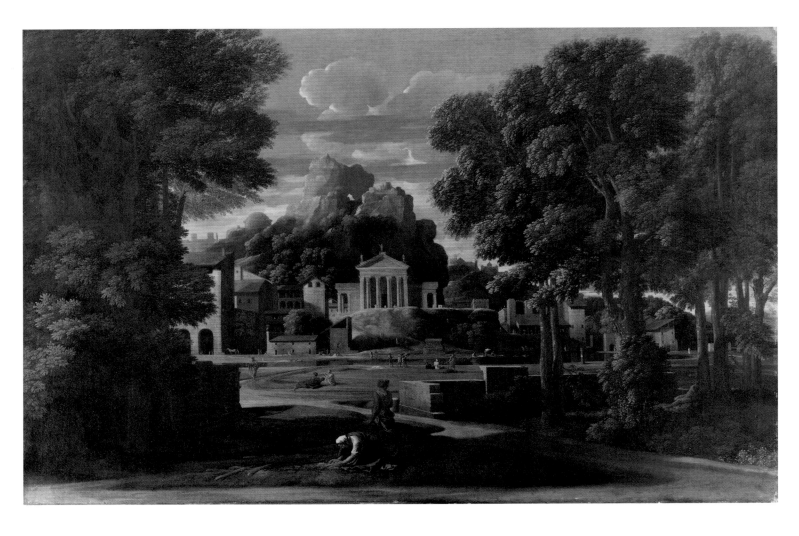

162

NICOLAS POUSSIN

French, 1594–1665

Landscape with the Ashes of Phocion

1648

Oil on canvas, 45⅞ × 70¼ inches
(116.5 × 178.5 cm)

Walker Art Gallery, Liverpool.
Purchased with the help of the
Art Fund and National Heritage
Memorial Fund

comparisons by pairing paintings that convey the artists' shared skill in treating, with great harmony and authority, monumental blocks of architectural elements, or crops of trees and bending roads—as in Poussin's *Landscape with the Ashes of Phocion* (1648; fig. 162) and Cézanne's *Mont Sainte-Victoire and the Viaduct of the Arc River Valley* (1882–85; fig. 163). In many ways, such juxtapositions confirmed Theodore Reff's early view that, "if Cézanne admired and studied Poussin, it was not as the creator of a specific classical style which he attempted to revive, but for those qualities of harmony and completeness in composition and orderliness in procedure that he shared," he hastened to add, "with many old masters," including Paolo Veronese and Peter Paul Rubens. (Reff, not wanting to exaggerate the Cézanne-Poussin relationship, noted the twenty-seven surviving drawings by Cézanne after Rubens, versus the three after Poussin.)[24]

Indeed, in their rustic glee, nearly all Cézanne's early Arcadian pictures, whether pastoral or antic, more apparently depend on Virgil's poetry (as Gauguin reminded us of the "several" Virgils to be found—happy, alluring, sexy) than on Poussin's paintings. And their freewheeling raucousness and direct interaction of figures, as seen in Cézanne's broadly worked sketch *Three Bathers* (c. 1875; see fig. 1), are more Rubens via Eugène Delacroix than Poussin. This is not to say that by the 1870s Cézanne did not have a complete grasp on Poussinesque nobility, with works, such as *Bathers* in the Metropolitan Museum of Art in New York (1874–75; fig. 164)—a more discrete, female variant of the larger, male version at the Barnes Foundation (*Bathers at Rest* of 1876–77; fig. 165)—whose gravity and solidity equal those of Poussin (and whose chaste refinement is

163

PAUL CÉZANNE

French, 1839–1906

*Mont Sainte-Victoire and
the Viaduct of the Arc River
Valley*

1882–85

Oil on canvas, 25¾ × 32⅛ inches
(65.4 × 81.6 cm)

The Metropolitan Museum of
Art, New York. H. O. Havemeyer
Collection, Bequest of Mrs. H. O.
Havemeyer, 1929 (29.100.64)

perhaps a nod to Pierre Puvis de Chavannes). In turn, it is tempting to see the pose of the figure on the right in *Bathers at Rest* as an echo, in reverse, of that of the shepherd in red in Poussin's *Arcadian Shepherds* (see fig. 161).

The Poussin association becomes truly salient (necessary for some) in Cézanne's figurative paintings created during the last decade of his life, in which the opposing forces of vigor and restraint—the Dionysian and Apollonian, if you will—that he negotiated early in his career come into degrees of balance with bathers that are nonspecific in time, elevated and noble, but also animated as if in connection to an offstage narrative (see, for example, his *Group of Bathers* of about 1895; fig. 166).[25] This realization is no better introduced here than with Cézanne's frieze of male bathers of about 1900–1902 (fig. 167), which combines a vibrant energy with an equally balletic elegance, and whose format and composition are reminiscent of classical sarcophagi—or, say, Poussin's *Bacchanalian Revel before a Term* (1632–33; fig. 168).[26]

It is with Cézanne's most ambitious painting, *The Large Bathers* at the Philadelphia Museum of Art (1900–1906; see page xii and fig. 155), that comparison with Poussin comes into full view, with remarkable critical approval, almost consensus. (Even for Reff, who was largely skeptical of the extent of the Cézanne-Poussin relationship, this painting is hard to imagine without Poussin.)[27] T. J. Clark, in his wonderfully confessional description of his struggles to come to terms with Cézanne's late bathers, declared that "Rubens—Cézanne's hero of heroes—is finally kept at bay in the Philadelphia picture. This *is* more like Poussin redone after nature, whereas in the Barnes

164

PAUL CÉZANNE

French, 1839–1906

Bathers

1874–75

Oil on canvas, 15 × 18⅛ inches (38.1 × 46 cm)

The Metropolitan Museum of Art, New York. Bequest of Joan Whitney Payson, 1975 (1976.201.12)

165

PAUL CÉZANNE

French, 1839–1906

Bathers at Rest

1876–77

Oil on canvas, 32⁵⁄₁₆ × 39⅞ inches (82 × 101.3 cm)

The Barnes Foundation, BF906

166

PAUL CÉZANNE

French, 1839–1906

Group of Bathers

c. 1895

Oil on canvas, 8⅛ × 12⅛ inches
(20.6 × 30.8 cm)

Philadelphia Museum of Art.
The Louise and Walter Arensberg
Collection, 1950-134-34

167

PAUL CÉZANNE

French, 1839–1906

Bathers

c. 1900–1902

Oil on canvas, 7⅞ × 13 inches
(20 × 33 cm)

Private collection

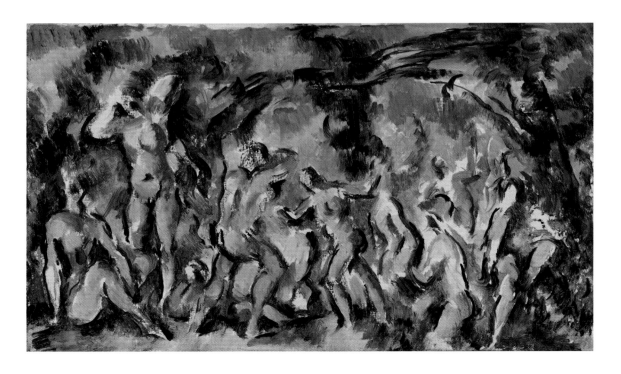

168

NICOLAS POUSSIN

French, 1594–1665

A Bacchanalian Revel before a Term

1632–33

Oil on canvas, 38⁹⁄₁₆ × 56¼ inches (98 × 142.8 cm)

National Gallery, London. Bought 1826

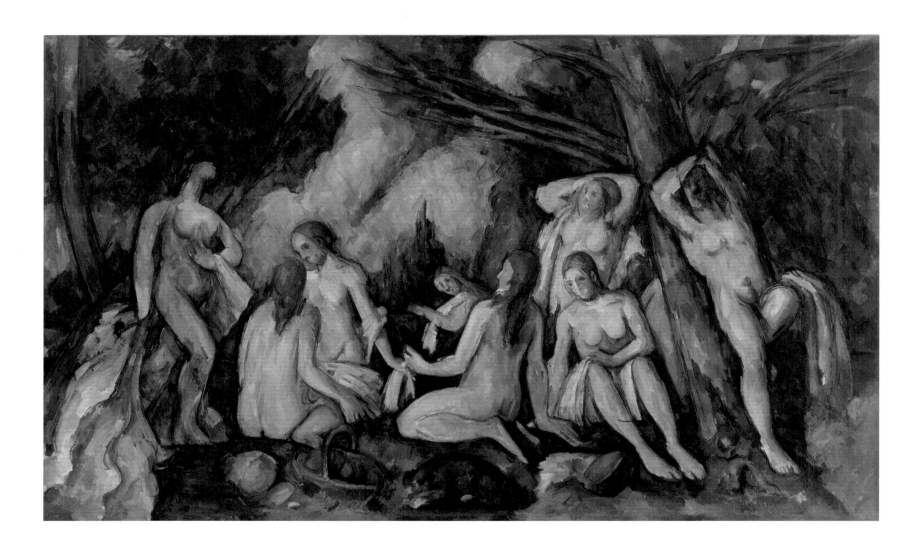

169

PAUL CÉZANNE

French, 1839–1906

The Large Bathers

c. 1895–1906

Oil on canvas, 4 feet 4⅛ inches × 7 feet 2¼ inches (1.33 × 2.19 m)

The Barnes Foundation, BF934

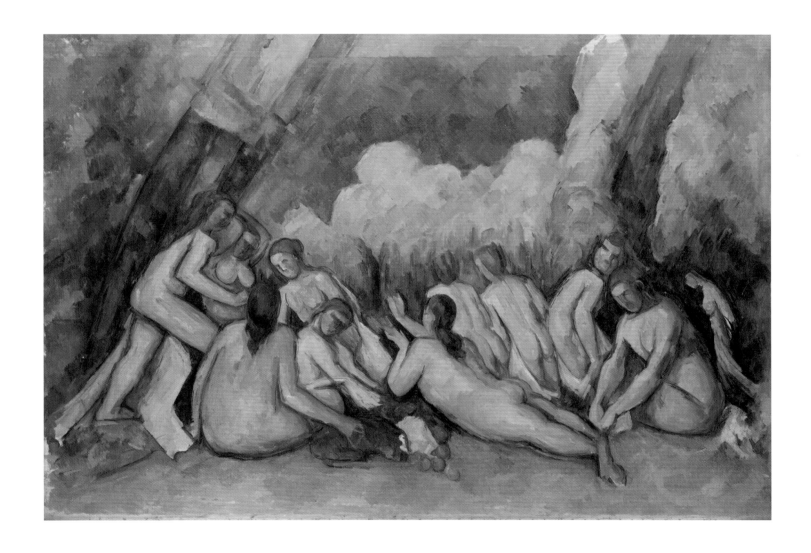

170

PAUL CÉZANNE

French, 1839–1906

The Large Bathers

1894–1905

Oil on canvas, 4 feet 2 1/16 inches × 6 feet 5 3/16 inches (1.28 × 1.96 m)

National Gallery, London. Purchased with a special grant and the aid of the Max Rayne Foundation, 1964

[see fig. 169] we are still essentially in [Rubens's] *Garden of Love*, or exploring another allegory of *Peace and War*."[28]

We can expand Clark's view by saying that the splendid and opulent Barnes *Large Bathers*, in its drama and profound sensuality, fulfilled so much of what had concerned Cézanne in his early investigations of bathers. This leaves *The Large Bathers* in the National Gallery in London (1894–1905; see fig. 170), the greatest enigma among the three ambitious pictures that concerned Cézanne so profoundly in the early twentieth century. The London painting, whose figures form a mass of blocked energy within a static and dense space, is the most free from precedents and, as such, the most forward-looking.

It is difficult to overlook how comfortably and engagingly the Philadelphia *Large Bathers*— the fated culmination of the Cézanne-Poussin exploration in both formal and poetic terms— pairs with Poussin's *Apollo and Daphne* (*Apollon amoureux de Daphné*) (1664; see fig. 136), with its exalted theater and harmonic complexity. The comparison not only resides in the compositional similarities of the pictures—the principals, Apollo for Poussin, the striding woman (Diana?) for Cézanne, both in bold profile on the left; and the reclining figures in the foreground forming inversed arches, which end on the right with two standing figures—but also in the ease with which the drama plays out in the Poussin and, by implication, in the Cézanne (even with potentially disruptive subplots introduced at backstage center in both pictures, a murder for Poussin and a single swimmer with two mysterious witnesses for Cézanne).[29] But perhaps most engaging in this comparative speculation is the essential sense of "stage business"—interactions, entrées and exits, characterizations—that concerned both artists, literally for Poussin, who of course was following a plotted text, and implicated but no less programmed for Cézanne, who perhaps was remembering one or several poems or plays, while keeping a discreet distance from his sources. Here is Cézanne's legacy—a legacy that would mean so much to Gauguin and Matisse, albeit in such different ways, not only in his making of great and lasting structures, but also in his self-conscious positioning of his art between antiquity and the modern age.

1. Schapiro referred to Cézanne's *Judgment of Paris* as *The Amorous Shepherd*, given the abundant number of apples the painting's protagonist holds (Paris need have only one). Schapiro, "The Apples of Cézanne: An Essay on the Meaning of Still-Life," in *Modern Art: 19th and 20th Centuries*, Selected Papers, no. 2 (New York: George Braziller, 1979), pp. 1–38.

2. Athanassoglou-Kallmyer, "Arcadia," in *Cézanne and Provence: The Painter in His Culture* (Chicago: University of Chicago Press, 2003), pp. 187–232; and Smith, "Joachim Gasquet, Virgil and Cézanne's Landscape: 'My Beloved Golden Age,'" *Apollo*, October 1998, pp. 11–23.

3. On the Cézanne-Poussin relationship, see esp. Richard Shiff, "The Poussin Legend," in *Cézanne and the End of Impressionism: A Study of the Theory, Technique, and Critical Evaluation of Modern Art* (Chicago: University of Chicago Press, 1984), pp. 175–84; Theodore Reff, "Cézanne and Poussin," *Journal of the Warburg and Courtauld Institutes*, vol. 23, nos. 1–2 (January–June 1960), pp. 150–74, and

"Cézanne et Poussin," *Art de France*, vol. 3 (1963), pp. 302–10; and Richard Verdi, *Cézanne and Poussin: The Classical Vision of Landscape*, exh. cat. (Edinburgh: National Galleries of Scotland, 1990).

4. In a poem to his friend Émile Zola, Cézanne mocked their childhood studies: "Wasn't it enough that Horace and Virgil, / Tacitus and Lucan, forced us for eight years / To look upon their torturous texts, / Without your adding yourself [i.e., the law] to [my unhappiness]!" Cézanne to Zola, December 7, 1858, in *Paul Cézanne: Letters*, ed. John Rewald, 4th ed. (1976; repr., New York: Da Capo, 1995), pp. 353–54, quoted in Athanassoglou-Kallymer, "Arcadia," p. 192.

5. Theodore Reff, "Reproductions and Books in Cézanne's Studio," *Gazette des beaux-arts*, vol. 56 (1960), p. 307. For all the awards Cézanne received for his excellence in Greek and Latin, see Gerstle Mack, *Paul Cézanne* (New York: Albert A. Knopf, 1935), pp. 19–20.

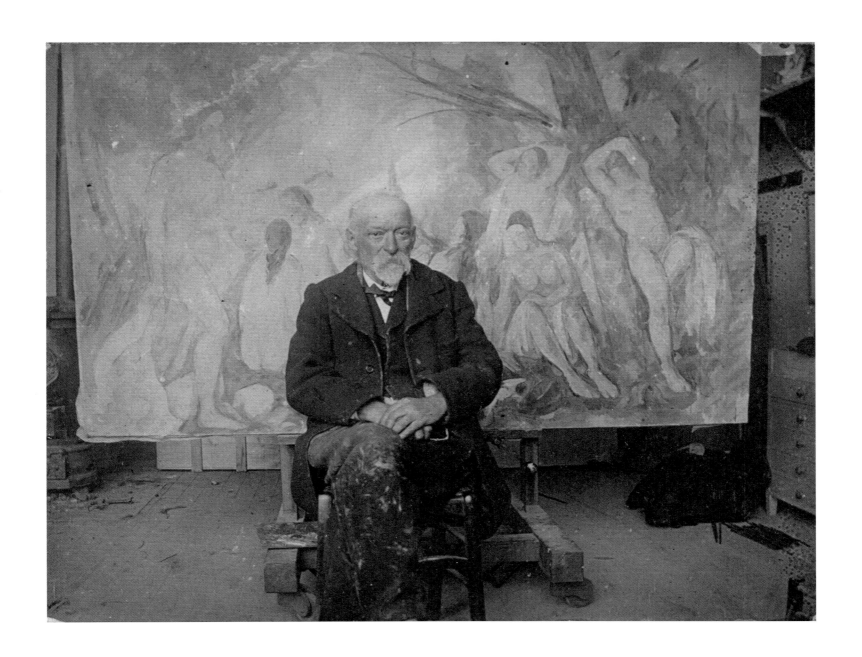

171

Cézanne in front of *The Large Bathers* (fig. 169) in his studio at Les Lauves in Aix

1904

Photograph by Émile Bernard (French, 1868–1941)

Silver print, 3¼ × 4³⁄₁₆ inches (8.2 × 10.7 cm)

Musée d'Orsay, Paris. Gift of the Société des Amis du Musée d'Orsay, 1994

6. "As you have translated Virgil's Second Eclogue, why not send it to me? Thank God, I am not a young girl and I shall not be shocked." Zola to Cézanne, December 30, 1859, in Rewald, *Paul Cézanne*, p. 47. Because the letters from Cézanne to Zola dating from the end of 1859 through 1862 are lost, it is unknown if Cézanne responded to Zola's request.

7. The phrase "the three inseparables" comes from Zola's novel *L'oeuvre*, which is widely regarded as a fictionalized account of the author's relationship with Cézanne: "Au college de Plassans, dès leur huitième, il y avait eu les trois inséparables, comme on les nommait, Claude Lantier, Pierre Sandoz et Louis Dubuche." Zola, *L'oeuvre* (Paris: G. Charpentier, 1886), p. 34. On Cézanne's boyhood friendships, see Wayne V. Anderson, *The Youth of Cézanne and Zola: Notoriety at Its Source; Art and Literature in Paris* ([Geneva]: Éditions Fabriart, 2003).

8. Cézanne to Zola, April 9, 1858, in Rewald, *Paul Cézanne*, pp. 17–18. On this letter and Cézanne's descriptions of pines in relation to Virgil's *Eclogues*, see Smith, "Joachim Gasquet," pp. 13–14.

9. Virgil, *Eclogues, Georgics, Aeneid I–VI*, vol. 1 of *Works*, trans. H. Rushton Fairclough, Loeb Classical Library (London: W. Heinemann, 1916).

10. For Cézanne's letter, see Cézanne to Zola, June 20, 1859, in Rewald, *Paul Cézanne*, pp. 37–40. See also Adrien Chappuis, *The Drawings of Paul Cézanne: A Catalogue Raisonné* (Greenwich, CT: New York Graphic Society, 1973), vol. 1, p. 62, cat. 38; vol. 2, cat. 38 (illus.).

11. According to Smith, Cézanne and Zola took on the personalities of characters from Virgil's first *Eclogue*—Cézanne, the "rustic" Meliboeus, and Zola, the "modern" Tityrus. Smith, "Joachim Gasquet," p. 14.

12. Cézanne to Zola, [month unknown] 29, 1858, in Rewald, *Paul Cézanne*, p. 23.

13. Gauguin to Émile Schuffenecker, January 14, 1885, in *Correspondance de Paul Gauguin, documents, témoignages*, ed. Victor Merlhès (Paris: Fondation Singer-Polignac, 1984), p. 88, trans. and quoted in Françoise Cachin, "A Century of Cézanne Criticism: From 1865 to 1906," in *Cézanne*, ed. Françoise Cachin and Joseph J. Rishel, exh. cat. (Philadelphia: Philadelphia Museum of Art, 1996), pp. 28–29. At the time of writing this appraisal, Gauguin owned six works by Cézanne. See Merete Bodelsen, "Gauguin's Cézannes," *Burlington Magazine*, vol. 104, no. 107 (May 1962), pp. 204, 206–9, 211, and "Gauguin, the Collector," *Burlington Magazine*, vol. 112, no. 810 (September 1970), pp. 605–6.

14. The best-known iteration of Cézanne's statement is based on Bernard's recollection published in 1921: "So I saw myself obliged to postpone my project of Poussin entirely remade after nature, and not built from notes of drawings and bits of studies" (Je me suis donc vu forcer d'ajourner

mon projet du Poussin entièrement refait sur nature, et non point construit de notes de dessins et de fragments d'études). Cézanne, quoted in Bernard, "Une conversation avec Paul Cézanne," in *Souvenirs sur Paul Cézanne* (Paris: R. G. Michel, 1925), pp. 122–23; quoted in Reff, "Cézanne and Poussin," p. 151 (my translation). Bernard's article originally was published in *Mercure de France*, June 1, 1921, pp. 372–97. A different version of this statement appears in an earlier (and, according to Reff, more reliable) article by Bernard of 1907: "Imagine Poussin remade entirely after nature; there is the classical I know" (Imaginez Poussin refait entièrement sur nature, voilà le classique que j'entends). Cézanne, quoted in Bernard, "Souvenirs sur Paul Cézanne et letters inédites," in Bernard, *Souvenirs sur Paul Cézanne*, pp. 87–88; quoted in Reff, "Cézanne and Poussin," p. 152 (my translation). The article originally was published in two parts in *Mercure de France*, October 1, 1907, pp. 385–404; October 16, 1907, pp. 606–27. For an English translation of the article, see Bernard, "Memories of Paul Cézanne," in *Conversations with Cézanne*, ed. Michael Doran, trans. Julie Lawrence Cochran (Berkeley: University of California Press, 2001), pp. 51–79. Reff has suggested that Gasquet's, Larguier's, and Vollard's versions of Cézanne's statement derive from Bernard's recollections, and that all these sources are "suspect." Reff, "Cézanne and Poussin," p. 151.

15. "Vivifier Poussin sur nature." Camoin, trans. and quoted in Shiff, "Poussin Legend," p. 181. According to Shiff, Camoin said this in response to the question, "What do you make of Cézanne?," which Charles Morice had posed in an article in *Mercure de France*. See ibid., pp. 181, 181n31; and Morice, "Enquête sur les tendances actuelles des arts plastiques," *Mercure de France*, August 1, 1905, pp. 353–54. For Denis's statement ("le Poussin de la nature morte et du paysage vert"), see Denis, "De Gauguin, de Whistler et de l'excès de théories" (1905), in Denis, *Théories, 1890–1910: Du symbolisme et de Gauguin vers un nouvel ordre classique*, 4th ed. (Paris: L. Rouart et J. Watelin, 1920), p. 204, trans. and quoted in Shiff, *Cézanne*, p. 181. Denis's article originally was published as "La peinture," *Chronique de l'Ermitage*, no. 11 (November 15, 1905), pp. 309–19. Richard Shiff and Richard Verdi have drawn attention to several figures, including Camoin, who commented on Cézanne's idea of remaking Poussin "after nature" before Bernard did—for example, the artist Francis Jourdain in 1904 and the collector Karl Ernst Osthaus in 1906. See Shiff, *Cézanne*, pp. 180–82; and Verdi, "Cézanne and Poussin: The Critical Context," in Verdi, *Cézanne and Poussin*, pp. 57–58.

16. See Theodore Reff, "Copyists in the Louvre, 1850–1870," *Art Bulletin*, vol. 46, no. 4 (December 1964), p. 555.

17. Cézanne's third surviving drawing after Poussin is after a fragment of a painting known as *The*

Concert (c. 1626–27; Musée du Louvre, Paris) from his *Venus and Mercury* (c. 1626–27; Dulwich Picture Gallery, London). For more on these three surviving drawings, see Chappuis, *Drawings*, vol. 1, p. 233, cats. 1011–13; vol. 2, cats. 1011–13 (illus.). Chappuis dated the drawings to 1887–90, but Reff has suggested that, based on their style, they were done slightly later, between 1890 and 1895. If Reff's dating is correct, then Cézanne could have made his drawings of the shepherd and shepherdess from *The Arcadian Shepherds* after his photograph of Poussin's painting rather than the actual canvas in the Louvre. Reff explained that, based on an inscription in the photograph's margin, Cézanne could not have purchased the reproduction of *The Arcadian Shepherds* before 1893. Reff, "Cézanne and Poussin," pp. 171, 171n148. See also Reff, "Reproductions and Books," p. 304.

18. On Gasquet's regionalism and his vision of Provence as Arcadia, see Athanassoglou-Kallmyer, "Arcadia," pp. 215–20. See also Richard Shiff, introduction to *Joachim Gasquet's Cézanne: A Memoir with Conversations*, trans. Christopher Pemberton (London: Thames and Hudson, 1991), pp. 15–24.

19. Cézanne's *Portrait of Joachim Gasquet* (1896; Národní Galerie, Prague) and *Portrait of Henri Gasquet* (1896; McNay Art Museum, San Antonio) are reproduced in John Rewald, *The Paintings of Paul Cézanne: A Catalogue Raisonné* (New York: Harry N. Abrams, 1996), vol. 1, pp. 486–88, cats. 809–10; vol. 2, pp. 280–81 (illus.).

20. Cézanne, in his note to Gasquet, wrote, "So far I have only been able to leaf though your poem. You have acquired the title of a young master . . . The artistic movement which Louis Bertrand characterises so well in his fine preface, which precedes the 'Chants Séculaires' is full of determination. March on and you will continue to open for the arts a new road leading to the Capitol." Cézanne to Gasquet, June 25, 1903, in Rewald, *Paul Cézanne*, p. 296. Gasquet's paean in the original French reads: "Poussin, je pense à toi, je revois l'Arcadie, / . . . / Et que, pour éveiller notre pays qui dort, / Sous ces arbres baignés d'austère reverie / Tu peignis les bergers d'un nouvel âge d'or. / O trop noble idéal, impuissante Arcadie!" Gasquet, "Nicolas Poussin," in *Les chants séculaires* (Paris: Société Éditions Littéraires et Artistiques, 1903), pp. 15–16 (my translation).

21. Gasquet, *Cézanne* (1921; repr., Paris: Éditions Bernheim-Jeune, 1926). For an English translation, see Pemberton, *Joachim Gasquet's Cézanne*.

22. Gasquet, "The Studio," in Pemberton, *Joachim Gasquet's Cézanne*, p. 211. The paintings by Poussin to which Gasquet's text refers are *The Four Seasons: Summer (Ruth and Boaz)* of 1660–64, *The Triumph of Flora* of 1628, and *The Four Seasons: Autumn (The Spies with the Grapes of the Promised Land)* of 1660–64, all of which are in the Musée du Louvre, Paris.

23. The exhibition was on view from August 9 to October 21, 1990. For the exhibition catalogue, see Verdi, *Cézanne and Poussin*. For the proceedings of the symposium held in conjunction with the exhibition, see Richard Kendall, ed., *Cézanne and Poussin: A Symposium* (Sheffield, UK: Sheffield Academic Press, 1993).

24. Reff, "Cézanne and Poussin," pp. 160–61. For Cézanne's drawings after Rubens, see Gertrude Berthold, *Cézanne und die alten Meister* ([Stuttgart]: W. Kohlhammer, [1958]), nos. 204–31.

25. On Cézanne's figurative pictures in relation to Poussin, see Katia Tsiakma, "Cézanne's and Poussin's Nudes," *Art Journal*, vol. 37, no. 2 (Winter 1977–78), pp. 120–32.

26. Ker Xavier Roussel, himself a near specialist in bacchantic animation, reproduced Cézanne's *Bathers* (fig. 167) in a lithograph of 1914. See Christian Geelhaar, "The Painters Who Had the Right Eyes: On the Reception of Cézanne's Bathers," in *Paul Cézanne: The Bathers*, by Mary Louise Krumrine, exh. cat. (New York: Harry N. Abrams, 1990), pp. 288–89, fig. 219.

27. See Reff, "Cézanne and Poussin" (1960), p. 173. In 1963 Reff revisited his stance on the Cézanne-Poussin relationship, concluding that Poussin's influence is most relevant in relation to the modes of expression in Cézanne's figurative works, not his landscapes, noting in particular Poussin's and Cézanne's parallel developments from "romantic" to "classical" treatments of the figure. It is important to keep in mind, however, that in this second article, Reff claimed that the human figure is essentially perfunctory (*sommaire*) in all three *Large Bathers*, suggesting a distinction between Cézanne's aesthetic principles and those of Poussin. Reff, "Cézanne et Poussin" (1963), pp. 302–3.

28. Clark, "Freud's Cézanne" (1995), in *Farewell to an Idea: Episodes from a History of Modernism* (New Haven, CT: Yale University Press, 1999), p. 159. Clark's statement refers to Rubens's *The Garden of Love* of about 1633 (Museo Nacional del Prado, Madrid) and his allegorical depictions of peace and war, such as *Minerva Protects Pax from Mars (Peace and War)* of 1629–30 (National Gallery, London) and *The Horrors of War* of about 1637–38 (Palazzo Pitti, Florence).

29. As Charles Dempsey explains in his essay in this catalogue, the murder is that of the prince Leucippus, who loved Daphne despite her sworn chastity and disguised himself as a woman to spend time with her. When his true identity was discovered, he was killed by two of Daphne's nymphs. See Dempsey, "The Painter's Arcadia," in this volume, p. 140. See also Charles Dempsey and Elizabeth Cropper, "Death in Arcadia," in *Nicolas Poussin: Friendship and the Love of Painting* (Princeton, NJ: Princeton University Press, 1996), pp. 304–7.

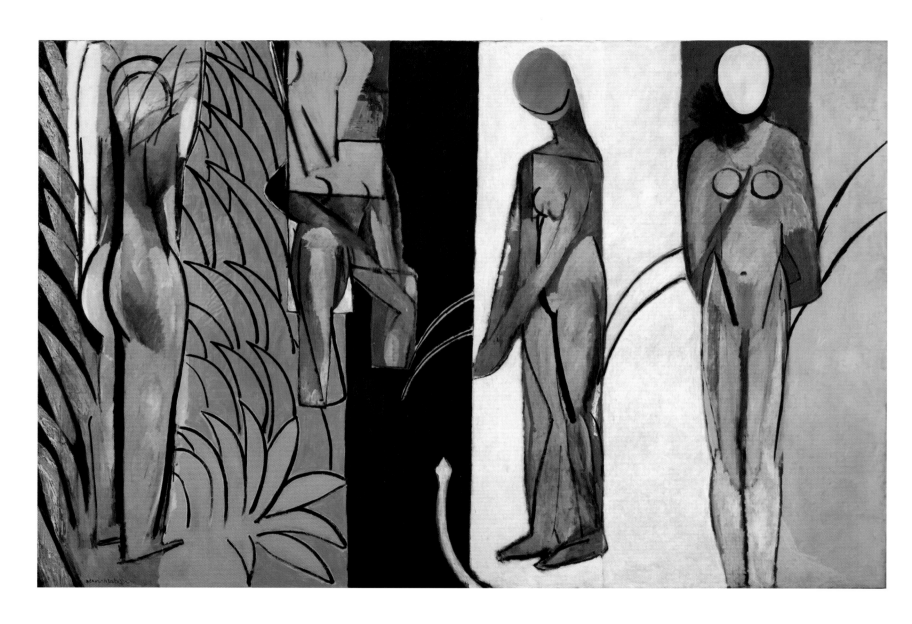

172

HENRI MATISSE
French, 1869–1954

Bathers by a River

March 1909–10, May–November 1913, and early spring 1916–October(?) 1917

Oil on canvas, 8 feet 6⅜ inches × 12 feet 10⁵⁄₁₆ inches (2.6 × 3.92 m)

The Art Institute of Chicago. Charles H. and Mary F. S. Worcester Collection, 1953.158

RE-VISIONING ARCADIA
Henri Matisse's *Bathers by a River*

STEPHANIE D'ALESSANDRO

Throughout his career Henri Matisse created numerous works related to the theme of Arcadia, from his decorative paintings of 1904–5 to his 1932–33 *Dance* mural for Albert C. Barnes (see fig. 66) to his large-scale paper cutouts of the 1950s. However, no other work held as significant a place or had as deep a connection to the theme as *Bathers by a River* (1909–10, 1913, 1916–17; see pages xiii–xiv and fig. 172), a canvas that may be best understood in relation to a statement made by the artist in 1936, at the time of his gift of Paul Cézanne's *Three Bathers* (1879–82; see fig. 2) to the Musée des Beaux-Arts de la Ville de Paris du Petit Palais. In his letter to the museum's director, Raymond Escholier, Matisse tried to summarize how Cézanne's picture had "morally" sustained him over thirty-seven years of ownership and how he had drawn from it "faith" and "perseverance": "Allow me to tell you that this picture is of the first importance in the work of Cézanne because it is a very dense, very complex realization of a composition that he carefully considered in several canvases which . . . are only the studies that culminated in this work."[1]

Indeed, Cézanne's painting was the basis for much of Matisse's work—as inspiration, as compass, and as subject. This was especially true of *Bathers by a River*, a painting Matisse likewise rehearsed in a number of earlier works.[2] In many ways, it was Matisse's ode to Cézanne, the great maker of bather compositions, as well as to other artists he respected who had painted the popular theme of Arcadia before him. But what was different for Matisse, as suggested in his statement on Cézanne's painting, was his change in emphasis: Whereas Cézanne painted his bather compositions across many canvases, Matisse focused on just one. Over a period of nearly eight years he returned to the same painting, reconsidering the theme and the composition at each stage. In doing so, he transformed not only the image but also the subject of Arcadia, moving it from a potent symbol for many to something for him alone—from Arcadia to bathers—and to a powerful vehicle for his formal experimentation. It is precisely in its density and complexity of both theme and realization that *Bathers by a River* deserves special consideration.

To appreciate the critical place of *Bathers by a River*, we must acknowledge the historical context in which Matisse conceived this work. The artist began to explore the theme of Arcadia around 1900.[3] For Matisse and his peers, the image of an idyllic golden age could be found in the south of France, where in the early 1900s he traveled to paint and which provided artistic inspiration

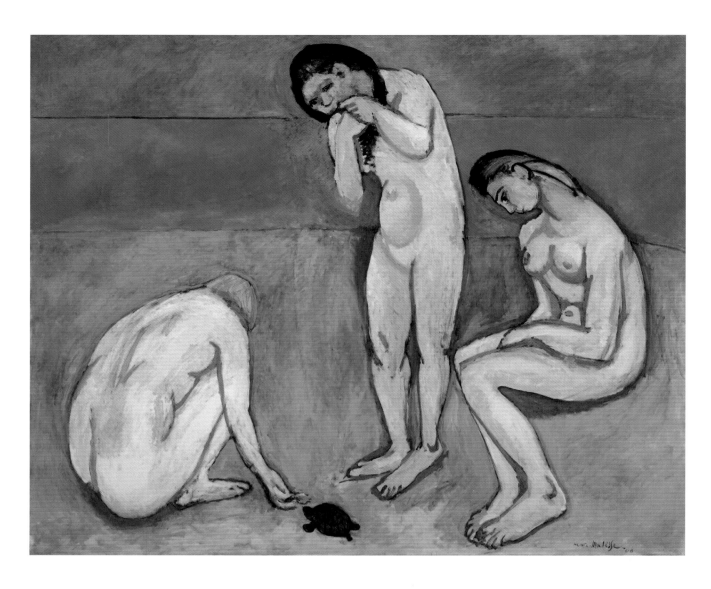

173
HENRI MATISSE
French, 1869–1954
Bathers with a Turtle
1907–8
Oil on canvas, 5 feet 11½ inches ×
7 feet 3 inches (1.81 × 2.2 m)
Saint Louis Art Museum. Gift of
Mr. and Mrs. Joseph Pulitzer, Jr.,
24:1964

for his first major paintings, *Luxe, calme et volupté* (1904–5; see fig. 57) and *Le bonheur de vivre* (1905–6; see fig. 58). The connection between bather compositions and the golden-age theme was clear to the artist: He identified the origin of the first painting's title in Charles Baudelaire's poem of pastoral idyll, "L'invitation au voyage" ("Invitation to the Voyage"; 1857), and he referred to the second, at least while it was underway, as "Arcadia."[4] Matisse looked to Cézanne for this theme, as well as to Nicolas Poussin, Pierre Puvis de Chavannes, and other classical and classically inspired artists whom he admired. At the same time, Matisse's appreciation of the theme drew upon romanticized notions of the noble savage as well as realities that were fueled by colonialist activities in nineteenth-century France. These associations were emboldened more immediately by the example of Paul Gauguin, whose work Matisse knew particularly well through his relationship with Gauguin's friend the painter Georges-Daniel de Monfreid, who owned a number of paintings and sculptures by Gauguin and who was preparing a major exhibition of the artist's work for Germany in the summer of 1905. Indeed, Matisse's knowledge of Gauguin's work was so direct that French painter Gustave Fayet invited him to make a new edition of the woodcuts for *Noa Noa*, Gauguin's ode to an unspoiled Arcadia, set in Tahiti.[5] Matisse would reference both primitive and classical Arcadia in his own work, with *Blue Nude (Memory of Biskra)* (1907; Baltimore Museum of Art) as an example of the former, and *Le Luxe I* and *Le Luxe II* (both of 1907; respectively, Musée

174

HENRI MATISSE
French, 1869–1954

Game of Bowls

1908
Oil on canvas, 44⅝ × 57⅛ inches
(113.5 × 145 cm)
The State Hermitage Museum,
Saint Petersburg

National d'Art Moderne, Centre Georges Pompidou, Paris, and Statens Museum for Kunst, Copenhagen), as examples of the latter.

By excerpting and then continually repainting, à la Cezanne, smaller figural (bather) groups from such works as *Luxe, calme et volupté* and *Le bonheur de vivre*, Matisse achieved his goal of paring down forms to their purest and most meaningful state, or, as he wrote in "Notes d'un peintre" (Notes of a painter; 1908), to their "truer, more essential character."[6] It was, however, with his *Bathers with a Turtle* (1907–8; fig. 173) that the artist found a new direction. While he had employed this particular figural group in earlier works, including *Three Bathers* (1907; Minneapolis Institute of Arts), and in the two *Luxe* compositions, he now eliminated the narrative beach and the golden-age context, respectively, and made the figures' poses more ambiguous (the standing figure with her hand in her mouth, for instance, previously stood in profile with a towel at her side). In so doing, Matisse removed any assurance of the figures' peaceful existence. Moreover, he made repeated revisions on the same canvas instead of starting a new one. *Bathers with a Turtle* was the work that Matisse's greatest early patron, Russian businessman Sergei Shchukin, admired in the artist's Paris studio. Disappointed that it was promised to German collector Karl Ernst Osthaus, Shchukin asked the artist to make him a similar canvas, which his patron would call *Bathers* (known today as *Game of Bowls* [1908; fig. 174]). While the composition is smaller in scale

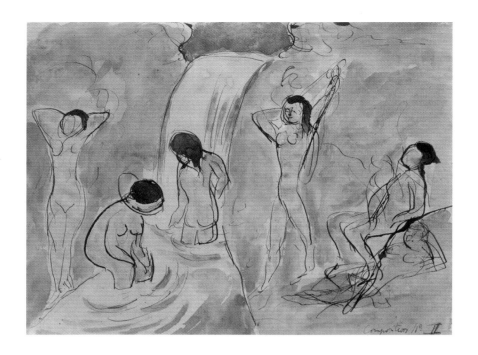

175

HENRI MATISSE
French, 1869–1954

Composition No. II

c. March 11, 1909
Watercolor on paper, 8⅝ × 11⅝ inches
(21.9 × 29.5 cm)
The State Pushkin Museum of Fine
Arts, Moscow

176

HENRI MATISSE
French, 1869–1954

Drawing on verso of letter

c. March 1909
Ink on paper
Archives Henri Matisse

than that of *Bathers with a Turtle*, Matisse repeated and recombined the figural poses of the earlier painting. Referring to the canvas as an *esquisse* (sketch), he tantalized the collector with the possibility of a grander project to come. Indeed, the painting would be instrumental in his achievement of a major commission from Shchukin the following year and, most critical for this discussion, in the inception of *Bathers by a River*.

Although its exact subjects and number of panels would be a matter of discussion between artist and patron for weeks to come, a commission for the staircase of Shchukin's home was firmly in place after a meeting in Matisse's studio in early 1909. Two paintings, *Dance (II)* and *Music* (both of 1910 and in the State Hermitage Museum, Saint Petersburg; for the latter, see fig. 179), would be the eventual result, though uncertainty about the details of the commission existed until April 9, when it finally became clear that the canvas known today as *Bathers by a River* would not be part of the project. A subject related to a golden-age theme had likely been discussed prior to the studio visit, however, for Matisse had started a nearly thirteen-foot-long *equisse* on the subject of dance (*Dance [I]* of 1909; Museum of Modern Art, New York) in preparation for the Shchukin commission. This work gave him the opportunity to merge his interest in harmonious color and organic arabesques as well as the vogue for painted *décorations* (pictures of historical or mythical subjects intended to evoke tranquility and uplift) with the popular theme of Arcadia. Matisse drew upon connections to a mythical pastoral paradise, which he would do again later that summer, when he traveled to Cavalière-sur-Mer in the south of France to work further on the program for Shchukin's decorative panels.

Matisse soon proposed the theme of bathers as a complement to the *Dance* panel, in order to produce an atmosphere of "repose."[7] He made watercolors of the two subjects and sent them to Shchukin in Moscow. The bathers watercolor (*Composition No. II* [c. March 11, 1909; fig. 175]) is the first image of the design that eventually became *Bathers by a River*: five women relaxing near a waterfall, nestled within a verdant, hilly landscape. Two bathe in the water, described in blue with

177

Matisse in front of a very early
stage of *Bathers by a River*
c. March 25, 1909
Archives Henri Matisse

178

X-radiograph of *Bathers by a River*

pink highlights, like that in *Luxe, calme et volupté* and in *Le bonheur de vivre*; ink lines trace working thoughts for figures, whose poses recall those Matisse used in earlier works, such as *Bathers with a Turtle*, as well as those he borrowed from Cézanne's *Three Bathers*. While Shchukin responded that the compositions were "very beautiful" and "noble in color and in line," he rejected the possibility of having paintings of nudity in his home and asked Matisse to "do the same *ronde* [*Dance (I)*], but with the young women in dresses. The same with composition no. 2 [the bathers]."[8] The artist soon devised a new sketch (fig. 176), dressing the two flanking figures in loose drapery, turning the woman in the stream away from the viewer, and eliminating the fifth bather. Matisse seems to have committed quickly to this composition, for, even as the final program of the decorative panels was confirmed, he wrote to Shchukin that he had started on the bathers canvas and would finish it before beginning an initial sketch of *Music*. A photograph showing the artist before a thirteen-foot-wide canvas, taken about March 25, 1909 (fig. 177), documents this early stage of the bathers composition: At left are the dynamic contours of a standing figure who turns her back from the viewer; she swings one arm up and around her head, like bathers in earlier compositions, such as the nymph in the left section of the ceramic triptych that Matisse made for Osthaus in 1907 (see fig. 69). Directly behind the artist's left shoulder is a second figure, who crouches near the water's edge; her face is similar to the standing bather in the *Luxe* compositions. The x-radiograph of *Bathers by a River* (fig. 178) reveals the trace of the first state of the fourth bather, who stands with her arm above her head, holding a towel; her stance is reminiscent of the standing figure in *Game of Bowls*. The palette of the composition was much like that of the watercolor, with light green foliage, a deep blue sky, a turquoise waterfall with pink highlights, a tan riverbed, and figures in warm pink. New to the composition was a yellow snake, menacing the Edenic image.

These documents confirm not only that *Bathers by a River* was part of Matisse's original program for Shchukin's commission by the beginning of April 1909, but also that the artist initiated the canvas well before he began the paintings that eventually decorated the staircase of his patron's home. Still more critical is the special status the picture assumed for the artist: Ultimately freed

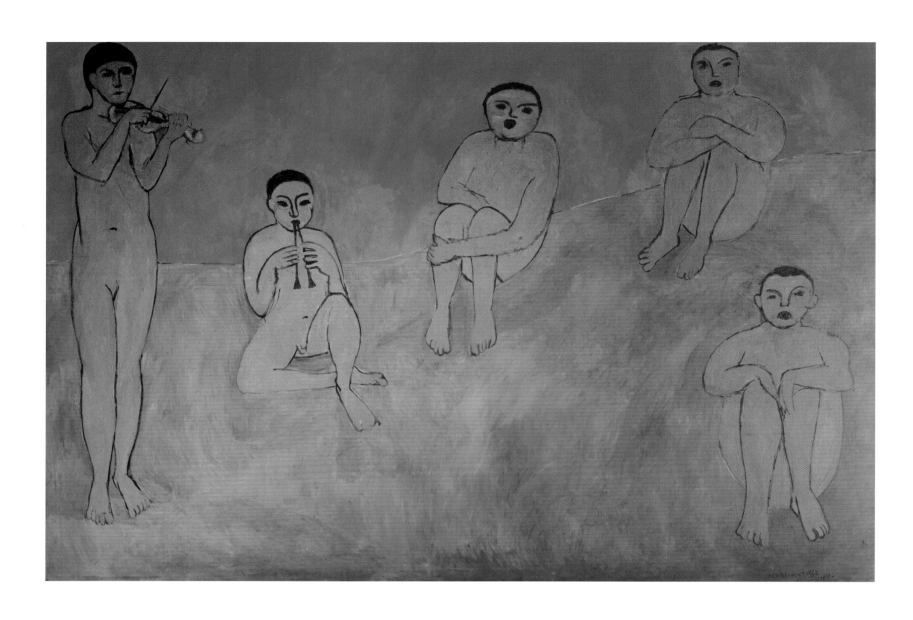

179

HENRI MATISSE

French, 1869–1954

Music

Winter–fall 1910

Oil on canvas, 8 feet 6⅜ inches × 12 feet 9⅛ inches (2.6 × 3.89 m)

The State Hermitage Museum, Saint Petersburg

from his patron's demands and the contractual obligations of his dealer, Matisse used *Bathers by a River* as a vehicle for continuing experimentation. The canvas echoes other works concurrently made in his studio and reflects influences from near and far. It pushed Matisse into unforeseen directions, always in formal dialogue with what was already on the canvas. Thus, the panel suggests his evolving ideas on the theme of Arcadia and ultimately came to represent something altogether different.

In fall 1909 Matisse moved to a new studio in Issy-les-Moulineaux, in the southwest suburbs of Paris. There he resumed work on his large composition in concert with, and in response to, the panels for Shchukin. However, because of his subsequent alterations to the canvas—scraping down abandoned forms and covering others with lead white—only a small constellation of changes can be dated to this moment. The *Bathers* x-radiograph shows that Matisse—responding to the stiffer, more powerfully built figures of *Dance (II)*, which he would have been working on at this time—strengthened the limbs of the figures, especially in the articulation of muscle in the fourth figure's left arm. He also altered the bathers' flesh and the foliage to match the intensified palettes of *Dance (II)* and *Music*. While the artist may have planned to continue *Bathers by a River* after completing Shchukin's panels, by the end of May 1910 he was not finished and he was exhausted as the Salon d'Automne approached. His hard work would not immediately be recognized at the exhibition: Instead, the panels met a negative response from the public and, initially at least, from Shchukin. Given the connection of *Bathers by a River* to this commission, it is not unreasonable to assume that when Matisse escaped Issy for Spain after the debut of *Dance (II)* and *Music*, he did so without having continued further work on the painting. Indeed, it was likely a full three years before he felt the freedom to return to it, bringing with him a different sense of Arcadia.

Matisse did not revisit *Bathers by a River* until May 1913, after he returned from the second of two trips to Morocco. His experiences there revived his consideration of the concept of Arcadia, although in the specific case of Morocco, it was more likely as an ideal that was no longer possible to attain.[9] Documentation suggests that he may have thought about making an Arcadian type of composition—a beach or bather scene—while in Morocco, but he ultimately returned to his canvas in Issy.[10] Upon his homecoming, much of his initial work on the painting reflected his Moroccan pictures as well as other influences around him—most specifically, the renewed presence of Cézanne and Gauguin. Just days after his return to Issy, the Galerie Levesque asked him to contact Shchukin and another Russian collector, Ivan Morozov, about the possibility of acquiring Gauguin's extraordinary *Where Do We Come From? What Are We? Where Are We Going? (D'où venons-nous? Que sommes-nous? Où allons-nous?)* (1897–98; see pages xi–xii and fig. 146).[11] Neither collector acted on the offer, but for Matisse, once again experiencing Gauguin's large-scale, overwhelmingly blue, paradisial canvas—just weeks after returning from Morocco—surely must have spurred him to think again about the direction of his picture. Moreover, the Galerie Bernheim-Jeune invited him to make one of Cézanne's works the subject of a print for a forthcoming publication. Matisse decided to translate a canvas in his own collection, *Fruits and Foliage* (c. 1890; private collection), into a lithograph.[12] While no documentation indicates why he did not choose to copy *Three Bathers*, it is likely that, with his work underway on *Bathers by a River*, he felt Cézanne's painting of bathers was already the subject of significant focus.

Even by mid-May 1913 the transformation of Matisse's composition was dramatic. A series of photographs showing him at work on *Bathers by the River*, taken by the American photographer Alvin Langdon Coburn, documents the degree to which his Moroccan experience influenced his work: In one (fig. 180), the standing figure on the left is now stiffly posed, floating against a dark background that recalls the composition of Matisse's *Fatma, the Mulatto Woman* (1912; private collection).[13] The artist has transformed the bather's once-graceful stance into a more rigid, upright one by blocking out the flesh and musculature of earlier limbs with dark, wedge-shaped forms; this exaggerated modeling suggests the dramatic effect of highlights and shadows he witnessed in the light of Morocco. Although Matisse had made most of his early revisions within the color palette of previous stages of the composition, as fall 1913 arrived he moved to a palette that was increasingly gray. During the summer and fall, he altered the rounded forms of the bathers and their surroundings to a more reduced and geometric style, possibly the result of his renewed association with Pablo Picasso. Indeed, the hieratic figures and austere monochrome of *Bathers by a River* parallel Picasso's 1911 decorative commission for American art collector Hamilton Easter Field, particularly its largest panel, depicting "a stream in the middle of town with some girls swimming."[14] While Picasso soon came to see that he was unsuccessfully trying to alter the internal scale of Cubism to meet the needs of large-scale panels, that did not stop others—such as Robert Delaunay, Albert Gleizes, and Jean Metzinger—from translating a more popular mode of Cubism into grand bather compositions soon afterward (see, for example, figs. 118, 125, and 126, respectively).

Matisse's progress on the canvas was significant enough that in a letter, possibly dating to November 1913, the artist Charles Camoin asked whether he planned to show it in the upcoming Salon. Although he did not submit it for exhibition, the artist arranged for Eugène Druet to photograph the panel (fig. 181). The official nature of the image suggests that Matisse recognized the importance of this stage of his work; in fact, his daughter, Marguerite, noted that he typically photographed his works when they had reached a certain state of completion.[15] Comparing the Coburn and Druet photographs shows the true nature of Matisse's accomplishment: Gone are the details of the figures' faces and hair, but new are the details of the bathers' environment—the leafy plants, rippling water, and rounded tree forms—elements from Issy and Morocco that Matisse merged to form a new kind of imaginary, but more contemporary, Arcadian landscape. Most remarkable is the change in palette to a tamped down range of grays. In his reworking, Matisse moved the canvas a step further from its original intent of Arcadian "repose": Instead, the changes in *Femmes nues, décoratif* (as the painting is identified in archival documents from this time) demonstrate a connection with contemporary Salon Cubism and its embrace of timeless subjects made modern. Matisse may have responded to the influences of vanguard painting, but his greatest inspiration was the canvas itself and the internal dialogue with its history, not only in relation to the theme but also to the essential forms of the composition.

Matisse likely ended his effort shortly after Druet's photograph, since his studio was unheated and work in the winter months would have been difficult. Art student Robert Rey, in fact, visited Issy that winter, in December 1913, and later published his impressions of a "deserted" and "frigid" studio, where he encountered a "scene in misty tones, highlighted with blue reflections, a strange scene where large figures can be made out, sketched in wide dark strokes."[16] This cool, reduced canvas, of course, was the once idyllic, pastel-colored *Bathers by a River*, now dramatically transformed in mood and palette. It is noteworthy that Rey did not recognize the scene as an Arcadian one—something Matisse would further challenge in the next stages of work on the picture.

Soon after Rey's visit, Matisse moved to a new studio in Paris and initiated an ambitious set of paintings spurred by his large canvas back in Issy. His experimentation was cut short seven months later by the outbreak of World War I, and it would be almost a year before he was able to return to his work and his studio in Issy. In the midst of personal and artistic challenges associated with the war, Matisse resumed *Bathers by a River* in the spring or summer of 1916, and the picture became the focus of a spectacular new period of reworking.[17]

During 1916 Matisse worked on what he would identify as some of the most "pivotal" creations of his career.[18] At the start he focused on *The Moroccans* (Museum of Modern Art, New York), a canvas he had considered several times since his first trip to Morocco in 1912 but began only now, as North African soldiers became more visible on the streets of Paris. He likewise resumed two long-standing sculptural projects, producing *Back III* and *Jeannette V*, both of which involved processes of scraping, incising, and elision, as well as additions of medium, to rework and distill forms through geometric reduction, fragmentation, and abstraction.[19] He also returned to *Bathers by a River*, which the Galerie Bernheim-Jeune photographed that November (fig. 182). Matisse nearly entombed his figures in thick layers of scumbled paint and a rigid geometry, while

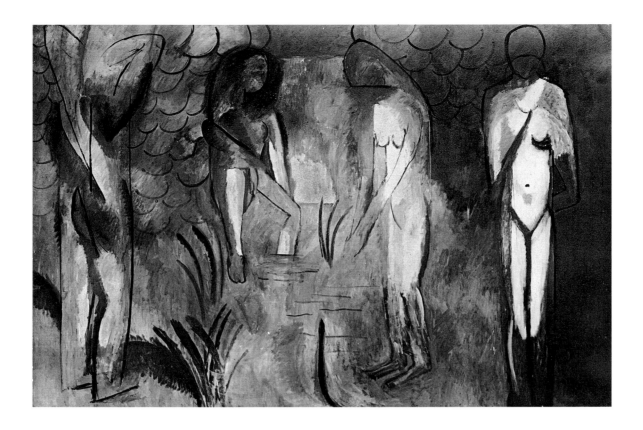

181

Matisse's *Bathers by a River* as it appeared
in early November 1913
Photograph by Eugène Druet
(French, 1868–1917)

he contrasted colored vertical bands with zigzagging palms and buoyant rivulets to build a structure of pulsating planes and forms over the once repose-inspiring scene. The canvas now recalled the dynamic work of Juan Gris and Gino Severini, as well as the continuing experiments of Picasso and Georges Braque. *Bathers by a River* also suggested connections to many of the works the artist had made in 1914 and in Issy in 1915–16, although it remained singular among the subjects of his focus.

In these works, the artist concentrated on what he called his "methods of modern construction," requiring them to be rigorously "composed, willed, and technically perfect."[20] This was a test of skill and conviction, as Matisse explained: "One should be able to rework a masterpiece at least once, to be very sure that one has not fallen victim—to one's nerves or to fate."[21] Indeed, these works function as records of the extraordinary test he set for himself and as material signs of the sheer physical effort and time he committed. While Matisse labored, he chronicled his activities; his words suggest a connection between the challenges facing both soldiers at the front and his own practice. To Camoin, Matisse confided, "I'm hoping to make it work, but what a lot of trouble. I'm not in the trenches, but I worry anyway."[22] And to dealer Léonce Rosenberg, he allowed that his works were "important . . . I can't say that it is not a struggle—but it is not the real one."[23] Earlier, in December 1914, after being rejected from military service, Matisse had asked his friend Marcel Sembat, a Socialist politician and writer, how he might still serve; Sembat's advice was "to continue to paint well."[24] While the works produced in 1916 do not directly reference the war in style or subject, their physical and mental challenge was part of Matisse's own response to the conflict.

Whether self-imposed or inspired in part by the larger national dialogue on wartime cultural production, Matisse's purposeful reengagement with the challenge of continuing to "paint well," is best expressed through *Bathers by a River*. Comparison of Druet's 1913 and Bernheim-Jeune's 1916 photographs identifies Matisse's specific focus, of abandoning the monochromatic tonality

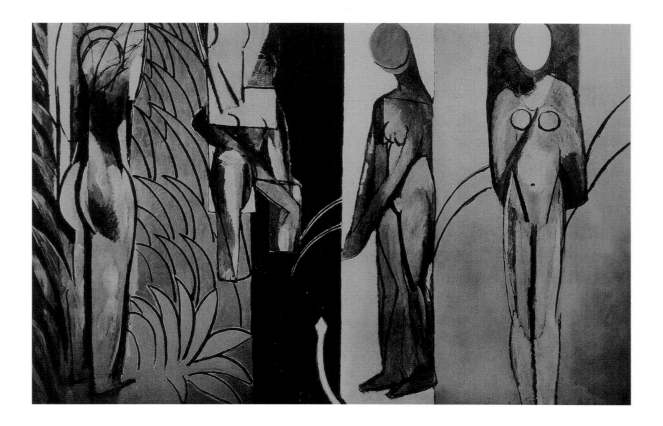

Matisse's *Bathers by a River* as it appeared
in November 1916
Photograph by Galerie Bernheim-Jeune

and modeling for a more animated and rigorously constructed composition distinguished on
the one hand by a pronounced definition of constituent parts and on the other by a complex
integration. Noteworthy is the elimination of a narrative background for a banded pattern,
which the artist revised as many as six times. His most intriguing work, however, occurs at the
left edge of the canvas. Here, he changed the band color four times before painting it pale blue
with a black leaf pattern. Later he put green over the blue; he then filled the inside of the leaves
with gray and the space between them with black, producing a shadowy depth between the
forms. Matisse next incised the contours of the leaves into the still-wet gray paint and scraped
down earlier layers of medium to reinforce the reserved silhouettes. His removals uncovered the
green of the hills from the very first composition along with colors from more recent layers.
Throughout the canvas Matisse excavated areas of the former stages of the painting and wove
them into the present composition. The sheer effort required to transform the picture so radi-
cally—and at the same time evoke the history of its production through its layered surface—is a
clear indication of Matisse's desire to challenge himself at the height of the war. It is also a sign
of his thinking about the theme of Arcadia at this time, of his merging of the past and present,
and of a certain duality.

Indeed, the final adjustments Matisse made to the canvas, in 1917 before his departure for
Nice, bear this out: They bring greater depth to the surface and integrate the space of the viewer
with that of the canvas. In one area of the painting, he made changes to the left-edge leaves, scrap-
ing back prominent black paint strokes within the forms, reshaping contours, and cleaning lines.
Inside the leaves, he incised over the scraped areas, revealing more color—especially white—from
the earlier, lower layers. Rhyming the zigzag brushwork in the green paint on the other side of the
first figure, these additions gave the left edge a greater sense of depth and soft volume, bringing

more cohesion to the whole. He also revised the band between the third and fourth figures by adding white over the blue in a thin, brushy scumble, a combination that prefigures the ethereal effects of some of his early Nice pictures. Evoking a sense of light and depth, these subtle adjustments offer the viewer a way into the space of the painting, and thus, into the composition itself.

But what, after eight years of work, did the composition represent? Surely, what once was connected to repose and idyll, was, by the middle of World War I, something else, but it may be far too simple to suggest a wartime, nostalgic paradise lost. *Bathers by a River* was a "pivotal" canvas for the artist, as he once stated, and its density—its "complex realization," to borrow the words he used in 1936 to describe Cézanne's *Three Bathers*—is at the crux of our understanding. Earlier, in the spring of 1916, Danish artist Axel Salto visited Matisse's studio in Issy and saw the canvas in progress—"an enormous painting that presented a row of figures placed next to each other in separate squares."[25] He might have been surprised to know that Matisse still saw in the canvas a scene of "bathing women," as he described to Rosenberg in 1916.[26] This receptive disjuncture suggests that rather than focus simply on its formal character or thematic origins, we must think of its extraordinary surface, which pulls us into its past but draws the past into its present. We must not consider Arcadia just as a subject matter, or bathers just as a kind of readymade motif for formal experimentation; rather, we must identify the dynamic interconnectedness that gives *Bathers by a River* its great power.

We are justifiably unable to find a single reading of this work: It reflects on a grand scale the many sources of Matisse's inspiration, from Arcadian images by artists ranging from the Old Masters to Cézanne, to the avant-garde developments of Cubism and Futurism, to Matisse's own inventive approaches to construction and abstraction, and his concentration on specific subjects and forms of expression. *Bathers by a River* evaded definitive summary in the years that followed its public debut in 1926, and it still does today, despite the fact that we are far more aware of its thematic and compositional complexities than ever before. Indeed, the painting's subject and formal innovations are linked inextricably; for while the canvas continued to move away from its original and more obvious Arcadian roots, Matisse never forgot its history. There is, in fact, a deep connection between the method of making and the subject matter within the work's surface. Matisse scraped down to previous layers, weaving earlier colors and hints of forms into the present image, always knowing what was below. And at the same time, the subject of Arcadia was continually at the foundation of his reworking, likely contested, adjusted, discounted, and perhaps even longed for at each new stage.

For Claude Duthuit (1931–2011)

1. Matisse to Escholier, November 10, 1936, in Raymond Escholier, *Henri Matisse*, Anciens et Modernes (Paris: Libraire Floury, 1937), pp. 17–18n2, trans. and quoted in Stephanie D'Alessandro and John Elderfield, *Matisse: Radical Invention, 1913–1917*, exh. cat. (Chicago: Art Institute of Chicago, 2010), p. 45.

2. For an in-depth investigation of *Bathers by a River*, see D'Alessandro and Elderfield, *Matisse*, in which much of the history summarized here is explored in greater detail. See esp. pp. 76–91, 104–7, 144–57, 174–77, 304–9, 346–49.

3. On Matisse's engagement with this theme, see especially Thomas Puttfarken, "Mutual Love and Golden Age: Matisse and 'gli Amori de' Carracci,'" *Burlington Magazine*, vol. 124, no. 949 (April 1982), pp. 203–8; Margaret Werth, *The Joy of Life: The Idyllic in French Art, circa 1900* (Berkeley: University of California Press, 2002); and Alastair Wright, *Matisse and the Subject of Modernism* (Princeton, NJ: Princeton University Press, 2004).

4. Matisse cited Baudelaire's poem as the source of the painting's title in a letter to Simon Bussy. Matisse to Bussy, September 19, 1905, Archives du Louvre et des Musées Nationaux, Paris, quoted in Rémi Labrusse and Jacqueline Munck, *Matisse, Derain: La verité du fauvisme* (Paris: Hazan, 2005), p. 237. In October 1905 Henri-Edmond Cross, responding to a letter Matisse had sent him earlier that month, wrote of "votre 'Arcadie'" (your "Arcadia"), borrowing the term Matisse had used in reference to *Le bonheur de vivre*. Cross to Matisse, October 1905, Archives Henri Matisse, quoted in Labrusse and Munck, *Matisse, Derain*, p. 239.

5. Matisse to Pierre Matisse, April 3, 1942, Pierre Matisse Archives, Pierpont Morgan Library, New York, quoted in Labrusse and Munck, *Matisse, Derain*, p. 252.

6. Matisse, "Notes d'un peintre," *La grande revue*, vol. 2, no. 24 (December 25, 1908), p. 736, trans. and quoted in D'Alessandro and Elderfield, *Matisse*, p. 69.

7. Matisse, quoted in Charles Estienne, "Des tendances de la peinture moderne: Entretien avec M. Henri Matisse," *Les nouvelles*, vol. 2, no. 106 (April 12, 1909), p. 4; trans. and quoted in D'Alessandro and Elderfield, *Matisse*, p. 89.

8. Shchukin to Matisse, March 16, 1909, Archives Henri Matisse, trans. and quoted in D'Alessandro and Elderfield, *Matisse*, p. 89.

9. For more on this issue, see Werth, *Joy of Life*, and Wright, *Matisse*. See also Jack Cowart et al., *Matisse in Morocco: The Paintings and Drawings, 1912–1913*, exh. cat. (Washington, DC: National Gallery of Art, 1990).

10. Camoin to Matisse, August 14, 1913, Archives Henri Matisse. For more on the puzzling nature of this letter, see D'Alessandro and Elderfield, *Matisse*, p. 173.

11. Shchukin to Matisse, May 14, 1913, and Matisse to Morosov, May 25, 1913; Archives Henri Matisse. See also D'Alessandro and Elderfield, *Matisse*, p. 146.

12. Cézanne's painting and Matisse's lithograph are illustrated in D'Alessandro and Elderfield, *Matisse*, p. 147, figs. 7 and 8, respectively. For the lithograph, see also Marguerite Duthuit-Matisse and Claude Duthuit, *Henri Matisse: Catalogue raisonné de l'oeuvre gravé* (Paris: Imprimerie Union, 1983), no. 1.

13. *Fatma, the Mulatto Woman* is reproduced in D'Alessandro and Elderfield, *Matisse*, p. 131.

14. Picasso to Georges Braque, July 25, 1911, trans. and quoted in *Picasso and Braque: Pioneering Cubism*, comp. William Stanley Rubin, exh. cat. (New York: Museum of Modern Art, 1989), p. 376; quoted in John Elderfield, chap. 13 in *Matisse, Picasso*, ed. Elizabeth Cowling et al., exh. cat. (London: Tate Publishing, 2002), p. 142. For more on Picasso's commission, see Elderfield, chap. 13, pp. 142–43; John Richardson, *A Life of Picasso* (New York: Random House, 1996), vol. 2, p. 170; and Rubin, *Picasso and Braque*, pp. 63–69.

15. John Elderfield, *Matisse in the Collection of the Museum of Modern Art, Including Remainder-Interest and Promised Gifts* (New York: Museum of Modern Art, 1978), p. 72n6.

16. Robert Rey, "Une heure chez Matisse," *L'opinion*, vol. 7, no. 2 (January 10, 1914), p. 60, trans. and quoted in D'Alessandro and Elderfield, *Matisse*, p. 177.

17. For more on Matisse's activities and circumstances during the war, see Stephanie D'Alessandro, "Interruptions and Returns" and "The Challenge of Painting," in D'Alessandro and Elderfield, *Matisse*, pp. 222–31 and 262–69, respectively.

18. Matisse, quoted by Katharine Kuh to Courtney Donnell, typescript interview, May 23, 1985, Curatorial Files, Art Institute of Chicago.

19. Both *Back III* and *Jeannette V* are illustrated in D'Alessandro and Elderfield, *Matisse*, nos. 42 and 45, respectively. See also Duthuit-Matisse and Duthuit, *Henri Matisse*, nos. 55 and 60, respectively.

20. For Matisse's phrase "methods of modern construction," see E. Tériade, "Matisse Speaks," pt. 2, *Art News Annual*, vol. 50, no. 7, (November 1951), p. 42. See D'Alessandro and Elderfield, *Matisse*, pp. 18–31, for an in-depth consideration of the phrase's meaning. For the second phrase ("composed, willed, and technically perfect"), see Gino Severini, "La peinture d'avant-garde," *Mercure de France*, vol. 121 (June 1, 1917), p. 456, trans. and quoted in D'Alessandro and Elderfield, *Matisse*, p. 263.

21. Matisse, quoted in Severini, "La peinture," p. 456, trans. and quoted in D'Alessandro and Elderfield, *Matisse*, p. 263.

22. Matisse to Camoin, January 19, 1916, Archives Camoin, Paris, trans. and quoted in D'Alessandro and Elderfield, *Matisse*, p. 263.

23. Matisse to Rosenberg, June 1, 1916, Manuscript Department, Musée National d'Art Moderne, Paris, trans. and quoted in D'Alessandro and Elderfield, *Matisse*, p. 263.

24. Matisse and Sembat's interchange is reported in Raymond Escholier, *Matisse, ce vivant* (Paris: Librarie Arthème Fayard, 1956), p. 112, trans. and quoted in D'Alessandro and Elderfield, *Matisse*, p. 263.

25. Axel Salto, "Henri Matisse," *Klingen*, vol. 1, no. 7 (April 1918), n.p., trans. and quoted in D'Alessandro and Elderfield, *Matisse*, p. 305.

26. Matisse to Rosenberg, June 1, 1916, trans. and quoted in D'Alessandro and Elderfield, *Matisse*, p. 305.

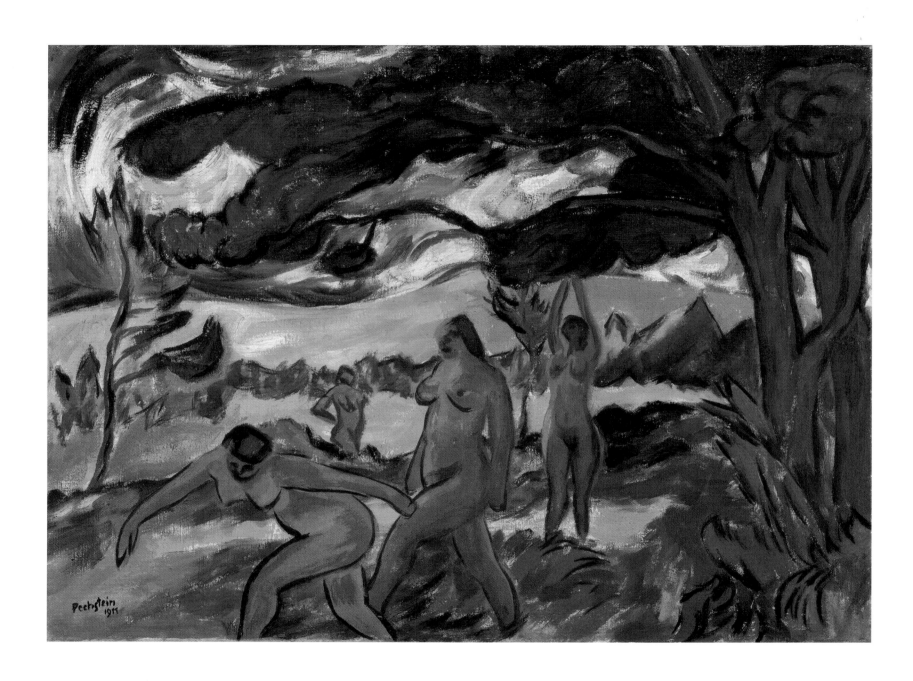

183

MAX PECHSTEIN

German, 1881–1955

Under the Trees

1911

Oil on canvas, 29 × 39 inches (73.7 × 99.1 cm)

Detroit Institute of Arts. City of Detroit Purchase

"DREAM THE MYTH ONWARDS"[1]
Visions of Arcadia in German Expressionist Art

TANJA PIRSIG-MARSHALL

THE REBIRTH OF ARCADIA

In late nineteenth-century Germany, there was a renewed interest among progressive artists in creating visions of an idealized paradise in which humanity and nature coexist harmoniously. Forward-thinking artists turned to nature and the archaic, including Greek mythology, for emotional authenticity and fulfilment.[2] They devoted themselves "to visions instead of reality, to the ideal instead of the banal, to landscapes of longing instead of faithful excerpts from nature."[3] Their compositions of pre-lapsarian innocence—often featuring young men and women disporting themselves in idyllic landscapes, with music and dancing—recall an idealized and timeless vision of classical Arcadia. For these artists, "the earthly paradise was the best expression of this deeply felt understanding between man and nature," as Werner Hofmann observed.

> In order to represent the equation of man with nature in the life process, limited by life and death, it was only necessary to divide paradisial man into different age groups, to extend the pure, imperishable being that knows no seasons into a future and a past—not with the purpose of reintroducing the time of clocks and calendars, but to reintegrate the life of man with the rhythmic processes of nature. And so the mythical took the place of the historical picture of mankind.[4]

Interest in Arcadia as an aesthetic concept, as Simon Reynolds has noted, was reborn in Germany in the 1870s with Hans von Marées, whose otherworldly paintings evoke a timeless, abstract beauty.[5] This interest attracted many followers, from Ludwig von Hofmann to a younger generation of artists including Max Beckmann and the Expressionists Ernst Ludwig Kirchner, Franz Marc, and August Macke. These artists recognized in Marées's work a mastery of composition and coherent structure—visible, for example, in his painting *Six Nude Men* (1874–80; Bayerische Staatsgemäldesammlungen, Munich), in which he attempted a total integration of figures and their natural surroundings—as well as a model for the ideal human image.[6] Marées's studies of the nude, as seen in his *Men by the Sea* (c. 1874; fig. 184), go "beyond an investigation of the physique in an attempt to express the quality of humanity *per se*," invoking the values of "dignity, noble-mindedness, and

184

HANS VON MARÉES

German, 1837–1887

Men by the Sea

c. 1874

Oil on canvas, 29½ × 37⅝ inches

(75 × 95.5 cm)

Von der Heydt Museum, Wuppertal,

Germany

tranquillity."[7] His figures seem unaware of time; psychology, drama, and intrigue, as well as traditional subject matter and allegorical context, are completely absent in his work.[8] He attempted not only to simplify forms, but also "to divorce his subjects from the contexts of the classical canon and historical background, to create 'contentless' imagery devoted solely to human existence in general."[9]

Marées's influence is evident in Hofmann's compositions of nude figures and lush, wooded landscapes, in which humanity and nature "enter into an almost paradisiacal union."[10] The writer Thomas Mann used Ludwig von Hofmann's works—including *The Spring* (1913–14; Thomas Mann Archive, Zurich), owned by Mann himself—as the inspiration for his novel *The Magic Mountain* (1924), which provides a prose-picture of Arcadia: "And all the sunny region, these open coastal heights and laughing rocky basins, even the sea itself out to the islands, where boats plied to and fro, was peopled far and wide. On every hand human beings, children of sun and sea, were stirring or sitting. Beautiful young human creatures, so blithe, so good and gay, so pleasing to see."[11]

As Marées and Hofmann had done, Beckmann used mythological subjects as "a means of expressing basic human aspirations."[12] In his *Young Men by the Sea* (1905; fig. 185), a key work in his stylistic transition from Jugendstil to Impressionism to Expressionism, male nudes are shown from several views—from the back, front, left, and right—as well as in standing and sitting positions. Even the classical image of the flute player appears. The rather consciously posed foreground figures contrast sharply with those in the background, who play in the surf. As Gert Schiff has suggested, Beckmann painted this canvas "with a view to Marées's archetypal conception of nudes in a landscape."[13]

185

MAX BECKMANN
German, 1884–1950

Young Men by the Sea

1905
Oil on canvas, 4 feet 10¼ inches ×
7 feet 8½ inches (1.4 × 2.3 m)
Schlossmuseum, Weimar, Germany

GOING AWAY

As the twentieth century approached, Germany's rapid industrialization and growing urban populations intensified the long-existing imbalance between the supposed simplicities of rural life and the complexities of modern city life.[14] In the face of urban, industrial, technological, and psychological upheaval, the German academy attempted to preserve tradition through the promotion of conservative artistic values that emphasized historical and literary subjects. Yet, in avant-garde circles, the new ideas of Carl Einstein, Sigmund Freud, Karl Marx, and Friedrich Nietzsche, as well as Charles Darwin and others outside the German-speaking world, strengthened the notion that society had to break with the old ways in order to compete and survive, and threatened the conservative structures of the country's Wilhelmine Empire.[15]

The growing contempt for the modern city "renewed ideas about paradise and unfulfilled longings for primitive naturalness."[16] Consequently, antiurban reform movements—such as the Wandervogel (literally, "migratory bird"), founded in 1901, which encouraged young people to shoulder their rucksacks and explore the great outdoors—became increasingly popular in Germany. Among progressive artists, these movements paved the way for a trend of "going away"—"of leaving urban centres and their art institutions in favour of rural artists' communities."[17] Some artists, including Otto Modersohn and Heinrich Johann Vogeler, fled their hidebound academic studies to settle in rural artists' colonies, while others, including Kirchner and fellow Expressionists, found their roots in the German countryside, in places remote and unfrequented by tourists— at the Moritzburg ponds near Dresden, on the deserted shores of the Baltic and North seas, and in the villages near Murnau, south of Munich. In these places, artists sought to discover the

"supposed instinctual freedom of tribal life" and explored their ideas of an earthly paradise, no longer through mythological allegories but through engagement with tangible nature.[18] In this respect, their forerunner was the French artist Paul Gauguin, who, in his search for a simple, paradisial life (a quest inspired by Jean-Jacques Rousseau's writings on the decadence of overcivilized Western societies), had left rural Brittany for Tahiti in 1891.[19]

Also popular among the antiurban movements in Germany was *Freikörperkultur* (nudism), which promoted the freedom of man and woman in nature, unfettered by clothing and the inhibitions of Western civilization, and which advocated "antidotes to city experience," such as vegetarianism, homeopathy, sun and air therapy, and dress reform.[20] On the Baltic island of Hiddensee, where visitors were free to sunbathe naked, an artists' colony was established in the tradition of the utopian community of Monte Verità in Ascona, Switzerland, which followed a rigid moral code of vegetarianism and nudism. The writer Gerhart Hauptmann credited the informal lifestyle of Hiddensee as an inspiration for his novel *The Island of the Great Mother* (1924), remarking that he never would have written it if he "had not seen the many beautiful, often completely naked women's bodies over the years and watched their carryings-on there."[21]

DIE BRÜCKE IN MORITZBURG

In 1905 in Dresden four architecture students—Kirchner, Fritz Bleyl, Erich Heckel, and Karl Schmidt-Rottluff—founded the artists' association known as Die Brücke (The Bridge), which would become closely associated with the Expressionist movement in Germany. Later members would include Otto Mueller, Emil Nolde, and Max Pechstein. The Brücke artists wanted to escape the demands of the modern city and to break free from academic constraints and conventions. By engaging with their natural surroundings and living a simple, primitive lifestyle, they would be able to reconcile humanity with nature, and art with life. As Carl Einstein asserted in 1926, "the paintings of the first Expressionists . . . were conceived as idylls that arose from their opposition to the city; one could speak of urban Romanticism, a protesting, almost moralizing Primitivism."[22]

The Brücke artists found their lost idyll at the Moritzburg ponds, where they spent considerable time during the summers of 1909 to 1911.[23] There they lived in the nude with their models, creating "a seemingly Arcadian world," as captured in Kirchner's *Bathers at Moritzburg* (1909/1926; fig. 186), that was in marked contrast to the conservative social conventions of Wilhelmine Germany.[24] In describing the community's utopian spirit, Pechstein recalled that "we lived in absolute harmony; we worked and we swam. If a male model was needed . . . one of us would jump into the breach."[25] This harmony is evident in the similarities among the Brücke's pictures, as they often painted the same models or scenes from slightly different viewpoints and in very similar manners, using brilliant planes and spots of color, as seen in Heckel's *Bathers at a Forest Pond*, Pechstein's *Open Air (Bathers at Moritzburg)*, and Kirchner's *Nudes Playing under a Tree*, all executed in 1910 (figs. 187–89).

The nude in nature has long been an expression of a desire for a paradisial idyll, and nude bathers as well as the female nude in general (see, for example, Kirchner's *Three Nudes in the Forest* of 1908/1920; fig. 190), became central subjects of the Brücke's paintings and drawings.[26] In many of their pictures, men and women appear embedded in nature—"physically wedged between rocks,

186

ERNST LUDWIG KIRCHNER

German, 1880–1938

Bathers at Moritzburg

1909, retouched 1926

Oil on canvas, 4 feet 11¹⁄₁₆ inches × 6 feet 6¾ inches (1.5 × 2 m)

Tate Modern, London. Purchased 1980

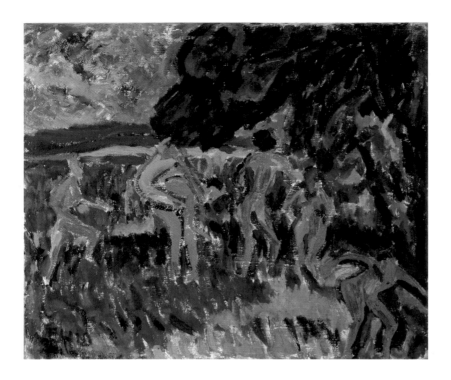

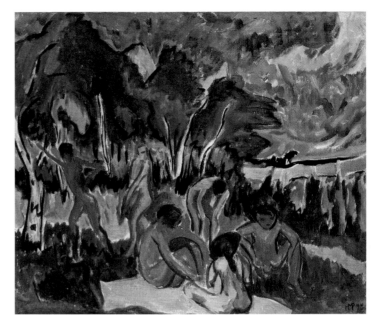

187

ERICH HECKEL

German, 1883–1970

Bathers at a Forest Pond

1910

Oil on canvas, 32½ × 37⅝ inches
(82.5 × 95.5 cm)

Museum Folkwang, Essen, Germany
(permanent loan from private estate
since 2005)

188

MAX PECHSTEIN

German, 1881–1955

Open Air (Bathers at Moritzburg)

1910

Oil on canvas, 27⁹⁄₁₆ × 31½ inches
(70 × 80 cm)

Lehmbruck Museum, Duisburg,
Germany

into the nooks of branches, between the rolling sea's waves or sprawled on the sand."[27] In Heckel's *Bathing in the Bay* (1912; fig. 191), for example, the golden skin tone of the bathers, who lack distinctive features, blends into the landscape's sandy shore. These figures, as is true in many of the Brücke's pictures, are not differentiated by psychological character and have no obvious binding relationship to one another.[28]

The Brücke artists, like Marées before them, sought "'the natural in man and nature" and in the relationship between man and woman.[29] This quest, together with the simple bohemianism of the Brücke's lifestyle, explains the subject of their pictures. As Pechstein recalled of Moritzburg, "I had the good fortune to always have had with me, in total naturalness, a human being whose movements I could absorb. Thus, I continued to understand man and woman and nature as one."[30] He captured the human body in motion in his painting *Under the Trees* (1911; see fig. 183), in which four nude women frolic in a brilliantly colored landscape.

ERNST LUDWIG KIRCHNER AT FEHMARN

In the summer of 1912, Kirchner, seeking a location even more remote than Moritzburg, returned to the Baltic island of Fehmarn, which he first had visited in 1908.[31] There, he found quarters with the keeper of the Staberhuk lighthouse, on the southeast end of the island. Kirchner returned to Fehmarn the next two summers, and although on each occasion he stayed for only a few weeks, his output was prodigious: Between 1912 and 1914, he produced—the majority on location—several hundred paintings, watercolors, and drawings of Fehmarn subjects.[32] During his visit in 1912 he was still working his way through the influence of the Ajanta cave paintings in India, illustrations of which he had first come across in the winter of 1910. The influence of the cave paintings, which Kirchner described as "all plane and yet absolute mass," is best seen in the monumental figures and softly but distinctly modeled forms in his 1911 painting *Five Bathers at the Lake* (fig. 192).[33] By 1913 Kirchner's figures had become more angular and attenuated and the landscape more dominant;

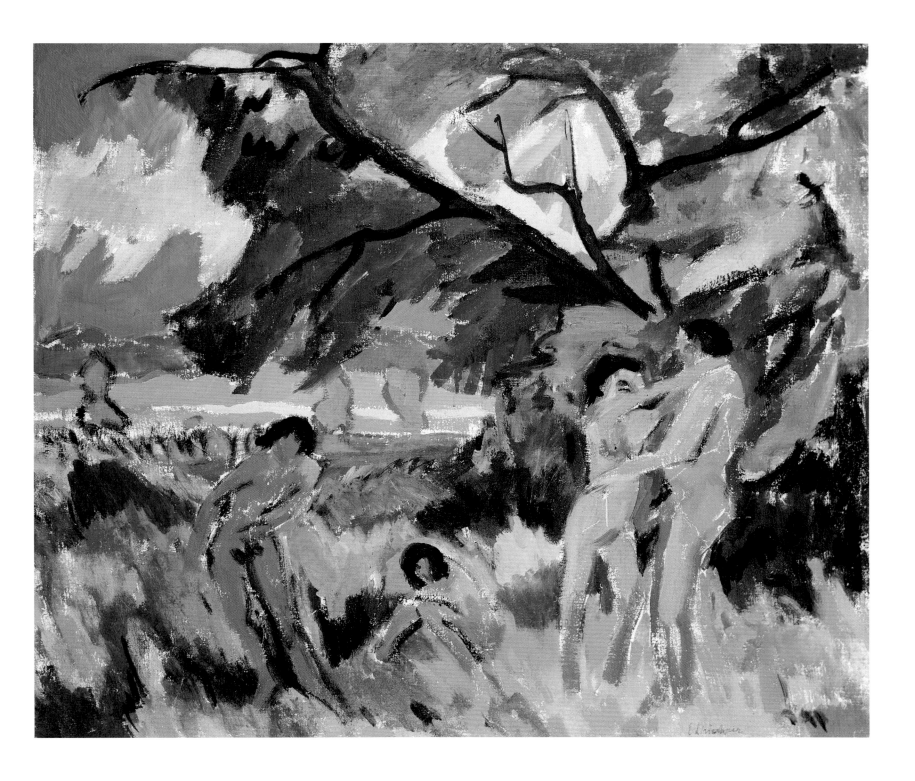

189

ERNST LUDWIG KIRCHNER

German, 1880–1938

Nudes Playing under a Tree

1910

Oil on canvas, 30⁵⁄₁₆ × 35³⁄₁₆ inches (77 × 89 cm)

Private collection (on deposit at the Pinakothek der Moderne, Munich)

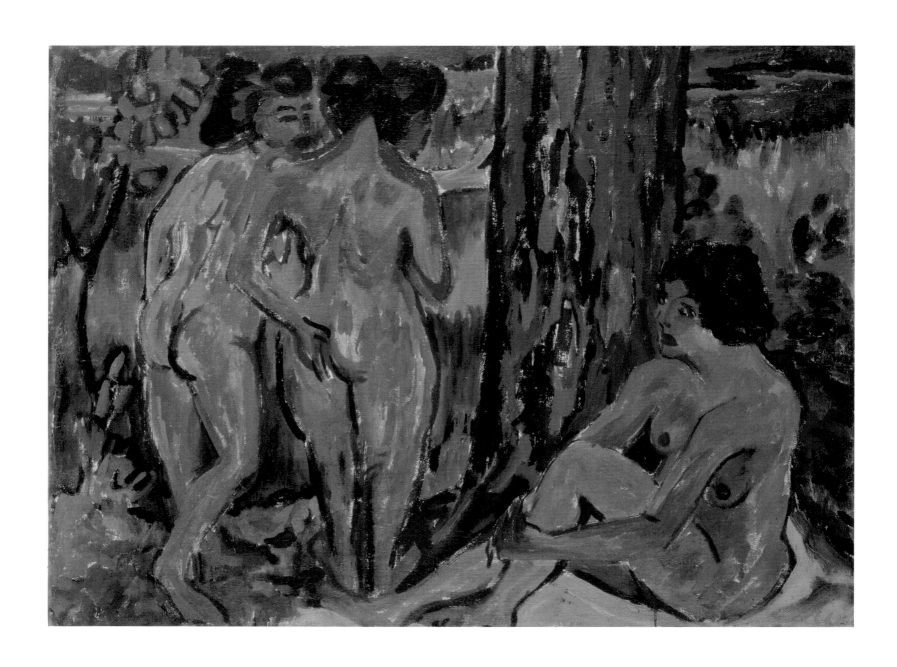

190

ERNST LUDWIG KIRCHNER

German, 1880–1938

Three Nudes in the Forest

1908, retouched 1920

Oil on canvas, 29⅞ × 39⅜ inches (75.9 × 100.1 cm)

Collection Stedelijk Museum, Amsterdam

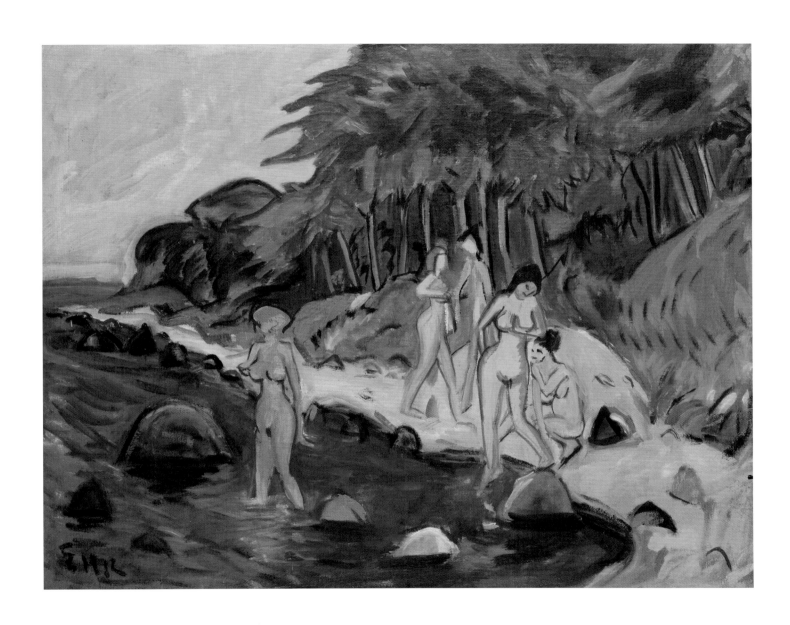

191

ERICH HECKEL

German, 1883–1970

Bathing in the Bay

1912

Oil on canvas, 27⁹⁄₁₆ × 31⁷⁄₈ inches (70 × 81 cm)

Kaiser Wilhelm Museum, Krefeld, Germany

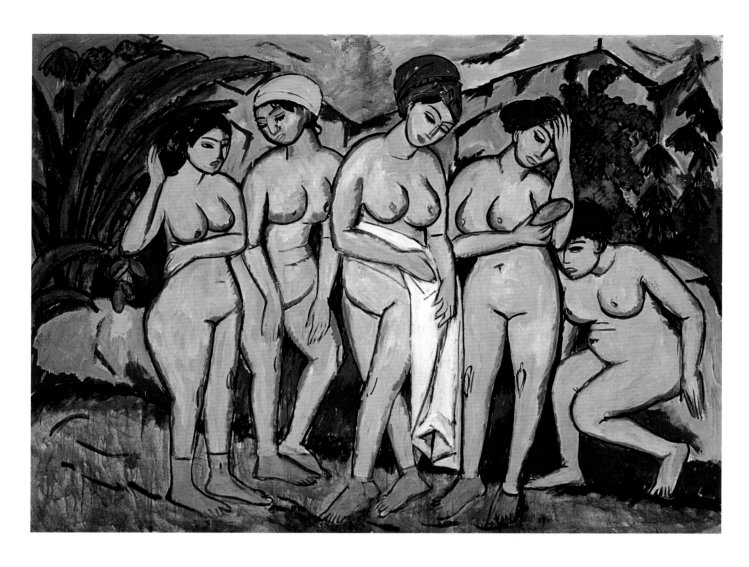

192

ERNST LUDWIG
KIRCHNER

German, 1880–1938

Five Bathers at the Lake

1911

Oil on canvas, 4 feet 11¼ inches ×
6 feet 6¾ inches (1.5 × 2 m)

Brücke Museum, Berlin

in *Bathers among Dunes (Fehmarn)*, of that year (fig. 193), dunes rise behind the slight, capering figures—an effect emphasized by the portrait format of the composition. The colors are more or less naturalistic, and the abbreviated forms are rendered in rapid brushstrokes with an emphasis on line. As is often the case in Kirchner's Fehmarn works, the figures engage in good-natured play in a carefree, idyllic environment—perhaps a paradise before the Fall.

Kirchner believed that Fehmarn offered the "richness of the South Seas."[34] His painting *Fehmarn Bay with Boats* (1913; fig. 194) shows a sweeping, rock-strewn beach backed by grassy dunes and trees, offering an idea of the island's topography. But Kirchner subtly exaggerated the scene, making the greenery particularly lush and the sand especially golden, so that the bay looks more like a tropical Pacific atoll than a breezy Baltic island. Indeed, as Wolfgang Henze has suggested, Kirchner did not simply depict a found reality in his Fehmarn works; rather, he created his own paradise, a constructed South Seas experience that included a boat made from a hollowed log and a grass hut on the beach within which he could eat and drink and find shelter from the wind and sun.[35]

For Kirchner, his time in Fehmarn was far more intense than that in Moritzburg: "[Fehmarn] was where I learned to give a form to the ultimate unity of man and nature and completed what I had begun in Moritzburg. The colours became milder and richer, the form stricter."[36] His partner, Erna Schilling, dominates his art from this period, as a symbol of both Woman and Nature.[37] According to Hermann Gerlinger, with her Kirchner experienced the unity

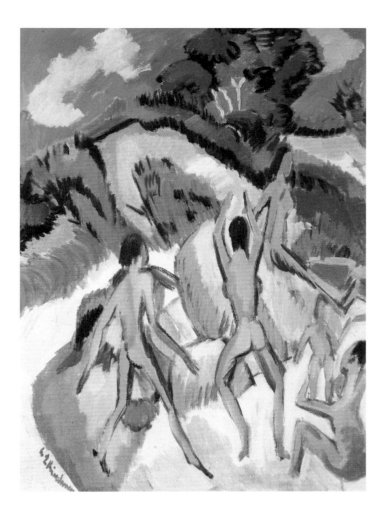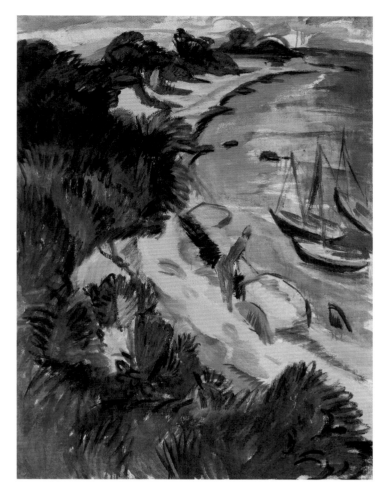

193

ERNST LUDWIG KIRCHNER

German, 1880–1938

Bathers among Dunes (Fehmarn)

1913
Oil on canvas, 47 × 35⁷⁄₁₆ inches
(119.5 × 90 cm)
Private collection

194

ERNST LUDWIG KIRCHNER

German, 1880–1938

Fehmarn Bay with Boats

1913
Oil on canvas, 47¼ × 35⁷⁄₁₆ inches
(120 × 90 cm)
Private collection

of man, woman, and nature not as a projection of his imagination, but as a reality. Rarely did he live in "such harmony with his surroundings."[38]

Kirchner's final stay in Fehmarn came to a sudden end when the outbreak of war in August 1914 forced him to leave his paradise, never to return. Later that year, in a letter to collector Gustav Schiefler, Kirchner wrote, "I found it hard to leave the place so abruptly because I was completely wrapped up in the countryside and life there and was able to get down to work almost without thinking."[39] Living amidst unspoiled nature, far from the metropolis of Berlin, contributed to the artist's happiness, and Fehmarn remained the embodiment of his lifelong dream of Arcadia.[40] In 1916, after suffering a nervous breakdown during military training, Kirchner executed a now-destroyed wall painting with Fehmarn motifs in the sanatorium at Königstein.[41] This, surely, was Kirchner's attempt to reimagine a period of innocence, his personal idyll, and to blot out his nerve-shattering experiences of World War I.

FRANZ MARC AND AUGUST MACKE'S *PARADISE*

Franz Marc and August Macke explored their visions of Arcadia in different ways from the Brücke painters. Their collaborative painting *Paradise* (1912; fig. 195), one of the few surviving Expressionist murals, is an important document not only of Expressionism but also of the friendship and close working relationship between the two artists. The mural, originally painted

195

FRANZ MARC
German, 1880–1916
and
AUGUST MACKE
German, 1887–1914

Paradise

1912
Oil on plaster, 13 feet ¹¹/₁₆ inch ×
5 feet 11¼ inches (4 × 1.8 m)
LWL—Landesmuseum für Kunst
und Kulturgeschichte, Münster

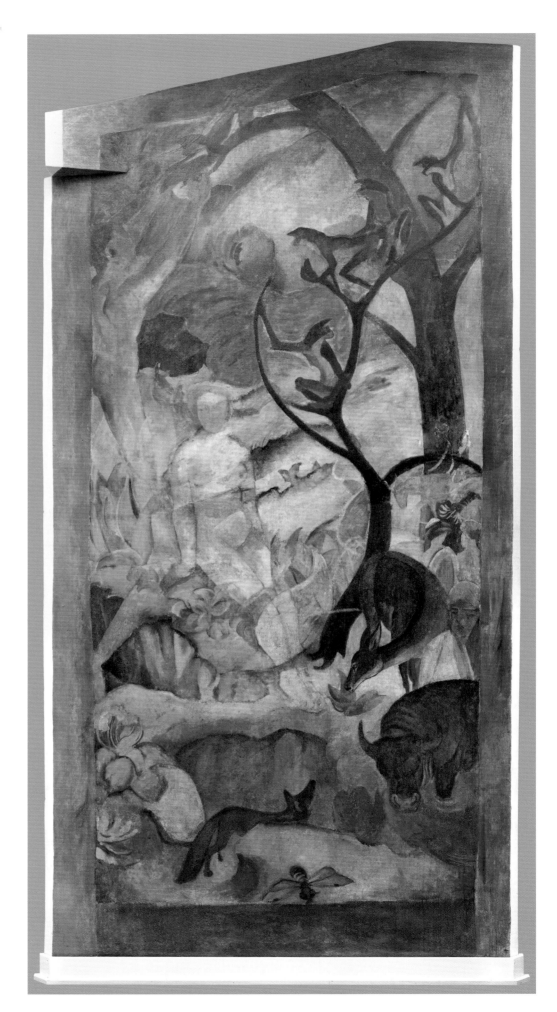

196

AUGUST MACKE

German, 1887–1914

*After Puvis's "Fisherman's
Family"*

From sketchbook no. 17, sheet 17

Winter 1907–8

Graphite on paper, 7⁵⁄₁₆ ×
4⅝ inches (18.5 × 11.8 cm)

LWL—Landesmuseum für Kunst
und Kulturgeschichte, Münster

197

AUGUST MACKE

German, 1887–1914

Figure Studies

From sketchbook no. 34, sheet 41

1910

Graphite on paper, 5½ × 3¼ inches
(13.9 × 8.3 cm)

LWL—Landesmuseum für Kunst
und Kulturgeschichte, Münster

on a wall in Macke's studio in Bonn and now in the collection of the Landesmuseum für Kunst und Kulturgeschichte in Münster, shows a verdant landscape at the center of which sits Eve, her naked figure partly overpainted. Before her a deer grazes, a bull wades in a pool, a fox looks on, and a wasp rests at the bottom of the composition. Behind Eve, Adam reaches up toward a tree populated by a troop of monkeys. Marc and Macke's figures, like those in Heckel's *Bathing in the Bay* (see fig. 191), are so much a part of the landscape that they almost melt into it. Here is a vision of man and woman living in harmony with nature.

The two artists met in Munich in January 1910, and their friendship developed rapidly through regular meetings and correspondence. The idea that they should jointly execute a wall painting first arose in a letter from Marc to Macke in late 1910, but was not finalized until October 1912.[42] Initially, they planned to illustrate a cavalry battle or the parting of the Red Sea, but in the end they chose a paradise scene. The size of the studio's wall determined the painting's format and dimensions (13 feet ¹¹⁄₁₆ inch × 5 feet 11¼ inches). The painting is not a fresco, for the artists applied oil paint directly to the wall, without any preparatory work or plaster.

Both Marc and Macke were influenced by Marées and Gauguin, as well as Paul Cézanne and Pierre Puvis de Chavannes. They had seen works by Marées in Munich in 1908–9, and by Cézanne, Gauguin, and Puvis at the Sonderbund exhibition in Cologne in 1912. Indeed, in their wall painting the arch formed by the tree recalls Cézanne's *Large Bathers* in the Philadelphia Museum of Art (see page

xii and fig. 155), and the poses of Adam and Eve strongly resemble those of the nude man and woman in Puvis's *Fisherman's Family* (1887; Art Institute of Chicago), which Macke had copied in his sketchbook in 1907–8 (fig. 196).[43]

Attributing the various elements of the composition to one artist or the other is difficult, demonstrating the seamlessness of the collaboration. Sketches and correspondence offer the only evidence of which artist conceived the composition's overall structure and which artist executed individual motifs. However, in the literature the majority of the elements — including the figure of Adam, the tree with monkeys, the animals, and a large part of the landscape — have been attributed to Marc.[44] In fact, Marc's 1911 painting on glass *Landscape with Animals and Rainbow* (Franz Marc Museum, Kochel, Germany) has a similar narrow vertical format with the composition built up in layers, resembling the axonometric perspective found in Chinese scroll painting. Yet, members of Macke's family attribute to him the two women in turbans and the donkey on the right, as well as the figures of Adam and Eve. Although a preliminary drawing by Macke (1910; fig. 197) suggests that the pose of Adam is influenced not only by Puvis's *Fisherman's Family* but also by Marées's painting *The Orange Picker* (1873; Staatliche Museen zu Berlin), this does not prove that Macke painted the figure. Conceivably, he may have been responsible for the figure's conception, while Marc actually painted it. The importance of the wall painting, however, does not lie in the attributions of the individual elements. Rather, its significance is as a physical record of the exchange of artistic experiences and experiments.

FRANZ MARC'S GARDEN OF ANIMALS

Marc's pursuit of representing the idea of paradise in his art originated in his interest in reconnecting humanity and nature anew. From 1909 onward depictions of Arcadian groups, mostly comprising naked youths on horseback, appear frequently in his sketchbooks.[45] Marc believed animals are "part of the endless chain of life. . . . [T]hey are the embodiment of the instinctive way of life, which men have left behind to their detriment after abandoning nature."[46] Marc, unlike Macke, rejected the idea that mankind has fallen, favoring instead a pantheistic vision of animals as an expression of unified existence. For him, "the ultimate model for the Garden of the Animals is Paradise. While the presence of man there may be tolerated, the significance of Paradise for humanity lies in its loss and the consequent hope that it may one day be regained."[47]

The influence of Gauguin, for whom Marc had great sympathy and for whom he painted paradisial *hommages à la Gauguin* (homages to Gauguin), is seen throughout Marc's oeuvre. Many of the French artist's pictorial elements — such as those in his painting *The White Horse* (1898; Musée d'Orsay, Paris), which was exhibited in Paris in 1906 and reproduced in the German magazine *Kunst und Künstler* in 1910 — can be found in Marc's works.[48] While German Jugendstil painters often located Arcadian scenes in springtime glades, in the 1890s Gauguin introduced an exotic, luxuriant vision of paradise. His South Sea idylls, with their seemingly carefree intermingling of animals, plants, and indigenous inhabitants, "had a tendency to merge, in the imagination of enthusiasts (such as Marc and his artist colleagues and contemporaries), with the Arcadia of antiquity."[49]

In 1911 the animals, not the humans, in Marc's landscapes begin to represent "the emotional and the sensual." Three paintings of 1912 — *The Dream* (fig. 198), *The Waterfall*, and *The*

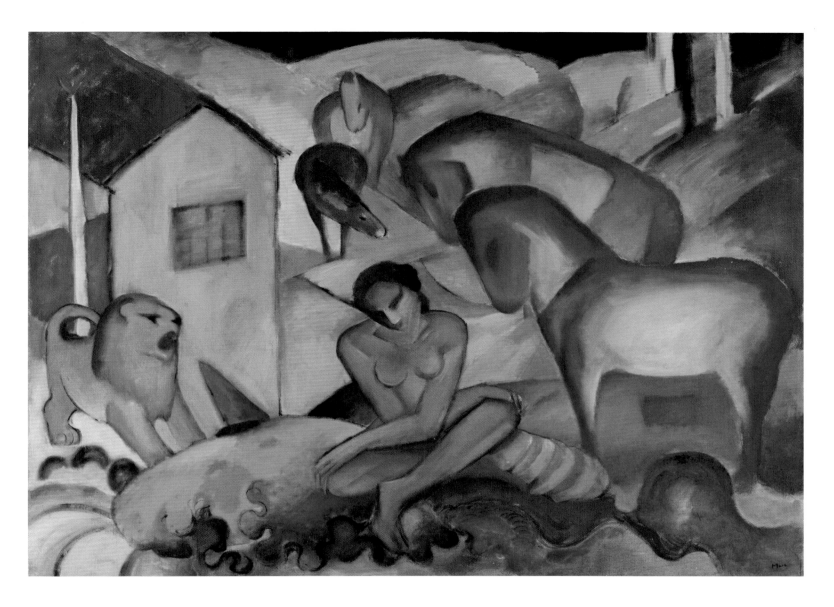

198

FRANZ MARC

German, 1880–1916

The Dream

1912

Oil on canvas, 39⁹⁄₁₆ × 53⅜ inches

(100.5 × 135.5 cm)

Museo Thyssen-Bornemisza, Madrid

Shepherds—show his restrained use of human figures, which "become merely morphological components of the landscape."[50] In *The Dream* a naked woman sits cross-legged in a hilly landscape, while two horses, standing in profile, watch over her, perhaps protecting her from the threatening presence of a lion. In *The Shepherds* a seated figure and a large blue horse watch over a reclining male nude. The sculptural figures, which resemble in style and form archaic statues of young men, appear to be part of the landscape. The immersion of the human form in landscape is taken a step further in *The Waterfall*, as the figures' coiled postures reflect the shapes in the surrounding landscape.

Marc achieved the closest approximation of paradise in his landscapes that include only animals, not humans, such as his *Deer in the Forest I* (1913; fig. 199).[51] In this and similar works he depicted "a world of luxuriant, sprawling plants and clear streams and pools, inhabited by creatures living in harmony with each other. . . . Even the relatively abstract images . . . convey the impression of Marc's genuine concern for his animals, his desire to provide them with their own environment, a geometrized Garden of Eden."[52] By interweaving shapes, employing contrasts and fades between planes and angles, and pictorially embedding animals in their environments, Marc achieved "a unity between innocent creatures and nature, and between nature and the cosmos—by always depicting the animals"—in Herman Nohl's words, "in their highest lives, in the intensified

199

FRANZ MARC

German, 1880–1916

Deer in the Forest I

1913

Oil on canvas, 39¾ × 41¼ inches (100.9 × 104.7 cm)

The Phillips Collection, Washington, DC. Gift from the estate of Katherine S. Dreier, 1953

expression of their peculiar energy."[53] In this Marc's work echoes the words of the poet Theodor Däubler: "Each animal embodies its own cosmic rhythm."[54]

AUGUST MACKE'S EARTHLY PARADISE

Macke's interest in the idea of paradise originated in his desire to experience the ideal garden, in which man and woman live in harmony with nature.[55] In a 1905 letter to his future wife, Elisabeth Gerhardt, Macke discussed this wish, writing, "I have long considered expressing the longing for the lost paradise. I believe I have been in some measures successful. It is not exactly the same as we have experienced it. I will represent 'Eve,' that is the woman who feels with a refined sensitivity as opposed to the energetic man. They are the two characters of this humanity, which so beautifully complete one another. The two are expulsed from paradise and now they would like to return."[56]

Form and color were important elements as he attempted to reimagine the myth of paradise in the language of his time.[57] He populated his sketchbooks with drawings of men and women in various poses, ranging from images of Adam and Eve, to idealized male nudes in Arcadian landscapes, to Rococo couples in idyllic settings, to modern couples. His sources of inspiration included Marées and the Swiss painter Arnold Böcklin, as well as earlier artists within the tradition, such as Raphael.[58] About 1911–12 Macke began to interweave Oriental motifs into his images of lovers in harmony with nature, as evident in his sketch *Oriental Lovers* (1911) and in his wall hanging *Animal and Humans in Oriental Dress* (1912).[59] Janice McCullagh has described the evolution of Macke's paradise imagery as merging and evolving from scenes of traditional iconography to "an earthly paradise formulated as an image of the utmost modernity. . . . His paradise is shown in terms of the cosmopolitan world of his own time, where art and nature, male and female, bourgeois and worker, and city and country are the dualistic reflections of an ultimate unity."[60]

CONCLUSION

In Germany in the early twentieth century, "the dream of paradise, traditionally the Classical Golden Age, or the biblical Eden," took "a decidedly primitivistic form."[61] Inspired by German and French sources—most important Marées, Cézanne, and Gauguin—as well as major cultural and societal changes, Kirchner, Marc, and Macke used different approaches to convey their personal visions of paradise. Kirchner, along with other members of the Brücke, fled the city for the German countryside, in search of a real paradise removed from the difficulties of modern urban life. His pictures of nude figures in landscapes, often set in his personal idylls of the Moritzburg ponds or the island of Fehmarn, symbolize a timeless harmony and a primordial age of innocence. Marc's theoretical approach explores the relationship between the earth and its creatures, whereas Macke's metaphorical projections of paradise combine traditional iconography with non-Western and modern motifs.[62] Although these artists' efforts to realize a personal Arcadia in the face of great cultural and societal changes soon were demolished when the machine age caught up with them in the shape of the World War I, the significance of paradise, as Marc believed, "lies in its loss and the consequent hope that it may one day be regained."[63]

1. C. G. Jung, quoted in August Macke to Elisabeth Gerhardt, July 14, 1905, Macke Archiv, LWL–Landesmuseum für Kunst und Kulturgeschichte, Münster (my translation). For Jung's phrase, see his chapter "The Psychology of the Child Archetype," in *Psyche and Symbol: A Selection from the Writings of C. G. Jung*, ed. Violet S. de Laszlo (Garden City, NY: Anchor Books, 1958), p. 123.

2. See Roland März, "Arcadia and Metropolis," in *Arcadia and Metropolis: Masterworks of German Expressionism from the Nationalgalerie Berlin*, ed. Roland März, exh. cat. (New York: Prestel, 2004), pp. 20–21. On the revived interest in Greek mythology in Germany around the turn of the twentieth century, see Ingrid Ehrhardt, "Kingdom of the Soul—An Introduction," in *Kingdom of the Soul: Symbolist Art in Germany, 1870–1920*, ed. Ingrid Ehrhardt and Simon Reynolds, trans. John W. Gabriel and Elisabeth Schwaiger, exh. cat. (Munich: Prestel, 2000), p. 9.

3. Ehrhardt, "Kingdom of the Soul," p. 10.

4. Hofmann, "The Earthly Paradise," in *The Earthly Paradise: Art in the Nineteenth Century*, trans. Brian Battershaw (New York: George Braziller, 1961), p. 384.

5. Reynolds, "The Longing for Arcadia," in Ehrhardt and Reynolds, *Kingdom of the Soul*, p. 57.

6. Although not discussed here, Marées's use of the triptych as a pictorial form was also an important influence on the Expressionists. See Gert Schiff, "Hans von Marées and His Place in Modern Painting," *Yale University Art Gallery Bulletin*, vol. 33, no. 3 (October 1972), pp. 97–99. Marées's *Six Nude Men* is illustrated in ibid., p. 97, fig. 9.

7. Ehrhardt, "Kingdom of the Soul," p. 12 (italics in original).

8. Schiff, "Marées," p. 91.

9. Ehrhardt, "Kingdom of the Soul," p. 12. See also Anne-S. Domm, *Der "klassische" Hans von Marées und die Existenzmalerei Anfang des 20. Jahrhunderts*, Miscellanea Bavarica Monacensia, vol. 146 (Munich: Kommissionsverlag UNI-Druck, 1989), p. 61.

10. Ingrid Ehrhardt, catalogue entry in Ehrhardt and Reynolds, *Kingdom of the Soul*, p. 64, cat. 17.

11. Mann, *The Magic Mountain*, trans. H. T. Lowe-Porter (New York: Vintage Books, 1969), p. 491. For Mann's admiration of Hofmann and his purchase of *The Spring*, see Reynolds, "Longing for Arcadia," p. 58.

12. Schiff, "Marées," p. 99.

13. Ibid., p. 98.

14. On this topic, see März, "Arcadia and Metropolis," pp. 20–32.

15. Norman Rosenthal, "Ernst Ludwig Kirchner, Expressionist," in *Ernst Ludwig Kirchner, 1880–1938*, ed. Jill Lloyd and Magdalena M. Moeller, exh. cat. (Washington, DC: National Gallery of Art, 2003), p. 9. See also März, "Arcadia and Metropolis," p. 20.

16. März, "Arcadia and Metropolis," p. 21.

17. Gill Perry, "'The Going Away'—A Preparation for the 'Modern'?," pt. 1 of "Primitivism and the 'Modern,'" in *Primitivism, Cubism, Abstraction: The Early Twentieth Century*, ed. Charles Harrison, Francis Frascina, and Gill Perry (1993; repr., New Haven, CT: Yale University Press, 1994), p. 34.

18. Donald Gordon, "German Expressionism," in *"Primitivism" in 20th Century Art: Affinity of the Tribal and the Modern*, ed. William Rubin, exh. cat. (New York: Museum of Modern Art, 1984), vol. 2, p. 370.

19. März, "Arcadia and Metropolis," p. 21. For Rousseau's writings, see *The Discourse on the Origin of Inequality* (1754) and *Of the Social Contract, or Principles of Political Right* (1762). For more on Gauguin's travels to Tahiti, see George T. M. Shackelford, "Trouble in Paradise," in this volume, pp. 143–61.

20. Jill Lloyd, "The *Brücke* Bathers: Back to Nature," in *German Expressionism: Primitivism and Modernity* (New Haven, CT: Yale University Press, 1991), p. 107. See also Corona Hepp, "Apostel und Gemeinde," in *Avantgarde: Moderne Kunst, Kulturkritik und Reformbewegungen nach der Jahrhundertwende* (Munich: Deutscher Taschenbuch Verlag, 1987), pp. 75–76.

21. Hauptmann, quoted in Rüdiger Bernhardt, "Seebad und Künstlerkolonie Hiddensee: Die Aufenthalte nach 1901," in *Gerhart Hauptmanns Hiddensee* (Hamburg: Ellert Richter, 1996), p. 66 (my translation).

22. Einstein, *Die Kunst des 20. Jahrhunderts* (Berlin: Propyläen-Verlag, 1926), p. 112, trans. and quoted in März, "Arcadia and Metropolis," p. 21.

23. Despite Gauguin's example, only two Brücke members, Nolde and Pechstein, would seek Arcadia outside of Germany. Nolde's and Pechstein's journeys to the South Seas and their relation to Gauguin and Primitivism have been studied extensively. See esp. Ingrid Heermann, "Tahiti—ein europäischer Traum," in *Paul Gauguin, Emil Nolde und die Kunst der Südsee: Ursprung und Vision*, ed. Patricia Rochard, Gerhard Kölsch, and Ute-Dorothee Eichert, exh. cat. (Mainz, Germany: Hermann Schmidt, 1997), pp. 78–84; and Gerd Dietrich, ed., *Max Pechstein, das ferne Paradies: Gemälde, Zeichnungen, Druckgraphik*, exh. cat. (Ostfildern-Ruit, Germany: G. Hatje, 1995).

24. März, "Arcadia and Metropolis," p. 21. See also Lloyd, "*Brücke* Bathers," p. 107.

25. Pechstein, *Erinnerungen*, ed. L. Reidemeister (Wiesbaden, Germany: Limes Verlag, 1960), p. 42, trans. and quoted in Ashley Bassie, "The Body and Nature," in *Expressionism* (New York: Parkstone, 2008), p. 41.

26. On the associations between the female nude and nature in Expressionist art, see Gill Perry, "'The Ascent to Nature'—Some Metaphors of 'Nature' in Early Expressionist Art," in *Expressionism Reassessed*, ed. Shulamith Behr, David Fanning, and Douglas Jarman (Manchester, UK: Manchester University Press, 1993). In his memoirs, Pechstein acknowledged that the Brücke members knew that in Moritzburg "it was possible to paint nudes in the open air undisturbed." Pechstein, *Erinnerungen*, p. 45, trans. and quoted in März, catalogue entry in März, *Arcadia and Metropolis*, p. 74, cat. 2.

27. Bassie, "Body and Nature," p. 49.

28. Robert J. Goldwater, *Primitivism in Modern Art*, rev. ed. (Cambridge, MA: Belknap, 1986), p. 110.

29. Will Grohmann, *E. L. Kirchner*, trans. Ilse Falk (New York: Arts, [1961]), pp. 30–32, quoted in Goldwater, *Primitivism*, p. 112.

30. Pechstein, *Erinnerungen*, p. 50 (my translation).

31. For a detailed account of Kirchner's Fehmarn period, see Heinz Spielmann, ed., *Ernst Ludwig Kirchner auf Fehmarn*, Brücke-Almanach, exh. cat. (Schleswig, Germany: Schleswig-Holsteinisches Landesmuseum, Schloß Gottorf, 1997).

32. See Wolfgang Henze, "Fehmarn in Kirchners Werk: Zeichnung, Pastell, Aquarell und Plastik auf Fehmarn—Einige Hinweise und Beispiele," in Spielmann, *Kirchner auf Fehmarn*, p. 23.

33. Kirchner to Nele van de Velde, summer 1919, trans. and quoted in Donald Gordon, "Kirchner," in *Ernst Ludwig Kirchner* (Cambridge, MA: Harvard University Press, 1968), p. 23. For more on the influence of the Ajanta cave paintings on Kirchner's work, see Magdalena M. Moeller, "Der Einfluss der indischen Ajanta-Malereien auf Kirchners Schaffen," in *Ernst Ludwig Kirchner zum 120: Geburtstag; Die Faszination des Exotischen*, exh. cat. (Munich: Ketterer Kunst, 2000), p. 4; Roland März, "Aggression Farbe, Energiefeld der Brücke Malerei 1905 bis 1914," in *Von der Brücke zum Blauen Reiter: Farbe, Form und Ausdruck in der deutschen Kunst von 1905 bis 1914*, ed. Tayfun Belgin, exh. cat. (Heidelberg, Germany: Edition Braus, 1996), p. 59; and Donald Gordon, *Expressionism, Art and Idea* (New Haven, CT: Yale University Press, 1987), p. 77.

34. Kirchner to [Gustav] Schiefler, December 31, 1912, quoted in *Briefwechsel 1910–1935/1938: Mit Briefen von und an Luise Schiefler und Erna Kirchner sowie weiteren Dokumenten aus Schieflers Korrespondenz-Ablage*, ed. Wolfgang Henze (Stuttgart: Belser, 1990), p. 61, no. 33; trans. and quoted in März, catalogue entry in März, *Arcadia and Metropolis*, p. 80, cat. 5.

35. Henze, "Fehmarn in Kirchners Werk," p. 30. Shelter from the elements was important in view of the fact that Kirchner worked and swam naked. As Dietrich Reinhardt has noted, Kirchner's and his companion Erna Schilling's nudity amused

the lighthouse keeper's children, but was less popular with the children's parents. Reinhardt, "Zeitgenössische Zeugnisse von Kirchners Fehmarn-Aufenthalten," in Spielmann, *Kirchner auf Fehmarn*, p. 38.

36. Kirchner, trans. and quoted in Bassie, "Body and Nature," p. 46. See also Hermann Gerlinger, "Die Fehmarn-Aufenthalte Ernst Ludwig Kirchners," in Spielmann, *Kirchner auf Fehmarn*, p. 16.

37. See, for example, his paintings *Erna at the Sea* (1913; private collection) and *Erna with Japanese Umbrella* (1913; Aargauer Kunsthaus, Aarau, Switzerland), and his watercolor *Nude with Red Hat* (1912; Schleswig-Holsteinisches Landesmuseum, Schleswig, Germany).

38. Gerlinger, "Die Fehmarn," p. 16 (my translation).

39. Kirchner to Schiefler, December 12, 1914, quoted in *Die Badenden: Mensch und Natur im deutschen Expressionismus; Erich Heckel, Ernst Ludwig Kirchner, August Macke, Franz Marc, Otto Mueller, Emil Nolde, Max Pechstein, Karl Schmidt-Rottluff*, ed. Jutta Hülsewig-Johnen and Thomas Kellein, exh. cat. (Bielefeld, Germany: Kunsthalle Bielefeld, 2000), p. 125; trans. and quoted in März, catalogue entry, p. 80, cat. 5.

40. Reinhardt, "Zeitgenössische Zeugnisse," p. 44.

41. The Königstein wall painting is illustrated in black and white in ibid., pp. 44–45.

42. For a detailed account of the wall painting and related materials, see Ernst-Gerhard Güse, "Franz Marc und August Macke 'Paradies' (1912) — das Wandbild aus dem Atelier Mackes in Bonn," in *Die Gemälde von Franz Marc und August Macke im Westfälischen Landesmuseum Münster*, ed. Ernst-Gerhard Güse ([Münster]: Landschaftsverband Westfalen-Lippe, Westfälisches Landesmuseum für Kunst und Kulturgeschichte, 1982), pp. 7–32. See also Cynthia Jaffee McCabe, "Artistic Collaboration in the Twentieth Century: The Period between Two Wars," in *Artistic Collaboration in the Twentieth Century* (Washington, DC: Smithsonian Institution Press, 1984), pp. 15–16.

43. Ursula Heiderich has discussed the importance of Cézanne's work in relation to Marc and Macke's wall painting, as well as to the work of other Expressionist artists. The compositional similarities between Puvis's *Fisherman's Family* and Marc and Macke's *Paradise* are noted by Heiderich in *August Macke: Zeichnungen aus den Skizzenbüchern* (Stuttgart: Hatje, 1986), p. 44.

44. Regarding the attributions of the various elements, see Annegret Hoberg and Isabelle Jansen, *Franz Marc: The Complete Works* (London: Philip Wilson, 2004), vol. 1, p. 210, cat. 184; Güse, "Franz Marc und August Macke," pp. 25–27; and McCabe, "Artistic Collaboration," p. 16.

45. For example, see his drawing *Rider Group and Female Nude (Arcadian Group in a Landscape)* of 1910–11,

illustrated in *Franz Marc: The Retrospective*, ed. Annegret Hoberg and Helmut Friedel, exh. cat. (Munich: Prestel, 2005), p. 222, cat. 149.

46. Barbara Eschenburg, "Animals in Franz Marc's World View and Pictures," in Hoberg and Friedel, *Franz Marc*, p. 57.

47. Andreas K. Vetter, "In the Garden of the Animals: Environment and Landscape in the Work of Franz Marc," in *Franz Marc: Horses*, ed. Christian von Holst, trans. Elizabeth Clegg and Claudia Spinner, exh. cat. (Ostfildern-Ruit, Germany: Hatje Cantz Verlag, 2000), p. 229.

48. *Kunst und Künstler*, vol. 8 (1910), pp. 86–101. On Gauguin's influence on Marc and for an illustration of *The White Horse*, see Vetter, "Garden of the Animals," p. 229, fig. 192. Gauguin's influence can be seen in Marc's *Scene with Horses and Horsemen* (1911; Germanisches Nationalmuseum, Nuremberg), *The Large Blue Horses* (1911; Walker Art Center, Minneapolis), and *Weasels Playing* (1911; private collection).

49. Vetter, "Garden of the Animals," p. 230.

50. This and the preceding quotation are from ibid. *The Shepherds* and *The Dream* are illustrated in ibid., figs. 103 and 104, respectively. *The Waterfall* is illustrated in Mark Rosenthal, *Franz Marc*, 2nd ed. (Munich: Prestel, 1992), pl. 38.

51. Vetter, "Garden of the Animals," p. 230.

52. Ibid.

53. Annegret Hoberg, "Franz Marc: Aspects of His Life and Work," in Hoberg and Friedel, *Franz Marc*, p. 42. Nohl, quoted in ibid.

54. Däubler, "Essay on Franz Marc" (1916), n.p., in Holst, *Horses*, p. 237.

55. Janice McCullagh, "Mackes Paradiesvision," in *August Macke: Gemälde, Aquarelle, Zeichnungen*, ed. Ernst-Gerhard Güse, exh. cat. (Munich: Bruckmann, 1987), p. 89. For more on the vision of paradise in Macke's work, see Janice McCullagh, "August Macke and the Vision of Paradise: An Iconographic Analysis" (PhD diss., University of Texas, Austin, 1980).

56. Macke to Gerhardt, June 1905, trans. and quoted in Janice McCullagh, "The Element of Time in August Macke's Urban Paradise," *Arts*, vol. 56, no. 1 (September 1981), p. 136.

57. For Macke's images of a modern urban paradise, see McCullagh, "Element of Time," pp. 136–41.

58. See Ernst-Gerhart Güse, comp., *Macke und die Tradition: Zeichnungen aus den Skizzenbüchern von 1904 bis 1914*, 2nd ed., Bildheft, no. 11 (Münster: Landschaftsverband Westfalen-Lippe, 1986), pp. 5–21; and Heiderich, *August Macke*, p. 44.

59. For an illustration of *Oriental Lovers*, see Güse, "Franz Marc und August Macke," p. 28, fig. 39. *Animal and Humans in Oriental Dress* (private

collection) is on long-term loan to the LWL — Landesmuseum für Kunst und Kulturgeschichte, Münster.

60. McCullagh, "August Macke," p. 8.

61. Ibid., p. 49.

62. Ibid.

63. Vetter, "Garden of the Animals," p. 229.

Checklist
of the
Exhibition

Compiled by

NAINA SALIGRAM

Checklist as of May 3, 2012

NOTES TO THE READER
The checklist has been organized alphabetically by artists' last names and then chronologically by dates of works.

The exhibition histories include all known exhibitions through 1917, the date of Henri Matisse's completion of *Bathers by a River* (see pages xiii–xiv and fig. 172).

Selected literature is limited to catalogues raisonnés and references most pertinent to the history of the object and to the theme of this exhibition and catalogue.

If no provenance, exhibition history, or literature is listed for a work, none is known.

ÉMILE BERNARD
French, 1868–1941

Bathers with Water Lilies
c. 1889
Oil on canvas
36½ × 28½ inches (92.7 × 72.4 cm)
Private collection
Fig. 37

This picture is among Bernard's earliest depictions of bathers, painted as part of an ambitious decorative scheme for his studio in Asnières, outside Paris. Given that the painting has the same dimensions as two canvases of similar style and subject, *Bathers* and *Bathers with Red Cow* (see figs. 35, 36), and that Bernard sold the three works together, it is almost certain that the artist considered them a unit. Details from the "triptych" can be seen in reverse in the background of self-portraits by the artist dating to 1889–90, which confirm that the pictures indeed were hanging in Bernard's studio at this time (see, for example, his self-portrait in the Musée de Brest, France). In the present canvas, the landscape is divided into three horizontal bands of flat color, and each of the six statuesque bathers is bound by a black outline, emblematic of the artist's emerging Cloisonnist style. The diagonal tree trunk that is pushed up to the picture's surface and the water-lily pond in the foreground suggest that Bernard may have been thinking of Japanese woodblock prints, known to him through his friend Vincent van Gogh, while the contrived poses of the nudes are parodies of academic study sheets, the young artist recently having abandoned his formal training.

PROVENANCE
Purchased by Ambroise Vollard (dealer) from the artist, May 22, 1901, along with *Bathers* (private collection; see fig. 35) and *Bathers with Red Cow* (Musée d'Orsay; see fig. 36).[1] Madeleine de Galéa (1875–1956). With Galerie La Cave, Paris. Private collection, by 1980

1. Fred Leeman, e-mail to Naina Saligram, February 18, 2012.

SELECTED LITERATURE
Luthi, Jean-Jacques. *Émile Bernard: Catalogue raisonné de l'oeuvre peint.* Paris: Éditions Side, 1982, p. 14, cat. 68 (illus.).

Stevens, MaryAnne. "Paintings: Bathers / Gemälde: Badende." In *Émile Bernard, 1868–1941: A Pioneer of Modern Art / Ein Wegbereiter der Moderne,* edited by MaryAnne Stevens. Exh. cat. Zwolle, The Netherlands: Waanders Verlag, 1990, pp. 159, 162–63, cat. 33 (illus.), cover (illus.).

Pickvance, Ronald. *Gauguin and the Pont-Aven School.* Exh. cat. Sydney: Art Gallery of New South Wales, 1994, p. 70, cat. 40 (illus.).

D'Souza, Aruna. *Cézanne's Bathers: Biography and the Erotics of Paint.* University Park, PA: Pennsylvania State University Press, 2008, p. 85.

PAUL CÉZANNE
French, 1839–1906

Bathers
1874–75
Oil on canvas
15 × 18⅛ inches (38.1 × 46 cm)
The Metropolitan Museum of Art, New York
Bequest of Joan Whitney Payson, 1975
(1976.201.12)
Fig. 164

Cézanne re-established and made his own the genre of nudes in a landscape, and this canvas is one of his earliest treatments of the theme. In the generalized character and poses of the figures, many of which are derived from paintings and sculptures Cézanne had studied from reproductions and in the Louvre, this painting provides a precedent for the two hundred-some images of bathers that would follow. Here, the six female nudes already reflect Cézanne's tendency to isolate the sexes in his bathing scenes. While the landscape has been compared to those depicted in his plein air pictures from Auvers, the village north of Paris where Cézanne moved in 1872 and worked outdoors with Camille Pissarro, this scene is invented, bringing together the realms of observation and imagination that the artist negotiated throughout his life. For Bernard Berenson, this

picture is a testament to Cézanne's sustained interest in the art of the Italian masters, alongside which it would have hung in the grand salon of the American collector Charles A. Loeser's villa in Florence.[1]

1. Berenson, introduction to *La peinture française à Florence*, exh. cat. (Florence: Electa Editrice, 1945), p. 21.

PROVENANCE

With Ambroise Vollard, Paris; by exchange with three other works by Cézanne for cash and "un tableau de Lautrec de chez Boussod (femme à la toilette)" (a painting by Lautrec from Boussod [Boussod, Valadon & Cie] [*Woman at Her Toilette*]) to Charles A. Loeser (1864–1928), Florence, January 25, 1897, until d. 1928; by inheritance to his wife, Olga Lebert Loeser (d. 1947), Florence, 1928, until d. 1947; by inheritance to their daughter, Matilda Loeser Calnan (1913–2000), Florence and Lausanne, 1947. Possibly with Bruscoli, Florence, by 1961. M. Guidi, Lausanne. With M. Knoedler & Co., New York, and De Hauke & Co., New York. With Hector Brame, Paris; sold to Mrs. Charles Shipman (Joan Whitney) Payson (1903–1975), New York and Manhasset, NY, November 1963, until d. 1975; bequest to the Metropolitan Museum of Art, New York, 1975

SELECTED LITERATURE

Tsiakma, Katia. "Cézanne's and Poussin's Nudes." *Art Journal*, vol. 37, no. 2 (Winter 1977–78), p. 122, fig. 7.

Krumrine, Mary Louise. *Paul Cézanne: The Bathers*. Exh. cat. New York: Harry N. Abrams, 1990, pp. 75, 123, 132, 137, 144, 148, 150, 187, 208, 240–41, 246, 312, cat. 15, nos. 2 (illus. [detail]), 88 (illus.).

Rewald, John. *The Paintings of Paul Cézanne: A Catalogue Raisonné*. New York: Harry N. Abrams, 1996, vol. 1, p. 176, cat. 256; vol. 2, p. 83, cat. 256 (illus.).

Rishel, Joseph J. Catalogue entry in *Cézanne*, edited by Françoise Cachin and Joseph J. Rishel. Exh. cat. Philadelphia: Philadelphia Museum of Art, 1996, p. 150, cat. 37 (illus.).

Bardazzi, Francesca. "Fabbri and Loeser: Cézanne Collecting." In *Cézanne in Florence: Two Collectors and the 1910 Exhibition of Impressionism*, edited by Francesca Bardazzi. Exh. cat. Milan: Electa, 2007, pp. 88 (illus. [detail]), 90, 112, 113 (illus.).

Three Bathers
c. 1875
Oil on canvas
12 × 13 inches (30.5 × 33 cm)
Private collection
Fig. 1

Painted about the same time as *Bathers* (see fig. 164), this canvas is distinguished by its playful energy and brusque brushwork. The English sculptor Henry Moore, who owned this work for almost thirty years, compared it to Cézanne's late masterpiece the Philadelphia *Large Bathers* (see page xii and fig. 155), remarking that despite its small format, "This one that I have has to me just as monumental a sense. . . . It's not perfect, it's a sketch. But then I don't like absolute perfection." In particular, he was drawn to the women Cézanne rendered here: "Not young girls but that wide, broad, mature woman. Matronly. Look at that back view of the figure on the left. What a strength . . . almost like the back of a gorilla, that kind of flatness."[1] In 1978 Moore translated the painting's three main figures into sculptures in the round, which bring new light to the solidity of Cézanne's forms.[2]

1. Moore, quoted in *Henry Moore on Sculpture*, ed. Philip James (London: Macdonald, 1966), pp. 190, 193.

2. Moore's sculpture, *Three Bathers—After Cézanne*, is illustrated in David Mitchinson, ed., *Henry Moore, Sculpture* (London: Macmillan, 1981), nos. 601–6.

PROVENANCE

Ambroise Vollard (1866–1939), Paris. With Paul Rosenberg, Paris and New York, 1951. With Galerie des Arts Anciens et Modernes, Paris, by 1958; with Marlborough Fine Art, London, 1959; Henry Moore (1898–1986), Much Hadham, UK, 1960, until d. 1986; his estate; private collection. Sale, Sotheby's, London, June 28, 1999, no. 12; purchased by the present owner

SELECTED LITERATURE

Bernard, Émile. *Sur Paul Cézanne*. Paris: R. G. Michel, 1925, p. 77 (illus.).

James, Philip, ed. *Henry Moore on Sculpture: A Collection of the Sculptor's Writings and Spoken Words*. London: Macdonald, 1966, pp. 190, 193, fig. 71.

Rewald, John. *The Paintings of Paul Cézanne: A Catalogue Raisonné*. New York: Harry N. Abrams, 1996, vol. 1, p. 240, cat. 361; vol. 2, p. 114, cat. 361 (illus.).

Rishel, Joseph J. Catalogue entry in *Cézanne*, edited by Françoise Cachin and Joseph J. Rishel. Exh. cat. Philadelphia: Philadelphia Museum of Art, 1996, p. 153, cat. 38 (illus.).

Group of Bathers
c. 1895
Oil on canvas
8⅛ × 12⅛ inches (20.6 × 30.8 cm)
Philadelphia Museum of Art. The Louise and Walter Arensberg Collection, 1950-134-34
Fig. 166

This small canvas of seven male bathers belongs to a series of paintings from the 1890s with similar arrangements of figures. Here, the bathers take on a heightened sense of anonymity; no faces are discernible. The standing figure on the right, in a contrapposto stance, turns toward the viewer but presents a blank countenance. Similarly, the seated nude on the far left faces forward, but his visage is shrouded with mottled brown paint, as if his head is actually being seen from behind. The three bathers in the right background lack human definition, instead resembling rocks or tree stumps that seem to merge with their surroundings. Small compositions such as this were the most intimate format for Cézanne's continued experimentations with the formal relationship between figure and landscape.

PROVENANCE

Possibly with Galerie Barbazanges, Paris; Louise and Walter C. Arensberg, Los Angeles, by c. 1918; gift to the Philadelphia Museum of Art, 1950

SELECTED LITERATURE

Rishel, Joseph J. *Cézanne in Philadelphia Collections*. Exh. cat. Philadelphia: Philadelphia Museum of Art, 1983, p. 41, cat. 19 (illus.).

Krumrine, Mary Louise. *Paul Cézanne: The Bathers*. Exh. cat. New York: Harry N. Abrams, 1990, pp. 168, 186, 315, cat. 57, no. 166 (illus.).

Rewald, John. *The Paintings of Paul Cézanne: A Catalogue Raisonné.* New York: Harry N. Abrams, 1996, vol. 1, p. 460, cat. 755; vol. 2, p. 257, cat. 755 (illus.).

Bathers
c. 1900–1902
Oil on canvas
7⅞ × 13 inches (20 × 33 cm)
Private collection
Fig. 167

In this rapidly executed painting from the last decade of his life, Cézanne turned to a darker palette, giving predominance to the color blue. A related sketch (c. 1900; Bridgestone Museum of Art, Tokyo) informs the thin application of paint here and the use of the blank canvas to denote positive shape, as in the arm of the standing bather on the left. While Cézanne's images of bathers are not explicitly narrative, the figures are shown in active engagement, and in this work, the poses of the central couple harken back to his earlier *Lutte d'amour* (see fig. 67). Here, the pair is part of a frieze-like group of figures whose dark contours contribute to a sense of projective relief reminiscent of antique sculpture.

PROVENANCE
Ambroise Vollard (1866–1939), Paris. Lord Kenneth Clark (1903–1983), Saltwood Castle, Kent, by 1939; by inheritance to his son Alan Clark (1928–1999), Saltwood Castle, Kent. With Alex Reid & Lefevre, London. With Richard L. Feigen, New York. With Harmon Fine Arts, New York. Sale, Sotheby's, New York, May 11, 1993, no. 26; purchased by Kobayashi Gallery, Tokyo; private collection; sale, Sotheby's, London, June 30, 1998, no. 13; purchased by the present owner

SELECTED LITERATURE
Dormoy, M. "Ambroise Vollard's Private Collection." *Formes* (September 1931), n.p. (illus.).

Krumrine, Mary Louise. *Paul Cézanne: The Bathers.* New York: Harry N. Abrams, 1990, pp. 183, 315, cat. 67, no. 168 (illus.).

Rewald, John. *The Paintings of Paul Cézanne: A Catalogue Raisonné.* New York: Harry N. Abrams, 1996, vol. 1, p. 516, cat. 866; vol. 2, p. 304, cat. 866 (illus.).

The Large Bathers
1900–1906
Oil on canvas
6 feet 10⅞ inches × 8 feet 2¾ inches (2.1 × 2.5 m)
Philadelphia Museum of Art. Purchased with the W. P. Wilstach Fund, W1937-1-1
Page xii and fig. 155

Cézanne painted three versions of *The Large Bathers* toward the end of his life, the culmination of his lifelong engagement with the bather subject. This canvas, his largest image of bathers, is thought to be unfinished (it was in the artist's studio at the time of his death in 1906). The arched trees framing the composition create a stage-like setting for the fourteen figures on a riverbank, as well as the lone swimmer in the middle ground and two ambiguous figures in the distance. Drawn from the artist's imagination and from art of the past, the bathers in the foreground are arranged in two groups, reinforcing the triangular structure formed by the trees and giving the picture a pronounced stability. While the other two versions of *The Large Bathers* (see figs. 169, 170) are heavily worked and dense, this one is lighter, in touch and in palette, and more open. The painting was featured in the artist's 1907 memorial exhibition, where it was celebrated as much for its nobility as its mystery.

PROVENANCE
Estate of the artist, 1906; purchased by Ambroise Vollard (dealer), Paris, from the artist's son, 1907; Auguste Pellerin (1852–1929), Paris, by 1923; by inheritance to his son, Jean-Victor Pellerin, Paris, 1929–36; with Wildenstein & Co., New York, acting as agent for Pellerin, 1936; sold to the City of Philadelphia for the W. P. Wilstach Collection, July 6, 1937

EXHIBITIONS
Exposition rétrospective d'oeuvres de Cézanne au Salon d'Automne. Grand Palais, Paris, October 1–22, 1907, no. 19.

XVIII Ausstellung der Berliner Secession. Ausstellunghaus am Kurfürstendamm, Berlin, 1909, no. 40.

SELECTED LITERATURE
Reff, Theodore. "Painting and Theory in the Final Decade." In *Cézanne: The Late Work.* Exh. cat. New York: Museum of Modern Art, 1977, pp. 38–44, pl. 189.

Krumrine, Mary Louise. *Paul Cézanne: The Bathers.* Exh. cat. New York: Harry N. Abrams, 1990, pp. 210–18, no. 179 (illus.).

Clark, T. J. "Freud's Cézanne" (1995). In *Farewell to an Idea: Episodes from a History of Modernism.* New Haven, CT: Yale University Press, 1999, pp. 152–67, fig. 88.

Rewald, John. *The Paintings of Paul Cézanne: A Catalogue Raisonné.* New York: Harry N. Abrams, 1996, vol. 1, pp. 247, 509–12, cat. 857, pl. 35; vol. 2, p. 301, cat. 857 (illus.).

Rishel, Joseph J. "Bathers." In *Cézanne,* edited by Françoise Cachin and Joseph J. Rishel. Exh. cat. Philadelphia: Philadelphia Museum of Art, 1996, pp. 496–505, cat. 219 (illus.).

JEAN-BAPTISTE-CAMILLE COROT
French, 1796–1875

The Bridge at Narni
1827
Oil on canvas
26¾ × 37¼ inches (68 × 94.6 cm)
National Gallery of Canada, Ottawa. Purchased 1939
Fig. 21

This painting, one of two pictures Corot sent to Paris for his artistic debut at the 1827 Salon, reflects how, from the very outset of his career, the artist positioned himself as the nineteenth-century heir to the French classical tradition. In 1825 he embarked on a three-year trip to Italy, and in September 1826 he visited the Ponte d'Augusto, an ancient bridge outside the hill town of Narni on the Via Flaminia, the famous road leading to Rome. He recorded his observations of the bridge and the valley of the Nera river in a plein air sketch (now in the Musée du Louvre), which became the basis for this painting, a studio composition begun that winter from his recollections of the site. While he remained faithful to the

clarity of light and the terrain's topography recorded in his earlier sketch, here Corot added maidens and goatherds in the foreground, as well as goats and trees on the left, turning the landscape of the Roman Campagna into a sacred grove whose inhabitants are continuations from ancient times.

PROVENANCE

The artist's posthumous sale, Hôtel Drouot, Paris, pt. 1, May 26–28, 1875, no. 21; purchased by Georges Lemaistre, nephew of the artist, Paris; by inheritance to Charles André, nephew of the artist, Paris; anonymous sale [Charles André], Hôtel Drouot, Paris, May 17, 1893, no. 3. Victor Desfossés, Paris; his sale, Paris, April 26, 1899, no. 16; purchased by Bernheim-Jeune & Cie (dealer), Paris. With Royal Galleries Ltd., New York. With F. Schnittjer & Son, New York; sold to the National Gallery of Canada, Ottawa, 1939

EXHIBITIONS

Salon of 1827. Musée Royal des Arts, Paris, 1827, no. 221.

Exposition du centenaire de Corot. Palais Galliéra, Paris, 1895, no. 116.

SELECTED LITERATURE

Robaut, Alfred. *L'oeuvre de Corot: Catalogue raisonné et illustré.* Paris: H. Floury, 1905, vol. 1, p. 46; vol. 2, p. 70, no. 199 (illus.).

Venturi, Lionello. *Corot, 1796–1875.* Exh. cat. Philadelphia: Philadelphia Museum of Art, 1946, pp. 14, 26, no. 6 (illus.).

Lurie, Ann Tzeutschler. "Corot: The Roman Campagna." *Bulletin of the Cleveland Museum of Art,* vol. 53, no. 2 (February 1966), pp. 52–56, fig. 4.

Galassi, Peter. *Corot in Italy: Open-Air Painting and the Classical-Landscape Tradition.* New Haven, CT: Yale University Press, 1991, pp. 166–70, pl. 203.

Pomarède, Vincent. Catalogue entry in *Corot,* by Gary Tinterow, Michael Pantazzi, and Vincent Pomarède. Exh. cat. New York: Metropolitan Museum of Art, 1996, pp. 76–78, cat. 27 (illus.).

Silenus
1838
Oil on canvas
8 feet 1½ inches × 5 feet 10½ inches (2.45 × 1.79 m)
The Minneapolis Institute of Arts. Bequest of J. Jerome Hill
Fig. 25

The source for this grand mythological painting is Virgil's sixth *Eclogue,* known as the "Song of Silenus," whose protagonist, according to ancient folklore, was the tutor of the wine god, Dionysus. Corot, working in close correspondence with Virgil's text, depicted in the lower left two nymphs playfully binding a drunken Silenus with his own garlands, a ploy to incite him to sing a lofty tale of the creation of the earth, the ages of man, and mythological narratives. Although the scene is one of ebullient gaiety, replete with a ring of dancers, the merriment is restrained: The somber figure reclining behind the tree on the left introduces an element of calm, even disquietude. When the painting was displayed at the 1838 Salon, critics were unfavorable, finding it too overtly fashioned after Poussin's multifigure compositions of bacchic celebration.

PROVENANCE

Sold by the artist to Weyl (dealer) in 1872, but not paid for until after the artist's death. With Cadart, Paris. Anonymous sale, Hôtel Drouot, Paris, February 19, 1877, no. 5; Jean Dollfus, Paris; his sale, Galerie Georges Petit, Paris, March 2, 1912, no. 4; purchased by Durand-Ruel (dealer) for James J. Hill (1838–1916), Saint Paul, MN (inv. no. 242); his son Louis W. Hill, Sr. (1872–1948); his son J. Jerome Hill (1905–1972), New York; bequest to the Minneapolis Institute of Arts, 1973

EXHIBITION

Salon of 1838. Musée Royal des Arts, Paris, 1838, no. 341.

SELECTED LITERATURE

Planche, Gustave. *Études sur l'école française (1831–1852): Peinture et sculpture.* Paris: M. Lévy Frères, 1855, vol. 2, pp. 141–42.

Robaut, Alfred. *L'oeuvre de Corot: Catalogue raisonné et illustré.* Paris: H. Floury, 1905, vol. 1, p. 82; vol. 2, p. 132, no. 368 (illus.).

Bazin, Germain. *Corot.* [Paris]: P. Tisne, 1942, pp. 8, 46, 115, no. 43 (illus.).

Pantazzi, Michael. Catalogue entry in *Corot,* by Gary Tinterow, Michael Pantazzi, and Vincent Pomarède. Exh. cat. New York: Metropolitan Museum of Art, 1996, pp. 162–64, cat. 64 (illus.).

The Little Shepherd
From the portfolio *Quarante clichés* (Paris: M. Le Garrec, 1921)
c. 1854
Glass print (*cliché verre*)
Plate: 13¼ × 10 inches (33.7 × 25.4 cm)
Philadelphia Museum of Art. Purchased with the John D. McIlhenny Fund, 1945-53-7[7]
Not illustrated in catalogue

When Corot submitted *Landscape, Setting Sun (The Little Shepherd)* (see fig. 24) to the 1840 Salon, the critic Charles Blanc declared, "I would wager that in the realm of painting no one else has understood the idyll the same way."[1] The painting, adapted from a study of trees made in the Tuscan town of Volterra six years prior, depicts a piping shepherd in an idealized landscape, the sensuality of the youth's ephebic form reinforced by the sinuous vines framing the composition on the right. In 1854 Corot made a series of three *clichés verres,* or glass prints, after the painting, using a new printing technique that produced multiples from the negatives of pictures drawn onto a light-colored ground. In this print (the second state of the second plate), the painting's precise forms are replaced with striking contrasts between light and dark. The glass print technique imbues the scene with a greater sense of drama and heightens the poetic and symbolic dimensions of Corot's imagined world with its tendency toward suggestion rather than description.

1. Blanc, "Salon de 1840," *Revue de progrès,* May 1, 1840, p. 358, trans. and quoted in Michael Pantazzi, catalogue entry in *Corot,* by Gary Tinterow, Michael Pantazzi, and Vincent Pomarède, exh. cat. (New York: Metropolitan Museum of Art, 1996), p. 183, cat. 76.

SELECTED LITERATURE

Delteil, Loys. *Le peintre-graveur illustré (XIX* et XX* *siècles)*. Paris: Chez l'auteur, 1910, vol. 5, no. 50 (illus.).

Barnard, Osbert H. "The 'Clichés-verre' of the Barbizon School." *Print-Collector's Quarterly*, vol. 9, no. 1 (April 1922), p. 153 (illus.).

Hédiard, Germain. *Le cliché-verre: Corot et la gravure diaphane*. Exh. cat. Geneva: Cabinet des Estampes du Musée d'Art et d'Histoire, 1982, pp. 52, 89–90, no. 22 (illus.).

Tinterow, Gary, Michael Pantazzi, and Vincent Pomarède. *Corot*. Exh. cat. New York: Metropolitan Museum of Art, 1996, p. 183.

Goatherd of Terni
c. 1871
Oil on canvas
32⅜ × 24⅝ inches (82.2 × 62.5 cm)
Philadelphia Museum of Art. Bequest of Charlotte Dorrance Wright, 1978-1-8
Fig. 23

In the summer of 1826, Corot, who lived and studied in Italy from 1825 to 1828, visited the city of Terni, north of Rome. This picture, painted some forty-five years later, is a mellow recollection of the landscape he discovered there. The lucidity and solidity of form that mark his first Salon canvas, *The Bridge at Narni* (1827; see fig. 21), a studio composition that he made during his tour of Italy, dissolves here into a remembered haze, a vaporous array of loose, feathery dabs of paint against a backdrop of the evening sky.

PROVENANCE

Dr. Dieulafoy, 1875. With Howard Young Galleries, New York, by April 1930; with Scott & Fowles, New York; sold to Charlotte Dorrance Wright (1911–1977) and William Coxe Wright (d. 1970), St. Davids, PA, July 17, 1952, until his d. 1970; Charlotte Dorrance Wright; bequest to the Philadelphia Museum of Art, 1978

EXHIBITION

Exposition de l'oeuvre de Corot. École National des Beaux-Arts, Paris, May 1875, no. 165.

SELECTED LITERATURE

Robaut, Alfred. *L'oeuvre de Corot: Catalogue raisonné et illustré*. Paris: H. Floury, 1905, vol. 3, p. 336, no. 2215; vol. 4, p. 275.

Frankfurter, Alfred M. "Masterpieces of Landscape Painting in American Collections." *Fine Arts*, vol. 18, no. 1 (December 1931), pp. 33 (illus.), 76.

Thompson, Jennifer A. Catalogue entry in *Masterpieces from the Philadelphia Museum of Art: Impressionism and Modern Art*, edited by Yōichirō Ide. Exh. cat. Tokyo: Yomiurishinbuntōkyōhonsha, 2007, p. 38, cat. 2 (illus.).

HENRI-EDMOND CROSS

French, 1856–1910

Mediterranean Shores
1895
Oil on canvas
25⅞ × 36½ inches (65.7 × 92.7 cm)
Mr. and Mrs. Walter F. Brown
Fig. 53

In 1891 Cross moved permanently to the Mediterranean coast, which became the setting for this painting. In this compact composition, whose parts are rhythmically melded along multiple arabesques, Cross reconciled the tradition of the out-of-time pastoral with the Impressionists' penchant for modern subjects. The four women in the foreground—each of whom might be modeled after the artist's wife, Irma—are shown in various states of dress and quickly transition from contemporary picnickers by the sea to classical muses or nymphs in a sacred grove. Henri Matisse would have seen this painting at Cross's solo exhibition at the Galerie Druet in Paris in 1905, if not even earlier, during the summer he spent in Saint-Tropez in 1904. Cross's picture has been cited as a direct prototype for Matisse's more radical departures into new definitions of idyllic subjects—namely, *Luxe, calme et volupté* (1904–5; see fig. 57) and *Le bonheur de vivre* (1905–6; see fig. 58).

PROVENANCE

Put on deposit by the artist with Galerie Druet, Paris. Sale, Palais Galliéra, Paris, May 25, 1976, no. 48bis. Sale, Galerie Koller, Zurich, May 26, 1979, no. 5086; purchased by the present owners

EXHIBITIONS

Salon de l'Art Nouveau. Hôtel Bing, Paris, December 26, 1895–January 1896, no. 61.

La Libre Esthétique. Musée d'Art Moderne, Brussels, February 25–April 1, 1897, no. 146.

Salon des Indépendants. Palais de Glace, Champs-Élysées, Paris, April 19–June 12, 1898, no. 140.

Henri Edmond Cross. Galerie Druet, Paris, March 21–April 8, 1905, no. 15.

Französische Künstler. Kunstverein, Munich, September 1906; Kunstverein, Frankfurt, October 1906; Galerie Arnold, Dresden, November 1906; Kunstverein, Karlsruhe, Germany, December 1906; Kunstverein, Stuttgart, January 1907, no. 18.

SELECTED LITERATURE

Compin, Isabelle. *H. E. Cross*. Paris: Quatre Chemins, 1964, pp. 140–41, no. 51 (illus.).

Bock, Catherine Cecelia. "Henri Matisse and Neo-Impressionism, 1898–1908." PhD diss., University of California, Los Angeles, 1977, pp. 245, 248, fig. 81.

Baligand, Françoise, et al. *Henri Edmond Cross, 1856–1910*. Exh. cat. Paris: Somogy Éditions d'Art, 1998, p. 120, no. 11 (illus.).

Werth, Margaret. *The Joy of Life: The Idyllic in French Art, circa 1900*. Berkeley: University of California Press, 2002, pp. 84, 119, 159, 166, 201, pl. 9.

Baligand, Françoise. "In search of harmony / Á la recherche d'harmonie." In *Cross and Neo-Impressionism: From Seurat to Matisse / Henri-Edmond Cross et le néo-impressionnisme: De Seurat à Matisse*, by Françoise Baligand et al. Exh. cat. Paris: Musée Marmottan Monet, 2011, pp. 77, 80, cat. 37 (illus.).

Study for "Faun" (fig. 54)
1905–6
Oil, charcoal, and pastel on paper, mounted on canvas
22¹⁄₁₆ × 18⅛ inches (56 × 46 cm)
Musée de Grenoble. Augutte-Sembat Bequest, 1923
Not illustrated in catalogue

See following entry for description.

PROVENANCE
Irma Cross, wife of the artist. With Bernheim-Jeune & Cie, Paris. Marcel Sembat (1862–1922), until d. 1922; his estate; Musée de Grenoble, Agutte-Sembat Bequest, 1923

SELECTED LITERATURE
Compin, Isabelle. *H. E. Cross.* Paris: Quatre Chemins, 1964, p. 243, cat. 143.

Franz, Erich, ed. *Signac et la libération de la couleur: De Matisse à Mondrian.* Exh. cat. Paris: Éditions de la Réunion des Musées Nationaux, 1997, p. 125, cat. 49 (illus.).

Werth, Margaret. *The Joy of Life: The Idyllic in French Art, circa 1900.* Berkeley: University of California Press, 2002, pp. 194–98, pl. 12.

Faun
1905–6
Oil on canvas
39⅜ × 31⅞ inches (100 × 81 cm)
Private collection
Fig. 54

In a 1905 letter to his friend Théo van Rysselberghe, Cross wrote, "I am starting a figure of a man, a dancing faun inspired by the verses of Mallarmé—a

rediscovery of imagined rhythm."[1] He was referring to the present composition (and its study; see entry above) and to Stéphane Mallarmé's celebrated poem "L'après-midi d'un faune" (1876), in which a faun, having awoken from slumber, recalls an amorous encounter with nymphs in an idyllic landscape. Cross's picture captures the moment when the faun, doubting that his memory is grounded in reality, is overtaken by frenzy:

> So when of grapes the clearness I've sucked,
> To banish regret by my ruse disavowed,
> Laughing, I lift the empty bunch to the sky,
> Blowing into its luminous skins and athirst
> To be drunk, till the evening I keep looking
> through.[2]

The painting, which was exhibited alongside Henri Matisse's *Bonheur de vivre* (see fig. 58) at the 1906 Salon des Indépendants, must have remained in the younger artist's mind: In 1932 Matisse portrayed his own striding faun for his illustrations of Mallarmé's poem (see fig. 64).

1. Cross to Van Rysselberghe, [summer 1905?], in Isabelle Compin, *H. E. Cross* (Paris: Quatre Chemins), 1964, p. 243.
2. Mallarmé, "The Afternoon of a Faun" (1876), in *Poems*, trans. Roger Fry (New York: New Directions, 1951), p. 85.

PROVENANCE
Sale, Hôtel Drouot, Paris, July 1, 1937, no. 111. Fine Arts Associates, New York. Sale, Christie's, New York, May 5, 2005, no. 317, bought in. Private collection

EXHIBITION
Salon des Indépendants. Grandes Serres de l'Alma, Cours-la-Reine, Paris, March 20–April 30, 1906, no. 1184.

SELECTED LITERATURE
Compin, Isabelle. *H. E. Cross.* Paris: Quatre Chemins, 1964, pp. 63, 242–43, no. 142 (illus.).

Werth, Margaret. *The Joy of Life: The Idyllic in French Art, circa 1900.* Berkeley: University of California Press, 2002, pp. 194–98, fig. 93.

Szymusiak, Dominique. "Matisse and Cross: A Friendship between Painters / Matisse et Cross: Une amitié de peintres." In *Cross and Neo-Impressionism: From Seurat to Matisse / Henri-Edmond Cross et le néo-impressionnisme: De Seurat à Matisse*, by Françoise Baligand et al. Exh. cat. Paris: Musée Marmottan Monet, 2011, pp. 162, 164, cat. 91 (illus.).

ROBERT DELAUNAY
French, 1885–1941

The City of Paris
1910–12
Oil on canvas
8 feet 9⅛ inches × 13 feet 3¹³⁄₁₆ inches
(2.67 × 4.06 m)
Musée National d'Art Moderne/Centre de Création Industrielle, Centre Georges Pompidou, Paris
Figs. 118, 121

In June 1911 the critic Guillaume Apollinaire praised the new circle of Cubists who had exhibited together that spring, announcing that they were now "ready to approach the vast subjects that yesterday's painters did not dare to undertake, leaving them to the presumptuous, outmoded, and boring daubers of the official salons."[1] The following year Delaunay fulfilled Apollinaire's charge with this painting, *The City of Paris.* Although he dated the work 1910–12, Delaunay most likely painted it over the course of a month, between February and March 1912, completing it in time for that year's Salon des Indépendants. The thin, fresco-like application of paint reflects its rapid execution—a testament to Delaunay's command of large formats, achieved through his early training in the workshop of a set designer—and his dating suggests that he considered the painting a summation of his artistic experiments over the previous two years. In the picture, Delaunay juxtaposed the allegorical Three Graces and the Eiffel Tower to visualize Paris past and present, a temporal expression of the concept of simultaneity that preoccupied him throughout his career.

1. Apollinaire, preface to the *Catalogue du 8ᵉ Salon annuel du cercle d'art "Les Indépendants" au Musée Moderne de Bruxelles* (1911), trans. and quoted in *Apollinaire on Art: Essays and Reviews, 1902–1918*, ed. LeRoy C. Bruenig (New York: Viking, 1972), p. 172.

PROVENANCE
Purchased by the French government from the artist, 1936

EXHIBITION
Salon des Indépendants. Baraquements du Quai d'Orsay, Pont de l'Alma, Paris, March 20–May 16, 1912, no. 868.

SELECTED LITERATURE

Habasque, Guy. "Catalogue de l'oeuvre de Robert Delaunay." In *Du Cubisme à l'art abstrait*, edited by Pierre Francastel. Paris: SEVPEN, 1957, p. 266, no. 100.

Hoog, Michel. "La ville de Paris de Robert Delaunay: Sources et développement." *La revue du Louvre*, vol. 15, no. 1 (1965), pp. 29–38, fig. 1.

Spate, Virginia. *Orphism: The Evolution of Non-figurative Painting in Paris, 1910–1914*. Oxford Studies in the History of Art and Architecture. Oxford: Oxford University Press, 1979, esp. pp. 80–89, pl. 136.

Buckberrough, Sherry A. *Robert Delaunay: The Discovery of Simultaneity*. Studies in the Fine Arts: The Avant-Garde, no. 21. Ann Arbor, MI: UMI Research Press, 1982, pp. 84–98, pl. 41.

Rousseau, Pascal. "La ville de Paris." *Robert Delaunay, 1906–1914: De l'impressionnisme à l'abstraction*. Exh. cat. Paris: Éditions du Centre Pompidou, 1999, pp. 156–61, 165 (illus.).

Three-Part Windows
1912
Oil on canvas
13⅞ × 36⅛ inches (35.2 × 91.8 cm)
Philadelphia Museum of Art. A. E. Gallatin Collection, 1952-61-13
Fig. 127

After completing *The City of Paris* in the spring of 1912 (see fig. 118), Delaunay immediately turned his attention to a series of more than twenty canvases of windows overlooking the city, which mark the artist's departure into near abstraction. This painting, made in June 1912, mirrors the tripartite structure of *The City of Paris* in its three views of the city, here recognizable only through the pointed tip of the Eiffel Tower, seen three times. Inspired in part by Leonardo's writings on perception, which describe the eye as a window onto the soul, as well as Stéphane Mallarmé's poem "Fenêtres" ("Windows"; 1863), Delaunay conceived of the works in this series as musical variants on a theme. This canvas was given the title *2nd Representation, Simultaneous Windows, City, 1st Part, 3 Motifs* when it was shown with twelve other "Windows" pictures at the Berlin gallery Der Sturm in 1913. The exhibition catalogue includes Guillaume Apollinaire's own poem "Fenêtres," a celebration of Delaunay's pictures of windows

that interpret light and color as a form of music or poetry.[1]

1. For the exhibition catalogue and Apollinaire's poem, see *R. Delaunay*, exh. cat. (Paris: [A. Marty], 1913). *Three-Part Windows* is illustrated as pl. 7.

PROVENANCE
Purchased by A. E. Gallatin (1881–1952), New York, from the artist, by June 1932; bequest to the Philadelphia Museum of Art, 1952

EXHIBITIONS
Zwölfte Ausstellung: R. Delaunay. Galerie Der Sturm, Berlin, January 27–February 20, 1913, no. 4.

Nemzetközi Postimpresszionista Kiallitas. Mûvészház Galéria, Budapest, April–May 1913, no. 44.

SELECTED LITERATURE
Habasque, Guy. "Catalogue de l'oeuvre de Robert Delaunay." In *Du Cubisme à l'art abstrait*, edited by Pierre Francastel. Paris: SEVPEN, 1957, p. 266, no. 112.

Buckberrough, Sherry A. *Robert Delaunay: The Discovery of Simultaneity*. Studies in the Fine Arts: The Avant-Garde, no. 21. Ann Arbor, MI: UMI Research Press, 1982, pp. 112, 116, pl. 49.

Hoberg, Annegret. Catalogue entry in *Delaunay und Deutschland*, edited by Peter-Klaus Schuster. Exh. cat. Cologne: DuMont Buchverlag, [1985], pp. 366–67, cat. 92, pl. 8.

Drutt, Matthew. *Visions of Paris: Robert Delaunay's Series*. Exh. cat. New York: Solomon R. Guggenheim Foundation, 1997, pp. 38–39, no. 54 (illus.).

Rousseau, Pascal. "Fenêtres." In *Robert Delaunay, 1906–1914: De l'impressionnisme à l'abstraction*. Exh. cat. Paris: Éditions du Centre Pompidou, 1999, pp. 168–69, 180 (illus.).

MAURICE DENIS
French, 1870–1943

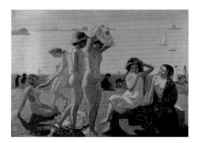

Women by the Sea
1911
Oil on canvas
45¹¹⁄₁₆ × 61⅞ inches (116 × 157.2 cm)
The Barnes Foundation, BF293
Fig. 43

Denis discovered the seaside town of Perros-Guirec, on the coast of Brittany, early in his life,

its importance to the artist marked by his decision to spend his honeymoon there in 1893. Thereafter, he returned for several summers, eventually purchasing the villa Silencio in 1908 as his family's vacation home. The picturesque site became the backdrop for many of Denis's pictures, especially beach scenes in which he depicted his friends and family in repose with a level of intimacy that is absent from his larger, decorative projects. In this canvas, Denis confronted modern details, such as the women's fashionable head-wraps and hats, with the image of the classical nude, blurring the realms of the contemporary and the timeless.

PROVENANCE
With Galerie Druet, Paris; sold to Dr. Albert C. Barnes (1872–1951), Merion, PA, November 6, 1912

ANDRÉ DERAIN
French, 1880–1954

Earthly Paradise
1906
Watercolor on paper
19⅝ × 25½ inches (50 × 65 cm)
Jean-Luc Baroni, London
Fig. 91

This watercolor, which is related to Derain's large painting *The Dance* (see fig. 88), depicts a mythic Eden, with a couple embracing underneath a fruit tree on the left and another seen from behind on the right. The male figure on the right turns his head downward, suggesting that the two couples represent Adam and Eve, before and after the Fall. Derain, who regularly frequented the Louvre, was deeply responsive to the history of art. He drew from the imagery of Michelangelo and Raphael for the multicolored snake coiled around the tree trunk. In *The Dance*, however, Derain disposed of overt biblical references and moved the snake to the ground, creating a synaesthetic composition in which color animates the painting with the music of a ritual dance. Here, the colors are less intense, and the faintly applied medium, in which the distorted figures appear to float, enhances the picture's dreamlike quality.

PROVENANCE

Sale, Fine Art Auctions Miami, December 4, 2011, no. 227; purchased by the present owner

SELECTED LITERATURE

Thut, Frederic. *Important Paintings and Sculptures Auction*. Auction cat. Miami: Fine Art Auctions, 2011, p. 68, no. 227 (illus.).

Bathers
1907
Oil on canvas
4 feet 4 inches × 6 feet 4¾ inches (1.32 × 1.95 m)
The Museum of Modern Art, New York
William S. Paley and Abby Aldrich Rockefeller Funds, 1980
Fig. 93

When Derain exhibited this painting alongside Matisse's *Blue Nude* (1907; Baltimore Museum of Art) at the 1907 Salon des Indépendants, critics were scandalized. Louis Vauxcelles, who, in 1905 had coined the use of the term *fauve* to describe the works of these artists, wrote of Derain's picture, "the barbaric simplifications of Monsieur Derain don't offend me any less: Cézannesque mottlings are dappled over the torsos of bathers plunged in horribly indigo waters."[1] These "barbaric simplifications," especially visible in the face of the central figure, register, in part, the artist's growing interest in African art, which he had begun collecting in 1906 when he purchased a Gabon fang mask from Maurice de Vlamnick. Derain frequented the Trocadéro ethnographic museum in Paris, and he studied non-Western art in the British Museum on his trips to London in 1906 and 1907. Here, the figures emerge from the background as if they were part of a sculptural relief, demonstrating Derain's experimentations with an abbreviated syncopation of form that marked an important development in the emergence of Cubism.

1. Vauxcelles, "Le Salon des Indépendants," *Gil Blas*, March 20, 1907, trans. and quoted in John Golding, "The Influence of Cubism in France, 1900–1914," in *Cubism: A History and an Analysis, 1907–1914*, 3rd ed. (Cambridge, MA: Belknap, 1988), p. 147.

PROVENANCE

With Galerie Druet, Paris; with Galerie Kahnweiler, Paris, by 1914; seized during World War I by the French government as enemy property and sold through Hôtel Drouot, Paris, May 7–8, 1923. With Galerie Katia Granoff, Paris. Sale, Hôtel Drouot, Paris, late 1920s; purchased by Josef Müller (1887–1977), Solothurn, Switzerland; by inheritance to his daughter, Monique Barbier, Presinge/Geneva, Switzerland, 1977; sold through Galerie Beyeler, Basel, to the Museum of Modern Art, New York, 1980

EXHIBITION

Salon des Indépendants. Grandes Serres de l'Alma, Cours-la-Reine, Paris, March 20–April 30, 1907, no. 1500.

SELECTED LITERATURE

Rubin, William. "Cézannisme and the Beginnings of Cubism." In *Cézanne: The Late Work*, edited by William Rubin. Exh. cat. New York: Museum of Modern Art, 1977, pp. 156 (illus.), 157–58.

Ball, Susan L. "The Early Figural Paintings of André Derain, 1905–1910: A Re-evaluation." *Zeitschrift für Kunstgeschichte*, vol. 43, no. 1 (1980), pp. 87–90, fig. 7.

Golding, John. *Cubism: A History and an Analysis, 1907–1914*. 3rd ed. Cambridge, MA: Belknap, 1988, pp. 146–48.

Kellerman, Michael. *André Derain: Catalogue raisonné de l'oeuvre peint*. Paris: Éditions Galerie Schmit, 1992, vol. 1, p. 237, no. 381 (illus.).

Munck, Jacqueline. "Les Baigneuses." In *André Derain: Le peintre du "trouble moderne,"* edited by Suzanne Pagé. Exh. cat. Paris: Musée d'Art Moderne de la Ville de Paris, 1994, pp. 166–72, no. 60 (illus.).

PAUL GAUGUIN

French, 1848–1903

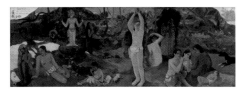

Where Do We Come From? What Are We? Where Are We Going? (D'où venons-nous? Que sommes-nous? Où allons-nous?)
1897–98
Oil on canvas
4 feet 6¾ inches × 12 feet 3½ inches (1.39 × 3.75 m)
Museum of Fine Arts, Boston. Tompkins Collection—Arthur Gordon Tompkins Fund, 36.270
Pages xi–xii and fig. 146

Gauguin painted this canvas, his self-conscious masterpiece, in Tahiti, where he had gone in search of a paradise unfettered by modern, urban life. His correspondence from this time suggests that this picture, which combines an observed Tahitian landscape with invented figures, can be read from right to left, intimating a progression through the stages of life, from the infant on the right to the crouching elderly woman on the left. The blue idol, a statue of the moon goddess Hina, indicates the presence of the supernatural in this meditation on the human condition. The painting's enigmatic title first appeared in Gauguin's 1897 essay "L'église catholique et les temps modernes" (The Catholic church and modern times) and has been associated with an array of literary and philosophical sources, including Honoré de Balzac's novella *Séraphita* (1834) and Thomas Carlyle's most influential work, *Sartor Resartus* (1836).

PROVENANCE

Sent from Tahiti by the artist to Georges-Daniel de Monfreid (dealer), Paris, summer 1898; consigned by Monfreid and Georges Chaudet (dealer), Paris, to Ambroise Vollard (dealer), Paris; sold to Gabriel Frizeau (1870–1938), Bordeaux, 1901; with Galerie Barbazanges, Paris, probably 1913; sold to J. B. Stang, Oslo, by 1920; probably sold by Stang to Alfred Gold (dealer), Berlin and Paris, 1935. With Marie Harriman Gallery, New York, 1936; sold to the Museum of Fine Arts, Boston, 1936

EXHIBITION

Exposition Gauguin. Galerie Vollard, Paris, November 17, 1898–early January 1899.

SELECTED LITERATURE

Fry, Roger. "On a Composition by Gauguin." *Burlington Magazine*, vol. 32, no. 180 (March 1918), pp. 84 (illus.), 85.

Segalen, Victor, and Joly-Segalen, eds. *Lettres de Gauguin à Daniel de Monfreid*. Rev. ed. Paris: G. Falaize, 1950, pp. 118–19, 121, 126–27, 134, 185, 217–18, 224.

Wildenstein, Georges. *Gauguin*. Paris: Les Beaux-Arts, 1964, vol. 1, pp. 232–34, no. 561 (illus.).

Shackelford, George T. M., and Claire Frèches-Thory. *Gauguin Tahiti*. Exh. cat. Boston: Museum of Fine Arts, 2004, esp. pp. 168, 177–203, cat. 144 (illus.).

Druick, Douglas. "Vollard and Gauguin: Fictions and Facts." In *Cézanne to Picasso: Ambroise Vollard, Patron of the Avant-Garde*, edited by Rebecca A. Rabinow. Exh. cat. New York: Metropolitan Museum of Art, 2006, pp. 69–71, cat. 96, fig. 13.

ALBERT GLEIZES

French, 1881–1953

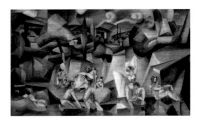

Bathers

1912

Oil on canvas

41⁵⁄₁₆ × 67⁵⁄₁₆ inches (105 × 171 cm)

Musée d'Art Moderne de la Ville de Paris

Fig. 125

This work, Gleizes's major canvas for 1912, was first exhibited at that year's Salon des Indépendants alongside Robert Delaunay's *City of Paris* (see fig. 118), and that fall it was shown again at the Section d'Or, the declarative Cubist exhibition. Like Delaunay's picture, *Bathers* contrasts the classical nude, here set in a suburban landscape, with elements of modern industrial life. In his tract "La tradition et le cubisme" (Tradition and Cubism; 1913), Gleizes, who was concerned particularly with framing Cubism as a continuation of established values, positioned himself as the modern perpetuator of the French classical lineage, and artists like Nicolas Poussin may well have been on his mind when he composed this picture. In 1911 the critic Roger Allard had praised Poussin's synthesis of stability and implied movement, in an attempt to demonstrate the compatibility of the classical tradition with the Salon Cubists' interest in the philosopher Henri Bergson's concept of duration, or the continuous change that is at the heart of modern life. As David Cottington has noted, such a reconciliation between tradition and modernity is exemplified in this canvas, suggesting that the poses, at once frozen and dynamic, resemble those of the figures in Poussin's *Arcadian Shepherds* (see fig. 141).[1]

1. Cottington, "Languages of Classicism," in *Cubism and Its Histories* (Manchester: Manchester University Press, 2004), p. 68.

PROVENANCE

Purchased by Dr. Maurice Girardin from the artist; bequest to the Musée d'Art Moderne de la Ville de Paris, 1953

EXHIBITIONS

Salon des Indépendants. Baraquements du Quai d'Orsay, Pont de l'Alma, Paris, March 20–May 16, 1912, no. 1347.

Salon de la Section d'Or. Galerie de la Boétie, Paris, October 10–30, 1912, no. 40.

Moderni Umeni. SVU Manes, Prague, February–March 1914, no. 36.

SELECTED LITERATURE

Apollinaire, Guillaume. *The Cubist Painters* (1913). Translated by Patricia Roseberry. [Harrogate, UK]: Broadwater House, 2000, pl. 4.

Alibert, Pierre. *Albert Gleizes: Naissance et avenir du cubisme*. [Paris]: Aubin Visconti, 1982, pp. 72–73 (illus.), 85–86.

Robbins, Daniel, and Pierre Georgel. *Albert Gleizes: Catalogue raisonné*. Edited by Anne Varichon. Paris: Somogy Éditions d'Art, 1998, vol. 1, p. 139, no. 381 (illus.).

Briend, Christian. "Albert Gleizes au Salon de la Section d'Or de 1912." In *La Section d'or: 1925, 1920, 1912*, edited by Cécile Debray and Françoise Lucbert. Exh. cat. Paris: Éditions Cercle d'Art, 2000, p. 73, fig. 21.

Cottington, David. *Cubism and Its Histories*. Manchester: Manchester University Press, 2004, pp. 68, 93–94, fig. 2.33.

NATALIA SERGEYEVNA GONCHAROVA

Russian, 1881–1962

Boys Bathing

c. 1910

Oil on canvas

45½ × 37 inches (115.5 × 94 cm)

Museum Wiesbaden, Germany

Fig. 129

Goncharova spent her youth in the idyllic Russian countryside, remembering that everything "chirped and droned to the hum of insects and the singing of birds. . . . This was my first introduction to life—happiness experienced not so much through seeing and hearing, as with one's entire body and soul."[1] In *Boys Bathing*, she translated the joyful exuberance of her childhood into a spirited depiction of male leisure, in which young boys, watched over by older companions,

bask in the splendors of nature. The painting, which was exhibited in 1912 in Moscow at the landmark exhibition of the Donkey's Tail (a group Goncharova and her companion Mikhail Larionov had founded the year before to assert their rejection of Western influence), could have been the work that the critic Varsonofy Parkin described as "a powerful sketch in bright green and red, painted with so much expression that most works of the French school of this type, i.e. Matisse, will seem pale and anemic."[2] With bold colors and short, constructive strokes à la Cézanne, Goncharova endowed the picture with movement and energy, reflecting, despite her aims, her indebtedness to French art and her affinities with German Expressionism, but, ultimately, her ties to her native land.

1. Goncharova, quoted in *Mikhail Larionov, Natalia Goncharova: Shedevry iz parizhskogo naslediya; Zhivopis'* (Moscow, 1999), p. 193; trans. and quoted in Elena Basner, *Natalia Goncharova: The Russian Years*, exh. cat. (Saint Petersburg: State Russian Museum, 2002), p. 10.

2. Parkin, *The Donkey's Tail and the Target* [in Russian] (1913), trans. and quoted in Mary Charmot, *Goncharova: Stage Designs and Paintings* (London: Oresko Books, 1979), p. 134.

PROVENANCE

Madam Larionov. With Leonard Hutton Galleries, New York. Private collection. With Annely Juda Fine Art, London; sold to Museum Wiesbaden, Germany, June 1989

EXHIBITION

The Donkey's Tail (Osilniy khvost). Moscow School of Painting, Sculpture, and Architecture, March 11–April 8, 1912, probably no. 74.

SELECTED LITERATURE

Fauves and Expressionists. Exh. cat. New York: Leonard Hutton Galleries, 1968, cat. 20 (illus.).

Charmot, Mary. *Goncharova: Stage Designs and Paintings*. London: Oresko Books, 1979, p. 34, no. 12 (illus.).

Parton, Anthony. *Goncharova: The Art and Design of Natalia Goncharova*. Suffolk, UK: Antique Collectors' Club, 2010, p. 115, pl. 121.

ERNST LUDWIG KIRCHNER

German, 1880–1938

Three Nudes in the Forest
1908, retouched 1920
Oil on canvas
29⅞ × 39⅜ inches (75.9 × 100.1 cm)
Collection Stedelijk Museum, Amsterdam
Fig. 190

This painting marks Kirchner's first depiction of nudes in a landscape, a subject that would occupy him for the rest of his career—the nude being, in his words, the "basis of all visual art."[1] The painting was begun at the end of 1908, the same year that important exhibitions of works by Vincent van Gogh and the French Fauves were held at Emil Richter's Dresden gallery, where the Die Brücke (The Bridge) artists exhibited annually from 1907 to 1909. In this picture, Kirchner translated the subjectivity and spontaneity of color that he admired in the work of these artists into a new, German idiom, marked by a raw, almost violent energy with rapid brushstrokes and coarse contours. The physicality of the paint matches that of the human figure: The uneven, exaggerated breasts of the seated figure emphasize her corporeality, and the verticality and color of the central nude mark her as the tree trunk's double. While this work most likely was composed using models in the studio, it anticipates Kirchner's direct studies of the nude outdoors during the following summer, which he spent with other Brücke artists at the Moritzburg ponds near Dresden.

1. Kirchner, "Chronik der Brücke" (1913), trans. Peter Selz, *College Art Journal*, vol. 10, no. 1 (Autumn 1950), p. 50.

PROVENANCE
Dr. Carl Hagemann (1867–1940), Frankfurt; Jan Wiegers (1893–1959); sold to Stedelijk Museum, Amsterdam, through H. E. Tenkink (lawyer), Amsterdam, 1948

SELECTED LITERATURE
Apollonio, Umbro. *"Die Brücke" et la cultura dell'espressionismo.* Venice: Alfieri, 1952, no. 29 (illus.).

Buchheim, Lotha-Günter. *Die Künstlergemeinschaft Brücke.* Feldafing, Germany: Buchheim, 1956, no. 159 (illus.).

Gordon, Donald E. *Ernst Ludwig Kirchner.* Cambridge, MA: Harvard University Press, 1968, pp. 57, 272, no. 44, pl. 12.

Langfeld, Gregor. *Duitse kunst in Nederland: Verzamelen, tentoonstellen, kritieken, 1919–1964.* Zwolle, The Netherlands: Waanders, 2004, p. 284.

ARISTIDE MAILLOL

French, 1861–1944

Virgil's *Eclogen* (*Eclogues*)
Translated into German by Rudolf Alexander Schroeder
Published by Cranach Press (Weimar, 1926)
Illustrated book with forty-three woodcuts
Book: 12½ × 9½ × 15/16 inches (31.8 × 24.1 × 2.4 cm)
Philadelphia Museum of Art. Gift of Carl Zigrosser, 1964-152-9
Fig. 78 (illus. above; see also figs. 79–82)

The idea to produce an illustrated edition of Virgil's *Eclogues* originated during the trip Maillol took with his patron Harry Kessler to Greece in 1908. Although Maillol started work on the illustrations soon after his return, the first edition was not published until 1926 due to delays caused by World War I. The artist's success as a book illustrator is, perhaps, surprising; he once declared, "I detest illustrated books. . . . I do them because I do not consider line engraving on wood to be an illustration; drawings done in this way are the equivalent of typographical characters."[1] Kessler, whose Cranach Press published the book, shared this perspective, and his edition of the *Eclogues* focuses on the reciprocity between the woodcut images and the type. Kessler chose a typeface designed by the eighteenth-century Venetian printer Nicolas Jenson, and Maillol created forty-three woodcuts and designed the ornaments, while the initial letters were cut by Eric Gill. Maillol developed a special hand-made paper for the project, which was manufactured by his nephew, Gaspard. The German edition of 294 books was joined by French and English editions in 1926 and 1927, respectively.

1. Maillol, quoted in Bertrand Lorquin, *Aristide Maillol* ([Milan]: Skira, 2002), p. 132.

PROVENANCE
Carl Zigrosser (1891–1975); gift to the Philadelphia Museum of Art, 1964

SELECTED LITERATURE
Rewald, John, ed. *The Woodcuts of Aristide Maillol: A Complete Catalogue with 176 Illustrations.* New York: Pantheon Books, 1951, pp. xx–xxv, xxxviii–xlii, nos. 8–53 (illus.).

Garvey, Eleanor M. *The Artist and the Book, 1860–1950, in Western Europe and the United States.* Exh. cat. Boston: Museum of Fine Arts, 1961, pp. 121–22, no. 172 (illus.).

Patterson, Annabel. *Pastoral and Ideology: Virgil to Valéry.* Berkeley: University of California Press, 1987, pp. 306–16, figs. 36–39.

Walter, Sabine. "Maillols Buchillustrationen." In *Aristide Maillol,* edited by Ursel Berger and Jörg Zutter. Exh. cat. New York: Prestel, 1996, pp. 63–66, no. 142 (illus.).

Lorquin, Bertrand. *Aristide Maillol.* [Milan]: Skira, 2002, pp. 132, 134 (illus.).

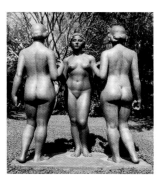

The Three Nymphs
1930–38
Lead
62 × 57⅜ × 31½ inches (157.5 × 145.7 × 80 cm)
National Gallery of Art, Washington, DC. Gift of Lucille Ellis Simon, in honor of the 50th anniversary of the National Gallery of Art, 1991.39.1
Fig. 73

Maillol worked on this sculpture, one of his last major projects, for eight years. He started in 1930 with the central figure, for which his pupil Lucie Passavant posed, eventually expanding the composition to a group of three. Although the arrangement of the figures resembles the typical form of the classical Three Graces, Maillol insisted his figures represented nymphs. The nudes on each end are almost mirror images of each other, but in reality none is exactly the same. When the unfinished but advanced plaster cast was exhibited in June 1937 in Paris, the figures' hands were decorated with garlands, and crowns of daisies and buttercups were placed on their heads. Maillol

completed the final details of the outer figures the following summer. The artist preferred that the group be cast in lead, of which six casts are known, in addition to two bronze casts.

PROVENANCE
Estate of the artist; sold to Lucille Ellis Simon, Los Angeles, through Marlborough-Gerson Gallery, New York, 1967; gift to the National Gallery of Art, Washington, DC, 1991

EXHIBITION
Les maîtres de l'art indépendant, 1895–1937. Petit Palais, Paris, June–October 1937 (unfinished plaster cast).

SELECTED LITERATURE
Cladel, Judith. *Aristide Maillol: Sa vie — son oeuvre — ses idées.* [Paris]: Éditions Bernard Grasset, 1937, pp. 120–21, 125–27, pl. 33 (unfinished plaster cast).

Alley, Ronald. *Catalogue of the Tate Gallery's Collection of Modern Art Other than Works by British Artists.* London: Tate Gallery, 1981, pp. 468 (illus. [Tate cast]), 469–70.

Cowling, Elizabeth. Catalogue entry in *On Classic Ground: Picasso, Léger, de Chirico and the New Classicism, 1910–1930,* edited by Elizabeth Cowling and Jennifer Mundy. Exh. cat. London: Tate Gallery, 1990, p. 156, cat. 95 (illus. [Tate cast]).

Luchs, Alison. *Art for the Nation: Gifts in Honor of the 50th Anniversary of the National Gallery of Art.* Exh. cat. Washington, DC: National Gallery of Art, 1991, pp. 336, 337 (illus.).

FRANZ MARC
German, 1880–1916

The Dream
1912
Oil on canvas
39⁹⁄₁₆ × 53⅜ inches (100.5 × 135.5 cm)
Museo Thyssen-Bornemisza, Madrid
Fig. 198

Although the human figure is rare in Marc's work, it is positioned prominently in this picture from 1912. The strip of shadowy black at the top of the composition suggests that it is nighttime and that the seated woman, her eyes closed, is in the midst of a dream. The yellow house on the left perhaps reflects the presence of the "real," the place from which the fantasy emerges. Marc, along with his fellow Blaue Reiter (Blue Rider) artists, admired the work of Henri Rousseau, and this picture has much in common with Rousseau's painting of the same title (see fig. 113). But unlike the French artist's composition — in which the woman is an intruder, or at best a voyeur, in the tropical paradise — the figure in Marc's painting is a part of her surroundings, reflecting the artist's desire to visualize the spirit of pantheistic unity that he believed should govern the world.

PROVENANCE
Wassily Kandinsky (1866–1944), by exchange with the artist for Kandinsky's painting *Improvisation 12 (Reiter)* (1910; Staatsgalerie Moderner Kunst, Munich); his wife, Nina (Nikolayevna Andreevskaya) Kandinsky, Neuilly-sur-Seine, France. With Leonard Hutton Galleries, New York. Baron Heinrich Thyssen-Bornemisza, Lugano, 1978

EXHIBITIONS
Franz Marc. Kunstsalon Ludwig Schames, Frankfurt, September 1912, no. 2.

Ausstellung der Sammlung Werner Ducker. Kunstverein, Barmen, Germany, December 1912.

Tierbild-Ausstellung: Franz Marc, Walter Klemm, Rudolf Schramm-Zittau, Alfons Purtscher. Kunstverein, Jena, Germany, February 16–March 19, 1913.

Vierzehnte-Ausstellung: Franz Marc. Galerie Der Sturm, Berlin, late March–April 1913.

Franz Marc: Gedächtnis-Ausstellung. Münchner Neue Secession, Galeriestrasse 26, Munich, September 14–October 15, 1916, no. 108.

Franz Marc: Gedächtnis-Ausstellung; Gemälde und Aquarelle/Holzschnitte. Galerie Der Sturm, Berlin, November 1916, no. 14.

Franz Marc: Gedächtnis-Ausstellung. Neues Museum, Nassauischer Kunstverein, Wiesbaden, Germany, March–April 1917, no. 38.

SELECTED LITERATURE
Lankheit, Klaus. *Franz Marc: Katalog der Werke.* Cologne: Verlag M. DuMont Schauberg, 1970, p. 60, no. 172 (illus.).

Vergo, Peter. *Expressionism and Modern German Painting from the Thyssen-Bornemisza Collection.* Milan: Electa, 1989, p. 68, cat. 23 (illus.).

Holst, Christian von, ed. *Franz Marc: Horses.* Translated by Elizabeth Clegg and Claudia Spinner. Exh. cat. Ostfildern, Germany: Hatje Cantz Verlag, 2000, pp. 118, 273, no. 69, fig. 103.

Hoberg, Annegret, and Isabelle Jansen. *Franz Marc: The Complete Works.* London: Philip Wilson, 2004, vol. 1, p. 196, cat. 175 (illus.).

Meyer-Büser, Susanne, ed. *Marc, Macke und Delaunay: Die Schönheit einer zerbrechenden Welt (1910–1914).* Exh. cat. Hannover, Germany: Sprengel Museum, 2009, p. 276, cat. 138 (illus.).

Deer in the Forest I
1913
Oil on canvas
39¾ × 41¼ inches (100.9 × 104.7 cm)
The Phillips Collection, Washington, DC. Gift from the estate of Katherine S. Dreier, 1953
Fig. 199

In this picture, Marc depicted a forest devoid of human presence, in which four deer, curled up and almost nymph-like in form, are surrounded by wispy lines that unite the canvas as an organic whole. For Marc, deer were the most innocent of creatures, and his interest in the animal developed in 1912 and 1913, culminating in this canvas, which reflects his mystical vision, his attempt to render the world not as it appears but as it is lived. As he wrote in 1911, "What does the doe have in common with the view of the world as it appears in people? Does it make any reasonable or artistic sense to paint the doe as it appears on our retina — or in the manner of the Cubists because we feel the world to be cubistic? . . . I could paint a picture called *The Doe.* Pisanello has painted them. I may also want to paint a picture, *The Doe Feels.* How infinitely more subtle must the painter's sensitivity be in order to paint that!"[1]

1. Marc, "How Does a Horse See the World?" (1911), in *Theories of Modern Art: A Source Book by Artists and Critics,* ed. Herschel B. Chipp (Berkeley: University of California Press, 1968), pp. 178–79.

PROVENANCE
Maria (Franck) Marc (1876–1955), wife of the artist, Ried, Germany; on loan to the Société Anonyme, New York, 1926; Katherine S. Dreier (1877–1952), West Redding, CT, 1927; gift to the Phillips Collection, Washington, DC, from her estate, 1953

EXHIBITIONS
Franz Marc. Kunstsalon Ludwig Schames, Frankfurt, September 1912, no. 15.

Franz Marc. Kunstsalon Ludwig Bock & Sohn, Hamburg, May 1913.

Moderne Kunstkring. Musée Municipal Suasso, Amsterdam, November 7–December 8, 1913, no. 157.

Franz Marc: Gedächtnis-Ausstellung. Münchner Neue Secession, Galeriestrasse 26, Munich, September 14–October 15, 1916, no. 133.

Franz Marc: Gedächtnis-Ausstellung. Neues Museum, Nassauischer Kunstverein, Wiesbaden, Germany, March–April 1917, no. 52.

SELECTED LITERATURE

Dreier, Katherine S. *Modern Art.* New York: Museum of Modern Art, 1926, p. 31 (illus.).

Lankheit, Klaus. *Franz Marc: Katalog der Werke.* Cologne: Verlag M. DuMont Schauberg, 1970, p. 70, no. 198 (illus.).

Rosenthal, Mark. *Franz Marc: 1880–1916.* Exh. cat. Berkeley: University Art Museum, University of California, 1979, p. 24, pl. 31.

Hoberg, Annegret, and Isabelle Jansen. *Franz Marc: The Complete Works.* London: Philip Wilson, 2004, vol. 1, p. 230, cat. 200 (illus.).

Meyer-Büser, Susanne, ed. *Marc, Macke und Delaunay: Die Schönheit einer zerbrechenden Welt (1910–1914).* Exh. cat. Hannover, Germany: Sprengel Museum, 2009, p. 277, cat. 165 (illus.).

HENRI MATISSE

French, 1869–1954

Nude in a Wood
1906
Oil on board, mounted on panel
16 × 12¾ inches (40.6 × 32.4 cm)
Brooklyn Museum. Gift of George F. Of, 52.150
Frontispiece and fig. 59

This work is one of a group of small paintings made during the second summer Matisse spent in the Mediterranean town of Collioure, where he approached for the first time the challenge of painting the nude en plein air. Given the conservative local culture, Matisse and his wife, Amélie, walked an hour into the woods surrounding the town so she could pose in the nude without disturbance. Working on a board that he placed in the lid of his paint box, Matisse experimented with palette and technique, capturing the swiftness of his exercise in observation through broken brushwork and defining the contours of his model with the bare canvas. This painting reflects how in the summer of 1906 Matisse refracted the

world of *Le bonheur de vivre* (see fig. 58) into individual elements, now grounded in life. *Nude in a Wood* is thought to be the first painting by Matisse to take permanent residence in the United States. When Sarah and Michael Stein purchased the canvas on behalf of the well-known frame maker George Of, they liked it so much that they acquired a similar, even sketchier version for themselves (*Nude in a Landscape,* 1906; V. Madrigal Collection, New York).

PROVENANCE

With Galerie Druet, Paris; sold to Michael and Sarah Stein for George F. Of, June 21, 1907; George F. Of (1876–1954), New York, 1907–51; gift to the Brooklyn Museum, 1952

EXHIBITIONS

Probably *Henri Matisse.* Little Galleries of the Photo-Secession (Gallery 291), New York, April 6–25, 1908.

International Exhibition of Modern Art (The Armory Show). 69th Regiment Armory, New York, February 17–March 15, 1913, no. 1065; Art Institute of Chicago, March 24–April 16, 1913, no. 250; Copley Hall, Copley Society of Art, Boston, April 28–May 18, 1913, no. 131.

SELECTED LITERATURE

Schneider, Pierre. *Matisse.* Translated by Michael Taylor and Bridget Stevens Romer. New York: Rizzoli, 1984, p. 325.

Freeman, Judi. *The Fauve Landscape.* Exh. cat. Los Angeles: Los Angeles County Museum of Art, 1990, p. 29, pl. 21.

Fourcade, Dominique, and Isabelle Monod-Fontaine, eds. *Henri Matisse, 1904–1917.* Exh. cat. Paris: Centre Georges Pompidou, 1993, pp. 184, 429, cat. 30 (illus.).

Flam, Jack. "Matisse à Collioure, évolution du style et datation des tableaux." In *Matisse—Derain: Collioure 1905, un été fauve,* by Joséphine Matamoros et al. Exh. cat. Paris: Gallimard, 2005, pp. 38, 40, cat. 133 (illus.).

Bishop, Janet. "Sarah and Michael Stein, Matisse, and America." In *The Steins Collect: Matisse, Picasso, and the Parisian Avant-Garde,* edited by Janet Bishop, Cécile Debray, and Rebecca A. Rabinow. Exh. cat. San Francisco, CA: San Francisco Museum of Modern Art, 2010, p. 133, pl. 92.

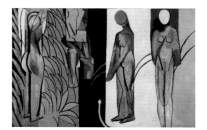

Bathers by a River
March 1909–10, May–November 1913, and early spring 1916–October(?) 1917
Oil on canvas
8 feet 6⅜ inches × 12 feet 10⁵⁄₁₆ inches
(2.6 × 3.92 m)
The Art Institute of Chicago. Charles H. and Mary F. S. Worcester Collection, 1953.158
Pages xiii–xiv and fig. 172

Matisse conceived of *Bathers by a River,* one of his largest works, in 1909 in relation to a commission for the stairway of Sergei Shchukin's Moscow mansion. The decorative scheme ultimately included the canvases *Dance (II)* and *Music* (both of 1910 and now in the State Hermitage Museum, Saint Petersburg; for *Music,* see fig. 179), but Matisse continued to develop this scene of bathers as an independent composition in multiple stages over eight years. In the final state, the succession of vertical bands gives the picture an implied narrative effect, while the stoic, statuesque figures remain isolated in separate fields. The lush foliage is suggestive of the work Matisse made during his trip to Morocco in the winter of 1912–13, after which he resumed work on this canvas, and the overall concern for structure reflects his personalized assimilations of contemporary artistic modes. When the writer Ameen Rihani saw the painting in February 1917 in Matisse's studio, he declared that *Bathers by a River* "promised to be a masterpiece of—Cubism, Futurism, Fauvism?—[Matisse] himself does not know. And there it stood, a huge canvas in greys, which baffles the understanding."[1]

1. Rihani, "Artists in War-Time," quoted in Stephanie D'Alessandro and John Elderfield, *Matisse: Radical Invention, 1913–1917,* exh. cat. (Chicago: Art Institute of Chicago, 2010), p. 347.

PROVENANCE

Purchased by Paul Guillaume (1891–1934), Paris, from the artist, September 14, 1926, until d. 1934; by inheritance to his wife, Juliette "Domenica" Lacaze (later Mme Jean Walter), Paris, 1934; sold to Henry and Rose Pearlman, New York, summer 1951; by exchange to the Art Institute of Chicago, 1953

EXHIBITION
Galerie Paul Guillaume, Paris, October 8, 1926.

SELECTED LITERATURE
Schneider, Pierre. *Matisse*. Translated by Michael Taylor and Bridget Stevens Romer. New York: Rizzoli, 1984, pp. 183, 284, 289 (illus.), 303, 381, 393, 469, 472–73, 489–90, 541, 552, 620, 622, 629.

Flam, Jack. *Matisse: The Man and His Art, 1869–1918*. Ithaca, NY: Cornell University Press, 1986, pp. 8, 249, 257, 261, 265, 301, 365–71, 405, 408, 414–17, 419, 422–23, fig. 420.

Bock, Catherine Cecelia. "Henri Matisse's *Bathers by a River*." *Art Institute of Chicago Museum Studies*, vol. 16, no. 1 (1990), pp. 44–55, fig. 1.

Carrier, David. "'You, Too, Are in Arcadia': Matisse's *Shchukin Triptych*." *High Art: Charles Baudelaire and the Origins of Modernist Paintings*. State Park, PA: Pennsylvania State University Press, 1996, pp. 128–51, fig. 13.

D'Alessandro, Stephanie, and John Elderfield. *Matisse: Radical Invention, 1913–1917*. Exh. cat. Chicago: Art Institute of Chicago, 2010, esp. pp. 76–91, 104–7, 144–57, 174–77, 304–9, 346–49, cat. 54 (illus.), fig. 4.

Poésies de Stéphane Mallarmé: Eaux-fortes originales de Henri Matisse

Published by Albert Skira (Lausanne, 1932)
Portfolio of twenty-nine etchings
Sheets: 13 × 9¹³/₁₆ inches (33 × 25 cm) each
Philadelphia Museum of Art. Gift of
Mrs. W. Averell Harriman, 1952-87-1a–cc
Fig. 62 (illus. above; see also figs. 61, 63, 64)

Matisse's first illustrated book, Stéphane Mallarmé's *Poésies* (originally published in 1899), was commissioned by the ambitious young publisher Albert Skira in 1930. Over two years, the artist worked on more than sixty plates, twenty-nine of which ultimately were selected for the book. Using a thin, lyrical line, the artist sought to activate the entire page with a fluid balance between the text and the images. In 1932 the book was published as an edition of 145 copies, thirty of which included an extra set of etchings annotated by the artist with printed *remarques*

(decorative marginalia). Upon the project's completion, Matisse declared, "After concluding these illustrations of the poems of Mallarmé, I would like to simply state: 'This is the work I have done after having read Mallarmé with pleasure.'"[1]

1. Matisse, quoted in Adelyn D. Breeskin, "Swans by Matisse," *American Magazine of Art*, vol. 28, no. 10 (October 1935), p. 622.

PROVENANCE
Mrs. W. Averell Harriman (1891–1986); gift to the Philadelphia Museum of Art, 1952

SELECTED LITERATURE
Breeskin, Adelyn D. "Swans by Matisse." *American Magazine of Art*, vol. 28, no. 10 (October 1935), pp. 622–28, 629 (illus.).

Matisse, Henri. "How I Made My Books" (1946). In *Matisse on Art*, edited by Jack Flam. London: Phaidon, 1973, pp. 107–9.

Barr, Alfred H., Jr. *Matisse: His Art and His Public*. New York: Museum of Modern Art, 1951, pp. 220, 244, 245 (illus.), 246, 467 (illus.).

Duthuit, Claude. *Henri Matisse: Catalogue raisonné des ouvrages illustrés*. Paris: C. Duthuit, 1988, pp. x, xiv, xvi, xvii–xix, 16–18, no. 5 (illus.).

Labrusse, Rémi. *Matisse: La condition d'image*. [Paris]: Gallimard, 1999, pp. 150–51, 159–69, figs. 41, 42.

JEAN METZINGER
French, 1883–1956

The Bathers
1913
Oil on canvas
58⅜ × 41⅞ inches (148.3 × 106.4 cm)
Philadelphia Museum of Art. The Louise and Walter Arensberg Collection, 1950-134-140
Fig. 126

Metzinger might have painted this canvas of bathing nudes juxtaposed with an image of a modern suburb, replete with a railway bridge, in response to his friend and collaborator Albert Gleizes's treatment of a similar subject (see fig. 125). Whereas Gleizes positioned his bathers before a landscape, Metzinger, who adopted a

vertical format, subsumed his figures into their surroundings, reducing them in number and scale to achieve a greater pictorial unity. The name "Meudon" inscribed on the back of the canvas refers to the Paris suburb where the artist spent his summers from 1911 to 1913.

PROVENANCE
Duchamp-Villon collection, Paris; sold to Louise and Walter C. Arensberg, Los Angeles, through Marcel Duchamp as agent, 1932; gift to the Philadelphia Museum of Art, 1950

SELECTED LITERATURE
Moser, Joann. *Jean Metzinger in Retrospect*. Exh. cat. Iowa City: University of Iowa Museum of Art, 1985, p. 44, no. 127 (illus.).

Arnason, H. H. *History of Modern Art: Painting, Sculpture, Architecture, Photography*. 3rd ed. New York: Harry N. Abrams, 1986, p. 174, fig. 246.

Kerr, Melissa. Catalogue entry in *Masterpieces from the Philadelphia Museum of Art: Impressionism and Modern Art*, edited by Yōichirō Ide. Exh. cat. Tokyo: Yomiurishinbuntōkyōhonsha, 2007, p. 148, cat. 48 (illus.).

Gantefürhrer-Trier, Anne. "The Bathers." In *Cubism*, edited by Uta Grosenick. Cologne: Taschen, 2009, pp. 68, 69 (illus.).

MAX PECHSTEIN
German, 1881–1955

Under the Trees
1911
Oil on canvas
29 × 39 inches (73.7 × 99.1 cm)
Detroit Institute of Arts. City of Detroit Purchase
Fig. 183

In the summer of 1909 Pechstein made his first visit to Nidden (now Nidia, Lithuania), a fishing village on the Baltic Sea, and returned with his wife in the summer of 1911, when he painted *Under the Trees*. Like the Moritzburg ponds outside Dresden where he had worked the previous summer with Ernst Ludwig Kirchner and other Brücke artists, this isolated village was an ideal setting for Pechstein's efforts to reclaim a simple way of life

in touch with nature. Committed to capturing spontaneity in art through actual experience, he exploited the dramatic poses of his models in his explorations of the female body in movement. Although the distortion of the figures reflects his interest in atavistic simplification, and the landscape's swirling strokes underscore its dynamism, the painting is nonetheless more serene than Kirchner's rugged image of nudes in the forest (see fig. 190). Pechstein had lived in Paris from late 1907 to 1908, and his absorption of the ease and decorative patterning of the French Fauves, especially Matisse, stayed with him after he returned to Germany. Here, he defined the figures with continuous outlines, giving prominence to the rhythm of the arabesque and the seamless integration of the individual into the overall composition.

PROVENANCE
With Galerie Gurlitt, Berlin; with Galerie Goldschmidt-Wallerstein, Berlin, by 1921; sold to Ralph H. Booth, president of the Arts Commission for the City of Detroit, late summer 1921; Detroit Institute of Arts, City of Detroit purchase, 1921

EXHIBITIONS
Neue Kunst, 2: Gesamtausstellung. Galerie Hans Goltz, Munich, September–October 1913, no. 121.

Max Pechstein: Gemälde, Glasfenster, Entwürfe und Kartons für Fenster und Mosaiken. Kunstsalon Gurlitt, Berlin, 1913, probably no. 20.

SELECTED LITERATURE
Selz, Peter. *German Expressionist Painting.* Berkeley: University of California Press, 1957, p. 135, pl. 42.

Uhr, Horst. *Masterpieces of German Expressionism at the Detroit Institute of Arts.* New York: Hudson Hills, 1982, pp. 190, 191 (illus.).

Moeller, Magdalena M., ed. *Max Pechstein: Sein malerisches Werk.* Exh. cat. Munich: Hirmer Verlag, 1996, p. 314, no. 61 (illus.).

Heller, Reinhold, ed. *Brücke: The Birth of Expressionism in Dresden and Berlin, 1905–1913.* Exh. cat. Ostfildern, German: Hatje Cantz Verlag, 2009, no. 18 (illus.).

Soika, Aya. *Max Pechstein: Das Werkverzeichnis der Ölgemälde.* Hamburg: Hirmer Verlag, 2011, vol. 1, p. 323, no. 1911/32 (illus.).

PABLO PICASSO
Spanish, 1881–1973

The Watering Place
1905–6
Gouache on tan paper board
14⅞ × 22⅞ inches (37.8 × 58.1 cm)
The Metropolitan Museum of Art, New York
Bequest of Scofield Thayer, 1982 (1984.433.274)
Fig. 104

In late 1905, after completing his large canvas *Family of Saltimbanques* (National Gallery of Art, Washington, DC), Picasso began preparing for a pendant of sorts, an equally large picture set in a similar arid landscape. The canvas was never completed (or perhaps never begun), but Picasso's intentions for a frieze-like arrangement of classical nudes and horses are best preserved in this compositional study. While *Family of Saltimbanques* emphasizes the isolation of individuals within the multifigure circus group, this gouache— *The Watering Place*, as the unrealized project and its studies are called—explores the communion between horses and riders. Many sources have been proposed for the composition, including the horse and rider scenes of Degas, Gauguin, and the fifteenth-century Italian painter Andrea Mantegna, as well as examples in the Parthenon.

PROVENANCE
With Galerie Alfred Flechtheim, Düsseldorf and Berlin, by 1913; sold to Scofield Thayer (1899–1982), Vienna and New York, May 1923; on extended loan to the Worcester Art Museum, Worcester, MA, 1931–82, inv. 31.765; bequest to the Metropolitan Museum of Art, New York, 1982

EXHIBITIONS
Ausstellung Pablo Picasso. Moderne Galerie (Heinrich Thannhauser), Munich, February 1913, no. 17.

Pablo Picasso. Rheinische Kunstsalon (Otto Feldmann), Cologne, March–April 1913, no. 13.

Possibly *Pablo Picasso.* Galerie Miethke, Vienna, February–March 1914, no. 43.

SELECTED LITERATURE
Pool, Phoebe. "Picasso's Neo-classicism: First Period, 1905–6." *Apollo,* vol. 81, no. 36 (February 1965), pp. 123–25, fig. 5.

Daix, Pierre, and Georges Boudaille. *Picasso: The Blue and Rose Periods; A Catalogue Raisonné of the Paintings, 1900–1906.* Translated by Phoebe Pool. Greenwich, CT: New York Graphic Society, 1966, pp. 87, 90, 92–94, 96–97, 99, 288, no. XIV.16 (illus.).

Palau i Fabre, Josep. *Picasso: The Early Years, 1881–1907.* Translated by Kenneth Lyons. Barcelona: Ediciones Polígrafa, 1985, pp. 434–35, 444, 549, no. 1197 (illus.).

Richardson, John. *A Life of Picasso.* New York: Random House, 1991, vol. 1, pp. 424, 425 (illus.), 427, 441.

Tinterow, Gary. Catalogue entry in *Picasso in the Metropolitan Museum of Art*, edited by Gary Tinterow and Susan Alyson Stein. Exh. cat. New York: Metropolitan Museum of Art, 2010, pp. 83–85, cat. 29 (illus.).

Adolescents
Summer 1906
Oil on canvas
61¹³⁄₁₆ × 46¹⁄₁₆ inches (157 × 117 cm)
Musée de l'Orangerie, Paris. Collection Jean Walter and Paul Guillaume
Fig. 100

This painting is one of Picasso's masterpieces from his summer in Gósol, a mountain town in the Spanish Pyrenees. The artist made multiple studies in ink and charcoal for the figure on the left, situating the nude both in a sylvan grove and in a decorative archway. In the final painting, he stripped away all anecdotal details just as he pared down the form of his figures in his ongoing explorations of the human body. While the monochrome terra-cotta color resembles that of the landscape in Gósol, the decontextualized background sets the picture outside time and place. The only sign of specificity is the earthenware jar atop the right figure's head (the Catalan region was famous for its pottery), but it is far more generic and obscure than similar objects found in other paintings Picasso made during this time (see, for example, figs. 101, 102). The figure carrying the vessel is almost certainly female,

suggested by the loose tendril of hair and the more slender frame, although her androgynous build has led to some speculation of gender ambiguity, especially in light of the photograph of nude adolescent boys owned by Picasso that has been proposed as a source for the composition.[1]

1. See Anne Baldassari, "1900–1906, Monochrome as Paradigm," in *Picasso and Photography: The Dark Mirror*, trans. Deke Dusinberre, exh. cat. (Paris: Flammarion, 1997), p. 40, fig. 43.

PROVENANCE
With Ambroise Vollard, Paris; sold to Paul Guillaume (1891–1934), Paris, c. 1930, until d. 1934; by inheritance to his wife, Juliette "Domenica" Lacaze (later Mme Jean Walter) (1898–1977), Paris; bequest to the French government

SELECTED LITERATURE
Daix, Pierre, and Georges Boudaille. *Picasso: The Blue and Rose Periods; A Catalogue Raisonné of the Paintings, 1900–1906*. Translated by Phoebe Pool. Greenwich, CT: New York Graphic Society, 1966, pp. 90, 97–98, 295, no. XV.11 (illus.).

Hoog, Michel. *Musée de l'Orangerie: Catalogue de la collection Jean Walter et Paul Guillaume*. Paris: Éditions de la Réunion des Musées Nationaux, 1984, p. 154, cat. 67 (illus.).

Palau i Fabre, Josep. *Picasso: The Early Years, 1881–1907*. Translated by Kenneth Lyons. Barcelona: Ediciones Polígrafa, 1985, pp. 447, 550, no. 1239 (illus.).

Baldassari, Anne. *Picasso and Photography: The Dark Mirror*. Translated by Deke Dusinberre. Exh. cat. Paris: Flammarion, 1997, p. 40, fig. 42.

Rosenblum, Robert. "Picasso in Gósol: The Calm before the Storm." In *Picasso: The Early Years, 1892–1906*, edited by Marilyn McCully. Exh. cat. Washington, DC: National Gallery of Art, 1997, p. 272, fig. 13.

Five Nudes (Study for "Les demoiselles d'Avignon") (fig. 99)
1907
Watercolor on cream wove paper
Sheet: 6⅞ × 8⅞ inches (17.5 × 22.5 cm)
Philadelphia Museum of Art. A. E. Gallatin Collection, 1952-61-103
Fig. 98

This watercolor is the final compositional study for Picasso's groundbreaking *Les demoiselles d'Avignon* (see fig. 99), and it is the only known version with the five-figure grouping of the final canvas. It marks the disappearance of the figure of the sailor found in earlier studies and represents the artist's conception for the painting before he replaced the faces of the two figures on the right with African masks, inspired by his visit to the Trocadéro ethnography museum in Paris in the summer of 1907. It has been proposed that Picasso made this watercolor after completing the final painting as a record of what the canvas would have looked like without the addition of the masks.[1] Despite its more rectangular format, this composition is very close to the final painting, with its ambiguous treatment of space, reduction of form, and segregation of figures. In an outdoor setting, the nudes might have been bathers enjoying a bucolic picnic, but here they confront the viewer from a theatrical interior.

1. John Golding, "The Triumph of Picasso," *New York Review of Books*, vol. 35 (July 21, 1988), p. 20.

PROVENANCE
Purchased by A. E. Gallatin (1881–1952), New York, probably from the artist, by July 1930; bequest to the Philadelphia Museum of Art, 1952

SELECTED LITERATURE
Zervos, Christian. *Pablo Picasso*. Paris: Cahiers d'Art, 1942, vol. 2, pt. 1, no. 21, pl. 13.

Barr, Alfred H., Jr. *Picasso: Fifty Years of His Art*. New York: Museum of Modern Art, 1946, p. 57, fig. C.

Tinterow, Gary. *Master Drawings by Picasso*. Exh. cat. Cambridge, MA: Fogg Art Museum, 1981, p. 88, cat. 28 (illus.).

Rubin, William. "La genèse des Demoiselles d'Avignon." In *Les Demoiselles d'Avignon*, edited by Hélène Seckel. Paris: Réunion des Musées Nationaux, 1988, vol. 1, cat. 28 (illus.); vol. 2, p. 415, no. 40 (illus.).

Steinberg, Leo. "The Philosophical Brothel." *October*, vol. 44 (Spring 1988), pp. 25, 37, 53, 58–60, 62, fig. 15.

The Three Graces
1922–23
Etching
Sheet: 12¹³⁄₁₆ × 7¾ inches (32.5 × 19.7 cm)
Philadelphia Museum of Art. Bequest of Sophie and Adrian Siegel, 1994-155-46
Fig. 109

Throughout the 1920s, the motif of three figures was one of Picasso's chief concerns, sustaining him across and between styles and taking form in his most significant canvases of the period. From 1922 to 1923, he worked on a series of etchings and drypoints of three closely arranged female figures drawn in pure contour, who appear as bathers by the sea, nudes in a decorative room, or, as here, the Three Graces. In this picture Picasso eliminated narrative details to focus on the three bodies that occupy the entire sheet, presenting them as both monumental and melancholic. While the lines at the lower left and right suggest a floor, and thus a room and context, they do not continue between the figures' legs, suggesting that the women, in their status as the eternal graces, transcend the setting. In art, going back to the Renaissance *paragone* (the rivalry between different art forms, especially between painting and sculpture), the Three Graces have been a standard means for representing a single form from multiple viewpoints. Here, Picasso addressed multiplicity through a dialogue between his Cubist and classical tendencies, showing the figure on the left both in profile and from the back, and integrating the three figures with shared contours and fluid transitions.

PROVENANCE

Sophie and Adrian Siegel; bequest to the Philadelphia Museum of Art, 1994

SELECTED LITERATURE

Geiser, Bernhard. *Picasso, peintre-graveur: Catalogue illustré de l'oeuvre gravé et lithographié, 1899–1931*. Berne: Geiser, 1933, vol. 1, no. 105 (illus.).

Bloch, Georges. *Pablo Picasso: Catalogue de l'oeuvre gravé et lithographié, 1904–1967*. Berne: Kornfeld et Klipstein, 1968, vol. 1, p. 34, no. 59 (illus.).

NICOLAS POUSSIN

French, 1594–1665

Apollo and Daphne (Apollon amoureux de Daphné)

1664
Oil on canvas
5 feet 1 inch × 6 feet 6¾ inches (1.55 × 2 m)
Musée du Louvre, Paris
Fig. 136

Toward the end of his life, Poussin gave this painting, his final work, to his patron Cardinal Camillo Massimi when he realized his deteriorating health would prevent him from finishing it. Unlike in his earlier, more conventional treatment of the story of Apollo's pursuit of Daphne (c. 1625; Alte Pinakothek, Munich)—who, according to Ovid, turned into a laurel tree in order to escape her suitor—here Poussin placed the protagonists on opposite sides of the composition. Apollo, draped in red, is seated on the left, while Daphne, who embraces her father, is seated on the right. Cupid has already struck Apollo and aims a lead-tipped arrow at Daphne to ensure she never returns the god's love. Although the basic premise is in keeping with Ovid's account of the tale, Poussin included several figures from peripheral tales derived from other sources, creating a composition that confronts the themes of love and death.

PROVENANCE

Gift from the artist to Cardinal Camillo Massimi (1620–1677), 1664, Massimi palace at the Quattro Fontane, Rome, 1664, until d. 1677; sold with his palace to Cardinal Francesco Nerli (1636–1708), by 1697; remained in the palace until at least 1762; sold to Guillaume Guillon Lethière (1760–1832), director of the French Academy in Rome from 1807 to 1811, by 1818. Sébastien Érard, by 1832; his sale, August 9, 1832, no. 191; purchased by Pierre Armand, marquis de Gouvello de Keriaval (1782–1870); sold to the Musée du Louvre, Paris, 1869

SELECTED LITERATURE

Panofsky, Erwin. "Poussin's 'Apollo and Daphne' in the Louvre." *Bulletin de la Société Poussin*, vol. 3 (1950), pp. 27–41, pl. 21.

Blunt, Anthony. *The Paintings of Nicolas Poussin: A Critical Catalogue*. London: Phaidon, 1966, p. 92, no. 131 (illus.).

———. *Nicolas Poussin*. The A. W. Mellon Lectures in the Fine Arts. New York: Bollingen Foundation, 1967, vol. 1, pp. 336–53; vol. 2, pls. 251, 251a–b.

Rosenberg, Pierre, and Louis-Antoine Prat. *Nicolas Poussin, 1594–1665*. Exh. cat. Paris: Réunion des Musées Nationaux, 1994, pp. 520–21, cat. 242 (illus.).

Cropper, Elizabeth, and Charles Dempsey. *Nicolas Poussin: Friendship and the Love of Painting*. Princeton, NJ: Princeton University Press, 1996, esp. pp. 303–12, pl. 11.

PIERRE PUVIS DE CHAVANNES

French, 1824–1898

Peace
1867
Oil on canvas
42⅞ × 58½ inches (108.9 × 148.6 cm)
Philadelphia Museum of Art. John G. Johnson Collection, 1917. Cat. 1062
Fig. 28

Puvis first gained critical acclaim with two monumental allegories of peace and war, *Concordia* and *Bellum*, respectively, which he submitted to the 1861 Salon with the designation "mural paintings," even though they did not yet have a destination. *Concordia* was purchased by the French government, to which the artist donated its companion in order to keep the pair together. Two years later he completed the cycle with a set of pendants, *Work* and *Repose*, which were acquired by the state to join the earlier pictures as decorations for the Musée de Napoléon in Amiens, an event that laid the foundation for Puvis's great fame as a public decorator. For *Work* and *Repose*, as for the reductions of the four murals he made in 1867, Puvis consciously switched from Latin to French titles, underscoring the nationalist resonance of the images. The present painting, the reduction of *Concordia*, depicts the societal advantages of peace played out in an antique realm. Nude and seminude figures in an idyllic landscape rest or engage in pleasant tasks, such as milking goats or collecting fruits. War is not far away—while the soldier on the left has cast aside his weapon, he stares out at the viewer, ready to spring back to battle—thus making the benefits of peace all the more urgent.

PROVENANCE

Purchased by Durand-Ruel (dealer), Paris, from the artist, c. 1872; Hiltbrunner collection, Paris, 1887; with Durand-Ruel, New York; by exchange with the artist's *War*, *Work*, and *Repose* (1867 reductions of Amiens murals) for cash and his *Autumn* to John G. Johnson (1841–1917), Philadelphia, November 28, 1888, until d. 1917; bequest to the City of Philadelphia, 1917

EXHIBITIONS

Exposition Universelle. Paris, April 1867, no. 526.

Exposition des peintures et des sculptures. Société des Amis des Arts de Bordeaux, 1868, no. 504.

Exposition de peinture et sculpture moderne de décoration et d'ornement. Musée des Arts Décoratifs, Palais de l'Industrie, Paris, 1881, no. 144.

Celebrated Paintings by Great French Masters. National Academy of Design, New York, May 25–June 30, 1887, no. 56.

Exposition de tableaux, pastels, dessins par M. Puvis de Chavannes. Galerie Durand-Ruel, Paris, November 20–December 20, 1887, no. 22.

The Johnson Collection. Philadelphia, November 1892, no. 192.

M. Puvis de Chavannes: Loan Exhibition of Paintings, Pastels and Decorations. Durand-Ruel Galleries, New York, December 15–31, 1894, no. 16.

Louisiana Purchase Exposition (Saint Louis World's Fair). 1904, no. 49.

SELECTED LITERATURE

Burty, Philippe. "Exposition de la Société des Beaux-arts de Bordeaux." *Gazette des beaux-arts*, vol. 24 (May 1868), pp. 496–97, 498 (illus.), 499–500.

D'Argencourt, Louise. Catalogue entry in *Puvis de Chavannes, 1824–1898*, by Louise D'Argencourt et al. Exh. cat. Ottawa: National Gallery of Canada, 1977, pp. 64–65, cat. 36 (illus.).

Philadelphia Museum of Art. *The Second Empire, 1852–1870: Art in France under Napoleon III*. Exh. cat. Philadelphia: Philadelphia Museum of Art, 1978, pp. 345–47, no. VI-97 (illus.).

Price, Aimée Brown. *Pierre Puvis de Chavannes*. New Haven, CT: Yale University Press, 2010, vol. 1, pp. 46, 56, 165; vol. 2, p. 131, cat. 154 (illus.).

Summer
1891
Oil on fabric
4 feet 10⅞ inches × 7 feet 7⁷/₁₆ inches (1.5 × 2.32 m)
The Cleveland Museum of Art. Gift of Mr. and Mrs. J. H. Wade, 1916.1056
Fig. 30

This painting is a reduced version of a mural (see fig. 29) commissioned in 1889 by the government of the French Republic for the foyer of the city hall in Paris, which had burned down during the insurrection of the Commune in 1871. The restoration of the foyer, known as the Zodiac Salon (which previously had been decorated with astrological reliefs by the sixteenth-century French sculptor Jean Goujon), called for two pendant murals on the theme of the seasons. As he had done for his earlier murals *Concordia* and *Bellum*, Puvis conceived of these paintings as allegorical foils, with *Summer* defined by nature's blessings, and its companion, *Winter*, by nature's severity. For *Summer*, in accord with his commission to represent the city of Paris, he chose to depict the Île de France along the Seine, though the mural's setting—described by critics as a "calm landscape from the eclogues" and a "Virgilian dream"—appears unspecific and eternal.[1] The mural's fresco-like surface and limited tonal range enhance its ethereal character. In the reduction, the absence of the foyer's door and the omission of the nursing mother and the harvesters from the mural's background place emphasis on the bathing nudes in the foreground, whose clear articulation and flattened forms would have attracted Puvis's avant-garde contemporaries.

1. René Maizeroy, "Le Salon du Champ de Mars," *Gil Blas*, May 15, 1891, p. 1, and Charles Frémine, "Le Salon du Champ de Mars," *Le Rappel*, May 15, 1891, p. 2; trans. and quoted in Jennifer L. Shaw, *Dream States: Puvis de Chavannes, Modernism, and the Fantasy of France* (New Haven, CT: Yale University Press, 2002), p. 162.

PROVENANCE
Purchased by Durand-Ruel (dealer), Paris, from the artist, October 29, 1891 (stock no. 1882); sold to Durand-Ruel (dealer), New York, January 5, 1892 (stock no. 864); sold to Mr. and Mrs. Jeptha H. Wade, Cleveland, November 16, 1892; gift to Cleveland Museum of Art, 1916

EXHIBITIONS
Probably Galerie Durand-Ruel, Paris, 1891.

Massachusetts Institute of Technology, Cambridge, MA, May 1892 (sponsored by St. Botolph Club, Boston).

World's Columbian Exposition (Chicago World's Fair). 1893, no. 2964.

SELECTED LITERATURE
Robinson, William H. "Puvis de Chavannes's 'Summer' and the Symbolist Avant-Garde." *Bulletin of the Cleveland Museum of Art*, vol. 78, no. 1 (January 1991), pp. 5–27, fig. 1.

D'Argencourt, Louise. *European Paintings of the 19th Century*. The Cleveland Museum of Art Catalogue of Paintings, pt. 4. [Cleveland]: Cleveland Museum of Art, 1999, pp. 507–9, cat. 177 (illus.).

Shaw, Jennifer L. *Dream States: Puvis de Chavannes, Modernism, and the Fantasy of France*. New Haven, CT: Yale University Press, 2002, p. 161, fig. 46.

Werth, Margaret. *The Joy of Life: The Idyllic in French Art, circa 1900*. Berkeley: University of California Press, 2002, p. 64, fig. 27.

Price, Aimée Brown. *Pierre Puvis de Chavannes*. New Haven, CT: Yale University Press, 2010, vol. 2, pp. 99, 341–42, cat. 353 (illus.).

NICHOLAS KONSTANTINOVICH ROERICH
Russian, 1874–1947

Our Forefathers
c. 1911
Tempera on burlap
18⅞ × 31⅛ inches (47.9 × 79.1 cm)
Philadelphia Museum of Art. Gift of Christian Brinton, 1941-79-67
Fig. 130

Roerich's early training as an archaeologist cultivated his lifelong interest in Russian history, and his attraction to the blurring of prehistory and mythology is reflected in the present painting.

The picture's pipe player is seated before a group of bears, which, according to Russian legend, are the forefathers of man and woman. The same composition, which exemplifies the mystical sensibilities that characterize Roerich's work throughout his career, exists in a larger version in tempera on canvas at the Ashmolean Museum in Oxford. Roerich painted the Ashmolean canvas, which he dated to 1911, as a study for the commission from Princess M. K. Tenisheva for a mosaic for the church at Talashkino, in western Russia. He likely made the present painting at the same time as the Ashmolean composition, at a moment when he was at work on the costume and set designs for Igor Stravinsky's ballet *The Rite of Spring*.

PROVENANCE
Christian Brinton (1870–1942), Philadelphia, by 1920; gift to the Philadelphia Museum of Art, 1941

SELECTED LITERATURE
Brinton, Christian. *The Nicholas Roerich Exhibition*. New York: Redfield-Kendirck-Odell, 1920, no. 140 (illus.).

Milner, John. *A Dictionary of Russian and Soviet Artists, 1420–1970*. Suffolk, UK: Antique Collectors' Club, 1993, p. 23 (illus. [Ashmolean version]).

Hill, Peter. *Stravinsky: The Rite of Spring*. New York: Cambridge University Press, 2000, pp. 5, 7 (Ashmolean version).

Taylor, Michael. *Paris through the Window: Marc Chagall and His Circle*. Exh. cat. Philadelphia: Philadelphia Museum of Art, 2011, p. 3, fig. 1.

HENRI ROUSSEAU
French, 1844–1910

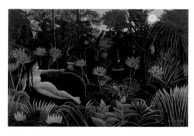

The Dream
1910
Oil on canvas
6 feet 8½ inches × 9 feet 9½ inches (2.04 × 2.98 m)
The Museum of Modern Art, New York. Gift of Nelson A. Rockefeller, 1954
Fig. 113

This painting, Rousseau's largest canvas, was the last work he exhibited at the Salon des Indépendants, showing it in 1910 just months before his death. There, it was displayed with the following poem:

Having fallen into a gentle sleep
Yadwigha, in a dream,
Heard the sounds of a musette
Played by a benevolent magician.
While the moon shone down
Upon the flowers, the green trees,
The wild serpents listed to
The instrument's merry tunes.[1]

Yadwigha, possibly a Polish girlfriend from Rousseau's youth, is represented here as the canonical female nude, who has been usurped from the history of art into a paradise of animals and tropical wildlife. When the artist, who never traveled outside France, studied exotic plants at the botanical gardens in Paris, he said he felt as if he were in a dream.[2]

1. Untitled poem from the pamphlet for the Salon des Indépendants, 1910, no. 4468, trans. and quoted in Michel Hoog, catalogue entry in *Henri Rousseau*, by Roger Shattuck et al., exh. cat. (New York: Museum of Modern Art, 1985), p. 252, cat. 66.

2. Arsène Alexandre, "La vie et l'oeuvre d'Henri Rousseau, peintre et ancien employé de l'Octroi," *Comoedia*, March 19, 1910.

PROVENANCE
Purchased by Ambroise Vollard (1866–1939), Paris, from the artist, February 1910; with M. Knoedler & Co., New York, November 1933–January 1934; sold to Sidney Janis (1896–1989), New York, January 1934; sold to Nelson A. Rockefeller (1908–1979), New York, May 1953; gift to the Museum of Modern Art, New York, on the occasion of the museum's twenty-fifth anniversary, 1954

EXHIBITION
Salon des Indépendants. Baraquements du Cours-la-Reine, Pont des Invalides, Paris, March 18–May 1, 1910, no. 4468.

SELECTED LITERATURE
Soffici, Ardengo. "La France jugée à l'étranger: Le peintre Henri Rousseau." *Mercure de France*, October 16, 1910, pp. 748–55.

Rich, Daniel Catton. *Henri Rousseau*. Exh. cat. New York: Museum of Modern Art, 1942, pp. 68 (illus.), 69, 73.

Certigny, Henry. *Le Douanier Rousseau en son temps: Biographie et catalogue raisonné*. Tokyo: Bunkazai Kenkyujo, 1984, vol. 2, pp. 652–60, cat. 305 (illus.).

Hoog, Michel. Catalogue entry in *Henri Rousseau*, by Roger Shattuck et al. Exh. cat. New York: Museum of Modern Art, 1985, pp. 250–51, 254, cat. 66 (illus.).

Morris, Frances, and Christopher Green, eds. *Henri Rousseau: Jungles in Paris*. Exh. cat. London: Tate Publishing, 2005, pp. 13–14, 19–20, 29, 36–38, 40, 72, 157–58, 161, 174, 188, 199, 202, no. 50 (illus.), fig. 1 (detail).

GEORGES SEURAT
French, 1859–1891

Landscape, Island of La Grande Jatte
1884, retouched c. 1885, painted border c. 1889–90
Oil on canvas
27½ × 33¾ inches (69.9 × 85.7 cm) with border
Private collection
Fig. 49

In May 1884 Seurat started making preparatory studies for his most ambitious project, *A Sunday on La Grande Jatte—1884* (see fig. 46). He likely began the present study, which lays out the landscape as it would appear in the final composition, that summer and completed it by December, when it was shown at the inaugural exhibition of the Société des Artistes Indépendants. He reworked the painting the next year, adding speckles of orange across the shadows in the foreground and in the trees in the background, an important contribution to his developing Divisionist style, which sought to integrate dashes of pure color in the eyes of the viewer. The setting of La Grande Jatte, an island in the Seine just outside the city limits of Paris, was a popular leisure destination and a familiar site for the Impressionists in the 1880s. Seurat's study emphasizes geographic specificity in its depiction of the expanse of green lawn from the park at the island's northwestern tip overlooking the town of Courbevoie. Heightening the inherent theatricality of his endeavor, the landscape appears here as an empty stage that would be animated by a cast of more than fifty figures and animals. The sailboats on the left and the tiny white strokes below the grove of trees, which have been identified as a dog, are harbingers of what is to come.

PROVENANCE
By inheritance to the artist's brother-in-law, Léon Appert, Paris, 1891, until at least 1905. His son, Léopold Appert, Paris, by 1908–9; with Alex Reid & Lefevre, Glasgow, 1926; with M. Knoedler & Co., London and New York (stock no. 16671), on joint account with C. W. Kraushaar Galleries, New York, October 1926; with Alex Reid & Lefevre, London, April 1929; sold to Mrs. Chester

Beatty (d. 1952), London, April 1929, until d. 1952; by inheritance to Sir Alfred Chester Beatty, Dublin, 1952; with Paul Rosenberg & Co., New York, 1955; sold to Mrs. John Hay (Betsey Cushing Roosevelt) Whitney (1908–1998), 1955, until d. 1998; Mr. and Mrs. John Hay Whitney estate sale, Sotheby's, New York, May 10, 1999, no. 15. Private collection

EXHIBITIONS
1ʳᵉ exposition de la Société des Artistes Indépendants, Salon d'hiver. Pavillon de la Ville de Paris, Champs-Élysées, December 10, 1884–January 17, 1885, no. 241.

Works in Oil and Pastel by the Impressionists of Paris. American Art Association, New York, April 10–28, 1886; National Academy of Design, New York, May 25–June 30, 1886, no. 112.

Salon des Indépendants. Pavillon de la Ville de Paris, Champs-Élysées, March 19–April 27, 1892, no. 1088.

Georges Seurat (1860 [sic]–1891): Oeuvres peintes et dessinées. La Revue Blanche, 23 Boulevard des Italiens, Paris, March 19–April 5, 1900, no. 15.

Salon des Indépendants: Exposition rétrospective Georges Seurat. Grandes Serres de l'Alma, Cours-la-Reine, Paris, March 24–April 30, 1905, no. 2.

Exposition Georges Seurat (1859–1891). Bernheim-Jeune & Cie, Paris, December 14, 1908–January 9, 1909, no. 50.

SELECTED LITERATURE
Clark, Kenneth. *Landscape into Art*. 1949. Reprint, London: John Murray, 1950, p. 117, pl. 96.

Hauke, C. M. de. *Seurat et son oeuvre*. Paris: Paul Brame et C. M. de Hauke, 1961, vol. 2, p. 82, no. 131 (illus.).

Herbert, Robert L. Catalogue entry in *Georges Seurat, 1859–1891*, by Robert L. Herbert et al. Exh. cat. New York: Metropolitan Museum of Art, 1991, pp. 204, 206, cat. 139 (illus.).

———. "Genesis of *La Grande Jatte*." In *Seurat and the Making of "La Grande Jatte,"* edited by Robert L. Herbert. Exh. cat. Chicago: Art Institute of Chicago, 2004, pp. 68, 78, no. 60 (illus.).

PAUL SIGNAC

French, 1863–1935

In the Time of Harmony (The Golden Age Is Not in the Past, It Is in the Future)
1893–95
Oil on canvas
9 feet 10⅛ inches × 13 feet 1½ inches (3 × 4 m)
Mairie de Montreuil, France
Fig. 44

This work will be represented in the exhibition by a study (1893, oil on canvas, 23¹/₁₆ × 31⅞ inches [58.6 × 81 cm], private collection).

In an 1891 letter to Henri-Edmond Cross, who had just moved to Cabasson in the south of France, Signac wrote, "How I envy your existence—dignified, simple, elevated, far from Paris and its so-called intellectual shit."[1] The next year Signac sought refuge along the Mediterranean, finding in Saint-Tropez physical beauty and an ease of life unknown in the capital. He created this painting as a monument to his surroundings. A mural-scale declaration of the artist's anarchist sentiments, the canvas gives visual form to the dream of a future utopia in which individual liberties lay the foundation for social harmony. While the subject makes clear Signac's political intentions, his anarchist values were equally (if not, for the artist, more importantly) realized in formal terms. The compositional symmetry around the child in the foreground lends the picture stability, while his Divisionist technique—a synthesis of individual strokes, one no more privileged than the next—offers an aesthetic equivalent of the unity and equality he depicted. Such reciprocity between ideology and form was Signac's fundamental artistic principle: "Justice in sociology; harmony in art: the same thing."[2]

1. Signac to Cross, November 1891, quoted in Françoise Cachin, "L'arrivée de Signac à Saint-Tropez," in *Signac et Saint-Tropez, 1892–1913,* by Françoise Cachin, Jean-Paul Monery, and Marina Ferretti-Bocquillon, exh. cat. (Saint-Tropez: Musée de l'Annonciade), pp. 13–14.

2. Unpublished manuscript, n.d. [c. 1902?], Archives Signac, Paris, trans. and quoted in Robert L. Herbert and Eugenia W. Herbert, "Artists and Anarchism: Unpublished Letters of Pissarro, Signac, and Others" (1960), in *From Millet to Léger: Essays in Social Art History,* by Robert L. Herbert (New Haven, CT: Yale University Press, 2002), p. 109.

PROVENANCE
Studio of the artist, rue La Fontaine, Paris, 1935; by inheritance to his wife, Berthe (Roblès) Signac (1862–1942), 1935; gift to the Mairie de Montreuil, March 6, 1938

EXHIBITIONS
Salon des Indépendants. Palais des Arts Libéraux, Champ-de-Mars, Paris, April 9–May 26, 1895, no. 1401.

La Libre Esthétique. Musée d'Art Moderne, Brussels, February 22–March 30, 1896, no. 389.

SELECTED LITERATURE
Velde, Henry van de. "Les expositions d'art: À Bruxelles, la peinture au 3ᵉ Salon de la Libre Esthétique." *La revue blanche,* March 15, 1896, pp. 284–87.

Ferretti-Bocquillon, Marina. Catalogue entry in *Signac et Saint-Tropez, 1892–1913,* by Françoise Cachin, Jean-Paul Monery, and Marina Ferretti-Bocquillon. Exh. cat. Saint-Tropez: Musée de l'Annonciade, 1992, pp. 50–59, cat. 7 (illus.).

Cachin, Françoise, and Marina Ferretti-Bocquillon, eds. *Signac: Catalogue raisonné de l'oeuvre peint.* Paris: Gallimard, 2000, pp. 52–53, 54–55 (illus.), 215–16, no. 253 (illus.).

Werth, Margaret. *The Joy of Life: The Idyllic in French Art, circa 1900.* Berkeley: University of California Press, 2002, esp. pp. 82–84, 88–94, 98, 103–19, 128–42, pl. 7.

Dymond, Anne. "A Politicized Pastoral: Signac and the Cultural Geography of Mediterranean France." *Art Bulletin,* vol. 85, no. 2 (June 2003), pp. 353–70, fig. 1.

Selected Bibliography

NOTES TO THE READER

The selected bibliography is divided into three sections: The first section is composed of key general references, including texts that relate to Arcadian themes in literature and art, as well as foundational texts on modern art movements covered in this catalogue. The second section includes selected references to Virgil, particularly to the *Eclogues*. The third, organized alphabetically by artists' last names, includes major references on the principal artists discussed in this catalogue.

SUGGESTED READING

Alpers, Paul. "What Is Pastoral?" *Critical Inquiry*, vol. 8, no. 3 (Spring 1982), pp. 437–60.

Barnes, Albert C. *The Art in Painting*. 1925. 3rd ed. Merion Station, PA: Barnes Foundation, 1976.

Cafritz, Robert C., Lawrence Gowing, and David Rosand. *Places of Delight: The Pastoral Landscape*. Exh. cat. Washington, DC: Phillips Collection in association with the National Gallery of Art, 1988.

Elderfield, John. *The "Wild Beasts": Fauvism and Its Affinities*. Exh. cat. New York: Museum of Modern Art, 1976.

Empson, William. *Some Versions of Pastoral*. New York: New Directions, 1974.

Freedman, Luba. *The Classical Pastoral in the Visual Arts*. New York: P. Lang, 1989.

Fry, Roger. "The French Post-Impressionists" (1912). In *Vision and Design*, edited by J. B. Bullen, pp. 166–70. London: Oxford University Press, 1981.

Golding, John. *Cubism: A History and an Analysis, 1907–1914*. 3rd ed. Cambridge, MA: Belknap, 1988.

Greenspan, Taube. "'Les Nostalgiques' Re-examined: The Idyllic Landscape in France, 1890–1905." PhD diss., City University of New York, 1981.

Herbert, James D. "The Golden Age and the French National Heritage." In *Fauve Painting: The Making of Cultural Politics*, pp. 112–45. New Haven, CT: Yale University Press, 1992.

Herbert, Robert L. *Neo-Impressionism*. Exh. cat. New York: Solomon R. Guggenheim Foundation, 1968.

Hofmann, Werner. *The Earthly Paradise: Art in the Nineteenth Century*. Translated by Brian Battershaw. New York: George Braziller, 1961.

Hunt, John Dixon, ed. *The Pastoral Landscape*. Studies in the History of Art, vol. 36. Washington, DC: National Gallery of Art, 1992.

Lemoine, Serge, ed. *From Puvis de Chavannes to Matisse and Picasso: Toward Modern Art*. Exh. cat. [Milan]: Bompioni, 2002.

Loughrey, Bryan, ed. *The Pastoral Mode: A Casebook*. New York: Macmillan, 1984.

März, Roland, ed. *Arcadia and Metropolis: Masterworks of German Expressionism from the Nationalgalerie Berlin*. Exh. cat. New York: Prestel, 2004.

Meyer-Büser, Susanne, ed. *Marc, Macke und Delaunay: Die Schönheit einer zerbrechenden Welt (1910–1914)*. Exh. cat. Hannover, Germany: Sprengel Museum, 2009. Published in English as *Marc, Macke und [sic] Delaunay: The Beauty of a Fragile World (1910–1914)*. Exh. cat. Hannover, Germany: Sprengel Museum, 2009.

Panofsky, Erwin. "*Et in Arcadia ego*: Poussin and the Elegiac Tradition." In *Meaning in the Visual Arts: Papers in and on Art History*, pp. 295–322. Garden City, NY: Doubleday, 1955.

Patterson, Annabel. *Pastoral and Ideology: Virgil to Valéry*. Berkeley: University of California Press, 1987.

Rewald, John. *Post-Impressionism: From Van Gogh to Gauguin*. New York: Museum of Modern Art, [1956].

Schama, Simon. *Landscape and Memory*. New York: Alfred A. Knopf, 1995.

Skoie, Mathilde, ed. *Pastoral and the Humanities: Arcadia Re-inscribed*. 1st ed. Exeter, UK: Bristol Phoenix Press, 2006.

Werth, Margaret. *The Joy of Life: The Idyllic in French Art, circa 1900*. Berkeley: University of California Press, 2002.

VIRGIL

Alpers, Paul. *The Singer of the Eclogues: A Study of Virgilian Pastoral, with a New Translation of the Eclogues*. Berkeley: University of California Press, 1979.

Broch, Hermann. *The Death of Virgil*. Translated by Jean Starr Untermeyer. New York: Pantheon Books, 1945.

Davis, Gregson. Introduction to *Virgil's "Eclogues."* Translated by Len Krisak. Philadelphia: University of Pennsylvania Press, 2010.

Lee, Owen. *Death and Rebirth in Virgil's Arcadia*. Albany: State University of New York Press, 1989.

Pasquier, Bernadette. *Virgile illustré: De la Renaissance à nos jours en France et en Italie*. Paris: Jean Tuzot, 1992.

Putnam, Michael C. J. *Virgil's Pastoral Art: Studies in the "Eclogues."* Princeton, NJ: Princeton University Press, 1970.

Snell, Bruno. "Arcadia: The Discovery of a Spiritual Landscape." In *The Discovery of the Mind: The Greek Origins of European Thought*, pp. 281–310. Translated by T. G. Rosenmeyer. Oxford: Basil Blackwell, 1953.

Virgil. *Works*. Vol. 1, *Eclogues, Georgics, Aeneid I–VI*. Translated by H. Rushton Fairclough. Loeb Classical Library. London: W. Heinemann, 1916.

Ziolkowski, Theodore. *Virgil and the Moderns*. Princeton, NJ: Princeton University Press, 1993.

ARTISTS

Émile Bernard

Bernard, Émile. *Propos sur l'art*. Edited by Anne Rivière. 2 vols. Collection écrits sur l'art. Paris: Nouvelles Éditions Séguier, 1994.

Luthi, Jean-Jacques. *Émile Bernard: Catalogue raisonné de l'oeuvre peint*. Paris: Éditions Side, 1982.

Stevens, MaryAnne, ed. *Émile Bernard, 1868–1941: A Pioneer of Modern Art / Ein Wegbereiter der Moderne*. Exh. cat. Zwolle, The Netherlands: Waanders Verlag, 1990.

Paul Cézanne

Athanassoglou-Kallmyer, Nina. *Cézanne and Provence: The Painter in His Culture.* Chicago: University of Chicago Press, 2003.

Bernard, Émile. *Souvenirs sur Paul Cézanne.* Paris: Société des Trentes, 1912.

Cachin, Françoise, and Joseph J. Rishel, eds. *Cézanne.* Exh. cat. Philadelphia: Philadelphia Museum of Art, 1996.

Cézanne, Paul. *Paul Cézanne: Letters.* Edited by John Rewald. 1976. 4th ed. Reprint, New York: Da Capo, 1995.

Clark, T. J. "Freud's Cézanne" (1995). In *Farewell to an Idea: Episodes from a History of Modernism,* pp. 139–67. New Haven, CT: Yale University Press, 1999.

Denis, Maurice. "Cézanne." *L'occident,* September 1907, pp. 118–33.

Doran, Michael, ed. *Conversations with Cézanne.* Translated by Julie Lawrence Cochran. Berkeley: University of California Press, 2001.

Gasquet, Joachim. *Joachim Gasquet's Cézanne: A Memoir with Conversations.* Translated by Christopher Pemberton. London: Thames and Hudson, 1991.

Kendall, Richard, ed. *Cézanne and Poussin: A Symposium.* Sheffield, UK: Sheffield Academic Press, 1993.

Krumrine, Mary Louise. *Paul Cézanne: The Bathers.* Exh. cat. New York: Harry N. Abrams, 1990.

Reff, Theodore. "Cézanne and Poussin." *Journal of the Warburg and Courtauld Institutes,* vol. 23, nos. 1–2 (January–June 1960), pp. 150–74.

Rewald, John. *The Paintings of Paul Cézanne: A Catalogue Raisonné.* 2 vols. New York: H. N. Abrams, 1996.

Rishel, Joseph J., and Katherine Sachs, eds. *Cézanne and Beyond.* Exh. cat. Philadelphia: Philadelphia Museum of Art, 2009.

Rubin, William, ed. *Cézanne: The Late Work.* Exh. cat. New York: Museum of Modern Art, 1977.

Shiff, Richard. *Cézanne and the End of Impressionism: A Study of the Theory, Technique, and Critical Evaluation of Modern Art.* Chicago: University of Chicago Press, 1984.

Smith, Paul. "Joachim Gasquet, Virgil and Cézanne's Landscape: 'My Beloved Golden Age.'" *Apollo,* October 1998, pp. 11–23.

Verdi, Richard. *Cézanne and Poussin: The Classical Vision of Landscape.* Exh. cat. Edinburgh: National Galleries of Scotland, 1990.

Jean-Baptiste-Camille Corot

Clarke, Michael. "Corot: Between the Classical and the Modern." In *Cézanne and Poussin: A Symposium,* edited by Richard Kendall, pp. 69–87. Sheffield, UK: Sheffield Academic Press, 1993.

Galassi, Peter. *Corot in Italy: Open-Air Painting and the Classical-Landscape Tradition.* New Haven, CT: Yale University Press, 1991.

Leymarie, Jean. *Corot.* New York: Rizzoli, 1979.

Pomarède, Vincent. *Corot.* Milan: Leonardo, 1996.

———, ed. *Corot e l'arte moderna: Souvenirs et Impressions.* Exh. cat. [Venice]: Marisilio, 2009.

Pomarède, Vincent, et al. *Corot: Naturaleza, Emoción, Recuerdo.* Exh. cat. Madrid: Fundación Colección Thyssen-Bornemisza, 2005.

Robaut, Alfred. *L'oeuvre de Corot: Catalogue raisonné et illustré.* Paris: H. Floury, 1905.

Stefani, Chriara, Vincent Pomarède, and Gérard de Wallens, eds. *Corot: Un artiste et son temps.* Colloquia proceedings, Musée du Louvre, Paris, March 1–2, 1996; Académie de France à Rome, March 9, 1996. Paris: Klincksieck, 1998.

Tinterow, Gary, Michael Pantazzi, and Vincent Pomarède. *Corot.* Exh. cat. New York: Metropolitan Museum of Art, 1996.

Henri-Edmond Cross

Baligand, Françoise, et al. *Cross and Neo-Impressionism: From Seurat to Matisse / Henri-Edmond Cross et le néo-impressionnisme: De Seurat à Matisse.* Exh. cat. Paris: Musée Marmottan Monet, 2011.

———. *Henri Edmond Cross, 1856–1910.* Exh. cat. Paris: Somogy Éditions d'Art, 1998.

Clévenot, Dominique. "Henri Edmond Cross à petites touches." *L'oeil,* no. 500 (October 1998), pp. 79–85.

Compin, Isabelle. *H. E. Cross.* Paris: Quatre Chemins, 1964.

Robert Delaunay

Buckberrough, Sherry A. *Robert Delaunay: The Discovery of Simultaneity.* Studies in the Fine Arts: The Avant-Garde, no. 21. Ann Arbor, MI: UMI Research Press, 1982.

Dorival, Bernard. "Robert Delaunay et l'oeuvre du Douanier Rousseau." *L'oeil,* no. 267 (October 1977), pp. 18–27.

Francastel, Pierre, ed. *Du Cubisme à l'art abstrait.* Paris: SEVPEN, 1957.

Hoog, Michel. *Robert et Sonia Delaunay.* Inventaire des collections publiques françaises, 15. Paris: Réunion des Musées Nationaux, 1967.

Robert et Sonia Delaunay. Exh. cat. Paris: Musée d'Art Moderne de la Ville de Paris, 1985.

Rosenthal, Mark, ed. *Visions of Paris: Robert Delaunay's Series.* Exh. cat. New York: Solomon R. Guggenheim Foundation, 1997.

Rousseau, Pascal. *Robert Delaunay, 1906–1914: De l'impressionnisme à l'abstraction.* Exh. cat. Paris: Éditions du Centre Pompidou, 1999.

Schuster, Peter-Klaus, ed. *Delaunay und Deutschland.* Exh. cat. Cologne: DuMont Buchverlag, [1985].

Spate, Virginia. *Orphism: The Evolution of Non-figurative Painting in Paris, 1910–1914.* Oxford Studies in the History of Art and Architecture. Oxford: Oxford University Press, 1979.

Vriesen, Gustav, and Max Imdahl. *Robert Delaunay: Light and Color.* Translated by Maria Pelikan. New York: Harry N. Abrams, 1967.

Maurice Denis

Bouillon, Jean-Paul. *Maurice Denis: Six essais.* Paris: Somogy Éditions d'Art, 2006.

———. ed. *Maurice Denis: Earthly Paradise, 1870–1943.* Exh. cat. Paris: Réunion des Musées Nationaux, 2006.

Cogeval, Guy, Claire Denis, and Thérèse Barruel. *Maurice Denis, 1870–1943.* Exh. cat. Ghent, Belgium: Sneock-Ducaju and Zoon, 1994.

Delannoy, Agnes, ed. *Lumières de sable: Plages de Maurice Denis.* Exh. cat. Paris: Somogy Éditions d'Art, 1997.

Delouche, Denise. *Maurice Denis et la Bretagne.* Paris: Éditions Palantines, 2010.

Denis, Maurice. *Le ciel et l'arcadie.* Edited by Jean-Paul Bouillon. Paris: Hermann, 1993.

———. *Théories, 1890–1910: Du symbolisme et de Gauguin vers un nouvel ordre classique.* 4th ed. Paris: L. Rouart et J. Watelin, 1920.

Maurice Denis et la Bretagne, Maurice Denis à Perros-Guirec. Exh. cat. Perros-Guirec, France: Maison des Traouieros, 1985.

André Derain

Ball, Susan L. "The Early Figural Paintings of André Derain, 1905–1910: A Re-evaluation." *Zeitschrift für Kunstgeschichte,* vol. 43, no. 1 (1980), pp. 79–96.

Dagen, Philip. "L'age d'or: Derain, Matisse et le bain turc." *Bulletin du Musée Ingres,* nos. 53–54 (December 1984), pp. 43–54.

Flam, Jack D. "Matisse and the Fauves." In *"Primitivism" in 20th Century Art: Affinity of the Tribal and the Modern,* edited by William Rubin, vol. 1, pp. 211–39. Exh. cat. New York: Museum of Modern Art, 1984.

Giry, Michel. "Une composition de Derain dite La danse." *Archives de l'art français,* vol. 25 (1978), pp. 443–47.

Hilaire, Georges. *Derain.* Geneva: Pierre Cailler, 1959.

Kellerman, Michael. *André Derain: Catalogue raisonné de l'oeuvre peint.* 3 vols. Paris: Éditions Galerie Schmit, 1992.

Labrusse, Rémi, and Jacqueline Munck. *Matisse, Derain: La verité du fauvisme.* Paris: Hazan, 2005.

Labrusse, Rémi, et al. *André Derain: The London Paintings.* Exh. cat. London: Courtauld Institute of Art Gallery, 2005.

Lee, Jane. *Derain.* Exh. cat. Oxford: Phaidon, 1990.

Matamoros, Joséphine, et al. *Matisse—Derain: Collioure 1905; Un été fauve.* Exh. cat. Paris: Gallimard, 2005.

Monod-Fontaine, Isabelle. *André Derain: An Outsider in French Art.* Exh. cat. Copenhagen: Statens Museum for Kunst, 2007.

Pagé, Suzanne, ed. *André Derain: Le peintre du "trouble moderne."* Exh. cat. Paris: Musée d'Art Moderne de la Ville de Paris, 1994.

Paul Gauguin

Brettell, Richard R., and Anne-Birgitte Fonsmark. *Gauguin and Impressionism.* Exh. cat. New Haven, CT: Yale University Press, 2005.

Brettell, Richard R., et al. *The Art of Paul Gauguin.* Exh. cat. Washington, DC: National Gallery of Art, 1988.

Childs, Elizabeth C. *Vanishing Paradise: Art and Exoticism in Colonial Tahiti, 1880–1901.* Berkeley: University of California Press, forthcoming.

Eisenman, Stephen F. *Gauguin's Skirt.* New York: Thames and Hudson, 1997.

———. *Paul Gauguin.* Barcelona: Ediciones Polígrafa, 2010.

Field, Richard S. *Paul Gauguin: The Paintings of the First Voyage to Tahiti.* New York: Garland, 1977.

Gauguin, Paul. *Correspondance de Paul Gauguin, documents, témoignages.* Edited by Victor Merlhès. Paris: Fondation Singer-Polignac, 1984.

———. *Paul Gauguin: Letters to His Wife and Friends.* Edited by Maurice Malingue. Translated by Henry J. Stenning. Cleveland: World, 1949.

———. *Gauguin's Letters from the South Seas.* Translated by Ruth Pielkovo. Reprint, New York: Dover, 1992.

Hoog, Michel. *Paul Gauguin: Life and Work.* Translated by Constance Devanthéry-Lewis. New York: Rizzoli, 1987.

Költzsch, Georg-W, ed. *Paul Gauguin: Das Verlorene Paradies.* Exh. cat. Cologne: DuMont, 1998.

Laudon, Paul, ed. *Rencontres Gauguin à Tahiti.* Colloquium proceedings, June 20–21, 1989. Papeete: Aurea, 1992.

Prather, Marla, and Charles F. Stuckey, eds. *Gauguin: A Retrospective.* Exh. cat. New York: Park Lane, 1987.

Shackelford, George T. M., and Claire Frèches-Thory. *Gauguin Tahiti.* Exh. cat. Boston: Museum of Fine Arts, 2004.

Solana, Guillermo, et al. *Gauguin and the Origins of Symbolism.* Exh. cat. [London]: Philip Wilson, 2004.

Thomson, Belinda, ed. *Gauguin: Maker of Myth.* Exh. cat. London: Tate Publishing, 2010.

Wildenstein, Daniel. *Gauguin: A Savage in the Making; Catalogue Raisonné of the Paintings, 1873–1888.* 2 vols. Milan: Skira, 2002.

Albert Gleizes

Alibert, Pierre. *Albert Gleizes: Naissance et avenir du cubisme.* [Paris]: Aubin Visconti, 1982.

Briend, Christian. *Albert Gleizes: El Cubismo en majestad.* Exh. cat. Barcelona: Museu Picasso, 2001.

Brooke, Peter. *Albert Gleizes: For and Against the Twentieth Century.* New Haven: Yale University Press, 2010.

Gleizes, Albert, and Jean Metzinger. "Cubism" (1912). In *Modern Artists on Art: Ten Unabridged Essays,* edited by Robert L. Herbert, pp. 1–18. 1964. Reprint, Englewood Cliffs, NJ: Prentice-Hall, 1965.

Robbins, Daniel. *Albert Gleizes, 1881–1953: Exposition rétrospective.* Exh. cat. Paris: Musée National d'Art Moderne, 1964.

Robbins, Daniel, and Pierre Georgel. *Albert Gleizes: Catalogue raisonné.* Edited by Anne Varichon. 2 vols. Paris: Somogy Éditions d'Art, 1998.

Natalia Sergeyevna Goncharova

Basner, Elena, et al. *Natalia Goncharova: The Russian Years.* Exh. cat. Saint Petersburg: State Russian Museum, 2002.

Boissel, Jessica. *Nathalie Gontcharova, Michel Larionov.* Exh. cat. Paris: Éditions du Centre Pompidou, 1995.

Bowlt, John E., and Matthew Drutt, eds. *Amazons of the Avant-Garde: Alexandra Exter, Natalia Goncharova, Liubov Popova, Olga Rozanova, Varvara Stepanova, and Nadezhda Udaltsova.* Exh. cat. New York: Solomon R. Guggenheim Foundation, 2000.

Charmot, Mary. *Goncharova: Stage Designs and Paintings.* London: Oresko Books, 1979.

Parton, Anthony. *Goncharova: The Art and Design of Natalia Goncharova.* Suffolk, UK: Antique Collectors' Club, 2010.

Sharp, Jane Ashton. *Russian Modernism between East and West: Natal'ia Goncharova and the Moscow Avant-Garde.* New York: Cambridge University Press, 2006.

Jean-Auguste-Dominique Ingres

Ockman, Carol. "The Restoration of the Chateau of Dampierre: Ingres, the Duc de Luynes and an Unrealized Vision of History." PhD diss., Yale University, 1982.

Pomarède, Vincent, et al., eds. *Ingres: 1780–1867.* Exh. cat. Paris: Éditions Gallimard, 2006.

Rosenblum, Robert. *Jean-Auguste-Dominique Ingres.* New York: Harry N. Abrams, 1967.

Shedd, Meredith. "Ingres as Archaeologist: The Image of Saturn in 'L'Age d'or' at Dampierre." *Zeitschrift für Kunstgeschichte,* vol. 51, no. 2 (1988), pp. 269–79.

Siegfried, Susan L. *Ingres: Painting Reimagined.* New Haven, CT: Yale University Press, 2009.

Siegfried, Susan L., and Adrian Rifkin, eds. *Fingering Ingres.* Malden, MA: Blackwell, 2001.

Tinterow, Gary, and Philip Conisbee, eds. *Portraits by Ingres: Image of an Epoch.* Exh. cat. New York: Metropolitan Museum of Art, 1999.

Ernst Ludwig Kirchner

Billag, Volkmar. *Künstler der Brücke in Moritzburg: Malerei, Zeichnung, Graphik, Plastik von Heckel, Kirchner, Pechstein, Bleyl.* Exh. cat. [Moritzburg]: Museums Schloss Moritzburg, 1995.

Gordon, Donald. *Ernst Ludwig Kirchner.* Cambridge, MA: Harvard University Press, 1968.

Grisebach, Lucius, and Annette Meyer zu Eissen. *Ernst Ludwig Kirchner, 1880–1938.* Exh. cat. Berlin: Nationalgalerie Berlin, 1979.

Heller, Reinhold, ed. *Brücke: The Birth of Expressionism in Dresden and Berlin, 1905–1913.* Exh. cat. Ostfildern, Germany: Hatje Cantz Verlag, 2009.

Krämer, Felix, et al. *Ernst Ludwig Kirchner: Retrospective.* Exh. cat. Frankfurt: Hatje Cantz, 2010.

Lloyd, Jill, and Magdalena M. Moeller, eds. *Ernst Ludwig Kirchner, 1880–1938.* Exh. cat. Washington, DC: National Gallery of Art, 2003.

Moeller, Magdalena M., and Roland Scott, eds. *Ernst Ludwig Kirchner: Gemälde, Acquarelle, Zeichnungen, und Druckgraphik.* Exh. cat. Munich: Hirmer Verlag, 1998.

Spieler, Reinhard, and Alexander B. Eiling. *Ernst Ludwig Kirchner: Drei Akte im Walde.* Exh. cat. Bielefeld, Germany: Kerber Art, 2010.

Spielmann, Heinz, ed. *Ernst Ludwig Kirchner auf Fehmarn.* Brücke-Almanach. Exh. cat. Schleswig, Germany: Schleswig-Holsteinisches Landesmuseum, Schloß Gottorf, 1997.

Aristide Maillol

Berger, Ursel, and Jörg Zutter, eds. *Aristide Maillol.* Exh. cat. New York: Prestel, 1996.

Cladel, Judith. *Aristide Maillol: Sa vie—son oeuvre—ses idées.* [Paris]: Éditions Bernard Grasset, 1937.

George, Waldemar. *Aristide Maillol.* Translated by Diana Imber. Greenwich, CT: New York Graphic Society, [1965].

Guérin, Marcel. *Catalogue raisonné de l'oeuvre gravé et lithographié de Aristide Maillol.* 2 vols. Geneva: Éditions Pierre Cailler, 1965.

Lorquin, Bertrand. *Aristide Maillol.* [Milan]: Skira, 2002.

Rewald, John. *Maillol.* New York: Hyperion, 1939.

———, ed. *The Woodcuts of Aristide Maillol: A Complete Catalogue with 176 Illustrations.* New York: Pantheon Books, 1951.

Vierny, Dina, et al. *Aristide Maillol.* Exh. cat. Paris: Fondation Dina Vierny-Musée Maillol, 2000.

Franz Marc

Franz, Erich, and Andrea Witte. *Franz Marc: Kräfte der Natur; Werke, 1912–1915.* Exh. cat. Münster: Hatje Cantz, 1993.

Hoberg, Annegret, and Isabelle Jansen. *Franz Marc: The Complete Works.* 2 vols. London: Philip Wilson, 2004.

Hoberg, Annegret, and Helmut Friedel, eds. *Franz Marc: The Retrospective.* Exh. cat. Munich: Prestel, 2005.

Holst, Christian von, ed. *Franz Marc: Horses.* Translated by Elizabeth Clegg and Claudia Spinner. Exh. cat. Ostfildern-Ruit, Germany: Hatje Cantz Verlag, 2000.

Lankheit, Klaus, ed. *Franz Marc im Urteil seiner Zeit.* Cologne: Verlag M. DuMont Schauberg, 1960.

———. *Franz Marc: Katalog der Werke.* Cologne: Verlag M. DuMont Schauberg 1970.

Pese, Claus. *Franz Marc: Leben und Werk.* Stuttgart: Belser Verlag, 1989.

Rosenthal, Mark. *Franz Marc, 1880–1916.* Exh. cat. Berkeley: University Art Museum, University of California, 1979.

Henri Matisse

Barr, Alfred H., Jr. *Matisse: His Art and His Public.* New York: Museum of Modern Art, 1951.

Bock, Catherine Cecelia. "Henri Matisse and Neo-Impressionism, 1898–1908." PhD diss., University of California, Los Angeles, 1977.

Bois, Yve-Alain. *Matisse and Picasso.* Exh. cat. 1998. Reprint, Paris: Flammarion, 2001.

Cowling, Elizabeth, et al. *Matisse, Picasso.* Exh. cat. London: Tate Publishing, 2002.

D'Alessandro, Stephanie, and John Elderfield. *Matisse: Radical Invention, 1913–1917.* Exh. cat. Chicago: Art Institute of Chicago, 2010.

Elderfield, John. *Henri Matisse: A Retrospective.* Exh. cat. New York: Museum of Modern Art, 1992.

Escholier, Raymond. *Henri Matisse.* Anciens et Modernes. Paris: Libraire Floury, 1937.

Flam, Jack, ed. *Matisse on Art.* London: Phaidon, 1973.

———. *Matisse: The Dance.* Exh. cat. Washington, DC: National Gallery of Art, 1993.

———. *Matisse: The Man and His Art, 1869–1918.* Ithaca, NY: Cornell University Press, 1986.

Fourcade, Dominique, and Isabelle Monod-Fontaine, eds. *Henri Matisse, 1904–1917.* Exh. cat. Paris: Centre Georges Pompidou, 1993.

Labrusse, Rémi, and Jacqueline Munck. *Matisse, Derain: La verité du fauvism.* Paris: Hazan, 2005.

Matamoros, Joséphine, et al. *Matisse—Derain: Collioure 1905, un été fauve.* Exh. cat. Paris: Gallimard, 2005.

Puttfarken, Thomas. "Mutual Love and Golden Age: Matisse and 'gli Amori de' Carracci.'" *Burlington Magazine,* vol. 124, no. 949 (April 1982), pp. 203–8.

Schneider, Pierre. *Matisse.* Translated by Michael Taylor and Bridget Stevens Romer. New York: Rizzoli, 1984.

Spurling, Hilary. *A Life of Henri Matisse: The Early Years, 1869–1908.* New York: Alfred A. Knopf, 1998.

———. *Matisse the Master: A Life of Henri Matisse; The Conquest of Colour, 1909–1954.* London: Hamish Hamilton, 2005.

Wright, Alastair. *Matisse and the Subject of Modernism.* Princeton, NJ: Princeton University Press, 2004.

Jean Metzinger

Apollinaire, Guillaume. "Jean Metzinger." In *The Cubist Painters,* pp. 62–68. 1913. Translated by Patricia Roseberry. [Harrogate, UK]: Broadwater House, 2000.

Gleizes, Albert, and Jean Metzinger. "Cubism" (1912). In *Modern Artists on Art: Ten Unabridged Essays,* edited by Robert L. Herbert, pp. 1–18. 1964. Reprint, Englewood Cliffs, NJ: Prentice-Hall, 1965.

Moser, Joann. *Jean Metzinger in Retrospect.* Exh. cat. Iowa City: University of Iowa Museum of Art, 1985.

Max Pechstein

Billag, Volkmar. *Künstler der Brücke in Moritzburg: Malerei, Zeichnung, Graphik, Plastik von Heckel, Kirchner, Pechstein, Bleyl.* Exh. cat. [Moritzburg]: Museums Schloss Moritzburg, 1995.

Dietrich, Gerd, et al. *Max Pechstein: Das ferne Paradies, Gemälde, Zeichnungen, Druckgraphik.* Exh. cat. Ostfildern, Germany: Verlag Gerd Hatje, 1995.

Moeller, Magdalena M., ed. *Max Pechstein: Sein malerisches Werk.* Exh. cat. Munich: Hirmer Verlag, 1996.

Osborn, Max. *Max Pechstein.* Berlin: Im Proplyläen-Verlag, 1922.

Pechstein, Max. *Erinnerungen.* Edited by L. Reidemeister. Wiesbaden, Germany: Limes Verlag, 1960.

Soika, Aya. *Max Pechstein: Das Werkverzeichnis der Ölgemälde.* 2 vols. Hamburg: Hirmer Verlag, 2011.

Pablo Picasso

Barr, Alfred H., Jr. *Picasso: Fifty Years of His Art.* New York: Museum of Modern Art, 1946.

Bois, Yve-Alain. *Matisse and Picasso.* Exh. cat. 1998. Reprint, Paris: Flammarion, 2001.

Cowling, Elizabeth. *Picasso: Style and Meaning.* London: Phaidon, 2000.

Cowling, Elizabeth, et al. *Matisse Picasso.* Exh. cat. London: Tate Publishing, 2002.

Daix, Pierre, and Georges Boudaille. *Picasso: The Blue and Rose Periods; A Catalogue Raisonné of the Paintings, 1900–1906.* Translated by Phoebe Pool. Greenwich, CT: New York Graphic Society, 1966.

Hirner, René, Marc Gundel, and Stefanie Rohleder. *Picasso: Zwischen Arena und Arkadien / Picasso: From Arena to Arcadia.* Exh. cat. Cologne: DuMont, 2001.

McCully, Marilyn, ed. *Picasso: The Early Years, 1892–1906.* Exh. cat. Washington, DC: National Gallery of Art, 1997.

Ocaña, M. Teresa, and Hans Christoph von Tavel, eds. *Picasso, 1905–1906: From the Rose Period to the Ochres of Gósol.* Exh. cat. Barcelona: Electa, 1992.

Palau i Fabre, Josep. *Picasso: The Early Years, 1881–1907.* Translated by Kenneth Lyons. Barcelona: Ediciones Polígrafa, 1985.

Penrose, Roland, and John Golding, eds. *Picasso in Retrospect.* New York: Praeger, 1973.

Pool, Phoebe. "Picasso's Neo-classicism: First Period, 1905–6." *Apollo,* vol. 81, no. 36 (February 1965), pp. 122–27.

Richardson, John. *A Life of Picasso.* 3 vols. New York: Random House, 1991–2007.

Tinterow, Gary, Brigitte Baer, and Carmen Giménez. *Picasso clásico.* Exh. cat. Málaga, Spain: Junta de Andalucía Consejería de Cultura y Medio Ambiente, 1992.

Zervos, Christian. *Pablo Picasso: Catalogue de l'oeuvre.* 33 vols. Paris: Cahiers d'art, 1932–78.

Nicolas Poussin

Bellori, Giovanni Pietro. *Le vite de' pittori, scultori, e architetti moderni.* Rome: Per il succeso, al Mascardi, 1672. Published in English as *The Lives of the Modern Painters.* Translated by Alice Sedgwick Wohl. With notes by Hellmut Wohl. Critical ed. New York: Cambridge University Press, 2005.

Blunt, Anthony. *Nicolas Poussin.* 2 vols. The A. W. Mellon Lectures in the Fine Arts. New York: Bollingen Foundation, 1967.

———. *The Paintings of Nicolas Poussin: A Critical Catalogue.* London: Phaidon, 1966.

Cropper, Elizabeth, and Charles Dempsey. *Nicolas Poussin: Friendship and the Love of Painting.* Princeton, NJ: Princeton University Press, 1996.

Dempsey, Charles. "Nicolas Poussin et l'invention de l'idylle mythologique." In *Daniel Arasse: Historien de l'art,* edited by Danièle Cohn, pp. 121–32. Paris: Cendres, 2010.

Friedlaender, Walter. *Nicolas Poussin: A New Approach.* Edited by Patricia Egan. New York: Harry N. Abrams, [1966].

Kauffmann, Georg. "Poussins letztes Werk." *Zeitschrift für Kunstgeschichte,* vol. 24 (1961), pp. 101–27.

Mérot, Alain, ed. *Nicolas Poussin (1594–1665).* Colloquium proceedings, Musée du Louvre, Paris, October 19–21, 1994. Paris: Documentation Française, 1996.

Rosenberg, Pierre, and Keith Christiansen, eds. *Poussin and Nature: Arcadian Visions.* Exh. cat. New York: Metropolitan Museum of Art, 2008.

Rosenberg, Pierre, and Louis-Antoine Prat. *Nicolas Poussin, 1594–1665.* Exh. cat. Paris: Réunion des Musées Nationaux, 1994.

Vetter, E. M. "Nicolas Poussins letztes Bild." *Pantheon,* vol. 29 (1971), pp. 210–25.

Pierre Puvis de Chavannes

D'Argencourt, Louise, et al. *Puvis de Chavannes, 1824–1898.* Exh. cat. Ottawa: National Gallery of Canada, 1977.

Goldwater, Robert. "Puvis de Chavannes: Some Reasons for a Reputation." *Art Bulletin,* vol. 28, no. 1 (March 1946), pp. 33–43.

Lemoine, Serge, ed. *Toward Modern Art: From Puvis de Chavannes to Matisse and Picasso.* Exh. cat. [Milan]: Bompioni, 2002.

Petrie, Brian, and Simon Lee. *Puvis de Chavannes.* Brookfield, VT: Ashgate, 1997.

Price, Aimée Brown. *Pierre Puvis de Chavannes.* 2 vols. New Haven, CT: Yale University Press, 2010.

Price, Aimée Brown, Jon Whiteley, and Geneviève Lacambre. *Pierre Puvis de Chavannes.* Exh. cat. Amsterdam: Van Gogh Museum, 1994.

Robinson, Joyce Henri. "A 'Nouvelle arcadie': Puvis de Chavannes and the Decorative Landscape in Fin-de-Siècle France." PhD diss., University of Virginia, 1993.

Shaw, Jennifer L. *Dream States: Puvis de Chavannes, Modernism, and the Fantasy of France.* New Haven, CT: Yale University Press, 2002.

Wattenmaker, Richard J. *Puvis de Chavannes and the Modern Tradition.* Exh. cat. Toronto: Art Gallery of Ontario, 1975.

Nicholas Konstantinovich Roerich

Conlan, Barnett D. *Roerich.* Edited by A. Pranide. Riga: Roerich Museum, 1939.

Ekstrom, Parmenia Migel. *Nicholas Roerich, Décors and Costumes for Diaghilev's Ballets Russes and Russian Operas.* Exh. cat. New York: Cordier and Ekstrom, 1974.

Ernst, Serge. *N. K. Rerikh.* Saint Petersburg: Sv. Evgenii, 1918.

Williams, Robert C. *Russian Art and American Money, 1900–1940.* Cambridge, MA: Harvard University Press, 1980.

Henri Rousseau

Alley, Ronald. *Portrait of a Primitive: The Art of Henri Rousseau.* Oxford: Phaidon, 1978.

Büttner, Philippe, et al. *Henri Rousseau.* Exh. cat. Basel: Fondation Beyeler, 2010.

Certigny, Henry. *Le Douanier Rousseau en son temps: Biographie et catalogue raisonné.* 2 vols. Tokyo: Bunkazai Kenkyujo, 1984.

Delaunay, Robert. "Henri Rousseau le Douanier." *L'amour de l'art,* vol. 1, no. 7 (November 1920), pp. 228–30.

Le Pichon, Yann. *Le monde du Henri Rousseau.* Aux sources de l'art. Paris: Éditions Robert Laffront, 1981.

Morris, Frances, and Christopher Green, eds. *Henri Rousseau: Jungles in Paris.* Exh. cat. London: Tate Publishing, 2005.

Rich, Daniel Catton. *Henri Rousseau.* Exh. cat. New York: Museum of Modern Art, 1942.

Shattuck, Roger, et al. *Henri Rousseau.* Exh. cat. New York: Museum of Modern Art, 1985.

Uhde, Wilhelm. *Henri Rousseau.* Paris: E. Figuière, 1911.

Vallier, Dora. *Henri Rousseau.* New York: Harry N. Abrams, [1962].

Georges Seurat

Dorra, Henri, and John Rewald. *Seurat: L'oeuvre peint, biographie, et catalogue critique.* Paris: Les Beaux-arts, 1959.

"The *Grande Jatte* at 100." Special issue. *Art Institute of Chicago Museum Studies,* vol. 14, no. 2 (1989).

Hauke, C. M. de. *Seurat et son oeuvre.* 2 vols. Paris: Paul Brame et C. M. de Hauke, 1961.

Herbert, Robert L. *Seurat: Drawings and Paintings.* New Haven: Yale University Press, 2001.

———, ed. *Seurat and the Making of "La Grande Jatte."* Exh. cat. Chicago: Art Institute of Chicago, 2004.

Herbert, Robert L., et al. *Georges Seurat, 1859–1891.* Exh. cat. New York: Metropolitan Museum of Art, 1991.

Rewald, John. *Seurat: A Biography.* New York: Harry N. Abrams, 1990.

Rich, Daniel Catton. *Seurat and the Evolution of "La Grande Jatte."* Chicago: University of Chicago Press, 1935.

Smith, Paul. *Seurat and the Avant-Garde.* New Haven, CT: Yale University Press, 1997.

Thomson, Richard. *Seurat.* Oxford: Phaidon, 1985.

Paul Signac

Cachin, Françoise. *Paul Signac.* Translated by Michael Bullock. Greenwich, CT: New York Graphic Society, 1971.

Cachin, Françoise, and Marina Ferretti-Bocquillon, eds. *Signac: Catalogue raisonné de l'oeuvre peint.* Paris: Gallimard, 2000.

Cachin, Françoise, Jean-Paul Monery, and Marina Ferretti-Bocquillon. *Signac et Saint-Tropez, 1892–1913.* Exh. cat. Saint-Tropez: Musée de l'Annonciade, 1992.

Distel, Anne, et al. *Signac, 1863–1935.* Exh. cat. Paris: Réunion des Musées Nationaux, 2001.

Franz, Erich, ed. *Signac et la libération de la couleur: De Matisse à Mondrian.* Exh. cat. Paris: Réunion des Musées Nationaux, 1997.

Herbert, Robert L., and Eugenia W. Herbert. "Artists and Anarchism: Unpublished Letters of Pissarro, Signac, and Others" (1960). In *From Millet to Léger: Essays in Social Art History,* by Robert L. Herbert, pp. 99–114. New Haven, CT: Yale University Press, 2002.

Index of Works Illustrated

Adolescents (Picasso, 1906), p. 84, fig. 100; pp. 86, 92, 227–28

After Poussin: Arcadian Shepherd (Cézanne, 1897–90), p. 167, fig. 159; p. 165

After Poussin: Arcadian Shepherdess (Cézanne, 1897–90), p. 167, fig. 160; p. 165

After Poussin's "Apollo and Daphne" (Matisse, 1930), p. 19, fig. 17; p. 18

After Puvis's "Fisherman's Family" (Macke, 1907–8), p. 207, fig. 196; p. 208

Afternoon of a Faun (The Concert) (Matisse, 1932), p. 61, fig. 65; p. 63

Andrians, The (Titian, 1523–26), p. 134, fig. 142; pp. 135–36

Apollo and Daphne (Apollon amoureux de Daphné) (Poussin, 1664), p. 124, fig. 136; pp. 18–19, 22, 138, 140, 176, 229

Arcadian Shepherds, The (Et in Arcadia ego) (Poussin, c. 1638), p. 133, fig. 141; p. 167, fig. 161 (detail); pp. 71, 138, 140, 165, 167, 169, 222

Bacchanal with a Woman Playing the Guitar (Poussin, c. 1627), p. 135, fig. 143; p. 136

Bacchanalian Revel before a Term, A (Poussin, 1632–33), p. 173, fig. 168; p. 169

Bacchic Dance (Derain, 1906), p. 77, fig. 92; p. 79

Bathers (Bernard, 1899), p. 38, fig. 35; pp. 39, 214

Bathers (Cézanne, 1874–75), p. 170, fig. 164; pp. 36, 168, 214–15

Bathers (Cézanne, c. 1900–1902), p. 172, fig. 167; pp. 169, 216

Bathers (Derain, 1907), p. 78, fig. 93; pp. 74, 221

Bathers (Derain, 1908), p. 80, fig. 96

Bathers (Gleizes, 1912), p. 105, fig. 125; pp. 104, 188, 222

Bathers, The (Metzinger, 1913), p. 106, fig. 126; pp. 107, 188, 226

Bathers among Dunes (Fehmarn) (Kirchner, 1913), p. 205, fig. 193; p. 204

Bathers at a Forest Pond (Heckel, 1910), p. 200, fig. 187; p. 198

Bathers at Moritzburg (Kirchner, 1909/1926), p. 199, fig. 186; p. 198

Bathers at Rest (Cézanne, 1876–77), p. 171, fig. 165; pp. 6, 39, 168, 169

Bathers by a River (Matisse, 1909–10, 1913, 1916–17), pp. xiii–xiv (illus.); p. 180, fig. 172; pp. 1, 3, 5, 7, 52, 181–85, 187–92, 225–26

Bathers in a Landscape (After Gauguin) (Derain, 1905), p. 74, fig. 87; p. 76

Bathers with a Turtle (Matisse, 1907–8), p. 182, fig. 173; pp. 1, 183–85

Bathers with Red Cow (Bernard, c. 1889), p. 38, fig. 36; pp. 39, 214

Bathers with Water Lilies (Bernard, 1889), p. 39, fig. 37; pp. 38, 214

Bathing (Drawing on letter to Émile Zola) (Cézanne, 1859), p. 166, fig. 158; p. 164

Bathing in the Bay (Heckel, 1912), p. 203, fig. 191; pp. 200, 207

Beckmann, Max
 Young Men by the Sea (1905), p. 197, fig. 185; p. 196

Bernard, Émile
 Bathers (1889), p. 38, fig. 35; pp. 39, 214

Bathers with Red Cow (c. 1889), p. 38, fig. 36; pp. 39, 214

Bathers with Water Lilies (1889), p. 39, fig. 37; pp. 38, 214

Landscape with Two Breton Girls (1892), p. 37, fig. 34; p. 39

Bonheur de vivre, Le (Matisse, 1905–6), p. 58, fig. 58; pp. 5, 48, 56, 59, 61, 68, 79, 90, 92, 182, 183, 185, 218, 219, 225

Bonjour, Monsieur Gauguin (Gauguin, 1889), p. 145, fig. 147; p. 146

Botticelli, Sandro
 Primavera, La (c. 1477), p. 154, fig. 151; pp. 101, 128, 155

Boy Leading a Horse (Picasso, 1905–6), p. 89, fig. 106; p. 92

Boy with Frog (Ray, 2008), p. 113, fig. 132; p. 112

Boys Bathing (Goncharova, c. 1910), p. 110, fig. 129; pp. 109, 111, 222

Brant, Sebastian
 Tomb of Daphnis, The (Illustration for *Ecl.* 5) (1502), p. 16, fig. 13; p. 15

Bridge at Narni, The (Corot, 1827), p. 23, fig. 21; pp. 216–17, 218

By the Sea (Gulf of Saint-Tropez) (Matisse, 1904), p. 56, fig. 55; p. 52

Carracci, Annibale
 Landscape with Flight into Egypt (1604), p. 132, fig. 140

Cézanne, Paul
 After Poussin: Arcadian Shepherd (1897–90), p. 167, fig. 159; p. 165

 After Poussin: Arcadian Shepherdess (1897–90), p. 167, fig. 160; p. 165

 Bathers (1874–75), p. 170, fig. 164; pp. 36, 168, 214–15

 Bathers (c. 1900–1902), p. 172, fig. 167; pp. 169, 216

 Bathers at Rest (1876–77), p. 171, fig. 165; pp. 6, 39, 168, 169

 Bathing (1859), p. 166, fig. 158; p. 164

 Group of Bathers (c. 1895), p. 172, fig. 166; pp. 169, 215–16

 Judgment of Paris, The (1883–85), p. 165, fig. 157; p. 163

 Large Bathers, The (1894–1905), p. 175, fig. 170; pp. 59, 176, 216

 Large Bathers, The (c. 1895–1906), p. 174, fig. 169; pp. 7, 39, 104, 165, 171, 176

 Large Bathers, The (1900–1906), p. xii (illus.); p. 162, fig. 155; pp. 1, 59, 94, 215, 216

 Lutte d'amour (c. 1880), p. 63, fig. 67; pp. 5, 216

 Mont Sainte-Victoire and the Viaduct of the Arc River Valley (1882–85), p. 169, fig. 163; p. 168

 Pastoral (1870), p. 9, fig. 11; p. 8

 Satyrs and Nymphs (c. 1867), p. 164, fig. 156; p. 163

 Still Life with Fruit Dish (1879–80), p. 6, fig. 5; pp. 5, 42

 Three Bathers (c. 1875), p. xvi, fig. 1; pp. 168, 215

 Three Bathers (1879–82), p. 2, fig. 2; pp. 1, 37, 181, 185, 187, 192

Chahut, Le (Seurat, 1889–90), p. 73, fig. 84; p. 74

Champs-élysées, Les (Derain, 1907–8), p. 79, fig. 95; p. 80

City of Paris, The (Delaunay, 1910–12), p. 100, fig. 118; p. 102, fig. 121 (detail); pp. 99, 101, 104, 107, 116, 188, 219–20

Composition No. II (Matisse, c. March 11, 1909), p. 184, fig. 175; pp. 5, 185

Composition: The Peasants (Picasso, 1906), p. 87, fig. 103; p. 86

Concert champêtre (attributed to Titian, c. 1509), p. 131, fig. 139; pp. 7, 130

Corot, Jean-Baptiste-Camille
 Bridge at Narni, The (1827), p. 23, fig. 21; pp. 216–17, 218
 Goatherd of Terni (c. 1871), p. 25, fig. 23; p. 218
 Landscape, Setting Sun (The Little Shepherd) (1840), p. 26, fig. 24; pp. 24, 217
 Little Shepherd, The (c. 1854), p. 217 (illus.); p. 218
 Morning, A (Dance of the Nymphs) (1850), p. 24, fig. 22
 Silenus (1838), p. 26, fig. 25; pp. 24, 28, 71, 217

Corydon and Thyrsis (Illustration for Ecl. 7) (Maillol, 1926), p. 71, fig. 82; p. 223

Cross, Henri-Edmond
 Evening Breeze (1893–94), p. 54, fig. 52; p. 52
 Excursion (1895), p. 53, fig. 51; p. 52
 Faun (1905–6), p. 55, fig. 54; pp. 52, 219
 Landscape with Goats (1895), p. 53, fig. 50; p. 52
 Mediterranean Shores (1895), p. 55, fig. 53; pp. 52, 218
 Study for "Faun" (1905–6), p. 219 (illus.)

Dance, The (Derain, 1906), p. 75, fig. 88; pp. 56, 79, 220

Dance, The (Matisse, 1930–32), p. 62, fig. 66; pp. 5, 18, 63, 181

Deer in the Forest I (Marc, 1913), p. 210, fig. 199; pp. 108, 209, 224–25

Delaunay, Robert
 City of Paris, The (1910–12), p. 100, fig. 118; p. 102, fig. 121 (detail); pp. 99, 101, 104, 107, 116, 188, 219–20
 Eiffel Tower, The (c. 1909), p. 103, fig. 122; p. 99
 Eiffel Tower, The (1910–11), p. 103, fig. 123; p. 99
 Three-Part Windows (1912), p. 107, fig. 127; p. 220

Delightful Day (Nave nave mahana) (Gauguin, 1896), p. 155, fig. 152; p. 5

Demoiselles d'Avignon, Les (Picasso, 1907), p. 83, fig. 99; pp. 76, 82, 92, 228

Denis, Maurice
 Eurydice (c. 1904), p. 42, fig. 40; p. 43
 Homage to Cézanne (1900), p. 41, fig. 39; pp. 6, 40
 Study for "The Beach" (Sketch for "The Golden Age") (1911), p. 44, fig. 42
 Visit to Cézanne (1906), p. 40, fig. 38
 Women by the Sea (1911), p. 45, fig. 43; p. 220

Derain, André
 Bacchic Dance (1906), p. 77, fig. 92; p. 79
 Bathers (1907), p. 78, fig. 93; pp. 74, 221
 Bathers (1908), p. 80, fig. 96
 Bathers in a Landscape (After Gauguin) (1905), p. 74, fig. 87; p. 76
 Champs-élysées, Les (1907–8), p. 79, fig. 95; p. 80

Dance, The (1906), p. 75, fig. 88; pp. 56, 79, 220

Earthly Paradise (1906), p. 77, fig. 91; pp. 79, 220–21

Golden Age, The (1905), p. 72, fig. 83; p. 74

Hunt, The (The Golden Age) (1938–44), p. 81, fig. 97; p. 80

Letter to Henri Matisse with a sketch of an unrealized painting (1905), p. 74, fig. 86; p. 76

Portrait of Henri Matisse (1905), p. 73, fig. 85; p. 74

Summer (After Poussin) (1904–6), p. 19, fig. 16; p. 18

Study of a Khmer or Indian Dancer (1906–7), p. 76, fig. 90; p. 79

Study of a Maori Carving (1906–7), p. 76, fig. 89; p. 79

Desire (Maillol, 1906–8), p. 66, fig. 72; p. 69

Drawing on verso of letter (Matisse, c. March 1909), p. 184, fig. 176

Dream, The (Marc, 1912), p. 209, fig. 198; pp. 108, 208, 224

Dream, The (Rousseau, 1910), p. 95, fig. 113; pp. 94, 224, 230–31

Dürer, Albrecht
 Pastoral Landscape with Shepherds Playing a Viola and Panpipes, A (1496), p. 16, fig. 12; p. 15

Earthly Paradise (Derain, 1906), p. 77, fig. 91; pp. 79, 220–21

Eiffel Tower, The (Delaunay, c. 1909), p. 103, fig. 122; p. 99

Eiffel Tower, The (Delaunay, 1910–11), p. 103, fig. 123; p. 99

Eliasson, Olafur
 New York City Waterfalls (2008), p. 116, fig. 135
 Weather Project, The (2003), p. 115, fig. 134; p. 116

Eurydice (Denis, c. 1904), p. 42, fig. 40; p. 43

Evening Breeze (Cross, 1893–94), p. 54, fig. 52; p. 52

Ever Is Over All (Rist, 1997), p. 114, fig. 133; p. 112

Excursion (Cross, 1895), p. 53, fig. 51; p. 52

Exotic Landscape (Rousseau, 1910), p. 97, fig. 115; p. 94

Faun (Cross, 1905–6), p. 55, fig. 54; pp. 52, 219

Faun Playing His Flute for a Group of Nymphs, A (Matisse, 1930–32), p. 60, fig. 62; pp. 18, 63, 71, 226

Faun with a Bunch of Grapes, A (Matisse, 1930–32), p. 60, fig. 64; pp. 18, 63, 71, 219, 226

Fehmarn Bay with Boats (Kirchner, 1913), p. 205, fig. 194; p. 204

Figure Studies (Macke, 1910), p. 207, fig. 197; p. 208

Five Bathers at the Lake (Kirchner, 1911), p. 204, fig. 192; p. 200

Five Nudes (Study for "Les demoiselles d'Avignon") (Picasso, 1907), p. 82, fig. 98; p. 228

Frontispiece for Virgil's Eclogen (Eclogues) (Maillol, 1926), p. 70, fig. 78; pp. 71, 223

Frontispiece to a manuscript of Virgil (Martini, c. 1340), p. 127, fig. 137; p. 126

Game of Bowls (Matisse, 1908), p. 183, fig. 174; p. 185

Garden of Love, The (Improvisation Number 27) (Kandinsky, 1912), p. 108, fig. 128; p. 109

Gauguin, Paul
 Bonjour, Monsieur Gauguin (1889), p. 145, fig. 147; p. 146
 Delightful Day (Nave nave mahana) (1896), p. 155, fig. 152; p. 5
 Landscape with Two Breton Women (1889), p. 146, fig. 148
 Riders on a Beach (1902), p. 88, fig. 105; p. 90
 Sacred Mountain, The (Parahi te marae) (1892), p. 150, fig. 150; p. 140
 Self-Portrait (1889), p. 4, fig. 4; p. 5
 Self-Portrait with Yellow Christ (1889–91), p. 147, fig. 149; p. 146
 Still Life with Bowl of Fruit and Lemons (c. 1889–90), p. 7, fig. 7; p. 6
 Still Life with Teapot and Fruit (1896), p. 7, fig. 8; p. 6
 Where Do We Come From? What Are We? Where Are We Going? (D'où venons-nous? Que sommes-nous? Où allons-nous?) (1897–98), pp. xi–xii (illus.); p. 142, fig. 146; pp. 3, 5–7, 36, 79, 112, 152, 153, 155, 156, 159, 187, 221
 Woman in Front of a Still Life by Cézanne (Gauguin, 1890), p. 6, fig. 6; p. 42

Girl with a Goat (Picasso, 1906), p. 86, fig. 102

Gleizes, Albert
 Bathers (1912), p. 105, fig. 125; pp. 104, 188, 222

Goatherd of Terni (Corot, c. 1871), p. 25, fig. 23; p. 218

Golden Age, The (Derain, 1905), p. 72, fig. 83; p. 74

Golden Age, The (Ingres, 1862), p. 21, fig. 19; p. 20

Goncharova, Natalia Sergeyevna
 Boys Bathing (c. 1910), p. 110, fig. 129; pp. 109, 111, 222

Group of Bathers (Cézanne, c. 1895), p. 172, fig. 166; pp. 169, 215–16

Happy Quartet (Rousseau, 1901–2), p. 98, fig. 117

Harem, The (Picasso, 1906), p. 90, fig. 107; p. 92

Heckel, Erich
 Bathers at a Forest Pond (1910), p. 200, fig. 187; p. 198
 Bathing in the Bay (1912), p. 203, fig. 191; pp. 200, 207

Homage to Cézanne (Denis, 1900), p. 41, fig. 39; pp. 6, 40

Hunt, The (The Golden Age) (Derain, 1938–44), p. 81, fig. 97; p. 80

In the Time of Harmony (The Golden Age Is Not in the Past, It Is in the Future) (Signac, 1893–95), p. 46, fig. 44; pp. 47–48, 232

In the Time of Harmony (The Joy of Life—Sunday at the Seaside) (Signac, 1895–96), p. 47, fig. 45; p. 48

Ingres, Jean-Auguste-Dominique
 Golden Age, The (1862), p. 21, fig. 19; p. 20
 Tu Marcellus eris (You Will Be Marcellus; Aen. 6:883) (c. 1812), p. 22, fig. 20

Inspiration of the Poet, The (Poussin, c. 1629–30), p. 17, fig. 14; pp. 16, 19

Inter Artes et Naturum (Puvis, 1890), p. 158, fig. 154; pp. 31, 156

Joy of Life, The (Antipolis) (Picasso, 1946), p. 93,
 fig. 112; p. 92
Judgment of Paris, The (Cézanne, 1883–85), p. 165,
 fig. 157; p. 163

Kandinsky, Wassily
 Garden of Love, The (Improvisation Number 27)
 (1912), p. 108, fig. 128; p. 109
Kirchner, Ernst Ludwig
 Bathers among Dunes (Fehmarn) (1913), p. 205,
 fig. 193; p. 204
 Bathers at Moritzburg (1909/1926), p. 199, fig. 186;
 p. 198
 Fehmarn Bay with Boats (1913), p. 205, fig. 194;
 p. 204
 Five Bathers at the Lake (1911), p. 204, fig. 192;
 p. 200
 Nudes Playing under a Tree (1910), p. 201, fig. 189;
 p. 198
 Three Nudes in the Forest (1908/1920), p. 202,
 fig. 190; pp. 198, 223

Landscape with a Man Killed by a Snake (Poussin,
 c. 1648), p. 43, fig. 41; p. 158
Landscape with Flight into Egypt (Carracci, 1604), p. 132,
 fig. 140
Landscape with Goats (Cross, 1895), p. 53, fig. 50; p. 52
Landscape with Polyphemus (Poussin, c. 1658), p. 139,
 fig. 145; p. 138
Landscape with the Ashes of Phocion (Poussin, 1648),
 p. 168, fig. 162
Landscape with Two Breton Girls (Bernard, 1892), p. 37,
 fig. 34; p. 39
Landscape with Two Breton Women (Gauguin, 1889),
 p. 146, fig. 148
Landscape, Island of La Grande Jatte (Seurat, 1884,
 c. 1885, c. 1889–90), p. 51, fig. 49; pp. 50, 231
Landscape, Setting Sun (The Little Shepherd) (Corot,
 1840), p. 26, fig. 24; pp. 24, 217
Large Bathers, The (Cézanne, 1894–1905), p. 175,
 fig. 170; pp. 59, 176, 216
Large Bathers, The (Cézanne, c. 1895–1906), p. 174,
 fig. 169; pp. 7, 39, 104, 165, 171, 176
Large Bathers, The (Cézanne, 1900–1906), p. xii
 (illus.); p. 162, fig. 155; pp. 1, 59, 94, 215, 216
Léger, Fernand
 Nudes in the Forest (1909–10), p. 101, fig. 119;
 p. 99
*Letter to Henri Matisse with a sketch of an
 unrealized painting* (Derain, 1905), p. 74,
 fig. 86; p. 76
Little Shepherd, The (Corot, c. 1854), p. 217 (illus.);
 p. 218
Luncheon on the Grass, The (Le déjeuner sur l'herbe)
 (Manet, 1863), p. 8, fig. 9; p. 7
Lutte d'amour (Cézanne, c. 1880), p. 63, fig. 67;
 pp. 5, 216
Luxe, calme et volupté (Matisse, 1904–5), p. 57, fig. 57;
 pp. 36, 56, 59, 68, 74, 182, 183, 185, 218

Macke, August
 After Puvis's "Fisherman's Family" (1907–8), p. 207,
 fig. 196; p. 208

Figure Studies (1910), p. 207, fig. 197; p. 208
Maillol, Aristide
 Corydon and Thyrsis (Illustration for *Ecl.* 7)
 (1926), p. 71, fig. 82; p. 223
 Desire (1906–8), p. 66, fig. 72; p. 69
 Frontispiece for Virgil's Eclogen (Eclogues) (1926),
 p. 70, fig. 78; pp. 71, 223
 Monument to Cézanne (1912–25), p. 69, fig. 75;
 pp. 66, 68
 *Nymphs, Goats, and Animals on a Mountain
 (Illustration for Ecl.* 1) (1926), p. 71, fig. 81;
 p. 223
 Pomona (1937), p. 66, fig. 71; p. 69
 Three Nymphs, The (1930–38), p. 67, fig. 73;
 pp. 69, 223–24
 Tityrus on His Pipe (Illustration for *Ecl.* 1)
 (1926), p. 70, fig. 79; pp. 71, 223
 Tomb of Daphnis, The (Illustration for *Ecl.* 5)
 (1926), p. 71, fig. 80; p. 223
 Virgil's Eclogen (Eclogues) (1926), pp. 70–71,
 figs. 78–82; p. 223
Manet, Édouard
 Luncheon on the Grass, The (Le déjeuner sur l'herbe)
 (1863), p. 8, fig. 9; p. 7
Marc, Franz
 Deer in the Forest I (1913), p. 210, fig. 199; pp. 108,
 209, 224–25
 Dream, The (1912), p. 209, fig. 198; pp. 108, 208,
 224
Marc, Franz, and August Macke
 Paradise (1912), p. 206, fig. 195; pp. 205, 207–8
Marées, Hans von
 Men by the Sea (c. 1874), p. 196, fig. 184; p. 195
Martini, Simone
 Frontispiece to a manuscript of Virgil
 (c. 1340), p. 127, fig. 137; p. 126
Matisse, Henri
 After Poussin's "Apollo and Daphne" (1930), p. 19,
 fig. 17; p. 18
 Afternoon of a Faun (The Concert) (1932), p. 61,
 fig. 65; p. 63
 Bathers by a River (1909–10, 1913, 1916–17),
 pp. xiii–xiv (illus.); p. 180, fig. 172; pp. 1, 3, 5,
 7, 52, 181–85, 187–92, 225–26
 Bathers with a Turtle (1907–8), p. 182, fig. 173;
 pp. 1, 183–85
 Bonheur de vivre, Le (1905–6), p. 58, fig. 58; pp. 5,
 48, 56, 59, 61, 68, 79, 90, 92, 182, 183, 185, 218,
 219, 225
 By the Sea (Gulf of Saint-Tropez) (1904), p. 56,
 fig. 55; p. 52
 Composition No. II (c. March 11, 1909), p. 184,
 fig. 175; pp. 5, 185
 Dance, The (1930–32), p. 62, fig. 66; pp. 5, 18, 63,
 181
 Drawing on verso of letter (c. March 1909),
 p. 184, fig. 176
 Faun Playing His Flute for a Group of Nymphs, A
 (1930–32), p. 60, fig. 62; pp. 18, 63, 71, 226
 Faun with a Bunch of Grapes, A (1930–32), p. 60,
 fig. 64; pp. 18, 63, 71, 219, 226
 Game of Bowls (1908), p. 183, fig. 174; p. 185
 Luxe, calme et volupté (1904–5), p. 57, fig. 57;

pp. 36, 56, 59, 68, 74, 182, 183, 185, 218
 Music (1910), p. 186, fig. 179; pp. 184, 185, 187
 Nude in a Wood (1906), frontispiece; p. 59,
 fig. 59; pp. 61, 225
 Nymph and Satyr (1907), p. 65, fig. 69; pp. 63, 185
 Nymph and Satyr (1908–9), p. 65, fig. 70; pp. 5, 63
 Pastoral (1906), p. 59, fig. 60; p. 61
 *Poésies de Stéphane Mallarmé: Eaux-fortes originales de
 Henri Matisse* (1932), p. 60, figs. 61–64; pp. 18,
 63, 71, 226
 Study for "Luxe, calme et volupté" (1904), p. 56,
 fig. 56
 Swan, A (1930–32), p. 60, fig. 63; pp. 18, 63, 71,
 226
 Verdure, La (Nymph in the Forest) (1935–c. 1943),
 p. 64, fig. 68; pp. 63, 80
 Vignette with Two Nymphs (1930–32), p. 60, fig. 61;
 pp. 18, 63, 71, 226
Mediterranean Shores (Cross, 1895), p. 55, fig. 53;
 pp. 52, 218
Men by the Sea (Marées, c. 1874), p. 196, fig. 184
Metzinger, Jean
 Bathers, The (1913), p. 107, fig. 126; pp. 107, 188,
 226
Mont Sainte-Victoire and the Viaduct of the Arc River Valley
 (Cézanne, 1882–85), p. 169, fig. 163; p. 168
Monument to Cézanne (Maillol, 1912–25), p. 69,
 fig. 75; pp. 66, 68
Morning, A (Dance of the Nymphs) (Corot, 1850),
 p. 24, fig. 22
Music (Matisse, 1910), p. 186, fig. 179; pp. 184, 185,
 187
Myself, Portrait — Landscape (Rousseau, 1890), p. 103,
 fig. 124; pp. 94, 99

New York City Waterfalls (Eliasson, 2008), p. 116,
 fig. 135
Nude in a Wood (Matisse, 1906), frontispiece; p. 59,
 fig. 59; pp. 61, 225
Nudes in the Forest (Léger, 1909–10), p. 101, fig. 119;
 p. 99
Nudes Playing under a Tree (Kirchner, 1910), p. 201,
 fig. 189; p. 198
Nymph and Satyr (Matisse, 1907), p. 65, fig. 69;
 pp. 63, 185
Nymph and Satyr (Matisse, 1908–9), p. 65, fig. 70;
 pp. 5, 63
Nymphs, Goats, and Animals on a Mountain (Illustration
 for *Ecl.* 1) (Maillol, 1926), p. 71, fig. 81; p. 223

Open Air (Bathers at Moritzburg) (Pechstein, 1910),
 p. 200, fig. 188; p. 198
*Opus 217: Against the Enamel of a Background Rhythmic
 with Beats and Angles, Tones, and Tints, Portrait of
 M. Félix Fénéon in 1890* (Signac, 1890), p. 50,
 fig. 48
Our Forefathers (Roerich, c. 1911), p. 111, fig. 130;
 pp. 112, 230

Pan (Signorelli, 1488–91), p. 128, fig. 138; pp. 129–31
Paradise (Marc and Macke, 1912), p. 206, fig. 195;
 pp. 205, 207–8
Pastoral (Cézanne, 1870), p. 9, fig. 11; p. 8

Pastoral (Matisse, 1906), p. 59, fig. 60; p. 61
Pastoral Landscape with Shepherds Playing a Viola and Panpipes, A (Dürer, 1496), p. 16, fig. 12; p. 15
Paul Signac (Seurat, 1889–90), p. 50, fig. 47; p. 48
Peace (Puvis, 1867), p. 31, fig. 28; pp. 32, 229–30
Pechstein, Max
 Open Air (Bathers at Moritzburg) (1910), p. 200, fig. 188; p. 198
 Under the Trees (1911), p. 194, fig. 183; pp. 200, 226–27
Picasso, Pablo
 Adolescents (1906), p. 84, fig. 100; pp. 86, 92, 227–28
 Boy Leading a Horse (1905–6), p. 89, fig. 106; p. 92
 Composition: The Peasants (1906), p. 87, fig. 103; p. 86
 Demoiselles d'Avignon, Les (1907), p. 83, fig. 99; pp. 76, 82, 92, 228
 Five Nudes (Study for "Les demoiselles d'Avignon") (1907), p. 82, fig. 98; p. 228
 Girl with a Goat (1906), p. 86, fig. 102
 Harem, The (1906), p. 90, fig. 107; p. 92
 Joy of Life, The (Antipolis) (1946), p. 93, fig. 112; p. 92
 Pipes of Pan, The (1923), p. 91, fig. 108; p. 92
 Struggle between Tereus and His Sister-in-Law Philomela (1931), p. 92, fig. 110
 Three Graces, The (1922–23), p. 92, fig. 109; pp. 228–29
 Two Youths (1906), p. 85, fig. 101; pp. 86, 92, 112
 Watering Place, The (1905–6), p. 88, fig. 104; pp. 90, 92, 227
Pilgrimage to the Island of Cythera (Watteau, 1717), p. 18, fig. 15; p. 16
Pipes of Pan, The (Picasso, 1923), p. 90, fig. 108; p. 92
Pleasant Land (Puvis, 1882), p. 35, fig. 33; p. 32
Poésies de Stéphane Mallarmé: Eaux-fortes originales de Henri Matisse (Matisse, 1932), p. 60, figs. 61–64; pp. 18, 63, 71, 226
Pomona (Maillol, 1937), p. 66, fig. 71; p. 69
Portrait of Henri Matisse (Derain, 1905), p. 73, fig. 85; p. 74
Poussin, Nicolas
 Apollo and Daphne (Apollon amoureux de Daphné) (1664), p. 124, fig. 136; pp. 18–19, 22, 138, 140, 176, 229
 Arcadian Shepherds, The (Et in Arcadia ego) (c. 1638), p. 133, fig. 141; p. 167, fig. 161 (detail); pp. 71, 138, 140, 165, 167, 169, 222
 Bacchanal with a Woman Playing the Guitar (c. 1627), p. 135, fig. 143; p. 136
 Bacchanalian Revel before a Term, A (1632–33), p. 173, fig. 168; p. 169
 Inspiration of the Poet, The (c. 1629–30), p. 17, fig. 14; pp. 16, 19
 Landscape with a Man Killed by a Snake (c. 1648), p. 43, fig. 41; p. 158
 Landscape with Polyphemus (c. 1658), p. 139, fig. 145; p. 138
 Landscape with the Ashes of Phocion (1648), p. 168, fig. 162
 Realm of Flora, The (1631), p. 157, fig. 153; pp. 137, 156
 Triumph of David, The (c. 1629), p. 137, fig. 144

Poussin, Nicolas, after
 Triumph of Silenus, The (Poussin, c. 1657), p. 28, fig. 26; p. 24
Primavera, La (Botticelli, c. 1477), p. 154, fig. 151; pp. 101, 128, 155
Puvis de Chavannes, Pierre
 Inter Artes et Naturum (1890), p. 158, fig. 154; pp. 31, 156
 Peace (1867), p. 31, fig. 28; pp. 32, 229–30
 Pleasant Land (1882), p. 35, fig. 33; p. 32
 Sacred Grove, Beloved of the Arts and Muses, The (1884–89), p. 35, fig. 32; p. 32
 Summer (1873), p. 34, fig. 31; p. 32
 Summer (1891, Cleveland), p. 33, fig. 30; pp. 32, 36, 156, 230
 Summer (1891, Paris), p. 32, fig. 29; p. 230
 Virgil, Bucolic Poetry (1896), p. 30, fig. 27

Ray, Charles
 Boy with Frog (2008), p. 113, fig. 132; p. 112
Realm of Flora, The (Poussin, 1631), p. 157, fig. 153; pp. 137, 156
Riders on a Beach (Gauguin, 1902), p. 88, fig. 105; p. 90
Rist, Pipilotti
 Ever Is Over All (1997), p. 114, fig. 133; p. 112
Roerich, Nicholas Konstantinovich
 Our Forefathers (c. 1911), p. 111, fig. 130; pp. 112, 230
Rousseau, Henri
 Dream, The (1910), p. 95, fig. 113; pp. 94, 224, 230–31
 Exotic Landscape (1910), p. 97, fig. 115; p. 94
 Happy Quartet (1901–2), p. 98, fig. 117
 Myself, Portrait—Landscape (1890), p. 103, fig. 124; pp. 94, 99
 Snake Charmer, The (1907), p. 96, fig. 114; p. 94
 Waterfall, The (1910), p. 97, fig. 116; p. 94

Sacred Grove, Beloved of the Arts and Muses, The (Puvis, 1884–89), p. 35, fig. 32; p. 32
Sacred Mountain, The (Parahi te marae) (Gauguin, 1892), p. 150, fig. 150; p. 140
Satyrs and Nymphs (Cézanne, c. 1867), p. 164, fig. 156; p. 163
Self-Portrait (Gauguin, 1889), p. 4, fig. 4; p. 5
Self-Portrait with Yellow Christ (Gauguin, 1889–91), p. 147, fig. 149; p. 146
Seurat, Georges
 Chahut, Le (1889–90), p. 73, fig. 84; p. 74
 Landscape, Island of La Grande Jatte (1884, c. 1885, c. 1889–90), p. 51, fig. 49; pp. 50, 231
 Paul Signac (1889–90), p. 50, fig. 47; p. 48
 Sunday on La Grande Jatte—1884, A (1884–86), p. 49, fig. 46; pp. 48, 50, 231
Signac, Paul
 In the Time of Harmony (The Golden Age Is Not in the Past, It Is in the Future) (1893–95), p. 46, fig. 44; pp. 47–48, 232
 In the Time of Harmony (The Joy of Life—Sunday at the Seaside) (1895–96), p. 47, fig. 45; p. 48
 Opus 217: Against the Enamel of a Background Rhythmic with Beats and Angles, Tones, and Tints,

Portrait of M. Félix Fénéon in 1890 (1890), p. 50, fig. 48
Signorelli, Luca
 Pan (1488–91), p. 128, fig. 138; pp. 129–31
Silenus (Corot, 1838), p. 26, fig. 25; pp. 24, 28, 71, 217
Snake Charmer, The (Rousseau, 1907), p. 96, fig. 114; p. 94
Still Life with Bowl of Fruit and Lemons (Gauguin, c. 1889–90), p. 7, fig. 7; p. 6
Still Life with Fruit Dish (Cézanne, 1879–80), p. 6, fig. 5; pp. 5, 42
Still Life with Teapot and Fruit (Gauguin, 1896), p. 7, fig. 8; p. 6
Struggle between Tereus and His Sister-in-Law Philomela (Picasso, 1931), p. 92, fig. 110
Study for "Faun" (Cross, 1905–6), p. 219 (illus.)
Study for "Luxe, calme et volupté" (Matisse, 1904), p. 56, fig. 56
Study for "The Beach" (Sketch for "The Golden Age") (Denis, 1911), p. 44, fig. 42
Study of a Khmer or Indian Dancer (Derain, 1906–7), p. 76, fig. 90; p. 79
Study of a Maori Carving (Derain, 1906–7), p. 76, fig. 89; p. 79
Summer (After Poussin) (Derain, 1904–6), p. 19, fig. 16; p. 18
Summer (Puvis, 1873), p. 34, fig. 31; p. 32
Summer (Puvis, 1891, Cleveland), p. 33, fig. 30; pp. 32, 36, 156, 230
Summer (Puvis, 1891, Paris), p. 32, fig. 29; p. 230
Sunday on La Grande Jatte—1884, A (Seurat, 1884–86), p. 49, fig. 46; pp. 48, 50, 231
Swan, A (Matisse, 1930–32), p. 60, fig. 63; pp. 18, 63, 71, 226

Three Bathers (Cézanne, c. 1875), p. xvi, fig. 1; pp. 168, 215
Three Bathers (Cézanne, 1879–82), p. 2, fig. 2; pp. 1, 37, 181, 185, 187, 192
Three Graces, The (c. 65–75), p. 102, fig. 120
Three Graces, The (Picasso, 1922–23), p. 92, fig. 109; pp. 228–29
Three Nudes in the Forest (Kirchner, 1908/1920), p. 202, fig. 190; pp. 198, 223
Three Nymphs, The (Maillol, 1930–38), p. 67, fig. 73; pp. 69, 223–24
Three-Part Windows (Delaunay, 1912), p. 107, fig. 127; p. 220
Titian
 Andrians, The (1523–26), p. 134, fig. 142; pp. 135–36
Titian, attributed to
 Concert champêtre (c. 1509), p. 131, fig. 139; pp. 7, 130
Tityrus on His Pipe (Illustration for Ecl. 1) (Maillol, 1926), p. 70, fig. 79; pp. 71, 223
Tomb of Daphnis, The (Illustration for Ecl. 5) (Brant, 1502), p. 16, fig. 13; p. 15
Tomb of Daphnis, The (Illustration for Ecl. 5) (Maillol, 1926), p. 71, fig. 80; p. 223
Triumph of David, The (Poussin, c. 1629), p. 137, fig. 144

Triumph of Silenus, The (after Poussin, c. 1657), p. 28,
 fig. 26; p. 24
Tu Marcellus eris (You Will Be Marcellus; *Aen.* 6:883)
 (Ingres, c. 1812), p. 22, fig. 20
Two Youths (Picasso, 1906), p. 85, fig. 101; pp. 86, 92,
 112
Twombly, Cy
 Virgilius (1975), p. 113, fig. 131; p. 112

Under the Trees (Pechstein, 1911), p. 194, fig. 183;
 pp. 200, 226–27

Verdure, La (Nymph in the Forest) (Matisse, 1935–
 c. 1943), p. 64, fig. 68; pp. 63, 80
Vignette with Two Nymphs (Matisse, 1930–32), p. 60,
 fig. 61; pp. 18, 63, 71, 226
Virgil, Bucolic Poetry (Puvis, 1896), p. 30, fig. 27
Virgil's *Eclogen (Eclogues)* (Maillol, 1926), pp. 70–71,
 figs. 78–82; p. 223
Virgilius (Twombly, 1975), p. 113, fig. 131; p. 112
Visit to Cézanne (Denis, 1906), p. 40, fig. 38

Waterfall, The (Rousseau, 1910), p. 97, fig. 116; p. 94
Watering Place, The (Picasso, 1905–6), p. 88, fig. 104;
 pp. 90, 92, 227
Watteau, Jean-Antoine
 Pilgrimage to the Island of Cythera (1717), p. 18,
 fig. 15; p. 16
Weather Project, The (Eliasson, 2003), p. 115, fig. 134;
 p. 116
*Where Do We Come From? What Are We? Where Are We
 Going? (D'où venons-nous? Que sommes-nous? Où
 allons-nous?)* (Gauguin, 1897–98), pp. xi–xii
 (illus.); p. 142, fig. 146; pp. 3, 5–7, 36, 79, 112,
 152, 153, 155, 156, 159, 187, 221
Woman in Front of a Still Life by Cézanne (Gauguin,
 1890), p. 6, fig. 6; p. 42
Women by the Sea (Denis, 1911), p. 45, fig. 43; p. 220

Young Men by the Sea (Beckmann, 1905), p. 197,
 fig. 185; p. 196

PHOTOGRAPHY CREDITS

Photographs were supplied by the owners and/or the following:

Achim Kukulies, Düsseldorf: fig. 69

Alfredo Dagli Orti / The Art Archive at Art Resource, NY: fig. 151

Alinari / Art Resource, NY; photography by Luciano Pedicini: figs. 120, 140

Archive Timothy McCarthy / Art Resource, NY: fig. 73

Archives H. Matisse: figs. 17, 56, 86, 176, 177, 179

The Art Archive at Art Resource, NY: figs. 70, 170

Photograph © The Art Institute of Chicago: pp. xiii–xiv, figs. 32, 116, 172

Courtesy the artist, Luhring Augustine, New York, and Hauser and Wirth: fig. 133

Courtesy the artist, Tanya Bonakdar Gallery, New York, and Neugerriemschneider, Berlin; photography by Jens Ziehe: figs. 134, 135

Photography © 2012 The Barnes Foundation: figs. 43, 58, 65, 66, 102, 103, 165, 169

Bibliothèque National de France: fig. 158

Blauel/ARTOTHEK: fig. 105

Blauel/Gnamm/ARTOTHEK: fig. 192

bpk, Berlin / Gemaeldegalerie, Staatliche Museen, Berlin / Art Resource, NY: fig. 138

bpk, Berlin / Nationalgalerie, Staatliche Museen, Berlin, Germany / Karin Maerz / Art Resource, NY: fig. 40

The Bridgeman Art Library International: figs. 49, 50, 88, 117, 189

Bridgeman-Giraudon / Art Resource, NY: figs. 20, 60, 154

Brooklyn Museum: frontispiece, fig. 59

© Christie's Images / The Bridgeman Art Library International: fig. 37

Chrysler Museum of Art, Norfolk, VA: fig. 51

© The Cleveland Museum of Art: figs. 30, 107

CNAC / MNAM / Dist. Réunion des Musées Nationaux / Art Resource, NY: figs. 16, 118, 121

© 2012 Detroit Institute of Arts: fig. 183

Foto Marburg / Art Resource, NY: fig. 77

Courtesy of George Eastman House, International Museum of Photography and Film: fig. 180

Gianni Dagli Orti / Art Resource, NY: fig. 72

Gianni Dagli Orti / The Art Archive at Art Resource, NY: fig. 14

Giraudon / The Bridgeman Art Library International: figs. 48, 125

Photography Collection, Harry Ransom Humanities Research Center, The University of Texas at Austin: fig. 111

© President and Fellows of Harvard College; photography by Katya Kallsen: fig. 19

Hermitage, St. Petersburg, Russia / The Bridgeman Art Library: fig. 76

Kharbine-Tapabor / The Art Archive at Art Resource, NY: fig. 42

Klassik Stiftung Weimar: fig. 185

Kunstmuseum Basel: figs. 159, 160

Erich Lessing / Art Resource, NY: figs. 2, 6, 9, 22, 36, 44, 46, 52, 84, 124, 136, 139, 141, 147, 149, 152, 153

Library of Congress: fig. 13

© LWL-LMKuK / ARTOTHEK: fig. 195

© The Metropolitan Museum of Art / Art Resource, NY; photography by Malcolm Varon: figs. 8, 104, 128, 163, 164

Joe Mikuliak: figs. 127, 150

Minneapolis Institute of Arts: fig. 25

Eric Mitchell: figs. 23, 85

Musée Picasso, Antibes, France / The Bridgeman Art Library: fig. 112

Museum Folkwang, Jens Nober: fig. 187

Museum Langmatt Stiftung Langmatt Sidney und Jenny Brown, Baden/Schweiz: fig. 7

Photograph © 2012 Museum of Fine Arts, Boston: pp. xi–xii; figs. 146, 148

Digital Image © The Museum of Modern Art / Licensed by SCALA / Art Resource, NY: figs. 5, 92, 93, 99, 106, 113, 131

© Museum Thyssen-Bornemisza, Madrid: fig. 198

Museum Wiesbaden: fig. 129

Photograph © National Gallery in Prague 2012: fig. 96

Image courtesy of the National Gallery of Art, Washington: figs. 4, 12, 67, 73, 101

© National Gallery of Canada: fig. 21

© National Gallery, London / Art Resource, NY: figs. 168, 170

The Norton Simon Foundation: fig. 115

Philadelphia Museum of Art: figs. 98, 123

The Phillips Collection, Washington, DC: fig. 199

© Photononstop/SuperStock: fig. 74

Réunion des Musées Nationaux / Art Resource, NY: figs. 24, 100; photography by J. G. Berizzi: fig. 108; photography by Hervé Lewandowski: figs. 39, 57, 114; photography by Stéphane Maréchalle: fig. 15; photography by Philippe Migeat: fig. 97; photography by René-Gabriel Ojéda: figs. 33, 108, 171; photography by Jean Schormans: fig. 31

Saint Louis Art Museum: fig. 173

Scala / Art Resource, NY: figs. 11, 38, 137, 144, 145, 162

Stedelijk Museum, Amsterdam: fig. 190

Tate, London / Art Resource, NY: fig. 186

Steven Tucker: fig. 53

Jason Wierzbicki: p. 217 (Corot, *Little Shepherd*); figs. 3, 61–64, 78–82, 109, 110

Graydon Wood: p. xii; figs. 28, 71, 122, 126, 130, 155, 166